MUSEUM DESIGN

ADVISORY COMMITTEE

This project was sponsored by the Museum Program
of the National Endowment for the Arts
in cooperation with The American Federation of Arts.
Susan Anthony Loria was Project Coordinator, The American Federation
of Arts.

MUSEUM DESIGN

Planning and Building for Art

Joan Darragh and James S. Snyder

New York Oxford
OXFORD UNIVERSITY PRESS in association with
The American Federation of Arts
and the National Endowment for the Arts
1993

Oxford University Press

Oxford New York Toronto
Delhi Bombay Calcutta Madras Karachi
Kuala Lumpur Singapore Hong Kong Tokyo
Nairobi Dar es Salaam Cape Town
Melbourne Auckland Madrid

and associated companies in
Berlin Ibadan

Published by Oxford University Press, Inc.,
200 Madison Avenue, New York, New York 10016

Oxford is a registered trademark of Oxford University Press

Library of Congress Cataloging-in-Publication Data
Darragh, Joan.
Museum design : planning and building for art /
Joan Darragh and James S. Snyder.
p. cm. Includes bibliographical references and index.
ISBN 0-19-506458-5 — ISBN 0-19-506459-3 (pbk.)
1. Art museum architecture—United States—Designs and plans.
2. Building—Estimates—United States.
3. Art museums—United States—Maintenance and repair.
I. Snyder, James S. II. Title.
NA6695.D37 1993 727'.7'0973—dc20 92-8289

Museum Design: Planning and Building, for Art
is the result of a research project initiated
and funded by the Museum Program of
the National Endowment for the Arts.

PREFACE

New museum architecture has appeared on the American landscape in almost every year since the 1970s, the decade of the centennial celebration of independence. The future promises little change; regardless of economic conditions, museum building will proceed at some pace. With this in mind, the Museum Program of the National Endowment for the Arts initiated in 1987 a research project that has now resulted in this book, designed to inform members of the American museum community—trustees, staff, patrons, civic leaders, architects, consultants, and others—about the process involved in planning, designing, and building or renovating museums, as well as moving into them. The Arts Endowment asked The American Federation of Arts (AFA) to administer the project under Susan Anthony Loria's direction. Principal funding came from the Museum Program of the National Endowment for the Arts. Nancy L. Pressly, then Assistant Director of the Museum Program, was the project's director and provided the vision and stewardship that saw this work to its completion.

A skilled committee of eight individuals whose collective wisdom and experience in museum affairs were exemplary served as advisers: Thomas Beeby, Dean of the School of Architecture, Yale University; Joan Darragh, Vice Director for Planning and Architecture, The Brooklyn Museum; Thomas Krens, Director, The Solomon R. Guggenheim Museum, New York; Laurence D. Miller, former Director, Laguna Gloria Art Museum, Austin, Texas; Steven A. Nash, Associate Director and Chief Curator, The Fine Arts Museums of San Francisco; Frederick M. Nicholas, Chairman of the Board of Trustees, The Museum of Contemporary Art, Los Angeles; Stuart Silver, President, Stuart Silver Associates, Scarsdale, New York; and James S.

Snyder, Deputy Director for Planning and Program Support, The Museum of Modern Art, New York. Joan Darragh and James Snyder went beyond their advisory role and consented to write the book. We are greatly indebted to them for their special contribution.

In addition, many individuals in museums across the country contributed by providing firsthand information to the project's researchers and authors on all aspects of their own building program experiences. Both the National Endowment for the Arts and the AFA wish to express their gratitude to those who gave freely of their time and energies with surveys and interviews. The following twenty museums participated: The Art Institute of Chicago; The Art Museum, Princeton University, New Jersey; Boise Art Museum, Idaho; The Brooklyn Museum; The Chrysler Museum, Norfolk; Virginia; Dallas Museum of Art; Emory University Museum of Art and Archaeology, Atlanta; Museum of Art, Fort Lauderdale, Florida; High Museum of Art, Atlanta; J. Paul Getty Museum, Malibu, California; Laguna Gloria Art Museum, Austin, Texas; The Menil Collection, Houston; Montgomery Museum of Fine Arts, Alabama; The Museum of Contemporary Art, Los Angeles; The Museum of Modern Art, New York; The Newark Museum, New Jersey; Newport Harbor Art Museum, Newport Beach, California; Peabody Museum of Salem, Massachusetts; Polk Museum of Art, Lakeland, Florida; Arthur M. Sackler Museum, Harvard University Art Museums, Cambridge, Massachusetts; Triton Museum of Art, Santa Clara, California; and Virginia Museum of Fine Arts, Richmond.

Many other members of the museum profession also aided in the research that supported the book. We are indebted to them for their thoughtfulness and understanding and for the advice they gave during the course of this project.

The National Endowment for the Arts and The American Federation of Arts believe that this book will make all those involved in building, expanding, and renovating museums more confident and enlightened participants in that process.

Andrew Oliver, Jr.
Director, Museum Program
National Endowment for the Arts

Serena Rattazzi
Director
The American Federation of Arts

PROJECT DIRECTOR'S ACKNOWLEDGMENTS

As Project Director, I would like to convey my gratitude and thanks to the many colleagues who have provided assistance through every stage of this endeavor. It is not possible to acknowledge everyone individually, but it is a tribute to the importance of this project to the museum field and the generosity of the museum profession that so many gave unstintingly of their time and knowledge. Responding promptly to requests for photographs and other information, many shared not only their triumphs but also their frustrations and failures. This openness extended beyond the survey participants and contributed immeasurably to the success of the project.

In addition to the Advisory Committee, which reviewed all stages of the manuscript, I would like to acknowledge the assistance of the following individuals who read early manuscript drafts and commented on the technical appendices: Calvert Audrain and William R. Leischer, The Art Institute of Chicago; William Austin, J. W. Bateson Company, Dallas; Joseph M. Chapman, Chapman Ducibella Associates, Wilton, Connecticut; Kevin E. Consey, Museum of Contemporary Art, Chicago; E. Verner Johnson, E. Verner Johnson and Associates, Inc., Boston; Katharine Lee, Virginia Museum of Fine Arts, Richmond; Marvin Maas, Consentini Associates, New York; Paul Perrot, Santa Barbara Museum of Art, California; David Robinson, Architect, Robinson, Mills & Williams, San Francisco; and J. Andrew Wilson, Smithsonian Institution, Office of Fire Protection, Washington, D.C. I would also like to thank Paula Terry, Coordinator for Special Constituencies at the National Endowment for the Arts, for her assistance in the preparation of Appendix A, "Accessibility," and for working closely with its author, John P. S. Salem.

This project extended over several years and was coordinated at the Ameri-

can Federation of Arts initially by Maureen Keefe, who, with the assistance of Jennifer Beesley, helped organize the first Advisory Committee meetings, and starting in 1988, by Susan Anthony Loria, who took over as Project Coordinator for the AFA, assuming the bulk of the responsibility for its administration and successful completion. On behalf of all those involved in this project, I would like to acknowledge the dedication Susan brought to this project and the professionalism and good cheer with which she coordinated every aspect. I would also like to thank Mark Gotlob, Rachel Klein, and Michaelyn Mitchell at the AFA for expediting the final stages of the manuscript—Rachel, for securing photographs and reproduction rights, and Michaelyn, Head of Publications, for coordinating the final draft of the manuscript and overseeing the production phase with Oxford University Press, and especially for her skillful and expert professional guidance, for which we all are in her debt.

Finally, I would like to thank Andrew Oliver, Director of the Museum Program at the National Endowment for the Arts, for his unwavering support for this project and all the members of the Advisory Committee for their invaluable contributions, especially Joan Darragh and James S. Snyder, who stepped beyond their original roles as committee members and wrote this excellent guide.

Nancy Pressly

AUTHORS' ACKNOWLEDGMENTS

The first meeting of the Advisory Committee formed by the National Endowment for the Arts to shepherd the creation of this book took place in September 1987. It is a testament to the determination of the many who played a role in its evolution that it is now completed and broadly available in published form.

The authors are most indebted to Nancy L. Pressly, former Assistant Director of the Museum Program, National Endowment for the Arts, and Project Director for this publication, whose sincere and tireless commitment to this project's success never faltered. Our gratitude is further extended to Andrew Oliver, Director of the Museum Program, National Endowment for the Arts, and Serena Rattazzi, Director, and Myrna Smoot, former Director, of the American Federation of Arts, for their thoughtful optimism in fostering this project. Their support likewise never waned.

Our colleagues were deeply engaged with this process, and it was a memorable privilege to share ideas and information with them in the series of meetings that forged the outline of problems and issues we were then challenged to address in our texts. We are indeed grateful to them, and, particularly among them, special thanks is due Stuart Silver for his many extra insights and for his initial draft of the text material on exhibition design.

A formidable amount of research preceded our work on the texts. The comprehensive diligence of Liza Broudy in site visits to and interviews with our survey participants proved especially enriching as our chapters unfolded. Her technical appendixes at the end of this volume are also a sound reflection of her considerable experience in the field.

On Liza's behalf, we add thanks to those who worked closely with her,

giving generously of their time: Jeffrey Cruikshank, Cambridge, Massachusetts; Mike Roscoe, former Virginia Deputy State Fire Marshal; Roger Clisby, The Chrysler Museum; Ann Gunn, Princeton University Art Museum; William Lull, Garrison & Lull Associates; Richard G. Munday, Architect; Michael V. Padden, Architect; and a number of professionals who prepared technical reviews of certain chapters: Joseph Fleischer, James Stewart Polshek & Partners, New York; Seamus Henchy, The Brooklyn Museum; Michael Koeppel, Christopher Norfleet, Robert Profeta, and Cary Spiegal, HRH Construction Corporation, New York; and Bartholomew Voorsanger, Bartholomew Voorsanger Associates, New York.

Juggling the details of a project of this scope over an extended period is not an easy task, especially when the participants are scattered across the country. We therefore owe much gratitude to the staffs of the National Endowment for the Arts and the American Federation of Arts. As noted already, the project was coordinated for the AFA first by Maureen Keefe and, after 1988, by Susan Anthony Loria, who orchestrated the activities of the Advisory Committee and then followed our preparations for and completion of the manuscript with dedicated and uncompromising equanimity. Thereafter, Mark Gotlob, Rachel Klein, and Michaelyn Mitchell at the AFA were especially helpful to us in guiding the manuscript through the many stages of production. Michaelyn, as Head of Publications, deserves particular recognition for her role as liaison with Oxford University Press, providing sound editorial counsel with superior good sense.

We are also particularly appreciative of the high professionalism of Joyce Berry, Irene Pavitt, and their colleagues at Oxford University Press, who brought this book to life, reminding us always of the needs of the audience for whom we were writing, and to Susan Miegs for meeting the challenge of a first editorial review aimed at merging our two separate voices into a single text. Our thanks go as well to Barbara Christen for assisting us with the bibliography.

The manuscript production assistance provided by Wanda Sweat at The Brooklyn Museum and first Beth Handler and then Shawn Campbell at The Museum of Modern Art cannot go unnoted. Their collective stamina and good cheer deserve our respect and admiration.

Finally, we wish to thank Robert T. Buck, Director, The Brooklyn Museum, and Richard E. Oldenburg, Director, The Museum of Modern Art, for encouraging us to accept the challenge of this project; along with them, we also thank our many professional colleagues, staff and trustees, architects and building professionals, in both our museums and elsewhere, whose intelligence and experience have informed our work at every stage.

New York J.D.
New York J.S.S.
July 1992

CONTENTS

II DESIGN

III CONSTRUCTION

IV OCCUPANCY

MUSEUM DESIGN

INTRODUCTION

B Y THE MID-1970S, after the great building boom of the 1960s and early 1970s, many thought that the great era of museum building was clearly over and that the rapid expansion that had permitted the art rush of the 1960s was not likely to return for some time.[1] Yet as early as 1982, the Whitney Museum of American Art presented an exhibition entitled "New American Art Museums," which examined museum expansion during the previous five years when, once again, an unprecedented number of American art museums had constructed or were planning new buildings or new additions. Museum expansion continued unabated throughout the 1980s. It might be tempting now to say that this trend is indeed finally over, but the number of art museums still contemplating expansion or already in the design phase, among them the San Francisco Museum of Modern Art (Mario Botta) and the Museum of Contemporary Art, Chicago (Josef Paul Kleihues), as well as the J. Paul Getty Museum (Richard Meier), the Museum of Contemporary Art, La Jolla (Robert Venturi), and the Museum of Fine Arts, Houston (Rafael Moneo), would seem to suggest otherwise.

In response to this surge in museum building and our knowledge of at least fifty to sixty additional projects either under consideration or in the early stages of planning and implementation, the Museum Program at the National Endowment for the Arts initiated a project in 1987 to produce a book on the planning and construction of new art museums and the expansion of existing facilities. The intent of this project was to help museums become informed and knowledgeable clients, able to assume responsibility for the management of the museum-building process and able to create, along with the project team of architects and consultants, a building both aesthetically and func-

tionally appropriate for their needs. Its inspiration came from the awareness among museum professionals that while new art museums, many of which were unquestionably important architecturally, had proliferated, too many of these buildings did not adequately meet the functional requirements of the art museum. Despite enormous budgets, headlines and excitement, and obvious gains, many museum clients did not get the buildings they needed.

This book will try to clarify the numerous complexities inherent in the building process—particularly for board members, museum administrators, and professional staff who are profoundly involved with and affected by both the process and the result. They are the individuals who are often called on to make far-reaching decisions in the midst of the process without the benefit of previous experience or insight into the ramifications of their choices.

The Museum Program, with the assistance of the American Federation of Arts in coordinating and implementing the project, brought together a distinguished Advisory Committee that represented what might be considered the primary players in such an undertaking: architect Thomas Beeby from the firm of Hammond, Beeby and Babka, Inc., Chicago, and Dean of the School of Architecture, Yale University; art museum directors Thomas Krens, then Director of the Williams College Art Museum and currently Director of The Solomon R. Guggenheim Museum, and Laurence D. Miller, who was at the time Director of the Laguna Gloria Art Museum; Steven A. Nash, Chief Curator at the Dallas Museum of Art during the period in which its new museum was built and currently Associate Director and Chief Curator at The Fine Arts Museums of San Francisco; Frederick M. Nicholas, Chairman of the Board of Trustees at The Museum of Contemporary Art, Los Angeles, and during the period of the museum's construction Chairman of the Building Committee; Stuart Silver of Stuart Silver Associates, an internationally known museum design consultant who was Director of Design at the Metropolitan Museum of Art for seventeen years; Joan Darragh, Vice Director for Planning and Architecture at The Brooklyn Museum and project director for the museum's master plan; and James S. Snyder, Deputy Director for Planning and Program Support at The Museum of Modern Art, who directed the museum's 1984 expansion and renovation program.

This book is largely a result of the Advisory Committee's collaborative effort. Through a series of meetings held over an eighteen-month period, the committee debated the content and form of the publication and the critical steps and issues in each phase of the building process. The committee also reviewed outlines prepared with the assistance of Liza Broudy and, later, Jeffrey Cruikshank, as well as the results of a survey conducted with some twenty art museums across the country that had gone through or were in the midst of a building program.[2] Staff, trustees, consultants, engineers, architects, construction managers, and contractors involved in these projects were interviewed in an effort to obtain an overview of the institutional experience

4

as well as the individual (and not always concurring) perspectives of the various participants. The survey pool represented a cross section of size, complexity, and governance—from the large city museum undergoing a multiphase master plan supervised by staff with the assistance of outside consultants, to the small private museum where the motivating force and decision maker was the donor and where the staff remained isolated from the process.

It was ultimately deemed most appropriate that the text be written by members of the Advisory Committee, and we are immensely grateful that Joan Darragh and James Snyder consented to take on this assignment. James Snyder took principal responsibility for writing Parts I and IV, and Joan Darragh for Parts II and III. These pairings underscore how the conceptual evolution of a project, beginning with its planning phase, can be fully realized only when the new space is occupied and how, similarly, the success of the construction phase of any project is linked inextricably to the success of the design phase that preceded it. The authors also engaged in a critical dialogue over each other's work, further enriching the explication of the process as a whole.

It is fair to say that while the preparation of this book has been an immensely informative experience for all involved, it has also been a time-consuming one. For better or for worse, it was a process that seems to have replicated that of its subject—having taken longer, been more complicated, and cost more than anything we anticipated! We believe, however, that the results will have been worth the effort and that the dissemination of this type of information will be helpful to museums considering expansion. While directed primarily to the art museum, this book, it is hoped, will be of assistance to all museums and to the various individuals on planning, design, and construction teams—not only the museum staff and trustees, but also the architects, construction managers and contractors, technical consultants, public officials, and donors.

New museums have been among the most architecturally interesting buildings of the past few decades, having attracted some of the most talented and internationally recognized architects of our time. As a building type, the public museum dates back to the late eighteenth and early nineteenth centuries. Its origins in houses and palaces, where rooms were specifically designed to display works of art, are even earlier. Among the first museums to open to the public were the Capitoline Museum in Rome (1734), which was the first public gallery for the display of classical sculpture; the Museo Pio-Clementino, a series of galleries added to the Vatican between 1770 and 1786; the Musée du Louvre in Paris (1784–1792); and the Dulwich College Picture Gallery in London (1811–1814), designed by Sir John Soane. Perhaps the most influential source for museum architecture in the nineteenth century

was J. L. Durand's designs for an art museum published in *Précis des leçons d'architecture* (1802–1805). Consisting of central courtyards and a rotunda surrounded by galleries with alternative solutions for gallery spaces, they served, most notably, as a model for Karl Friedrich Schinkel's masterpiece, the Altes Museum (1823–1830) in Berlin. This monumental two-story building with an imposing flight of steps served in turn as the inspiration for such masterpieces as the 1893 design by McKim, Mead & White for The Brooklyn Museum and, even as late as 1941, the National Gallery of Art in Washington, D.C.[3]

The first art museum building boom in the United States, beginning in the latter part of the nineteenth century in response to centennial celebrations of American independence, was slowed only by the Great Depression of the 1930s and the outbreak of World War II in 1940. This period saw the creation of such major institutions as the The Metropolitan Museum of Art, New York, and the Museum of Fine Arts, Boston (both in 1870); The Brooklyn Museum; the Saint Louis Art Museum (1879–1881); The Art Institute of Chicago (1893); the Palace of Fine Arts (1915) and the De Young Memorial Museum (1916), both in San Francisco; the Cleveland Museum of Art (1916); the Detroit Institute of Arts (1927); the Philadelphia Museum of Art (1919–1928); and the National Gallery of Art (1937–1941), as well as the construction of new buildings for the Walker Art Gallery, Bowdoin College, Brunswick, Maine (1892–1893); the Corcoran Gallery of Art, Washington, D.C. (1896); the Albright(-Knox) Art Gallery, Buffalo, New York (1900–1905); and the Museum of Fine Arts, Boston (1906–1909), almost all of which were conceived in the classical mode. This period was followed by the creation of such classic modernist masterpieces as The Museum of Modern Art (Philip Goodwin and Edward Durell Stone, 1939); The Solomon R. Guggenheim Museum, designed by Frank Lloyd Wright in 1943 but not completed until 1959; and the Eliel Saarinen (1944–1948) wing at the Des Moines Art Center.

The work of a new generation of architects appeared in the 1960s and 1970s, in the completion of such indisputably important buildings as Philip Johnson's Munson-Williams-Proctor Institute in Utica, New York (1960), and Sheldon Memorial Art Gallery at the University of Nebraska, Lincoln (1963); I. M. Pei's Everson Museum of Art in Syracuse, New York (1961–1969), and his addition to the Des Moines Art Center (1968); Marcel Breuer's Whitney Museum of American Art in New York (1963–1966); the Walker Art Center in Minneapolis, designed by Edward Larrabee Barnes, Architect, FAIA, (1971); the University Art Museum in Berkeley (Mario J. Ciampi, 1971); Louis Kahn's Kimbell Art Museum in Fort Worth (1972), and Yale Center for British Art in New Haven (1977), completed after his death; the East Building of the National Gallery of Art (I. M. Pei and Partners, 1978); and the execution of the first stages of Kevin Roche and John Dinkeloo's master plan for the expansion of The Metropolitan Museum of Art.

The design of the American art museum has evolved from the nineteenth- and early-twentieth-century Beaux-Arts palace through a variety of modernist interpretations and possibly full circle in the form of many recent, historically referenced variations.

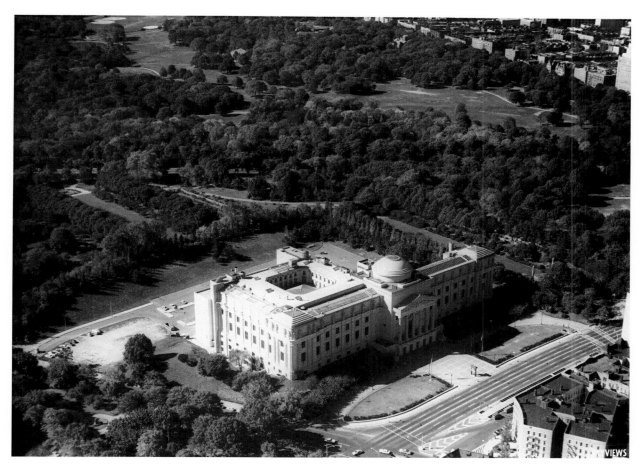

The Brooklyn Museum, Brooklyn, New York. North façade, showing the surrounding Brooklyn Botanical Gardens and Prospect Park (McKim, Mead & White, 1893–1927). (Courtesy The Brooklyn Museum. Photo: Skyviews Survey, Inc.)

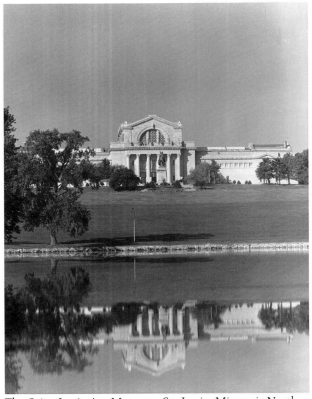

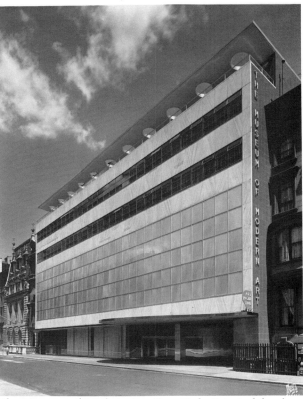

The Saint Louis Art Museum, St. Louis, Missouri. North façade (Cass Gilbert, 1904). (Courtesy The Saint Louis Art Museum)

The Museum of Modern Art, New York. Principal façade (Goodwin and Stone, 1939). (Courtesy The Museum of Modern Art, New York. Photo: Wurts Brothers)

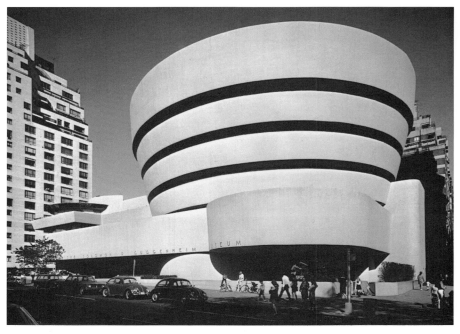

The Solomon R. Guggenheim Museum, New York. Principal façade (Frank Lloyd Wright, 1959). (Photograph copyright The Solomon R. Guggenheim Foundation. Photo: Robert E. Mates)

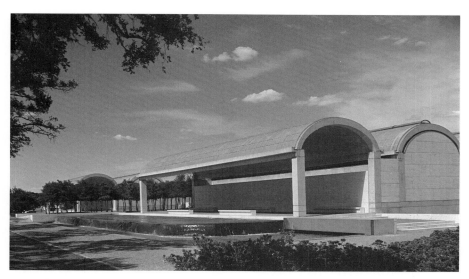

Kimbell Art Museum, Fort Worth, Texas. Principal façade (Louis Kahn, 1962). (Courtesy Kimbell Art Museum, Fort Worth, Texas)

Everson Museum of Art, Syracuse, New York. North façade (I. M. Pei & Partners, 1968). (Courtesy Everson Museum of Art, Syracuse, N.Y. Photo: Courtney Frisse)

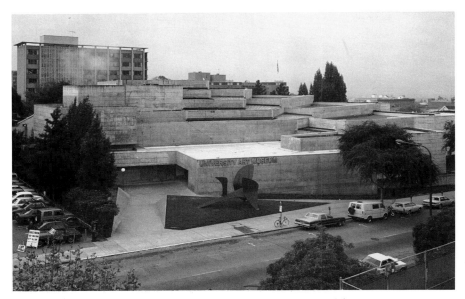

University Art Museum, University of California, Berkeley, California. Main entry (Mario Ciampi, 1971). (Courtesy University Art Museum and Pacific Film Archive, University of California at Berkeley. Photo: Benjamin Blackwell)

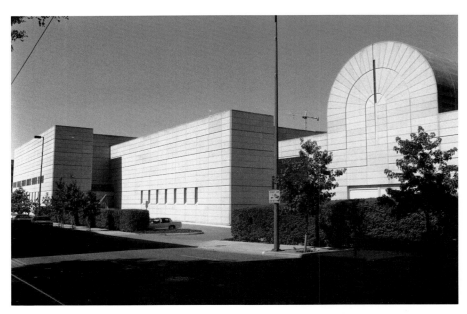

Dallas Museum of Art, Dallas, Texas. West façade (Edward Larrabee Barnes Associates, 1984). (Courtesy Dallas Museum of Art. Photo: Scott Hagar, 1991)

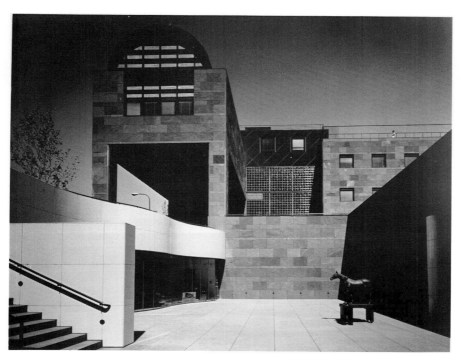

The Museum of Contemporary Art, Los Angeles, California. Principal entry (Arata Isozaki & Associates, 1986). (Courtesy The Museum of Contemporary Art, Los Angeles. Photo: Yasuhiro Ishimoto)

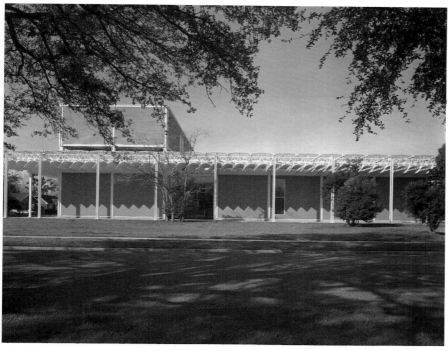

The Menil Collection, Houston, Texas. East façade (Renzo Piano, Atelier Piano/Richard Fitzgerald & Associates, 1987). (Courtesy The Menil Collection. Photo: Hickey-Robertson, Houston)

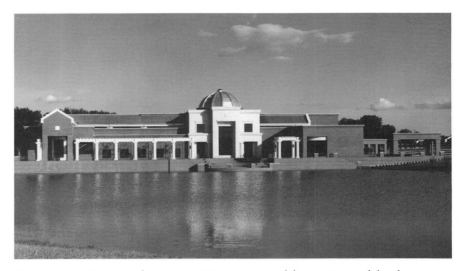

Montgomery Museum of Fine Arts, Montgomery, Alabama. Principal façade
(Barganier McKee Sims Architects Associated, 1988). (Courtesy Montgomery Museum
of Fine Arts, Montgomery, Alabama)

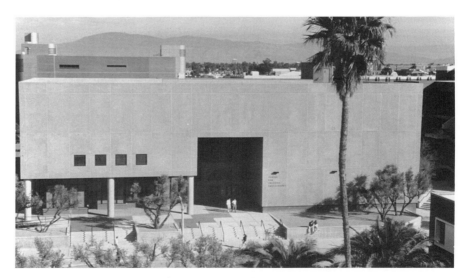

Center for Creative Photography, University of Arizona, Tucson, Arizona. Principal
façade (Burlini/Silberschlag Ltd., 1989). (Copyright Center for Creative Photography,
Arizona Board of Regents. Photo: Dianne Nilsen)

During the 1980s, numerous museums opened new buildings, among them the Dallas Museum of Art (Edward Larrabee Barnes Associates, 1984); the Portland Museum of Art, Maine (Henry W. Cobb, I. M. Pei & Partners, 1983); the High Museum of Art, Atlanta (Richard Meier, 1983); The Patrick and Beatrice Haggerty Museum of Art, Marquette University, Milwaukee (Ford, Powell, & Carson/Kahler, Slater, Torphy, Engberg, 1984); The Menil Collection, Houston (Renzo Piano and Richard Fitzgerald, 1987); The Museum of Contemporary Art, Los Angeles (Arata Isozaki, 1986); the Arthur M. Sackler Museum, Harvard University Art Museums (James Stirling Michael Wilford and Associates, Chartered Architects); the Polk Museum of Art, Lakeland, Florida (Straughn Furr Associates, Architects, 1988); the Center for Creative Photography, Tucson (Burlini/Silberschlag Ltd., 1989); and the Montgomery Museum of Fine Arts, Alabama (Barganier McKee Sims Architects Associated, 1988). There were also major new additions and/or renovations to the art museums at Princeton University (Mitchell/Giurgola Architects New York, 1988), Emory University (Michael Graves, 1985), Williams College (Moore Grover Harper, 1987), and Dartmouth College (Charles W. Moore and Centerbrook Architects and Planners, 1985), as well as to The Museum of Modern Art, New York (Cesar Pelli & Associates, 1979–1984); The Saint Louis Art Museum (Smith-Enzeroth Inc., with Moore-Ruble-Yudell, 1987); the Des Moines Art Center (Richard Meier & Partners, 1985); the Los Angeles County Museum of Art (Hardy Holzman Pfeiffer Associates, 1987); The Art Institute of Chicago (Hammond, Beeby and Babka, Inc., 1988); the Virginia Museum of Fine Arts, Richmond (Hardy Holzman Pfeiffer Associates, 1985); the Boise Art Museum, Idaho (Mark Mack/Trout Young, 1988); The Chrysler Museum, Norfolk, Virginia (Hartman-Cox Architects, 1988); the Memphis Brooks Museum of Art, Tennessee (Skidmore, Owings & Merrill, 1989); and The Newark Museum, New Jersey (Michael Graves, 1989). And, most recently, Robert Venturi's new building for the Seattle Art Museum opened in downtown Seattle in the winter of 1991/1992.

The expansion in museum architecture during this period has not been limited to the United States. Notable are James Stirling's wing for the Neue Staatsgalerie in Stuttgart (1984), the addition to the Museum für Kunsthandwerk, Frankfurt, by Richard Meier & Partners (1985), Hans Hollein's Museum für Moderne Kunst in Frankfurt (1991), Robert Venturi's addition to the National Gallery in London (1991), Moshe Safdie's new building for the National Gallery in Ottawa (1988), and Douglas Cardinal's Canadian Museum of Civilization (1990), also in Ottawa, to cite but a few.

Designing an art museum is a challenging commission for an architect. It brings with it intense public and critical scrutiny. The resulting building is potentially a monument of public pride and civic rejuvenation that few other building types can rival. It may also be a cornerstone of the cultural profile of a university campus, a city, or a region. The commission is demanding

because the art museum is very specifically designed for the needs and desires of a particular client (the building is usually occupied by only one institution) and because of the museum's complexity as a building type in terms of the exactness and sophistication of its mechanical systems and the high quality of finish demanded. In addition, there is relatively little consensus within the museum profession on such fundamental issues as natural light, fire suppression, or security, or exact standards for such central concerns as proper humidity (i.e., tolerance limits), air movement and condensation control, or structural loads. This lack of consensus extends to virtually all aspects of the design of exhibition spaces—the height of ceilings, the size of galleries, types of lighting, and the choice of surface materials and use of color.

In addition, while the primary mission of art museums to collect, preserve, present, and interpret works of art has changed little in the past 100 years, there has been a fundamental shift in the programmatic and institutional objectives of museums in response to changing social, demographic, economic, and cultural forces. The definition of a museum in philosophical and programmatic terms has evolved from a place of quiet contemplation of works of art to one that encompasses social and commercial activities, scientific investigation, scholarly research, and educational programs, as well as the presentation of not only the visual arts but other art forms as well. Increasingly, it is a place that must also be able to accommodate large crowds, providing not only adequate circulation space but also all the amenities necessary to serve the public.

Despite these challenges, the art museum has remained a coveted commission. As a building type, the museum focuses attention on architecture's dual nature, dramatizing the inherent tension between the needs of the user and the desire of the architect for an aesthetic statement. The challenge is "how to bring together the art of architecture and the art of art,"[4] providing a hospitable and physically interesting home for art, without the building as "object" rivalling the collections it houses and the functions it is supposed to perform.

This tension is not necessarily unhealthy. If the museum as client has a clear understanding of its collections and long-term programming needs and of the museum design process, it can be a strong client—and later, owner—and assume the same level of responsibility as the architect for the success or failure of the building. Working together in an atmosphere of mutual respect, architect and client can, through a process of trial and error, refinement and adjustment, bring a balance to the conflict between image and needs, form and function. Renzo Piano, for one, welcomes this kind of dynamic dialogue. He describes good clients as very tough and sufficiently educated, articulate, and confident to engage in the game of Ping-Pong, to which he likens the give-and-take of the healthy architect–client relationship.[5]

This book stresses the importance of the planning process and the need for the museum as client to have a clear idea of its mission and objectives and to

be able to articulate in very specific terms what it wants. Everything that follows depends on the success of the planning stage and the comprehensiveness of the architectural program. Planning not only is time-consuming, but also demands intensive involvement on the part of staff. It is complicated socially and politically. It necessitates arriving at a consensus of how a museum envisions its future and the image it wishes to convey to the community and the art world at large. Managed well, the planning process can generate the kind of community, board, and staff endorsement necessary to help ensure the project's success.

It is during this period that leadership generally emerges and a team is put in place to guide the building process to its conclusion. Inevitably, some members will change, but continuity is also necessary. This team helps to identify an in-house project director and implement a clearly understood decision-making process, including how decisions are conveyed to the staff. It is essential for someone to supervise the information flow and for people to know who should be informed and when, not only for staff morale but also for efficiency of operation. The museum's constituencies and neighbors and the political community must also be kept apprised of how the project is progressing. Managing the flow of information not only is crucial to good public relations, but also may prove critical to garnering support from various sectors in the community as the project develops.

As the project team enlarges and the architects, construction manager (or contractor), outside technical consultants, engineers, and construction personnel are identified, a clear communication network and management structure must be set in place. As Thomas Beeby noted during one of the Advisory Committee discussions, construction historically has been an adversarial environment in conflict, ideologically and economically, with each party thinking it is the most significant member of the team. One way to avoid this situation is to define the responsibilities of each professional member of the team and then hold him or her to them. The word *professional* is stressed, for it is essential for the core project team of architect, construction manager or contractor, and client to work together with a common goal in an atmosphere of mutual respect and trust. Regularly scheduled meetings and oral and written documentation are also essential. If an adversarial relationship develops among any of the primary participants, the project will suffer.

During the planning phase, it is also important to understand the quantum leap that occurs in economic terms when a museum expands. Our survey showed how difficult it was for museums to grasp the financial implications of the changes that were to take place, particularly without a historical basis to make accurate projections for operating costs, programmatic activities, space needs, and staff size—the last being consistently underestimated. The financial implications of sophisticated systems were also not well understood. Decisions made in relation to budget projections (and this can extend to responses to initial estimates of construction costs following the completion

of the architectural program) are one example of what Stuart Silver referred to in the Advisory Committee meetings as "red flag," or milestone, decisions of particular importance. Decisions made at such critical junctures can affect the entire process that follows.

The architectural program is the most important document to emerge from the planning phase, and it is the primary reference document for client and architect throughout the design and construction period. It should contain both a quantitative and a qualitative statement. The first is a technical document, including a clear description of space needs, programmatic activities, requirements of specific collections and support services and how they relate to one another, special access considerations for the physically impaired, and performance criteria for the various mechanical systems. Some of this technical information is very difficult to gather, especially that related to security, heating, ventilation, and air-conditioning (HVAC) systems, and fire suppression. Since technology changes so rapidly, discussions with colleagues are an essential means of keeping abreast of new developments.

Repeatedly throughout the survey, museums spoke of problems with their mechanical and security systems and how important it was to have staff who were conversant in such areas. This need for technical understanding extends to such basic design and construction concepts and terms as "net to gross," or what one committee member referred to as "the dreaded net to gross." Coordination among the architect, mechanical engineers, and other technical consultants very early in the design process was also considered crucial. Paul Winkler, one of the survey participants, noted that the art museum is a highly technical machine, and if the mechanical necessities critical to its functioning are not properly addressed from the beginning, the aesthetic image that both the architect and the client wish to achieve can be impaired.

The architectural program must also contain what The Menil Collection described as a "brief of ideas" explaining the philosophy of the museum, the image it wishes to project, and its conception of its programmatic role in the community. This qualitative statement should impart the museum's philosophy of how art should be seen and experienced. It need not be dry; rather, it can be an eloquent and compelling document providing the architect with a vision of the institution. While this information may also be intangible, it can be among the most valuable to be conveyed to the architect. It can be a series of declarative statements, such as "We want a response to art. We want a sympathetic environment for the public." Or it can be a more philosophical expression: the Getty Museum wished to emphasize the spirit of contemplation, beautiful light, and harmonious settings; The Menil Collection wished art to be the dominant presence in the building, where the primacy of the object would be stressed over didactic functions. Dominique de Menil also wanted a building with spaces sympathetic to art and human scale and in which there was an interplay of exterior and interior spaces and, very important, a contextual relationship to the older neighborhood of Houston.

Many of those surveyed indicated that despite careful programming, the staff and the building team can get so involved in technical discussions and management issues that they lose perspective on the purpose of the project, and the works of art can become secondary or assumed. The accommodation of art—the primacy of displaying and handling art—should be stressed at every major stage, from developing the architectural program, through selecting the architect, to reviewing designs and models, and, finally, to placing the works of art in the building. Colin Amery, a British architectural critic, states this priority most eloquently in describing the search for an architect for the National Gallery in London:

> When we were looking at the short list of candidates to build the new wing, one of the things we wanted to discover from the prospective architects—and I think we succeeded in finding this out—was how they react to pictures, and how they want us to react to the museum's pictures when they're hanging in their new setting. After all, that's the most important thing.[6]

Planning must also extend into the occupancy period, which can be the most rewarding—and stressful—part of the whole long process. The team approach to the building process should not stop with the purge of the last pipe and the laying of the last carpet. The survey revealed that staff were often inadequately prepared for the long shakedown period that most buildings require. They were also not prepared for the logistical challenges of moving works of art, reinstalling collections, settling into new offices, and preparing for opening exhibitions and official ceremonies, all of which often took place under the glare of intense publicity.

Last, in approaching a building project, there is also the human reality: the cost in time and emotion cannot be emphasized too strongly. The building process is implemented by people, and there are the inevitable disappointments, delays, frustrations, successes and failures, conflicts of ego, and differences of opinion. Burnout and exhaustion may affect all involved. Patience, compromise, tolerance, and, above all, leadership become essential. If we were to cite one recurring theme in the survey in addition to the need for proper planning, it would be the importance of leadership and how crucial it is for the client team to give authority to one person. Day-to-day decision making is too cumbersome for a committee, especially during construction. Looking back on the renovation and expansion of The Newark Art Museum, Samuel Miller, the director of the museum, offered this advice:

> I think it is important for people to realize as they enter such a project that patience is, of course, essential. Whoever is in charge has got to totally believe in the project so that he or she can act as diplomat to handle all the frayed nerves; the resident psychiatrist to cope with periodic nervous breakdowns; and finally be a task master, cracking the whip to keep the whole thing going.[7]

Frederick Nicholas, chairman of the Building Committee with a leadership role during the construction of The Museum of Contemporary Art in Los Angeles, provided similar advice: "A strong leader is essential, one who is dedicated, capable, politically astute, demanding of performance, mean if they have to be but also respectful and nurturing of the various talents on the team, encouraging them to do their very best."[8]

In many ways this book represents the cumulative experience of the museum field for over a decade. It cannot answer or even pose every question, but it can alert the prospective museum client to the key issues, to the importance of adequate planning, to the critical path of communication and decision making, to the teamwork necessary, and to the human reality that, as one Advisory Committee member phrased it, "building expansion is simply a tough business involving the disruption of the entire institution."

What is certain is that planning and constructing an art museum is a flexing, pulsating process: players and circumstances may change in midstream, and certain decisions and assumptions may have to be revisited. Institutions and individuals must be responsive to the possibility of frequent change and be prepared to compromise. What is also certain is that this is not a process that can achieve perfection. No two projects are alike, and there are no exact standards as to what makes a good art museum. There is no perfect building, but an informed and knowledgeable client ensures that the process will be well managed and, with luck, that the results will satisfy the needs of the three primary users: the works of art, the audience, and the professional staff. The purpose of this book is to help achieve this end.

NOTES

1. See, for example, Paul Goldberger, "What Should a Museum Building Be?" *Artnews* 74 (October 1975): 37. A decade later, Grace Glueck commented that there was "growth in art facilities across the country that makes the building spree of the 1970s, once thought to be abated, look like a practice run" ("The Art Boom Sets Off a Museum Building Spree," *New York Times*, 23 June 1985, sec. 2, p. 1).

2. For a list of the museums and the individuals who participated in the survey, see the Summary.

3. See Helen Searing's excellent essay on the art museum as a building type, "The Development of a Museum Typology," in *Building the New Museum*, ed. Suzanne Stephens (New York: Architectural League of New York, 1985), pp. 14–23, and, for a discussion of the art museum in the United States, Searing, *New American Art Museums* (New York: Whitney Museum of American Art, 1982), pp. 11–72.

4. Colin Amery, "Selecting an Architect for the National Gallery," in *Building the New Museum*, p. 27.

5. E. M. Farrelly, Peter Davey, and Charlotte Ellis, "Piano Practice: Picking up the Pieces and Running with Them," *Architectural Review* 171 (March 1987): 34.

6. Amery, "Selecting an Architect for the National Gallery," p. 26.

7. Samuel Miller to Joan Darragh, 18 September 1990.

8. Frederick Nicholas, conversations with Nancy L. Pressly.

I

PLANNING

During the past twenty-five years, there has been an extraordinary art museum building boom in the United States. The building of new museums and the expansion and rebuilding of existing museums have focused attention on the nation's art museums, reflecting both a rising tide of popular enthusiasm for the country's cultural resources and an assertion by the art museum community of its rightful place in the nation's cultural heritage.

Certain projects trumpeted the early phase of this phenomenon—flagships heralding the procession of new, revitalized, and expanded museum facilities that would follow in what has essentially become an institutional generation of new museum building.

In the late 1960s, The Metropolitan Museum of Art in New York engaged the nationally prominent architectural firm of Kevin Roche, John Dinkeloo and Associates to create, and over the succeeding twenty-five years to realize, an architectural master plan that would transform its grand but outdated and inadequately sized Beaux-Arts home into what would become during the 1980s one of New York City's highest attended tourist attractions and certainly one of the hubs of the city's cultural and institutional life.

In 1970, the National Gallery of Art in Washington, D.C., announced the selection of I. M. Pei, an internationally recognized architect, to design its new East Building. Over the next eight years, its evolution became the focus of widespread public interest and attention as the National Gallery staff worked to achieve advanced professional and technical standards within a grand and architecturally distinctive envelope; ultimately they created a dazzling symbol of the nation's cultural eminence.

Not that these two projects alone stimulated the boom of museum building that followed. Indeed, many other museums were concurrently embarking on projects of comparative ambition, reflecting nearly a century of growth in the collecting patterns and the professionalism and professional sophistication of American museums. However, the Met, as the largest art museum in the nation, and the National Gallery, as the nation's art museum, were extremely visible, and they were easily exemplary. Their success drew immediate and positive popular response, and that response seemed to signal a new and broad public enthusiasm for cultural enrichment. The demand triggered by this enthusiasm spread across the nation. In city after city, the need was recognized for new, expanded, and improved art museum facilities. Witnessing the beneficial success of such developments, communities themselves could initiate efforts to build and rebuild their museums to benefit from the newly demonstrated magnetism of expanded cultural enterprise. Observing the achievements of their sister institutions, other museums could emulate new technical and professional standards that they might, in projects of their own undertaking, hope to meet or even surpass. The continuing success of projects across the country only stimulated ever-increasing interest and en-

thusiasm, and the number of projects initiated and executed throughout the 1980s did not abate.

Will this pace continue? While conjecture may be pointless, it is appropriate to note that economic, governmental, and political changes nationwide and abroad can certainly affect such a trend. The close of the 1980s and the start of the 1990s have certainly suggested climatic changes that may slow new museum building. At the same time, the objective motivations for building in a given city or region, anywhere in the nation, are likely to be far more microcosmic.

New collections will be offered to existing museums that can commit themselves to the safe and appropriate care and keeping of these works only by renovating facilities or constructing new ones. Donors will offer funds to build facilities or the land on which to site them. Opportunities for mixed-use development may lead to joint-venture development to yield new cultural facilities. Cities or regions embarking on revitalization may identify museum or other cultural participation as central to their planning. While national and international economic and political trends may temporarily dampen the pace of expansion, these opportunities will continue to arise.

An enormous volume of experience has been accumulated during the past generation of museum building, and it is the goal of this book to distill the lessons of that experience for the nation's next generation of museum builders.

1

MUSEUMS NEW AND OLD: NOTABLE DISTINCTIONS

WHILE THIS BOOK will attempt to address issues common to the building process for all art museums—old, new, and in between—it may be helpful to begin by highlighting distinctions among them.

THE NEW MUSEUM ORGANIZATION

In considering the museum-building process, the simplest organizational form is perhaps the new museum. Since it has no existing facilities and no previous home, it must begin at the beginning, and its motivation to build is clearly and simply to create a home. If a preexisting facility is available for its use, it can potentially be occupied in its existing form, but that is unlikely. It is far more likely that the new museum, blessed with an available existing facility, would be faced with one of two basic options: restoration or adaptive reuse.

Restoration is the revitalization through careful refurbishment of existing structure and detailing that is of recognized architectural or historical significance. By its nature, restoration can limit the potential uses of an existing facility as an institutional home. On the other hand, the historical and architectural significance of a restored facility can sometimes enhance the new museum. Adaptive reuse—a more likely and more flexible approach—is the modification and reconstruction of existing architecture to make it suitable for the purposes of a new occupant. In either case, the process documented in the following pages will be instrumental to the successful preparation of a preexisting building to house a new museum organization.

Should a new museum not have the opportunity to adapt an existing facility, it must build from nothing, physically as well as organizationally. A new organization begins with the cleanest possible slate, free of the encumbrance of the preconceptions that invariably attach to a project initiated by an existing organization. And, with no physical or organizational history of its own, it must rely on the accumulated history of other institutions in the museum field for its base of experience.

THE EXISTING MUSEUM ORGANIZATION

Given their individual histories, existing organizations must respond to a broader range of motivations and options for physical growth or change than that available to new museums. The museum may need to grow or change simply as a result of the physical condition—or physical constraints—of its existing facilities. On the other hand, in the course of organizational growth

A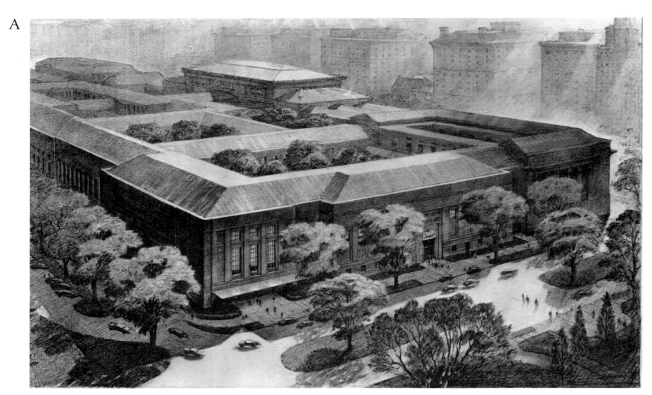

(a) An expansion plan, "Project for the Reconstruction of the Metropolitan Museum of Art in the Near Future," was published in Walter Pach's *The Art Museum in America* (1948). (b) More than forty years later, the museum is completing the master plan that evolved from its subsequent planning efforts, as shown in this aerial view taken in 1982. ([a] Hugh Ferris, Drawing of Proposed Changes. All rights reserved, The Metropolitan Museum of Art. [b] Courtesy Pan: Image/Robert C. Schwartz)

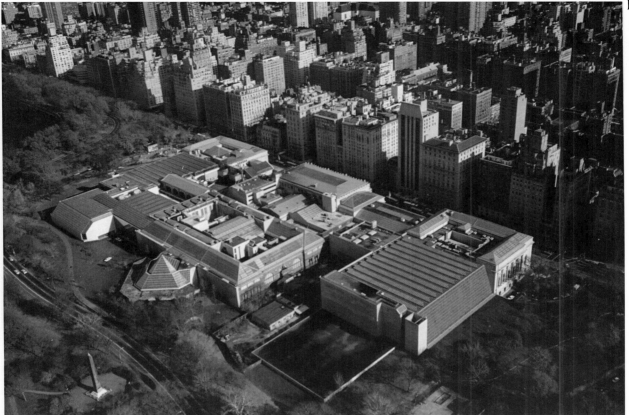

and development, it may form new or expanded goals that can be met only by re-forming, expanding, or creating altogether new space.

The stimulus to change or grow may be internal: the professional staff may feel that it is constrained or that it cannot fulfill its professional obligations to the museum's collections and visitors. It may be that these physical constraints are identified first by trustees or other governing authorities who perceive the limits of an organization's existing home. Or staff and trustees together may formulate future institutional goals that cannot be realized within the physical confines of an existing home. In all these cases, an existing organization's sense of its future needs will be based on its past experience and on the already realized potential of its existing facilities.

Assuming an existing physical structure, a first option is renovation. In all cases, renovation consists of adapting existing structures for rehabilitated use. If a structure has architectural or historical significance, a further consideration is whether historic restoration is necessary, appropriate, or even desirable.

Should an existing facility simply lack sufficient area to accommodate existing or proposed programs and services, expansion may be the solution.

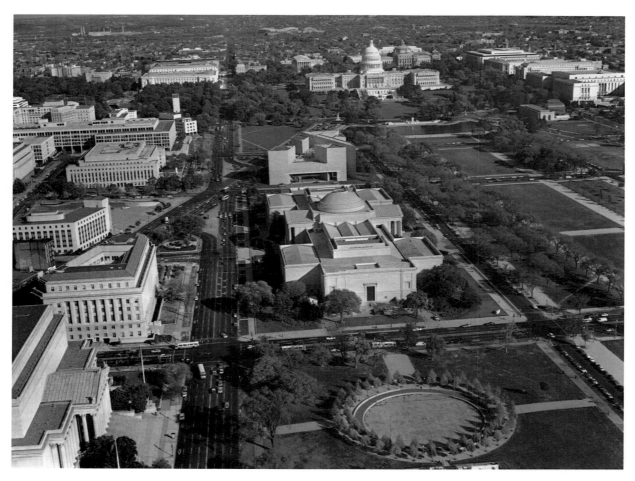

Although connected below-grade, The National Gallery of Art, East Building (I. M. Pei & Partners, 1978) (upper center), presents architecturally a discrete, free-standing addition to the original West Building (John Russell Pope, 1941) (center). (Courtesy The National Gallery of Art, Washington, D.C.)

Expansion may entail the annexation of a new facility to an existing one that remains unchanged, or it may necessitate some adaptive reorganization of existing space that can easily pave the way for renovating existing facilities in concert with adjacent expansion.

Last, an existing organization may determine that relocation to a new site is the most logical solution to its evolving needs, leading either to a search for facilities to be adapted for reuse or to an entirely new construction project at a new site. Although an existing museum can find itself in the same situation as a new organization, embarking on either the construction of a new facility or the rehabilitation of a facility that has been used for other purposes, there is one important distinction: the existing museum brings to the planning of new facilities its own accumulated experience. The new organization has no

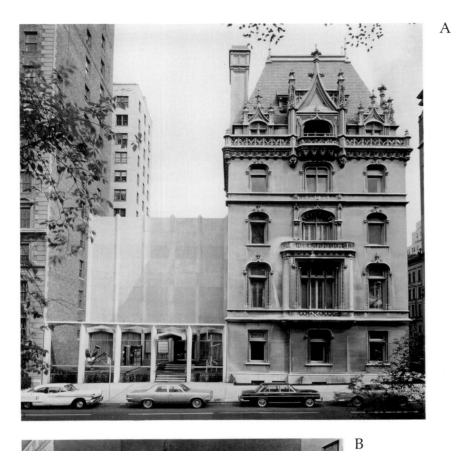

A

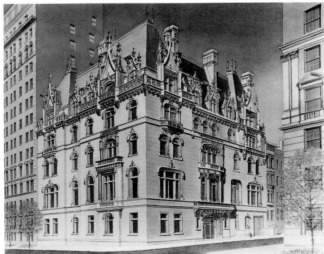

B

(a) The Jewish Museum, New York, which has occupied the landmark Warburg Mansion of 1908 (right) and the adjacent List Building Annex of 1962 (left), is currently undergoing an expansion and renovation for which the architectural solution is a replication of the Warburg Mansion's notable profile and detailing. (b) Rendering of the new Jewish Museum (Kevin Roche John Dinkeloo and Associates). ([a] Courtesy The Jewish Museum. [b] Courtesy Kevin Roche John Dinkeloo and Associates)

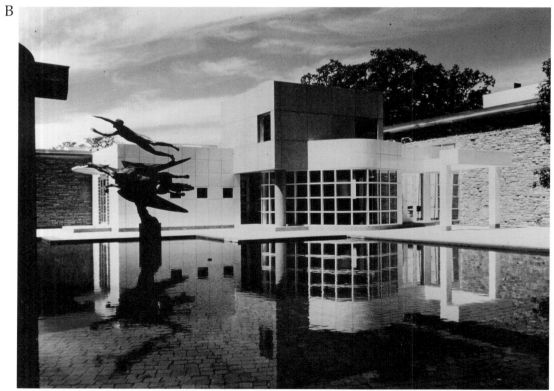

The Des Moines Art Center shows a distinctive example of the architectural evolution of museum facilities, through expansions to its original Eliel Saarinen building of 1944–1948, first by I. M. Pei in 1968 (a), and then by Richard Meier in 1985 (b). (Courtesy Des Moines Art Center)

such experience and must look to the museum field as a whole to reap the benefit of its collective history.

COMMON AND UNCOMMON CONCERNS

Any museum building project must spring firmly from a recognition and understanding of that museum's mission and purpose. The new museum organization must first formulate its mission and then decide on the needs that its new museum building will serve. The existing organization must assess and refine its mission and similarly decide how its needs can be met by renovation, expansion, or new construction. This effort initiates and then anchors any building planning process, whether for a new or an existing organization, whether in new or existing facilities.

Next, external forces, among them community, local government, and special constituencies of all kinds, including elderly and disabled patrons, may identify needs and concerns that must be addressed in planning for new space. Sometimes these forces actually provide the impetus for planning a new museum. A community in the midst of revitalization or in search of a fresh regional identity may instigate plans for a new cultural facility. Special constituencies may urge that an existing cultural facility be renovated or expanded to meet the needs of a changing community or to rectify what they regard as a museum's shortcomings in fulfilling a community's existing needs—for example, in complying with federally mandated requirements for access for the disabled.

Such external stimuli must be considered in context, as they must in any organization's planning for physical development. Building a museum is a process and must be managed as such. The conception of any project changes, is refined, and grows in response to a substantial volume of input from a variety of sources. However, what must always remain in sight and form the basis for decision making is an organization's underlying objectives for building.

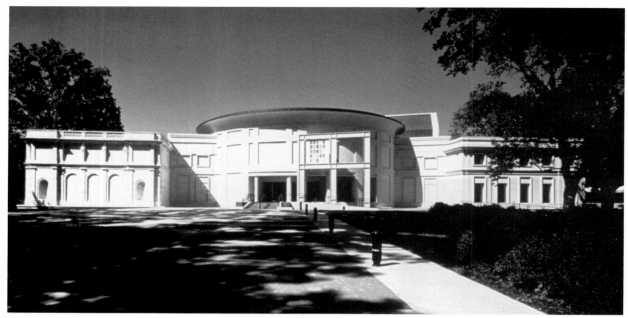

The present-day Memphis Brooks Museum of Art, Memphis, Tennessee, expanded its original building (James Gamble Rogers, 1915) (left), located in Frederick Law Olmsted's Overton Park, with a major new wing and Great Hall (Skidmore, Owings & Merrill, with Memphis project architects Askew, Nixon, Fergusen & Wolfe, Inc., 1989). (Courtesy Memphis Brooks Museum of Art)

The text that follows outlines the stages of this process in a manner that can be helpful to institutions embarking on building programs. The types of institutions may vary. The types of projects that they undertake technically—whether renovation, expansion, or new construction—may vary. But the considerations that should be made to help ensure success are essentially the same.

There are other aspects of a museum's organization and management that will warrant some degree of consideration. One is form of governance, a factor that has tremendous impact on the decision-making process. Museum organizations are either publicly or privately governed, and they are either independent or under the auspices of a university or some other larger organizational authority. A museum's land and buildings may be owned by the museum itself, by a city or other public authority, by a university, or by some other public or private body. These governance and ownership distinctions are critical, since they will determine the breadth of the cast of characters involved in the decision making that will shape a given project, and they

will dictate which authorities' approvals may be required, whose regulations need to be met, and whose constituencies need to be heard.

Also, all projects are conducted either as single-phase undertakings or as multiple-phase efforts that may be part of a larger plan—a master plan—envisioned over a long term. This distinction affects how a project's design is undertaken and establishes a horizon that may or may not suggest differing approaches to project management.

2
PLANNING:
AN OVERVIEW

E VERY MUSEUM MUST BEGIN the planning process for new facilities with a review of its mission. The conceptual cornerstone of any building planning process, the *mission statement* (or statement of purpose) is a concise articulation of a museum's goals and objectives, formed at its origin and preserved throughout its existence—preserved, but never static, since it must always reflect and respond to organizational growth or change. The outset of a new building planning process is a critical moment for reviewing a museum's mission, with the objective of forming it afresh (for a new organization) or affirming it or re-forming it (for an existing museum).

Having assessed—or reassessed—its mission, a museum at the start of planning for new facilities then moves to determine what is needed to fulfill the goals of the newly affirmed mission. The *needs analysis* may at this stage be a general statement with little in the way of quantifiable criteria, but it offers the basis for building a consensus among relevant parties about what may one day become a plan for an actual building.

After analyzing its critical needs, a museum then turns to a consideration of available resources, both exploitable resources (such as property rights, financial assets, and volunteer supporters), which can be instrumental in achieving needs, and resources that are to be nurtured by the realization of a building plan (among them its collections and professional staff). This *resource analysis* is most effective when it is conducted as part of a museum-wide long-range-planning effort, which also becomes critical at this stage. A *long-range plan* enables a museum to look at the implications, both fiscal and programmatic, of exploiting existing and prospective resources to achieve identified needs. Priorities can then be set for those needs, and what is

actually required to achieve them can be explored both financially and operationally.

These steps precede a formal building planning process, and indeed they represent in many respects the kind of long-range planning for future development that many museums strive to pursue regularly. What follows in a particular building planning process is to articulate a formal *program statement,* specifying a particular set of building needs, and then to proceed to develop the *architectural program* that will be the basis for planning and designing the corresponding museum facilities.

This process entails a significant investment of time, which necessitates the commitment of professional, volunteer, and financial resources. Some of the phases described here can and should be undertaken by professional staff and board members. Others may require outside professionals or representatives of special-interest groups. All phases require the committed participation of those involved and a willingness to engage in planning exercises that must lead to consensus on issues important to a museum's future. Executing these steps successfully forces a keen awareness of process, which can itself be beneficial. Further, it can stimulate a level of self-awareness that enhances the formation of a unified future vision and can, in turn, solidify the leadership needed to achieve that vision.

THE MISSION STATEMENT

The mission statement is an organization's first conceptual building block, forming the basis for its subsequent analysis and determination of needs. The mission statement can be simple: "the display on a temporary and rotating basis of contemporary works of art by regional artists." It can be general: "to help the public understand and enjoy the visual arts of contemporary times." It can be specific: "to assemble a collection of artifacts of Native American culture for interpretive display and to organize related educational programming for school-age children."

For a new organization, such a statement must then trigger a series of considerations:

1. What kinds of programs will be planned to carry out the organization's stated purpose?

2. What kinds of audiences—and in what numbers and with what ages, abilities, and levels of perception—will these programs be intended to serve?

3. What other ancillary services will be provided to accommodate these audiences?

4. What are the special requirements of the region from which these audiences are drawn?

5. What level of staffing will be needed to organize these programs and to manage them and the services and facilities needed to implement them?

6. What resources will be needed to sustain these programs and services, and how can they be assured?

By raising and answering these kinds of questions, even informally, one begins to build the theoretical frame of an organization's new home.

Since a new organization lacks a historical frame of reference, it must turn elsewhere for the wherewithal to posit needs and translate them into objective requirements for space and facilities. At later stages, when these requirements must become technically and quantifiably precise, professional assistance may be necessary and appropriate. At this stage, the best source of counsel for a new organization is likely to be sister institutions—both those that have a similar mission, regardless of their geographic proximity, and those that have a different purpose, but are nearby and may be serving similar constituencies. The pool of sister museums can in all cases be an extremely valuable resource. Museums may build only once within a given professional generation, so the experience garnered during the construction process may not have subsequent value for that organization itself, but it can be especially helpful for other newly forming museums, as well as for all museums embarking on new construction.

An existing museum presumably has a precise and defined mission that has over time formed the basis for its programming and for the development of its facilities. As it contemplates expansion or new construction, the museum must therefore consider its mission and either reaffirm it or revise it. While it remains critically important, as with a new organization, to ask afresh the questions about program, audience, service, staffing, and accommodation, the answers for the existing museum can be developed in relation to existing programs and facilities.

Determining the specific leadership hierarchy for decision making is critical at this early stage. Identifying the specific players for a given project and establishing hierarchical organization among them are essential to defining a procedure for decision making and assuring the identity of the project's leaders from the earliest stages.

As any project evolves, different people are key at different stages. And yet, from the very outset, certain players are essential, and they ideally remain constant throughout. In the best case, the individuals themselves are constants. When this is not possible, their roles must be so. This core group is necessarily composed of the museum's professional director, those designated by the director to be responsible for future planning, other representatives of the professional staff who can speak knowledgeably about professional issues, and a representative or representatives of the museum's governing authority.

If governments or other umbrella authorities, such as universities, play a formal role in the museum's governance, they, too, are typically represented.

Again, it should be emphasized that a group such as this is a core group. It will grow and shrink as needed during a project's life, and its precise formation will vary from institution to institution. However, it must always reflect a museum's leadership, both professional and volunteer, and its continuity is important, since much time will elapse between the first theoretical glimpse of a new or revised mission and the completion of a fully realized museum facility. It must also always reflect the knowledge and understanding of a museum's professional staff.

Recognizing these criteria for a project's core organization is key at the outset, since, over any project's life, many players may temporarily oversee stages of its growth and development. However, once completed, a new or renewed museum belongs to itself—to its board and to the professionals responsible for its operation. Establishing that sense of ownership at the outset, and reinforcing it throughout, will ensure that it remains intact when a project ends. At that point, a museum either begins or resumes functioning, and the volunteer and professional leadership that takes it forward must be at one with the leadership that has seen to its realization.

A practical corollary to the question of who the core players are is that of how to establish a decision-making hierarchy among them. What is essential is that there be a decision-making hierarchy. From the refinement or new articulation of the museum's mission through the execution of a project's last details, it must be possible to know where and how a decision on any matter is to be made (Fig. 1). Again, as a project evolves, the pool of participants grows and shrinks, grows again and shrinks again, making it all the more important that such a hierarchy be clear. Technically a museum's governing body has responsibility for all decisions affecting its operation and its well-being, and the authority to make such decisions typically is delegated to individual board officers or members, to the professional director, or to the director's staff. The way in which this responsibility for decisions is delegated varies among institutions, and it is therefore not possible to outline an optimal approach. There can be a formalized process practiced by a committee of identified players or a simple delegation of authority. And the method of delegation can operate differently for different levels of decision making.

Last, for both the new museum and the existing one, it is crucial, even in the initial planning stage, to be attentive to community issues that will significantly affect the identification of institutional needs. Like an institution's mission itself, which must be formed, affirmed, or revised as part of the initial assessment, community issues must be assessed. The new organization identifies and defines its community and discerns how its mission conforms with the desires of that community. The existing museum examines how the community has been served in the past, in what ways the community is

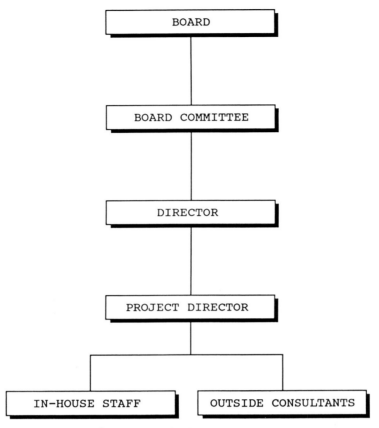

Figure 1. Project-planning organization.

changing, and to what extent the community's desires can and should be accommodated by the museum's evolving program. In all cases, changing demographics are an important consideration, since a museum's new facilities must be planned to serve communal needs for many years to come. If a museum's planning is sensitive to its community and if the community is made aware early on of the museum's desire for future involvement with community, then an important opportunity exists for the community to have a growing sense of ownership and participation in the realization of the museum's future. Where much in planning a museum building springs from within the museum's internal organization, whether existing or newly evolving, community is a major external force never to be overlooked.

THE ASSESSMENT OF NEEDS

Hard upon the consideration of mission follows the first assessment of what is needed to fulfill that mission. Simple as it seems, the assessment of needs is

in fact a complex step. It requires galvanizing the cast of characters outlined earlier to achieve the preliminary consensus that must precede any further planning. Without developing such a consensus at this stage, a museum cannot hope to bring a project successfully to its conclusion.

A needs assessment is literally an analysis of what an organization needs. It can begin as nothing more than a statement of physical requirements. This statement may be motivated by programmatic constraints, needs, or desires. It may be formulated by curatorial staff working within the constraints of an existing organization's physical facilities and shaped in part by the needs of patrons and visitors who, by virtue of age or disability, cannot use existing facilities. Or it may be motivated by financial needs or constraints, and it may reflect a financial analysis of an existing or a proposed new facility which indicates that a certain physical scale of operation is required to stimulate a viable fiscal operation.

A museum that has outgrown its collection or temporary exhibition space can assess an incremental need for gallery space in relation to existing spaces. If its collecting patterns are changing and it is increasing its involvement with new or different mediums, these shifts can dictate needs relating to physical scale or other technical requirements for incremental gallery spaces. A museum that is adding a film or performance program needs an auditorium or a performance space. A museum that is contemplating the addition of a food-service operation to generate revenue, to serve an existing audience, or to attract a new one needs a restaurant. A new organization, though, cannot develop its sense of future needs on the basis of any comparisons with current physical or operational constraints. It must look to its incipient leadership and to its sister institutions in developing this first critical step.

The needs assessment necessarily engages members of the core group, since their consensus and endorsement will be critical. Initiating this process may also be the first opportunity to engage more broadly the museum's professional staff. The director may by this time have delegated the planning responsibility to a senior staff member (for these purposes to be identified hereafter as the project director), or such a role may already exist in some museums in which responsibility for planning is formally delegated. At this stage, and on the basis of a new or recast mission statement, professional departments should be asked to articulate future needs. A formal survey or informal meetings and discussions can be used to generate an expression of needs at all levels of the museum's operation. It should also be made clear that this is a first assessment of future needs and requirements, disregarding physical or financial constraints and assembled before these needs are assigned priorities.

The objective of this initial assessment is to introduce the staff to the idea of planning to meet future needs and to stimulate creative thinking in this area. It is important to note that this is not necessarily a simple task, since

staff can be as much constrained by the routines of existing programs and facilities as challenged by the prospect of new environments in which to expand and improve them.

RESOURCES FOR BUILDING

One way to stimulate thinking about needs is to couple it with an analysis of resources, since, as a museum begins to consider what it will build, it must also focus equally on the resources that will support its construction planning. These resources fall into two categories: resources to be nurtured through the realization of a building plan and resources to be exploited in accomplishing it.

Nurturable Resources

Resources meant to be nurtured by the accomplishment of a building plan are those that any new building program must be geared to serve and that therefore must be given full consideration in the first formulation of needs. Building programs quickly take on lives of their own as they get under way and as they progress through design and construction. Along the way, it is not uncommon for a project's underlying goals—philosophical as well as programmatic, organizational, and functional—to become subordinated to more immediate concerns, such as making deadlines, effecting targeted budget reductions, or expediting construction schedules. While the urgency of such issues is not to be overlooked, it is also absolutely essential that an organization not at any stage forget the project's underlying objectives. A clear reckoning, from the outset, of the institutional resources that are intended to be strengthened by the accomplishment of a building plan can be a basis for establishing priorities throughout a project's life.

Collections

While all museums are chartered differently, most, if not all, are formed as repositories for artifacts of material culture, charged first and foremost with responsibility for the care and safekeeping of collections. Existing museums may have well-developed collections, together with mandates to expand or improve them. New museums may be the beneficiaries of collections and may similarly be mandated to see to the growth and strengthening of new collections. Both existing and new museums may be charged solely with the care and safekeeping of a static body of collection material.

At the core of nearly every museum's purpose, collections are an essential resource, the strengthening of which must be key to its objectives. Further, in the case of collections, the relevant planning issues are not solely philosoph-

ical and programmatic. Rather, they can be among the most physically and technically precise criteria that must be considered in any planning process. In addressing the care of its collections, a museum is therefore necessarily addressing issues of handling, storage, installation, environment, and life and safety. These issues are central to the formal development of a project's architectural program and will also affect most directly the extent to which a new building can nurture a museum's collections.

Programs and Services

A museum's ongoing programs and services are another key resource to be strengthened through new building. They include the full array of collection programs and services, exhibitions, library and research activities, film and performing-arts programs, and other public programs and amenities. As the manifestation of a museum's mission, they, too, must be evaluated, affirmed or modified, and perhaps expanded in the course of considering the opportunities inherent in planning a new building. Since programs and services are presumably well identified in the minds of a museum's constituencies, their future in the context of a new building plan may be key to retaining the loyalty and support of those constituencies.

Staff

The professional staff is, of course, a resource of paramount significance, with its collective knowledge and history of a museum's collection development and management practices, reflecting the level and professionalism of its programs and services. No one knows better the limitations of a museum's facilities or programs than those who have been obliged to work within their constraints. The planning stage is therefore the time to clarify the scope of the staff's responsibilities and to engage staff members fully with the planning process. They will be obliged to live through the planning, design, and construction of a museum project, and, upon conclusion, both to maintain past standards and to exploit the potential of new facilities to enhance collection practices and strengthen programs and services.

New building planning is often an opportunity for introducing changes or improving standards that an existing museum's staff may not readily appreciate. Outside experts may be needed to help staff members understand both what a new building can accomplish for them and how it can be exploited by them. However, this should be considered part of the nurturing process, rather than any reason to diminish the importance of the staff as a resource.

An important consideration in this context is to assess the physical abilities—and limits on physical ability—of the staff. As enforcement mechanisms for accessibility requirements become increasingly effective, it cannot be assumed that all future staff will be able-bodied, so planning for full accessibility is key to ensuring the unlimited utilization of staff as a resource.

Facilities

While it may seem obvious, both existing facilities and those to be newly created need to be considered as nurturable resources. Existing facilities fall into this category for several reasons. First, whether new or old, existing museum buildings are symbols of institutional and, in many cases, civic pride. Not all are literally the Beaux-Arts productions of earlier museum generations in the United States, but even such disparate architectures as the Guggenheim Museum in New York and the High Museum in Atlanta exude the institutional and civic force and forcefulness of their Beaux-Arts antecedents. In more mundane terms, they also offer a basis on which to judge what works physically and what does not. They provide concrete examples of physical limitations, and they can serve, in effect, as testing laboratories for methods, details, technologies, and the like. And if a project involves restoration, rehabilitated use, or the expansion of existing premises, then these facilities literally *are* the resource around which a building plan is to be developed, so that the scrutiny and cultivation of existing buildings can be enormously important.

Newly created facilities must from the outset be considered as nurturable resources that will, by definition, provide the setting for a museum's future programs and services. They will also fulfill the operating potential that the museum, by studying its physical needs in the context of its future objectives for program development and financial stability, will expect from its new facilities—ranging from program offerings and architectural environments that will stimulate attendance and membership participation, through bookstores and restaurants to generate revenue, to technologically advanced operating systems that can effect cost savings.

In considering facilities as resources, museums can begin to recognize the importance of proper maintenance, repair, and replacement to both new facilities planning and longer-term operational planning. Museum buildings, like all others, have a useful life beyond which they cannot perform effectively without concerted attention being given to maintenance, repair, and replacement. Traditionally, many museums have not been well enough funded to provide what may have seemed, in the past, to be the luxury of an available budget for these purposes. Indeed, the astonishing level of new museum construction in the United States over the past two decades has been occasioned in no small part by the need to replace the worn-out museum buildings of earlier decades.

If museums force themselves to allocate funds for this purpose on an annual basis, by recognizing the need to nurture their buildings (whether new or old), the new construction projects of the future can focus increasingly on programmatic and functional issues and less on urgently needed physical replacement. And, in the interim, facilities can function fully as the resources they are intended to be.

Constituencies

Repeated reference has been made to the constituencies from whom the museum must elicit guidance and support and for whom it provides its facilities, programs, and services. Together, they represent the last nurturable resource for consideration here, to be cultivated throughout the planning for new facilities. A museum charged with the care and safekeeping of collections does so for the benefit of its visitors, both its general public and its specialized constituencies. Its programs and services are provided primarily for its visitors, whose needs its facilities must accommodate. Visitors can be effective indicators of the limits of existing facilities and can form the core of an expanded pool of future visitors to new facilities.

In considering the legal and regulatory requirements of government and the local community in developing new building plans, the special-interest sectors of a museum's audience, among them disabled and elderly patrons, can also be an effective resource for information about what has and has not worked in the past, and what will and will not meet the future needs of constituent groups.

Exploitable Resources

With a very few exceptions, museums typically have had at their disposal relatively few exploitable resources that have the potential to contribute significantly to the successful realization of a project. They can also influence the form a project takes—in its organization or financing or, more literally, physical development—and must therefore be considered at the outset, as needs are being determined. Those resources that do exist must be cultivated with care, and special care must also be taken to ensure that less traditional resources are not overlooked. The wave of museum construction and expansion during the past two decades has yielded a range of innovative methods for making better use of traditionally valuable or not so valuable resources.

Board and Volunteer Leadership

One must begin by recognizing the value of an organization's board and volunteer leadership. This group often represents a community's deepest commitment to the organization, being made up of individuals who can bring to the organization a range of skills, experiences, and connections that considerably expand its own internal resources. These may include specifically applicable professional skills in project development, construction management, and real estate. They most certainly will include ties to organizations and individuals outside a museum's own family, which will be important as the museum considers external obligations and if, as its planning evolves, it requires the endorsement and support of its community. Board and volunteer leaders play a significant role in any fund raising, particularly when a special

A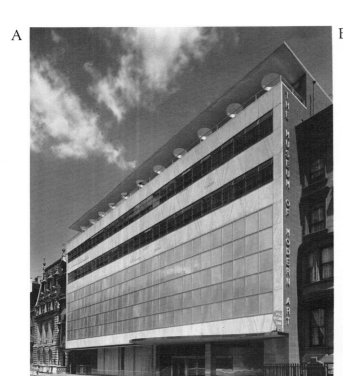

B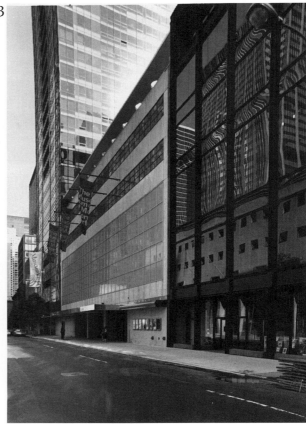

The influences of urban siting and mixed-use development potential are exemplified by the evolution of the architecture of The Museum of Modern Art, New York. (a) Its 1939 building by Philip Goodwin and Edward Durell Stone turned its back on the Beaux-Arts traditions of earlier American museums and presented an understated façade to its distinctly urban street setting. (b) The museum's 1984 expansion by Cesar Pelli, incorporating the mixed-use component of a contiguous, privately developed residential tower, doubled the length of its street-front presence. (c) The expansion also provided for the integration of its central garden element, originally designed by Philip Johnson in 1953, with its expanded facilities and the adjacent residential tower. (Courtesy The Museum of Modern Art, New York. Photos: [a] Wurts Brothers; [b] Adam Bartos)

effort is mounted for a building campaign. In all these areas, board leadership becomes crucial to a project's success and can only be helpful in achieving building objectives.

Local Alliances
Cultural, political, financial, and legal alliances within a museum's community, either through formal associations or simply through the network of community involvement, are an essential resource. Regardless of whether a project is developed by a private or a public museum, involving privately or

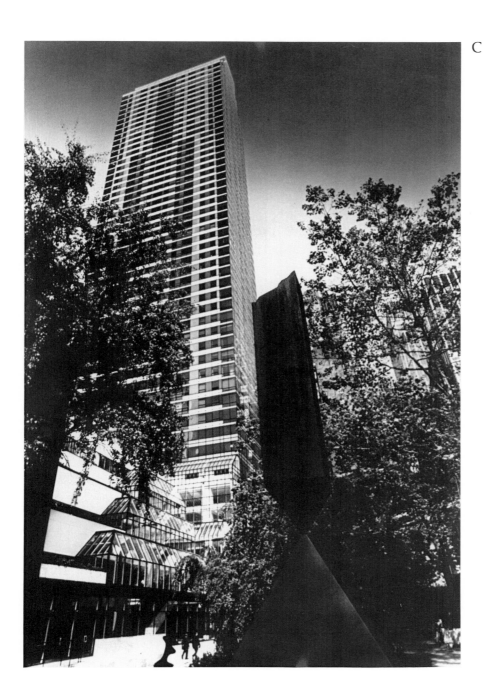

publicly owned land and facilities, it acquires at some stage a public profile in its community and is therefore subject to public scrutiny. In this regard, for example, the passage in 1990 of the Americans with Disabilities Act means that any disabled person can bring suit against a place of public accommodation, such as a museum, for failure to provide access. Working toward a consensus with local disability groups early on can help avert such problems.

In general, the importance of consensus building, internally and externally, publicly and privately, in support of an organization's building planning will continue to be stressed throughout this discussion. What is relevant here is the paramount significance of local alliances as a resource to be mined from a project's earliest stages.

Financial Assets
An organization's financial assets, and its capacity to generate them, are a key resource. Traditionally, funding for building programs has been secured in a limited number of ways. A handful of particularly well-endowed museums may simply have unrestricted funds available for construction. More typically, a museum's professional and volunteer leadership organizes a fund-raising campaign to tap its own and its community's giving potential, using a building program as the impetus for such efforts. Publicly owned museums may also have the option of supplementing such efforts through the capital-funding budgets of their local governing authorities.

During the past twenty years, with the dramatic rise in museum building projects in this country, museum organizations have grown more innovative in their use of other forms of financing and have exploited existing financial assets or fund-raising potential in a somewhat different manner: they have been able increasingly to look to public authorities to issue tax-exempt financing to fund building projects, secured by existing unrestricted funds, by pledges to fund-raising campaigns in progress, or by an organization's operating revenues. Whereas universities and hospitals have long used existing or anticipated financial assets to secure other forms of financing, museums have only recently begun to do so. The list is long and ranges from The Museum of Modern Art to the Dallas Museum of Art, from the Museum of Fine Arts in Boston to the Polk Museum of Art in Lakeland, Florida.

Colleagues in the Professional Network
As more museums in the United States have had the experience of building new facilities, the museum community itself has become a remarkable resource, and no museum should undertake a building program without exploiting it to the fullest. Problems and particulars may differ in their specifics; but the overriding concerns of museums as operating organizations that store and display collections and receive and serve the public are the same, and the accumulated experience of the field is invaluable.

Site and Property Rights
Perhaps in no other category have museums grown more resourceful in recent years than in the utilization of real estate and related property rights for the benefit of their own physical growth. Examples abound from around the country of instances in which museums have been able to utilize the value of property or property rights they own or control to provide the wherewithal

to expand, build, or rebuild facilities. In New York, The Museum of Modern Art entered in 1979 into a real-estate transaction through which it transferred unused development rights for sale to a private developer, realizing a $17 million gain in its unrestricted funds and providing the impetus for the financing and construction of a major expansion and renovation program. In Los Angeles, The Museum of Contemporary Art came into being through the commitment of a private developer to allocate land and construct a museum facility as part of the terms of an urban-redevelopment transaction under the aegis of that city's Community Redevelopment Authority.

The particulars of the many stories such as these are fascinating in the details of their execution. But what matters in each case is that the museum was able to utilize the value of the property on which it sits or proposes to sit, whether privately or publicly owned.

The potential benefits of site and property rights also bring with them related concerns. For example, opportunities to participate in new development can involve site issues that are controversial. Location, uses of contiguous property, mandated design criteria, and other site restrictions are only a few of the site-related issues that can engage museums in controversial and therefore potentially protracted and publicly visible situations. While such issues should not prevent a museum from pursuing significant benefits, it is also important to recognize potentially offsetting disadvantages.

Facilities

A museum's own existing facility—or a new museum's prospective facility, if it is an existing site—may be an exploitable resource. It may be a historic building or a landmark site, with significant potential for restoration. It may have signature value for a particular community or constituency that can be realized in the form of community endorsement or financial support.

To understand the potential and the limitations of existing facilities, it may also be useful at this preliminary stage to commission an engineer's report to understand their condition and to uncover any compliance issues relating to health, safety, and access for the disabled that would have to be addressed as part of any subsequent plan development.

It is important to note that while the focus here has been on the potential benefit to be derived from exploiting and cultivating resources, existing resources can also represent limits that must be reckoned with realistically in an effective planning process. The prospect of a cold shower of reality should never be wholly forgotten during deliberations; in this regard, reckoning realistically with the limits of a museum's resources can be a very useful exercise. There are physical limits to any given site. There are financial limits to the philanthropic capacity of a museum's supporters. There may be dis-

A

B

46

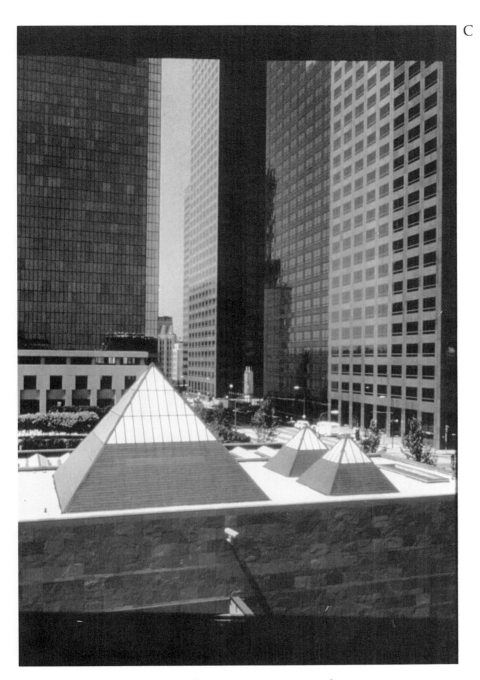

The Museum of Modern Art's evolution in response to an urban context compares with the more recent story of The Museum of Contemporary Art, Los Angeles, California, which was born of the desire to include a significant cultural component in a major downtown redevelopment plan. (Courtesy The Museum of Contemporary Art. Photos: [a] Squidds & Nunns; [b] Tim Street-Porter; [c] John Eden)

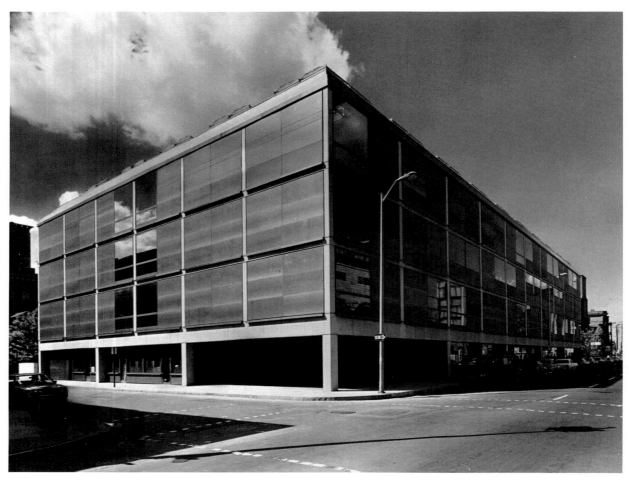

The Yale Center for British Art, New Haven, Connecticut, evidences new museum design responding directly to its urban context, with retail shops incorporated into its street-level façades. (Courtesy Yale Center for British Art. Photo: Tom Brown)

tinct limits to the extent to which certain kinds of collections and certain forms of programming can be developed. Nonetheless, the recognition that such limits exist is intended not to cool the enthusiasm with which a museum undertakes a building project, but to ensure that its planning ultimately does not stray from the reality of what is feasible.

LONG-RANGE PLANNING

At this stage, an informal, museumwide assessment of future needs is well under way, perhaps accompanied by an analysis of the resources just described. Since these expressions of needs are neither edited nor assigned any

order of priority, they are as likely to represent desires as needs. They are likely to be disparate, redundant, and possibly even contradictory. Nonetheless, the objective has been to stimulate informal and creative thought, rather than to solidify a singular conclusion. This process has been successful if it has engaged the museum internally and if it contains the kernels of what may eventually become formalized as the program for a particular museum building project.

It is possible, although not essential, to attempt to summarize a museum's process thus far in an informal statement of need, based on its consideration of its mission and its unedited needs assessment in light of any and all existing resources. This exercise can highlight the extent to which a museum is undergoing institutional self-assessment as a first step toward new museum planning. It does not, however, take into consideration significant long-range issues.

Since every judgment that is made in assessing a museum's mission and its needs affects its future operations, no building planning process should proceed without the concurrent development of a related long-range plan. A long-range plan provides the context for considering the future implications of physical planning to meet physical needs. This context should be established early, when the museum begins assessing its physical needs. It should then be examined regularly throughout the building planning process, so that the museum can determine at an early stage the operational and financial consequences of decisions about physical space and the programs and services that various areas are intended to house.

Physical planning is planning for change. Successful physical planning yields at its conclusion a new physical reality with resounding implications for an organization's future operation. Considering physical growth in the context of a full-scale, long-range plan enables an organization to anticipate change and the implications of change in every aspect of its operation. Where the process of assessing needs looks to the past and the present, such considerations can then be expanded for the purposes of long-range planning.

Programs and services. What programs and services, both curatorial and educational, will be provided in a new, newly expanded, or newly renovated or restored facility? Are these an extension of existing programs and services, or are they new?

Staffing. What staffing will be required to create these programs and services? What staffing will be required to produce and operate them?

Audience. What audience or audiences will these programs and services be designed to reach? Are these new or existing audiences? What are their characteristics, and how will these change over time in light of shifting demographics? What staffing will be required to reach them and then to serve them? Is this existing or new staffing?

Operating implications. What is entailed in operating, maintaining, powering, and securing the new facilities that will house these programs and services? What are the related new and/or incremental staffing requirements?

Financial implications. What are the new or incremental costs associated with achieving the levels of programming activity outlined earlier? What are the financial implications? What are a particular organization's objectives for its bottom line? What are the revenue opportunities, either new or incremental, associated with the levels of programming, service, and operation outlined earlier?

Fund-raising implications. What kinds of endowment and operating support goals must be established to enable an organization to use new facilities and to achieve desired levels of programming and service within financially responsible parameters? What is entailed in determining the feasibility of these goals?

Government and community concerns. How do government and community concerns and responsibilities affect planning in all of the above areas? What are the special requirements for physical accessibility? Are there obligations for certain levels of community participation? What is the composition of the community as a whole, and are special audiences or constituencies to be addressed?

The questions are many and substantial, and much discussion could be devoted to each. The point here is to emphasize that this range of questions should be raised from the outset: the first assessment of needs should stimulate thinking about all these other considerations and can, in the process, trigger effective long-range planning.

Such a process may not be neat, and it may be composed of a number of separate but related parts. However, it should always involve the leadership group described earlier, and it should always recognize that, from the very start of a building planning process, there are reverberations that affect all aspects of an organization's future operation. To the extent that such an effort is effective during the course of a building program, it can also become a tool for first forecasting and then measuring an organization's ongoing performance, and it can reinforce strongly the notion that the theory of an early physical planning effort does one day become the reality of a new, renewed, or expanded museum operation.

3

THE FORMAL PLANNING PROCESS

Our discussion until now has been about laying the groundwork for a building planning process. It has been about institutional self-assessment and about putting in place certain mechanisms for evaluating past and present in the context of future. It has also been about galvanizing professional and board leaders and staff and volunteer participants, sensitizing them to physical-planning issues, and beginning to engage them in considering future needs.

What follows will describe the steps from the broad and informal assessment of needs and resources to the first formal stage of a museum's building project: the making of an architectural program. First, it is important to underscore two essential criteria that will ultimately be key to a given project's success: formation of vision and solidification of leadership.

First, an organization must have or form a vision of its future needs, determined by now from the consideration or reconsideration of its mission. Its clarification of that mission will provide the foundation for a particular building plan. In the course of a building project, many distractions can arise. Pressures invariably build on many fronts. Time, financial constraints, and conflicting objectives can divert an organization's planning from its underlying goals if a clear vision of those goals is not always firmly in place.

Second, it is equally important that project leadership be securely in place in order to ensure that this vision forms and that it prevails during the rigors of the building process. Professional, board, and volunteer leadership must guide a project throughout its life, endorsing its vision, eliciting support for it, mining and enriching its resources, and fully realizing its vision in the completed building. It is essential that the communication network, initiated

tentatively and perhaps informally earlier, be put in place securely as the leadership moves from the consideration of needs and resources to the development of a particular project's scope.

Internally, this communication network must ensure that the professional leadership can use the experience and expertise of the professional staff. Externally, it must apprise constituents of a project's development and gauge levels of support. Both internally and externally, responsiveness is key, so that open communication is essentially a way to guarantee that those who plan and build stay in touch with those who use and support.

MAKING A PROGRAM STATEMENT

With the immediate goal of forging the outline of a building plan from the earlier broad consideration of needs, a museum's leadership will move to create a *program statement.* This document can take many forms, and its presentation can be detailed or general. However, it must include an outline of physical needs, intended to meet a carefully considered set of program, financial, and operating requirements.

This statement must be prepared either by the museum's leadership or on its behalf. In an existing organization, it is likely to be generated internally, by the professional director, by his or her planning staff, or by other senior staff designated by the director. In a new organization, it may be prepared by or under the aegis of the volunteers or board members who participated in the organization's formation, if professional direction is not yet in place.

Since at this stage the document does not have to be technical or detailed, it is not necessary to seek the kinds of specialized expertise that will become important at later stages of the project. If outside consultants are engaged, their purpose is more likely to stimulate and clarify thoughts about the organization's future goals than to identify the specific needs of a facility. This sort of counsel can be provided by a long-range-planning consultant or a strategic-planning consultant and should at this point be limited to helping an organization's leadership distill its ideas for the future. Initially the program statement may be as simple as "to provide gallery space for the display of new work by regional artists and studio space for regional artists to conduct studio workshops for high-school and college-age students." Certainly it can also be far more complex, depending on the size and developmental sophistication of the organization.

Note here again the critical designation of leadership, since it is from this point forward that it must be asserted. And it is from this point that an organization needs to consider how its leadership can effectively organize its building planning. The board president or a member of the board may take a leading role, which may lead to the creation of a board committee devoted to

new building planning. Internally, particularly at this early stage, the professional director may well shoulder the burden of preliminary building planning, since he or she is also necessarily the organization's key professional spokesperson for its future goals. Depending on a museum's size and complexity, its director may from the outset delegate this and subsequent planning stages to a senior staff member, under whose jurisdiction this form of planning may already fall, and who, as a given project develops, will be designated as the project director.

In devising a program statement, it may be helpful to summarize the steps that have already been taken to narrow the museum's focus to a particular set of building objectives. First, a museum's mission must be articulated. Second, there is discussion of the programs and services, both curatorial and educational, that must be sustained, expanded, or revised to meet the museum's goals. Third, the needs of the facility are reviewed. This process involves consideration not just of gallery spaces and other public spaces, but also of all ancillary support and circulation spaces necessary to accommodate the programs and services that fulfill a museum's mission. Fourth, there is an assessment of staffing needs that will also affect the creation and maintenance of facilities. At the same time, there must be consideration of expanding operational and financial requirements for all aspects of the organization.

The program statement will not include precise criteria (the architectural program will include that information), and it is meant to be neither neat nor definitive. It will, however, trigger the important task of exploring a particular project's long-range feasibility, a process that will unfold sequentially through three separate but related steps.

Spatial and Architectural Feasibility

From a simple outline of needs, a museum can begin to approximate the gross volume of space that would be required to meet them and then immediately to assess the potential and limits of existing sites and facilities and to understand the limits of existing locations. If entirely new sites or facilities are to be involved, however, this exercise can develop in reverse: first approximate space needs are projected and then criteria are developed to establish minimum facility and site requirements. In either case, the result should be the calculation of gross volumes of generic space, to be either newly constructed or reconstructed, to fulfill future needs.

Funding and Fund-raising Feasibility

With a preliminary sense of the gross space that would be required, the museum can begin to assess, again in generic terms, related costs of construction. These costs can provide a first indication of the funding requirements

for a given project, thereby presenting the first opportunity to consider the feasibility of raising the level of support needed to undertake it.

Future Operating Feasibility

In this same vein, by envisioning a new facility on a certain physical scale, financial and operating staff can develop theoretical operating scenarios and consider their financial consequences. Existing organizations must consider levels of unrestricted support, traditionally in the form of endowments and other kinds of annual contributions, that may have to be expanded to make the operation of a new facility viable. Here fund-raising professionals, who have already begun to focus on capital needs to construct a new building, must coordinate their efforts with those of professional staff, whose focus is on financial and operating issues.

Architectural planning, fund-raising capability, and financial and operating analysis are the interrelated components of project planning that must be integrated from this stage forward in a project's development. For an organization with long-range planning already in place, this is familiar territory. For a new organization, the act of visualizing future physical development can be the impetus for formalizing a long-range organizational plan as an essential part of its ongoing operation.

WHO DOES THE WORK?

At this stage the immediate objectives, in summary, are to articulate future physical needs, quantify those needs spatially, establish cost parameters, assess fund-raising capabilities, and analyze operating and financial consequences. To the extent possible, these efforts are still best undertaken internally, since this stage still concerns crystallizing and affirming an organization's own needs for undertaking a building program. However, one must recognize realistically the differences among museums' internal resources. A large and long-established museum with a history of physical expansion will have internal professional capabilities and board resources that are different from those of a large organization with no such experience. Both will have far more specialized expertise than will a small existing organization. And all existing organizations will be more prepared internally for this kind of process than will a newly forming one.

It is desirable for an organization to exploit existing staff and board to accomplish these objectives during preliminary planning, but it is important to be realistic about the commitment of time, especially the time away from other responsibilities, that may be required. If this is not possible, it may be

appropriate to engage outside professionals to assist with long-range organizational planning; to provide preliminary architectural, construction-management, and fund-raising consulting services; and to introduce financial- and operational-planning methods.

CONCLUSION: THE PLANNING FOUNDATION

The long-term objective of a well-organized building planning process is not simply to build, but also happily to occupy and operate in a successfully completed facility. The conceptual urges that ignite a new or an existing organization to think about building one day become the realities of a project's completion. It is essential that an organization never lose sight of this seemingly simple truth. What is deemed feasible will be tested when it is realized in a completed project, so every consideration made and every resolution formed during a project's planning phase becomes part of the experience of occupancy. An understanding of this relationship between planning and occupying—initial conception and completed reality—is valuable in guiding an organization through the stages of the building process and serves as a reminder that a museum must always remain in control of its building process. What is planned is what will be built, and the anticipation of what will be built shapes the planning process.

There are a few axiomatic generalizations to keep in mind as an organization formulates its architectural program, the first formal step in a particular project. In concluding this discussion of the early planning stages, it is useful to summarize them and to underscore their importance.

The objective of any organization's building planning must be to fulfill its needs and to serve its purposes. These must be its paramount considerations during planning, design, construction, and occupancy.

As it moves through the building process, a museum's leadership must remember that the museum is the client. It commissions the work; it engages the consultants, specialists, and experts who will design and execute the work; and it becomes the owner and occupant of the completed job. (As noted earlier, museums functioning under the aegis of other authorities, public or private, may not technically own their own land and buildings. However, for the purposes of this book, all museums are considered to be both clients for and owners of their projects.) While many others may play significant roles throughout the process, it is the museum that must ever be in control, since it is the museum that must in the end bear the consequences of any and all decisions.

From the planning stage springs all that follows, so it is essential that that stage be purposefully set. A museum and its leadership must be prepared at the outset of formal planning to make a substantial commitment of time, staff

resources, and financial support to the planning process. During the planning phase, it is also crucial to acknowledge the amount of time necessary to accomplish the assessment of a museum's needs and the full explication of those needs in an architectural program. And, as the building process moves forward, a museum should seek to control the timetable from planning through occupancy, in the knowledge that the significance of controlling the schedule weighs differently at each stage.

Either by designating existing staff or by hiring staff with expertise in project development, there must be staff resources available to devote themselves fully to the task of building planning. Finally, the leadership must be aware that planning is costly. The obvious corollary to the commitment of time and staff is the commitment of adequate financial resources to ensure that the necessary time and expertise are available.

4

ARCHITECTURAL PROGRAMMING

BEFORE A FORMAL ARCHITECTURAL PROGRAM is made, the planning phase of project development focuses on laying the groundwork properly for what may or may not become the basis for initiating a particular building plan. In a sense, all activity prior to this point has been about cultivating a frame of mind that lets an organization think about future space needs and put those thoughts in the context of other future organizational issues. Many scenarios may be formulated, and many interpretations of needs and resources may be tested before a single scenario becomes the basis for pursuing a given building plan.

These exercises are an opportunity to engage professional staff in thinking about future needs, and if they make board leaders receptive to options and opportunities for physical growth, then they are in fact likely to give rise to richer, more enlightened, and possibly more creative answers to the underlying question of how to meet an organization's goals for physical growth. Nonetheless, the time will come when a program statement will be affirmed that passes at least the preliminary tests for feasibility in relation to future goals for funding, finances, and operations. A museum will then begin to prepare an architectural program, a formal document that will play a key role in architect selection, design development, and even construction management and execution.

As an editorial and quantitative blueprint that must precede the evolution of a particular project's design, the architectural program is the opportunity for a museum as an architectural client to construct the outline around which a building's architectural story grows. It can take various physical forms. It can be a finished document, printed and bound; it can be a three-ring binder,

The design of entrances and entry spaces carries much of the weight of the qualitative objectives that must be set forth in a museum's architectural program. The Beaux-Arts tradition of making visitors feel they have arrived at a place of distinction through ceremonial portals, up grand staircases, and into monumentally scaled spaces has been adapted over time through many new and different forms and technologies.

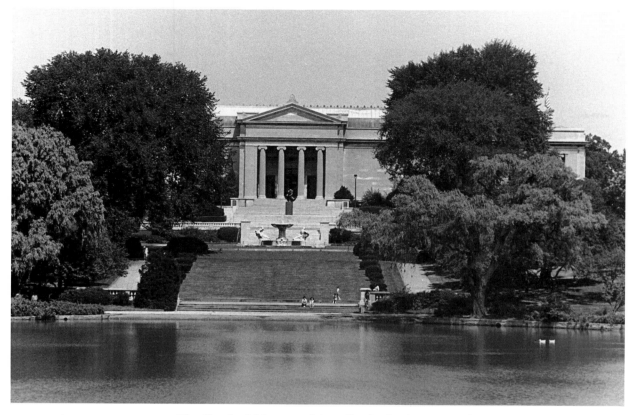

The Cleveland Museum of Art, Cleveland, Ohio. View of an archetypal ceremonial approach, to the south façade across from Wade Park Lagoon (Hubbell and Beves, 1916). (Photo: The Cleveland Museum of Art/Robert Falk)

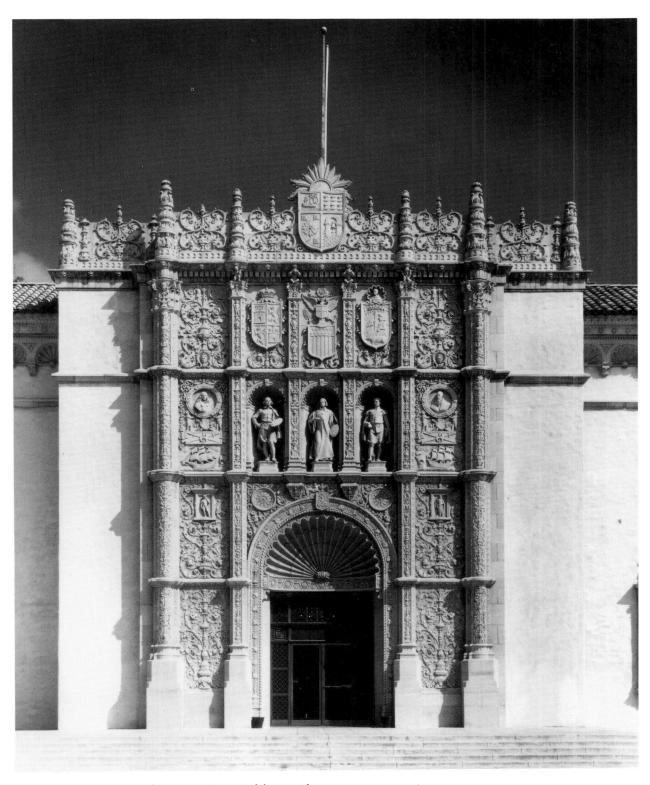

The San Diego Museum of Art, San Diego, California. The main entrance retains a
ceremonial character, but adopts a distinctly regional architectural vocabulary (William
Templeton Johnson, 1924–1926). (Courtesy The San Diego Museum of Art)

At the Polk Museum of Art in Lakeland, Florida (Straughn Furr Associates, Architects, 1988), a parking lot replaces the grand lawn, offering convenience for visitors arriving by automobile. (Courtesy Polk Museum of Art, Lakeland, Florida)

At The Newark Museum, Newark, New Jersey, the South Wing Entrance uses ceremonial doors and scale to elevate the children's experience of arrival (Michael Graves, 1989). (Courtesy The Newark Museum, Newark, New Jersey)

A

The notion of monumental stairs, through designs that are at the same time historically referenced and contemporary in detailing, is retained at (a) The Saint Louis Art Museum, Grand Staircase, West Wing (Charles Moore, Moore-Ruble-Yudell, 1987), and (b) the Virginia Museum of Fine Arts, West Wing (Hardy Holzman Pfeiffer Associates, 1985). ([a] Courtesy The Saint Louis Art Museum. Photo: Robert Pettus. [b] Courtesy Virginia Museum of Fine Arts)

B

A

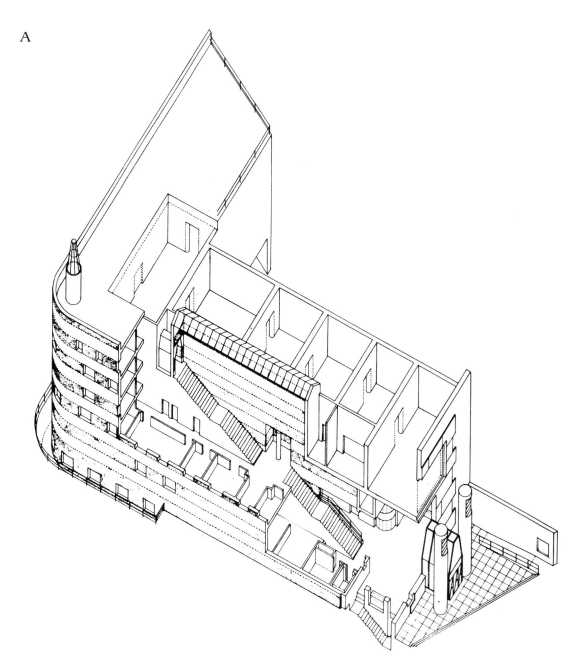

(a) James Stirling's design for the Arthur M. Sackler Museum, Harvard University Art Museums, inserts its "grand" stair between the public and nonpublic spaces of the museum at all levels, as shown in this cutaway axonometric view, which demonstrates this main stairway's relationship to all levels. The main entry is at lower right. (b) The photographic view down the main stairway shows the museum's entry hall, interpreted here as a very modestly scaled foyer area (James Stirling Michael Wilford and Associates, Chartered Architects, 1985). ([a] Courtesy James Stirling Michael Wilford and Associates. [b] Courtesy Arthur M. Sackler Museum, Harvard University. Photo: Timothy Hursley)

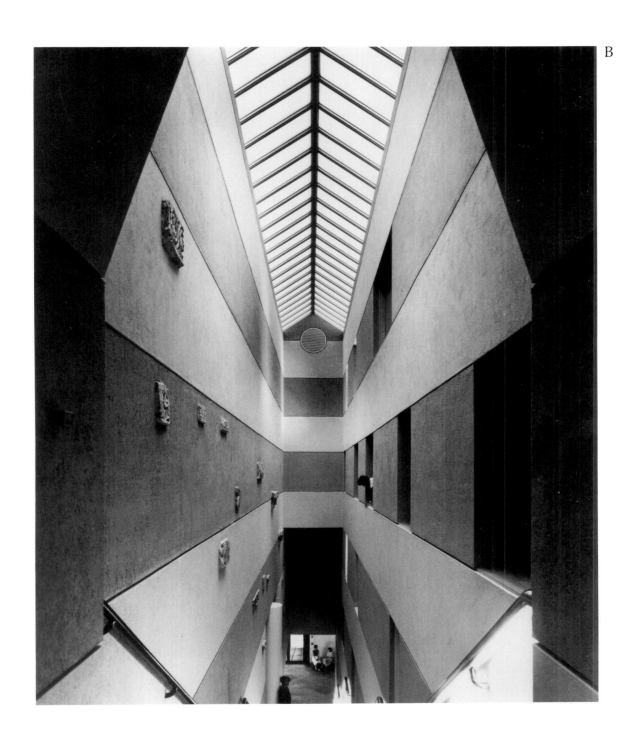

A

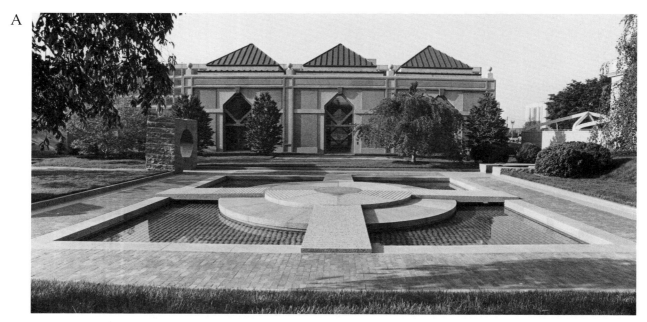

(a) The Entry Pavilion of the Arthur M. Sackler Gallery, Smithsonian Institution, Washington, D.C., is the gallery's only above-grade presence, with the bulk of its space—and its full architectural presence—not visible to the arriving visitor (Shepley Bulfinch Richardson and Abbott Architects, 1987). (b) In a complete reversal of tradition, the gallery's Central Staircase carries visitors down, not up, to its galleries, all of which are organized below-grade. (Courtesy Arthur M. Sackler Gallery. Photos: Kim Neilson)

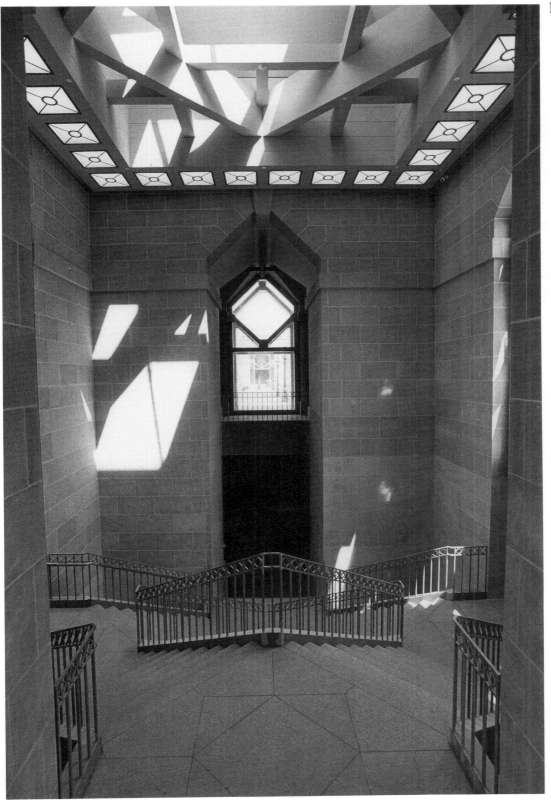

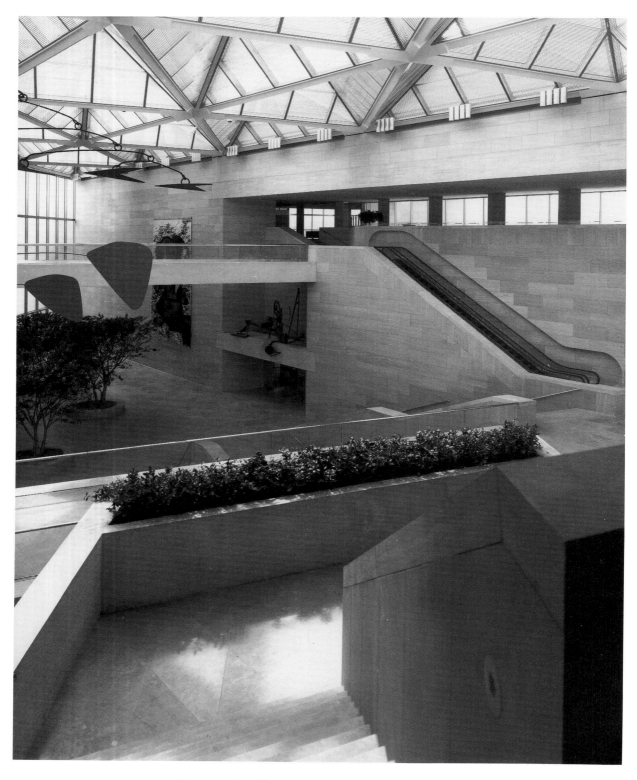

The National Gallery of Art, East Building, utilizes escalators to carry arriving visitors through an entry courtyard of grand scale, as is seen in this view of the courtyard from the upper level (I. M. Pei & Partners, 1978). (Courtesy The National Gallery of Art, Washington, D.C.)

with sufficient space for revisions and addenda; it can be a well-organized file cabinet of systematically arranged subject files. But it must be exhaustive, and, even more, it must be a living and breathing document that can be subject to repeated refinements and revisions as a project develops through its design phase and even its construction phase. It should be a firm and definitive statement that is also responsive to the opportunities brought about by time, creative focus, and ongoing technical research and development.

The architectural program must grow increasingly clear and unambiguous as it becomes increasingly concrete, specific, and detailed. Since its purpose ultimately is to provide the basis for an architect's design, it must use terminology and be in a format that will be comprehensible to an architect. After it is completed and delivered, many assumptions regarding scale of spaces, adjacencies, and the like will be tested during the design phase, and that testing may yield further beneficial changes.

An architectural program must include three essential components. First, it must be a qualitative statement of what the client museum wishes to achieve, treating editorially each part of a proposed building—its exterior, its interior, and all its public and nonpublic spaces. It should begin, generally and philosophically, by summarizing the museum's mission and articulating the philosophy and image it wants its facilities to evoke. It should discuss the museum's collection practices and objectives and outline its programmatic and educational intentions. It should attempt to characterize both the experience it wants its facilities to signify and the physical context in which those experiences are to take place. It must finally describe the special requirements of its collections and programs.

Second, it must provide a quantitative inventory of all the parts of a proposed project, listing cumulatively every space, with each space identified functionally (e.g., gallery, office, laboratory) and organizationally (e.g. department, medium). In this section of the program, spaces that will be needed for every functionally distinct area of a proposed facility must be quantified. Area requirements must be estimated, initially by generalized function, to arrive at the net—that is, usable—square footage needs for each space in the new facility.

Finally, it must contain a catalogue of quantitative technical criteria needed to make the inventoried spaces meet standards for museum operations. This last category covers, for every inventoried space, the full range of technical requirements, including ceiling heights, dimensional clearances, floor loading requirements, environmental criteria, artificial- and natural-lighting specifications, and accessibility requirements for physically disabled staff and visitors. The expertise of outside consultants is likely to be needed for this effort, and it should be understood that any consultants engaged at this stage do not necessarily have a continuing role subsequently in the design phase.

As the architectural program is developed, the first two categories of infor-

mation—the qualitative statement and the quantification of spatial needs—establish the scope of a given project. The third category—a project's technical criteria—forms the basis for developing a project's specifications.

PREPARING AN ARCHITECTURAL PROGRAM

For an organization of any size, the decision to begin an architectural program calls for an explicit delegation of responsibility for project direction and execution (Fig. 2). This responsibility is delegated according to the internal resources of a particular museum. There is also a distinction to be made between who directs the writing of the program and who actually writes it. If at all possible, a member of the existing staff (or of a new organization's forming staff) should direct the creation of the program. Since it is an organization's own goals that must be served by its building planning efforts, the participation of individuals well versed in its programs and facilities can help ensure that focus at this stage.

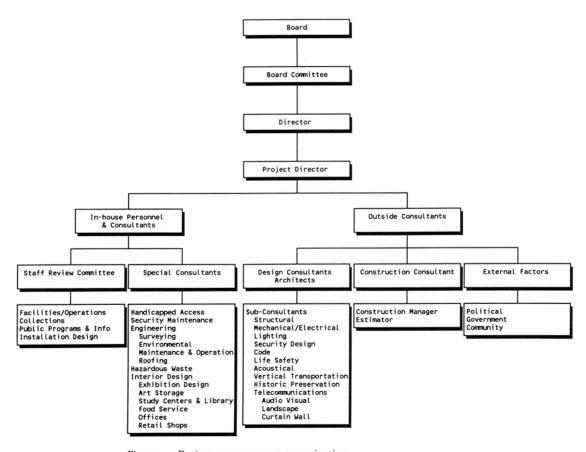

Figure 2. Project-management organization.

In a large museum, a senior staff member, perhaps already identified as project director, may already have responsibility for long-range planning. And if there has been prior physical expansion or development, this or another senior staff member may also have responsibility for architectural planning. In smaller museums, it is likely that a single deputy or assistant director has both responsibilities. In any case, it is critical to recognize the magnitude of the assignment and the difficulty, if not impossibility, of having the museum's director undertake it directly while continuing to oversee every other aspect of a museum's ongoing operation. Indeed, it is questionable whether any senior staff member who might be delegated to oversee the development of a museum's architectural program can still retain other major responsibilities without significant support.

For a new museum, the situation is obviously very different. A new professional director may find that the responsibility for forging an architectural program is indeed one of his or her first tasks.

In any case, the making of the program should be guided by someone who knows intimately a museum's program, audiences, operations, and facilities, as well as its goals and objectives, and who intimately understands the objectives of realizing new space.

It is highly unlikely that any museum's staff has sufficient expertise to undertake internally the actual writing of the program. Certain very large museums (and, again, perhaps only those that have had experience with expansion) may have in-house planning staffs with architectural-planning capability that are qualified to do this work, but most will have to go outside for the requisite expertise. If the funds exist, this may be the first opportunity to "staff up" internally for the challenge that lies ahead through the full planning, design, and construction cycle. If strengthening a museum's internal capability to manage the building process is a desirable objective, this is the time to do so. With the museum-building boom of the past two decades, a professional specialty in museum planning and architectural consulting has evolved to meet the demand. Museum or institutional experience is desirable, but not essential, since the task at this stage is to understand a particular museum's needs and requirements and not to extrapolate from the needs and requirements of others. (That ability becomes more valuable at later stages and is available through other means.) Indeed, one can easily argue that it is better to engage an outsider who is free of any preconceived ideas or biases.

If it is not possible to bring this expertise in-house through an expansion of staff, it can be commissioned on a consulting basis, for which the same criteria apply. The disadvantage is that making a project's architectural program becomes an enterprise of encyclopedic proportions; accomplishing it internally with existing or expanded staff, rather than buying it on a consulting basis, can be a powerful tool in a project's overall development. Since a

responsive program continues to change as a project evolves, its maker should ideally be involved until a project's completion. During the design phase, program requirements and criteria will be revisited regularly as design options offer varying ways to address stated needs, and the programmer can contribute significantly to the consideration of such issues.

The programmer and the staff member responsible for overseeing the programming effort need to be sure in collecting information and shaping the program document that they are covering all bases and hearing all relevant voices. To do so, they will want to talk with many people:

1. Staff members, who have been primed for participation by their earlier involvement in needs assessment.

2. Trustees, who have participated in reviewing the mission and whose support and endorsement ultimately are critical.

3. Technical consultants, who have expertise in areas where the staff do not. The range of such areas can include collection-related issues, such as conservation and lighting; service-related matters, such as retail and restaurants; and facilities-related issues, such as energy management, computerization, and telecommunications.

4. The network of sister institutions that have had comparable experiences.

5. Government and community representatives, who may have a particular focus on institutional obligations or community needs.

To collect the information they need, they may conduct individual interviews or organize meetings or retreats. They may distribute questionnaires or formulate worksheets for their own use during interviews and meetings. They should certainly be encouraged to talk with colleagues outside the museum, in the field, and to visit other institutions with relevant histories.

A SAMPLE OUTLINE

Since one of the key functions of an architectural program is to inventory a project's physical scope, it may be helpful to outline one way of organizing such an inventory—in this case using all the spaces of a new museum facility as an example (Table 1). In this example, the proposed new facility is separated first into the two major divisions of public and nonpublic spaces. Then, within each of these major categories, spaces are further divided according to their functions. One useful way to approach the public spaces is from the perspective of a visitor arriving at the museum. A similarly useful way to organize the nonpublic spaces is from the perspective of an arriving work of art.

Table 1. ARCHITECTURAL PROGRAM SPACE DEFINITION

Public areas	
Free spaces	*Paid spaces*
Entry	Galleries
Visitor services	Exhibition
Checkroom	Collection
Admissions	Auditorium(s)
Information	Retail sales?
Retail sales?	Restrooms
Restrooms?	Food services
Telephones	Orientation/ education?
Food services	Libraries?
Orientation/ education?	
Group visits	

Nonpublic areas	
Art-related spaces	*Non-art-related spaces*
Loading dock, shipping and receiving	Staff spaces
Photography, matting, and framing	Offices
Conservation lab(s)	Meeting rooms
Art storage	Lunch rooms
Collection management	Lounges
Research/study centers	Lockers
Libraries?	Operating spaces
	Services (data-processing, telecommunications, stockroom)
	Shops (carpentry, painting, electrical)
	Mechanical equipment rooms
	Storage

Public Spaces

The sequence of spaces that are encountered by an arriving visitor follows, along with questions that may help either to quantify related spatial requirements or to identify relevant criteria for the space.

I. Entry

A. Do visitors arrive on foot, by automobile, or by mass transit?

B. How are visitors meant to feel, and what are they meant to experience, on arrival?

C. What are the relevant climatic conditions? Is the weather often inclement? Are canopies or covered driveways important? Are revolving doors necessary?

D. What is the projected volume of traffic that will use the entrance? Is all traffic intended to flow unsegregated through all entrances?

E. Is access for the physically disabled and the elderly provided at all entrances?

F. What are the requirements for off-hours entry?

II. Visitor services

A. Coat checking

1. What kinds of coat-checking facilities are to be provided?

2. Are packages and umbrellas to be checked along with coats?

3. What is the coat-checking capacity in relation to the projected volume of public traffic for the museum?

B. Admission

1. Does the museum charge admission?

2. What method of admission sales will be utilized? paper tickets? buttons? turnstiles?

3. Are the number and configuration of ticket-sales locations sufficient to accommodate the projected volume of public traffic?

C. Visitor information

1. Is visitor information dispensed by staff or solely by displayed printed materials? Is it dispensed in the same location where the tickets are sold? Is it available for visually or hearing disabled visitors? Is it centralized or decentralized?

2. Are there related membership-sales activities?

3. Is information dispensed in a free zone or the paid zone of the museum?

D. Retail sales

1. Is the retail-sales installation conceived as part of the information-dispensing activity or the membership-sales activity?

2. Is the retail installation in a free zone or in the paid zone of the museum?

E. Restrooms and telephones

1. Are restrooms and telephones provided in free zones or only in paid zones of the museum?

2. Is the toilet count sufficient both to meet code requirements based on gross area and to serve the projected volume of public traffic? Are the needs of physically disabled visitors accommodated?

F. Food services

1. Are the food-service operations in a free zone or in the paid zone of the museum?

2. What capacity can they serve? How does this capacity relate to the projected volume of traffic for the museum?

3. Are food-service operations provided as a public service to the visitors, or are they intended as revenue generators?

4. For revenue-generating facilities, what are the policies for rental use and access? Should segregated access be provided?

III. Orientation and educational facilities

A. General considerations

1. Are orientation and educational programs currently provided? In what ways might they be changed in new or expanded facilities?

2. To what extent are new audiovisual or other teaching technologies to be incorporated in new facilities? Can they be reproduced in forms accessible to the visually and hearing disabled?

3. Are these facilities segregated from the facilities available to the general public?

4. Are they in a free zone or in the paid zone of the museum?

5. What are the size and nature of the audience to be served by these facilities?

B. Auditoriums

1. What types of programming are contemplated for auditorium use? film? performance? music?

2. How large or small an auditorium is needed to accommodate the overall projected volume of traffic for the new facilities?

3. Are separate checkroom and restroom facilities required specifically for the auditoriums?

4. Are amplification systems for the hearing disabled provided?

5. Will off-hours access be required? Is segregated access necessary or desirable?

C. Group visits and school groups

 1. Do group accommodations refer to facilities only, or are special forms of programming available for visiting groups?

 2. What is the projected size of group-visit audiences in relation to the projected volume of traffic for the museum?

 3. Are separate checkroom and restroom facilities desirable or appropriate? Is a segregated entrance desirable or appropriate?

IV. Galleries

 A. Exhibition

 1. What are the square-footage requirements for exhibition-gallery space as distinct from collection-gallery space?

 2. What are the environmental criteria for temporary exhibition galleries? What are the electronic-security criteria?

 3. What are the load-bearing criteria for temporary installation spaces?

 4. What methods are used for temporary wall construction and installation?

 5. What is the optimal lighting system? Is daylight an integral part of the lighting-system design?

 B. Collections

 1. What is the relative apportionment of available collection-gallery space among the various collection mediums?

 2. How are gallery finishes, details, lighting criteria, environmental criteria, and load-bearing criteria different for the various relevant collection mediums? What options are available?

 3. What installation techniques are optimal for the various collection mediums? for audiences with special physical requirements?

Nonpublic Spaces

Nonpublic spaces can be categorized as those that are exclusively or primarily for art handling and management and those that are staff and related service areas.

Art

Following the path of a work of art as it arrives at a museum facility, one can chart the sequence of functional areas the artwork encounters as it moves through the museum.

I. Art handling

 A. Loading dock, shipping and receiving

 1. Do climatic conditions require a fully covered loading-dock facility?

2. What are the dimensional requirements for truck activity and for art-handling activity?

3. What are the load-bearing requirements?

4. Must one facility receive all in-coming shipments, both art and non-art? Can these activities be segregated in any way?

5. How is dock activity supervised and made secure?

6. How is the arrival facility situated in relation to the shipping and receiving facilities?

7. Is elevator transit required? If so, what are the dimensional requirements and load-bearing requirements for the elevator(s)?

8. Is the shipping and receiving area only for packing and handling or also for examining and temporarily storing shipments? Is the size of the facility adequate for the projected volume of art-handling activity?

9. What ceiling heights are required?

B. Photography, matting, and framing

1. How do these areas communicate with the shipping and receiving areas? Do all access routes and areas have the same dimensional, load-bearing, environmental, and security criteria?

2. What is the minimally required headroom for all such areas?

C. Conservation laboratories

1. Based on existing laboratory facilities and on the comparative size of individual collection mediums, what degree of specialization and growth is contemplated for individual labs?

2. What are the specialized requirements for labs serving different collection mediums? What are the specialized criteria in the following categories: environmental control, natural light, artificial lighting, equipment, hazardous materials, minimum dimensions for access and headroom, floor loading?

3. What are the requirements for location with respect to galleries and storage areas for related mediums?

4. What new technologies should be anticipated and with what specialized installation and use requirements?

5. Are facilities accessible to physically disabled staff?

D. Art storage

1. What are the area requirements for storage, as compared with the installation capacity of the collection galleries? What are the special requirements of various collection mediums?

2. What are the specialized environmental, dimensional, and load-bearing requirements for various collection mediums?

3. Are there distinctions to be made between temporary and long-term storage, and between on-site and off-site storage?

4. What are the applicable local code requirements for fire protection in storage areas? Are there alternatives for art storage as distinct from other types of storage?

5. What are the minimal headroom and other dimensional requirements for all access routes among art-storage areas and all other art-handling areas?

II. Art management

A. Collections and curatorial management

1. What is the administrative structure for collections management? Are collections stored and supervised by individual curatorial departments or by the registrar? What are the responsibilities of each with respect to collections management?

2. Are stored collections accessible to nonstaff? Is this access provided through collection study facilities? Are these facilities adjacent to collection storage areas or within curatorial study facilities? Are they adjacent to or within curatorial departments?

3. What are the specialized requirements (spatial, systems, and natural- or artificial-lighting criteria) for study handling of collections?

4. What supervision and security mechanisms are required?

B. Research

1. What is the museum's commitment to access for research? How is this translated spatially?

2. Do curatorial study areas or centers exist within the museum? Are they centralized or decentralized within curatorial areas?

3. Does a library collection exist? Is it centralized? Is it decentralized within curatorial areas?

4. Are the library collections specialized? Do they contain rare materials? What are the specialized criteria for environmental control, security, and access?

5. What new technologies should be anticipated for information processing, storage, and access?

6. Do archives exist? Are they administratively centralized with other research collections, or are they segregated?

7. Do archives contain rare materials? What are the specialized criteria for environmental control, security, and access?

Non-art

In developing an architectural program, a museum must focus as much on staff, general service, and administrative functions and spaces as on the seem-

ingly more important areas involving its collection and exhibition practices. Sadly this is not often done, and museums can easily find themselves too small to house the forces that must maintain and serve their fully grown facilities and programs.

ADMINISTRATION AND STAFF. With regard to staff office areas, it is crucial that a museum ask many questions about future needs.

1. For each departmental area, what levels of staffing will be needed to program, operate, and maintain new facilities?

2. How do departmental areas relate administratively? How should they relate spatially?

3. Is there an organizational attitude about the relationship between management style and physical environment? Is open-office planning appropriate or desirable?

4. What are the requirements for group meeting spaces? What are the special requirements for board and other governing committee meeting spaces?

5. What new office, information, and telecommunication technologies should be anticipated?

6. Is there a commitment to computerization? If so, at what level and for what types of applications?

7. Are all facilities accessible to disabled staff?

OPERATIONS. It is also crucial that an assessment be made of the size of the plant-management and maintenance staff that a new facility will require, particularly in view of any technical advances that may be anticipated and of the equipment and storage needs of those forces.

1. What incremental staffing is needed for mechanical-plant management, for facilities maintenance, and for security?

2. What are the requirements, possibly union-mandated, for these employees for lockers, lunch facilities, showers, and other amenities?

3. What is the anticipated increase in bulk-storage requirements for supplies relating to operations and maintenance?

4. What new equipment is required for operating and maintaining a new plant? What special storage requirements do these present?

Disney World devotes an entire underground city, as large as the park itself, to the staff, systems, supplies, and equipment that program, operate, and maintain its facilities. Sadly, very few museums have the luxury to afford that level of accommodation. With limited resources, most museums must think realistically first and foremost about the collections they acquire and preserve and the exhibitions they produce, and their behind-the-scenes machinery necessarily becomes a lesser priority. Nonetheless, in preparing the architectural program, there is every reason to consider fully a museum's projected needs in these areas.

A

The evolution of the architecture of the Walker Art Center over the past twenty years has given resolution both to its immediate physical site and to its larger site placement within the context of urban Minneapolis. Its 1971 building by Edward Larrabee Barnes, Architect, FAIA, opposite an underdeveloped park site near downtown Minneapolis (a), acquired a true sense of place in 1988, with the creation of the Minneapolis Sculpture Garden (as seen from the terrace) (b), which spreads an apron in front of the museum and builds a link to downtown Minneapolis across Siah Armajani's commissioned footbridge (c). (Courtesy Walker Art Center, Minneapolis)

This outline is only one way of organizing a museum's efforts to collect the necessary data. For museums whose holdings comprise a number of diverse and unrelated collections, where use, access, care, and related issues of programming and services must be considered completely separately for each, it may be preferable to organize the outline with separate sections for each collection and its particular needs, with generally applicable considerations made only at the end. Rather than beginning by distinguishing between public and nonpublic spaces, the set of questions might begin by differentiating between art and non-art, or between art and service.

B

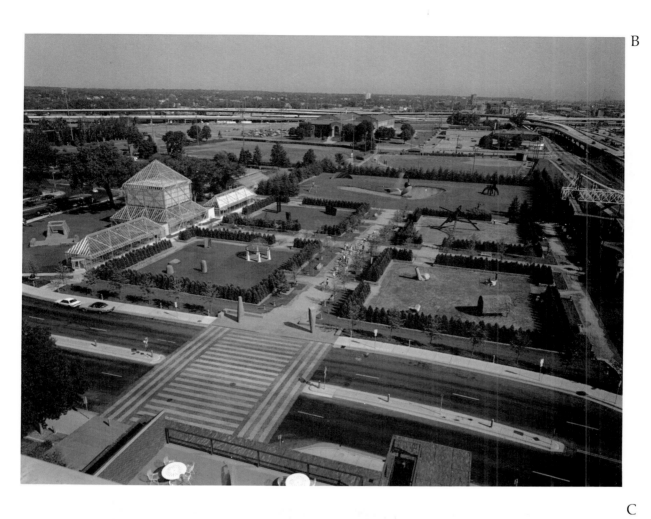

C

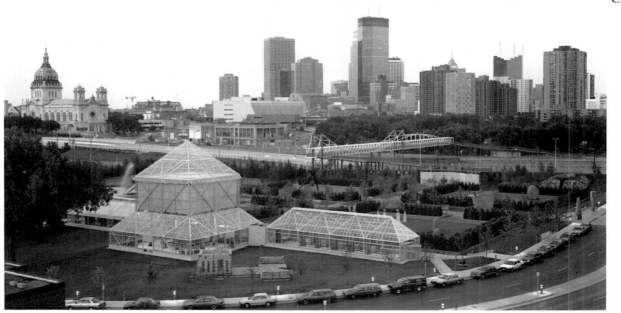

A

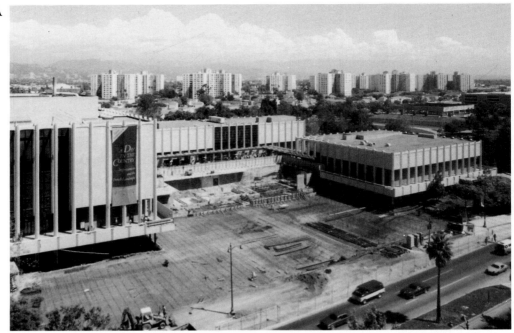

The construction of the Robert O. Anderson Building at the Los Angeles County Museum of Art, in 1987, provided an opportunity both to expand the museum complex, with a new facility for twentieth-century art, and to reorient completely its principal façade presentation to Wilshire Boulevard and, with it, the whole experience of approach, entry, and circulation within the museum complex. (a) Site preparation, construction photo; (b) Wilshire Boulevard façade (Hardy Holzman Pfeiffer Associates, 1987). (Courtesy Los Angeles County Museum of Art. Photos: [a] Tim Street-Porter; [b] Copyright 1990 Museum Associates, Los Angeles, California)

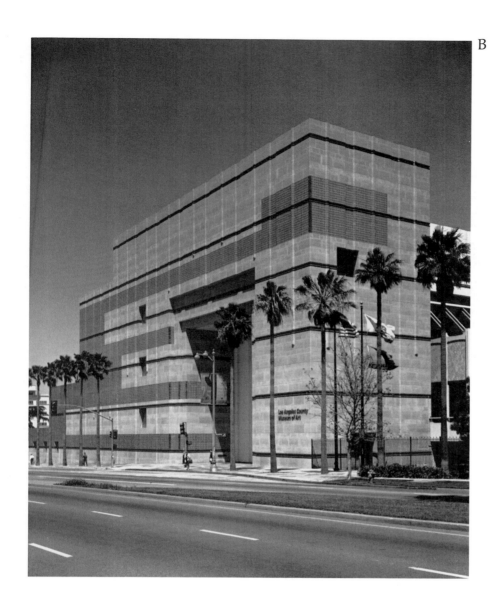

A

Museum retail spaces present a range of design challenges and solutions. (a) Uniquely, at The Hudson River Museum, Yonkers, New York, Red Grooms was commissioned to create The Bookstore 1979, which also functions as the museum's retail shop. (Courtesy The Hudson River Museum of Westchester, Yonkers, New York) (b) More recently, to address space constraints that precluded on-site retail expansion, The Museum of Modern Art opened its MoMA Design Store, in a commercial building opposite the museum's main premises. (Courtesy The Museum of Modern Art, New York. Photos: Hambrecht Terrell International)

B

The restroom is a significant public amenity that cannot be overlooked. Adequate restroom facilities are a matter of visitor comfort and of local code compliance. At Emory University's Museum of Art and Archaeology, Atlanta, Michael Graves fulfilled these needs with a facility of highly distinctive design (Michael Graves, 1985). (Courtesy Emory University Museum of Art and Archaeology)

An important amenity for many museums is the restaurant. However, depending on the constituency to be served, the types of food, service, and facility can vary widely. (a) At the Field Museum of Natural History, Chicago, the service operator and a museum administrator survey the construction in progress of the museum's McDonald's franchise, which opened in 1987. (b) This contrasts dramatically with the Museum of Fine Arts, Boston, where the West Wing includes an elegant setting for fine dining (I. M. Pei & Partners, 1981). ([a] Courtesy Field Museum of Natural History. [b] Courtesy Museum of Fine Arts, Boston)

Auditoriums and lecture halls are significant spaces. Beyond the simple issue of seating capacity, there are many specific requirements to be quantified in the architectural program, among them acoustical requirements, lighting, sound and visual projection, and fixed equipment.

Newark Museum, Newark, New Jersey. The Billy Johnson Auditorium (Michael Graves, 1989). (Courtesy Newark Museum, Newark, New Jersey)

University Art Museum, University of California, Berkeley, California. The George Gund Theater (Mario Ciampi, 1970). (Courtesy University Art Museum and Pacific Film Archive, University of California at Berkeley. Photo: Benjamin Blackwell)

As educational and research centers, museum libraries, study rooms, and teaching spaces are core elements of a museum's program.

Yale Center for British Art, New Haven, Connecticut. Reference library. (Courtesy Yale Center for British Art. Photo: Richard Caspole)

The Art Museum, Princeton University, Princeton, New Jersey (Mitchell/Giurgola Architects New York, 1989). Classroom in the David H. McAlpin Study Center. (Courtesy The Art Museum, Princeton University. Photo: William N. Taylor)

Montgomery Museum of Fine Arts, Montgomery, Alabama (Barganier McKee Sims Architects Associated, 1988). Artworks gallery. (Courtesy Montgomery Museum of Fine Arts. Photo: Fouts Commercial Photography)

DRAFTING THE ARCHITECTURAL PROGRAM

With the completion of the architectural program, enormously important data have been compiled defining the proposed scope of a project. These data yield quantitative information so that the square-footage areas estimated for each functional requirement can be tabulated to yield the physical parameters of a project. They generate qualitative planning through the editorial considerations stimulated by the kinds of questions raised in the outline. And they generate technical requirements and elicit views about the kind and quality of architecture that may be desirable or appropriate.

The importance of staff input, from the curatorial voice articulating concerns about collection management and curatorial programming to the operating staff focusing on running and maintaining the physical plant, has been emphasized repeatedly. Since, by this point, staff members will have invested a significant amount of time and effort, it is important to ensure that, once fully engaged with the process, they continue to feel that they are a part of it. At the same time, they may have expectations about what a particular project may or may not be able to achieve, and it is important that they understand

Conservation laboratories have enormously specialized technical requirements, such as operating criteria for laboratory equipment, special ventilation, lighting, and surface materials.

The Bishop Museum, Honolulu, Hawaii. Conservation lab. (Courtesy The Bishop Museum)

how decisions are made on an ongoing basis and that they be advised of decisions, through timely and reliable communication.

No program can absorb and endorse every recommendation. Once all the relevant information has been collected, it must be digested, shaped, and edited for forge the completed program. The programmer, together with the project director designated to direct the program's making, must work to shape the program to represent the objectives that the museum's professional and board leadership have endorsed. It should be understood clearly by the larger body of participants that it is the members of this hierarchy who are responsible for putting the program in its completed form. On the other hand, to maintain an overall sense of participatory effort and goodwill, the decision makers must regularly and openly disseminate information about their progress and regularly and openly receive new input—an interchange that can indeed enhance the process during this and the succeeding design phase.

Indianapolis Museum of Art, Indianapolis, Indiana. Conservation lab. (Courtesy Indianapolis Museum of Art. Photo: Copyright Wilbur Montgomery WM Photographic Services)

It is also essential to document the decision-making process that transforms program data into the formal program. As decisions are made that clarify the program's many components, they should be recorded in meeting minutes and internal memoranda or through other appropriate methods. As time passes, the basis for certain decisions, even especially critical ones, may fade from institutional memory. And decisions that may not seem particularly important when they are made may grow to have much greater significance. During the design phase, after the program is completed but while design issues continue to be considered and reconsidered, the design architects may want or need access to documentation for certain decisions. Staff involved in the initial assessment of needs may want to recall the rationale behind such decisions. As planning and design proceed, decisions are made and remade, and the seeming clarity of one moment may become the chaos of the next. A clear record of decision making can provide underlying comfort and help to keep confidence and enthusiasm among the broad group of players in an exercise where consensus is key, since ultimately and realistically, decision making must be entrusted to a few.

5

WHAT NEXT?
A POINT OF DEPARTURE

THE COMPLETION OF THE FORMAL architectural program signals the beginning of the actual, as distinct from the theoretical, project, with a defined scope and character. As such, it is also a watershed moment, offering the first real opportunity to fix and test the parameters of a particular project.

THE FIRST PROJECT BUDGET

Once the physical scope of a project has been determined, the first project budget can be computed, although, at this stage, it may be based more on formulaic estimating standards and estimated square footages than on detailed calculations of precise measurements and unit costs. Nonetheless, tied for the first time to a given project's defined scope, it will provide the comparative basis for all subsequent project costing efforts.

The component parts of this first project budget can be organized to fall within certain standard construction categories. These are typically refined and grouped into more detailed categories as the project and its budget grow more detailed.

I. Soft costs
 A. Predevelopment and planning
 1. Consultants
 2. Lawyers

B. Fees
 1. Architects
 2. Engineers
 3. Specialized consultants
C. Project management
 1. Museum project management
 2. Construction management
D. Staging
 1. Mobilization and relocation
 2. Occupancy

II. Hard costs
 A. Site
 1. Acquisition
 2. Demolition
 3. Removal of hazardous materials
 B. Construction
 1. Construction contracts
 2. Site work and landscaping
 3. Construction contingencies
 C. Furniture and equipment
 1. Movable furnishings and equipment
 2. Specialized interior installations
 a. Auditoriums
 b. Specialized storage
 c. Restaurants
 d. Retail

III. Project contingencies
 A. Contingencies for scope development

More will follow in succeeding chapters about the composition of these budget categories. At this stage, it is likely that many will be calculated simply as standard percentages of the estimated hard costs for constructing facilities of the scope outlined in the architectural program. Determining an estimated hard cost for actual construction is therefore the first and most critical budgetary task at this stage, followed by the determination of applicable percentage standards for most other budget categories. It should be noted that these will vary from region to region throughout the United States and among different types of construction projects.

Since most museums will not have the in-house staff to accomplish this first budgetary exercise (although a large museum that is or has been en-

gaged in architectural planning may have this resource in a staff architect, planner, or construction manager), they will need outside help in construction cost estimating. This assistance can be provided by professional firms specializing in cost estimating, construction-management firms or general-contracting firms that offer cost-estimating services, or individual construction-management consultants.

The decision regarding where to seek help in cost estimating often dovetails with the first serious consideration of how a museum wishes to build the project management team that will oversee a project's execution (see Fig. 2). Often, the only consultant engaged thus far will have been the specialist who wrote the architectural program. Although the architectural program will continue to be developed, it is a commissioned piece owned by the museum, and any subsequent refinement can be under the aegis of the senior staff member overseeing it. Cost estimating, on the other hand, will be an integral part of the periodic assessment of a project's progress, so it is wise at this stage to make sure that an appropriate mechanism to provide this service is in place for the duration of the project.

The project director (assuming that the museum's director has by now delegated responsibility to a senior member of his or her management staff) may propose to build an in-house team of project- and construction-management professionals, to be engaged as their particular forms of expertise are required. If so, the project director could at this stage hire a construction-management professional—an owner's representative—whose role would include consulting on all matters relating to a project's development and its construction management and who would therefore be responsible for the first cost estimates either directly or by hiring independent cost-estimating services. Alternately, the project director could propose hiring a construction-management firm to provide estimating services initially and a full range of services later, during design and construction. This choice will be discussed at greater length in Parts II and III. It is presented here, since it first becomes a consideration when it is time to estimate project costs.

THE FIRST FEASIBILITY REVIEW

Regardless of how the project budget is first calculated, it is a critical step that ushers in the first concrete assessments of a project's feasibility. Can the funds needed to accomplish a project of the scale revealed by the initial project budget be raised? What are the future operating costs and the related operating implications of the facilities envisioned in the architectural program?

Earlier, with the formulation of the program statement, the museum's fund-raising and financial professionals and its trustee and volunteer committees undertook a preliminary consideration of what would be feasible. At

this stage, with dollar costs calculated on the basis of a defined project, these considerations need to proceed in earnest. If consideration of a possible building program has been included in a museum's long-range planning, these feasibility analyses are simply a next logical step. If not, now is the time to galvanize fund-raising staff and relevant board committees to study the feasibility of raising the needed support. Outside consulting assistance may be appropriate but at this stage is not essential, depending on the capability of in-house staff and resources. However, the involvement of both the professional staff and the board is certainly critical, since these considerations become the basis for decisions about plans that a museum must now affirm and then implement.

Similarly, financial and operating staff must assess the operating implications of the architectural program and formulate a first incremental operating budget that anticipates the staffing levels, operating costs, and maintenance burdens of the proposed facilities. With this budget, factored into a museum's long-range financial forecasting, the professional staff and trustees can assess the financial implications of a proposed building program for a museum's future operating budget. If ongoing planning mechanisms are not in place for this kind of analysis, it is critical that they be established now. The museum's professional staff and board must appreciate the consequences of any such proposed new facilities, since, from this point forward, they must be the proponents of the project that is beginning to take shape.

In this respect, this moment is a significant point of departure. If a project is deemed financially and operationally feasible by a museum's staff and trustees, they are ready to begin the next formal stage. Conversely, if doubts and questions surface or if a project's scope is found not to be feasible, either financially or operationally, then board and staff members must consider substantially reducing the scope of a project, or even possibly abandoning it.

Through the several stages of a project, these opportunities for assessment and reconsideration, which succeeding chapters will highlight, present themselves. They are fundamental to keeping a project responsibly on track, and they are key to ensuring that all parties, professional and volunteer, board and staff, understand the implications of the decisions reached during each stage.

With the conclusion of the formal planning phase, once the architectural program is complete and the assessments of budget, funding capability, and financial feasibility are positive, a museum proceeds to the first step in the design phase: selecting an architect. However, as this new phase begins, it is important to reiterate that planning does not end with the planning phase, but only with the completion and occupancy of a new museum building. The decisions and refinements of every stage will affect the eventual result, and their implications must always be considered. The first steps and all succeeding steps resonate, and the end result—the completed museum project—is finally the product of all these steps and their accumulated reverberations.

Leadership and direction must be identified, responsibility must be delegated, and authority must be vested in individuals to ensure that the process works smoothly. There must be board leadership and delegated board responsibility, and there must be commensurate professional leadership and delegated staff responsibility. Nonetheless, these designated leaders must be receptive to the staff, the board and other volunteer support groups, and the larger community in order to build a consensus and to forge collectively a museum's sense of ownership of a project as it develops. Each subsequent phase of project development will offer the occasion, and mandate the necessity, for reaffirmation of this consensus.

II

DESIGN

6

FIRST STEP TOWARD DESIGN: SELECTION OF THE ARCHITECT

AFTER DECIDING TO BUILD, the logical and most critical next step—and the first design decision the museum makes—is selection of the architect. Since this decision has immediate stylistic implications, the museum as client and owner must prepare for the selection process, and the project leaders must be well informed to make a meaningful and lasting choice.

No matter what approach is used, no matter who is responsible for making the choice, once the choice is made it is one of generational permanence, at the very least. Trustees, directors, and curators may all turn over before another new space is built or rebuilt. The choice of the architect usually has a life span at least equal to that of the project leaders, and in some cases the architect's tenure may outlast that of the director, the chairman of the board, or other project principals. In all likelihood, when the choice of architect is released to the press, there will be a substantial amount of publicity, and a long and lasting relationship will ensue.

More permanent than a binding contract between architect and museum is the building that is produced. Architects have individual styles and predilections that must be matched with the project. Frank Lloyd Wright produced a very different kind of museum from Louis Kahn. The appropriate architect has not only the experience to handle a job of a certain magnitude and building type, but also the aesthetic sympathy, aptitude, and desire that matches the project's specific requirements, the site potential, and the leaders' vision.

WHO SELECTS THE ARCHITECT?

The project leaders are charged with the responsibility of choosing the architect and therefore with deciding the institution's architectural future. The development of the museum's building requires the same considerate long-term vision as the development of its mission and its collections. The process of building requires that project leaders articulate their vision of the developing institution. The magnitude of the project in both size and design must be thoroughly comprehended in order for the vision to be realized. Most important, the funding available and the proposed physical scope must be compatible.

An institution's architectural development evolves from an understanding of its past as well as a vision of its future. Thus it is best to involve experienced participants in choosing the architect. Institutional architects are almost always selected by a board-level selection committee that represents the museum as the owner/client. The composition of that committee is an important and sensitive issue, and the twenty museums' responses to the survey conducted for this book reinforce the notion that determining who participates can be complex and controversial, at both board and staff levels. The committee should include key members of the board (preferably those who have represented the project from the outset), the director, and, when appropriate, professional staff. In some instances, government and community leaders should also be considered.

Committee structure can become both challenging and creative; some members may be added to the committee as nonvoting advisers, which can be a helpful way to include outside and staff advisers when the board does not wish to extend decision making beyond itself. As evidenced in this project's survey, the board will at the minimum need the advice of outside architectural professionals and internal professional staff.

Staff participation can be a sensitive issue. The process of selecting an architect represents the changes to come, which may be threatening to staff. Staff members know intimately how to operate the current facility and are most deeply involved with its functioning. In selecting an architect, a prudent board will be concerned with both functional and aesthetic considerations, and board and staff must understand each other's requirements. The link between the staff and the board is the director, whose role is to draw from the staff's knowledge and to respond to the staff's concerns. In the surveyed museums, staff members were included in the selection process as often as they were not. Staff morale is also important to a successful project, and one way suggested to engage staff members is to make them aware of the project's progress through a staff representative, either voting or nonvoting, on the selection committee. Depending on the size of the institution, this might be the director or another designee from the professional staff.

A last and sensitive footnote is how also to engage a project's financial supporters. Surveyed museums have reported various experiences on this front. There may be strong voices among those who feel literally invested in a project. Those who are considering major contributions may also wish to be involved. Similarly, a way to encourage prospective donors of substantial building funds can be to give them an opportunity to participate.

<div align="right">

WHAT THE COMMITTEE MUST KNOW
TO MAKE THE CHOICE

</div>

Those responsible for selecting a project's architect should be fully apprised of the project's goals and the way in which architectural issues can govern their choice. All members of the committee and their advisers should be well versed in (1) the scope of the project, (2) the program's specific requirements, (3) the capabilities of the considered architects, (4) the criteria for a successful client–architect relationship, and (5) relevant government and community concerns.

The Scope of the Project

Before selecting an architect, all members of the selection committee must clearly have the same vision for the project, which is first represented by the program statement and which triggers the development of the architectural program. This can be a difficult part of the process, since it requires consensus early on with regard to a project's goals (see Chapter 4).

The qualitative program statement provides prospective architects with a narrative summary of how a museum perceives its mission, its internal workings (both professionally and communally), and its relationship to its community. This statement in the museum's language, which reflects how and what it wants its future to be, will ultimately be interpreted in physical form through the selected architect. A lot of thought must go into the statement. It is important to include issues such as the necessity of a welcoming, accessible image in the community and the relation of the institution's educational program to the public-school system, local universities, and so on.

The architectural program will extend to the architect a perception in narrative terms of how the museum collections should be displayed, to be translated by the architect into appropriately designed exhibition spaces.

To choose an architect whose work best matches what is envisioned in the program statement, the committee must know the architect's work. It is essential that members of the committee either travel to see the work of architects under consideration or be given materials such as illustrated presentations and publications to get a feel for an architect's sensibility. It is also

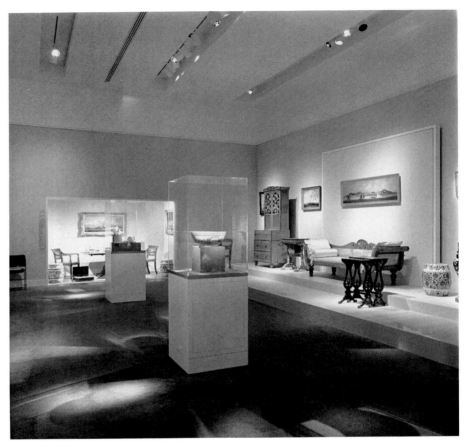

The major programmatic objective of the Chinese Export Decorative Arts Gallery, Peabody Museum of Salem, Massachusetts (Kallmann McKinnell & Wood, Architects, Inc., 1988), was to install the collection in a well-lighted and unadorned environment. (Courtesy Peabody Museum of Salem. Photo: Mark Sexton)

key to find out from other museums where architects have done work how well their architects interpreted their aesthetic and programmatic objectives.

The Program's Specific Requirements

To choose an architect, the client must have at least the program statement, if not also the groundwork, for a complete architectural program (see Chapter 4). Whatever programming stage the museum has achieved, it is crucial that it understand its needs and have established goals before selecting the architect.

The selection committee must understand the type of work to be undertaken, be it restoration, adaptive reuse, expansion, or new construction. A new building on a new site, for example, provides the opportunity for a museum to create a new aesthetic mark. However, the design of an addition may be constrained by the aesthetic mark of an existing building.

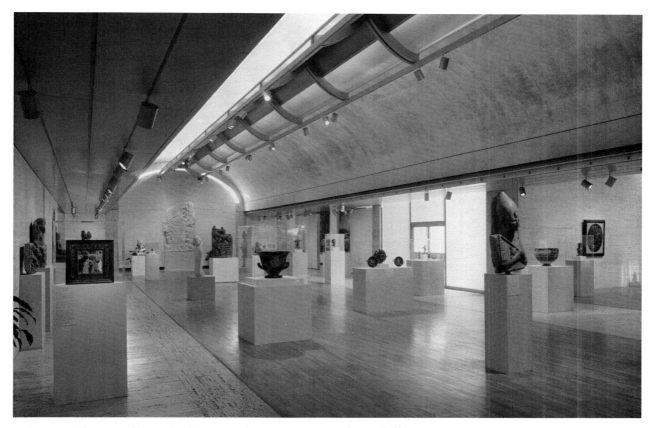

Permanent collection galleries also have special requirements. At the Kimbell Art Museum, Fort Worth, Texas, collection installation requirements for lighting and gallery detailing are fully integrated with interior architectural objectives (Louis Kahn, 1962).

The museum should therefore be aware of architects' experience with the type of building project it is undertaking. If a renovation, what will be the extent of the renovation? Will there be a complete gutting of existing facilities, with entirely new systems and rebuilt interiors, or a rehabilitation and upgrade utilizing some existing systems and interior finishes? Is this a historic restoration of a landmarked or treasured site, or is this the adaptive reuse of an old government or industrial building into a retrofitted new art museum? Is this a completely new building? The chosen architect should have the experience to address the specific needs of the project.

An existing site and building may help to narrow the choice if the committee knows it wants a design that will match the style of the existing building. For example, if an addition is planned for a landmark building, local governance or institutional preference may impose such a requirement. If the building is to be altered substantially and there are no such constraints, the preference may be either to pursue a design direction in keeping with the extant style or to depart

A

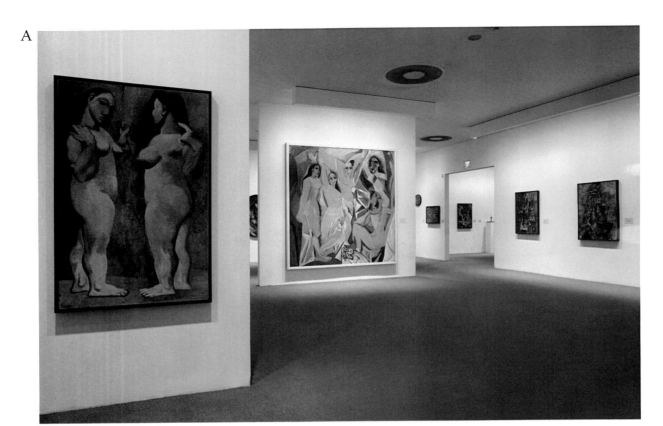

At The Museum of Modern Art, New York, a classic modernist installation aesthetic dominates the early modern collection galleries (a), while the helicopter installation at the entrance to the museum's architecture and design galleries (b), at the top of its Garden Hall escalator system, presented other nontraditional challenges. (Courtesy The Museum of Modern Art, New York. Photos: [a] Kate Keller; [b] Adam Bartos)

boldly from the existing style. The chosen architect should have demonstrated sensitivity to this kind of questioning.

The challenge may arise from an intent to retrofit an existing building, as art museums—for example, galleries at colleges and universities—are often created from buildings that have had a different earlier use. Other considerations might be site related. Is a surrounding park or recreational use required? Is the site flanked by similar building types? Is it part of an urban-redevelopment project? A new building without a selected site offers a different challenge.

The physical needs of a museum require special consideration. Of extraordinary concern are security, circulation, the layout of exhibition galleries, public amenities, and, most challenging, environmental zoning and control issues. The art museum is a place of public assembly that should provide comfort and accessibility to its visitors at the same time that it provides a

protective and secure environment for its collections. It is an academic environment that needs to be user-friendly. All these criteria should be prescribed in the architectural program.

The Capability of the Candidates

In searching for an architect, in addition to the vision represented in the program statement, committee members must understand the type of building they are representing and the design challenges it presents—all of which is described in the architectural program—to be able to assess the experience of the architects under consideration. The specific requirements of a given

The contemporary galleries at the Virginia Museum of Fine Arts, Richmond, were designed specifically to meet the installation requirements of the Lewis Gallery, which houses the twentieth-century collection. (Courtesy Virginia Museum of Fine Arts)

building type are outlined in the quantitative inventory and performance criteria of the program. Understanding this material will give insight to the technical demands being placed on the architect.

As a building type, art museums are similar to zoos and aquariums, except that they have living collections. But from a design and construction perspective, museums as institutions are probably most akin to hospitals and department stores. Like hospitals, they have persistent and periodic demands to change, improve, and expand their facilities. They deal in specialized engineering systems and have similar security concerns. Where hospitals are run by administrators and physicians, a museum's professional leadership is similarly divided between administrators and specialized professionals—cu-

The renovation of the European paintings galleries at The Art Institute of Chicago is notable for its careful attention to the particular criteria of the mediums on display (Skidmore, Owings & Merrill, 1988) (Copyright 1991 The Art Institute of Chicago. All rights reserved)

rators. However, the museum is also much like a department store in its need for oriented public circulation through secured areas housing frequently changing installations.

The architect must be capable of appreciating this specificity and diversity of the museum client's needs. An ideal architectural team would combine both visionary leadership and administrative expertise, experienced with the types of design problems that a particular project presents. Architects who have built only residential projects, for example, would have to prove they are capable of providing the quality of finish, sophisticated engineering, and public amenities that a museum requires.

The Art Institute of Chicago, Regenstein Hall, Daniel F. and Ada L. Rice Building (Hammond Beeby and Babka, Inc., 1988). This exhibition gallery is designed for flexible use, with high ceilings and a modular-grid system that allows for adaptable wall and lighting plans and for rezoning of mechanical systems, in order to satisfy a range of uses, as shown here in an installation of contemporary work from the Gerald S. Elliott collection. (Courtesy The Art Institute of Chicago)

A

The range of materials that art museums can be called on to install in their temporary galleries is evident in (a) the "Automobile and Culture" exhibition installation at The Museum of Contemporary Art/Temporary Contemporary, Los Angeles (Frank Gehry, 1981–1985) and (b) the Caribbean Festival Arts installation at The Saint Louis Museum of Art. ([a] Courtesy The Museum of Contemporary Art/Temporary Contemporary. Photo: Squidds & Nunns. [b] Courtesy The Saint Louis Museum of Art)

In this process, a museum must also decide how large a field of architects it wishes to survey. Is its identity international, national, regional, or local, and should the architect's identity be similarly international or local? If the field is larger than the local community, the museum should also be aware that it may need to provide local production services, in which case the choice of a local production architect must be equally carefully reviewed.

The project leaders may elect to survey as broad a range of architects' styles as possible before they make a decision. But in the end, a decision will have to be made, after which there usually is no turning back. Architects cannot be asked to radically change their aesthetic to suit the stylistic expectations of a project's leadership, so selection committees must focus on whom and what they are seeing, and must recognize that what they choose is what they will get. Built work is a testament to an architect's beliefs and a demonstration of his or her sensibilities and priorities, so it is essential to look at built projects before making a choice.

B

A

B

At The William Benton Museum of Art, University of Connecticut, Storrs, a dining hall (a), shown here in 1937, was transformed in 1966 through adaptive reuse into new museum galleries (b). (Courtesy The William Benton Museum of Art, University of Connecticut, Connecticut's State Art Museum. Photo [b]: Paul Rovetti)

The Client–Architect Relationship

Great buildings are in part the product of effective client–architect relationships. Frank Woolworth and Cass Gilbert built the Woolworth Building in 1913 as a team. The client's needs and vision were interpreted through modern technology, creating the early landmark skyscraper. Most museum clients are a "client group" of trustees, director, and relevant staff, with government and community representatives sometimes included. The selection committee represents this client pool during the search for an architect. Sometimes when a single collection or private donor is involved, the architect may have direct access to an individual's singular vision. Usually, however, it is the committee's collective vision that is represented, perhaps by a single spokesperson in the form of a chairman, with requirements clearly spelled out in the program.

The temperament and personal styles of prospective architects are also important considerations. Client references are also essential in evaluating these points.

The first opportunity for the museum as client to be assertive and to test a prospective client–architect relationship is during the selection period. And this test is key, since the dynamic between the owner and the architect is an essential part of the design and building process.

Government and Community Concerns

Museums are civic buildings, and frequently they fall under some form of government regulation. In some cases, the museum client may be a government agency rather than the museum corporation. For example, a local municipality that owns the land or the building may either directly hire or govern the selection of the architect. The museum as tenant in such a case must assert itself in the process. All communications may have to pass through a government project administrator, with the museum board and staff relegated to the position of adviser and tenant–user. In some cases, the local or federal government may provide all or part of the project funding and may therefore have a review relationship with the project in which the museum board (or staff) administers the selection, design, and construction of the project but must submit to government review and possibly approval along the way. If a project involves a landmarked property or is located within a historic district, certain regulatory agencies may have to be consulted.

Government officials often sit as ex officio members of museum boards, and their involvement in the selection process may help expedite a project at a later stage, especially if government supervision is mandated. The most im-

A

B

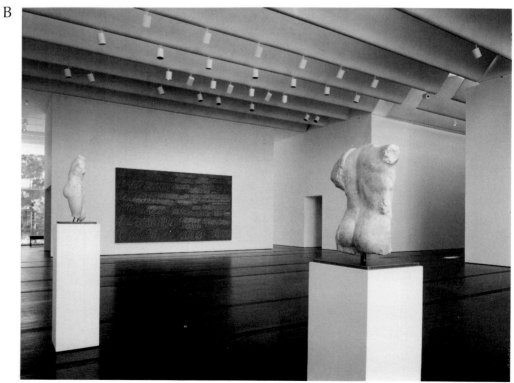

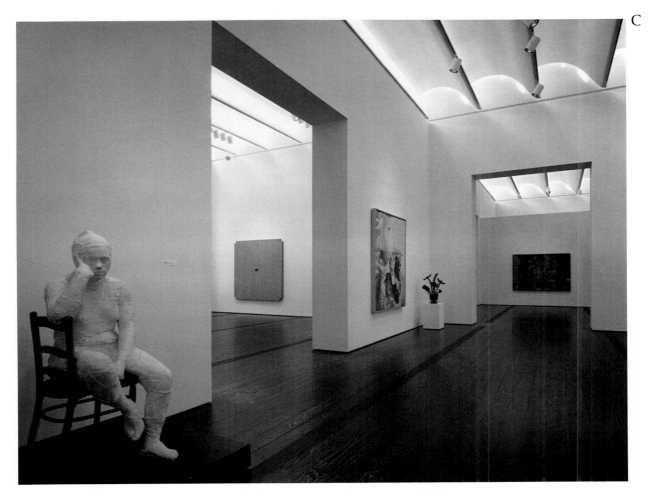

The Menil Collection, Houston, Texas, is a wholly new museum that occupies a facility designed and constructed specifically to house it (Renzo Piano, Atelier Piano/Richard Fitzgerald & Associates, 1987). (a) North arcade, looking west; (b) entrance foyer; (c) 20th-Century Gallery. (Courtesy The Menil Collection. Photos: Hickey-Robertson, Houston)

Architect Arata Isozaki presents his model for the new Museum of Contemporary Art, Los Angeles, 1983. (Courtesy The Museum of Contemporary Art, Los Angeles. Photo: Vanguard Photography)

portant point to remember is that any government involvement adds time to the process. In the building process, time means money, and that consideration must be factored into planning, schedule making, and budgeting.

Government funding and community pressure go hand in hand. Strong community support may endorse and encourage building allocations. Or adversarial groups left unattended can press for funding to be reduced. Most local community interests consider "their" museums to be treasures of their communities, and if they are not consulted early on and engaged somehow with the process, they may feel neglected. Keeping such groups informed can be achieved through special presentations where a project is identified as a source of community pride and educational enrichment. The community can be more effectively engaged early on if asked to help with fund raising, to assist with government lobbying efforts, and to endorse the project publicly.

HOW TO SELECT THE ARCHITECT

Museums report that one of the most difficult problems is deciding the precise method for selecting the architect. Once the selection committee is

formed and has been prepared, the process can begin. Whatever the method, two constants are certain.

1. The choice will be one of significant public interest, opinion, and, frequently, controversy.
2. Not everyone will be satisfied with the choice. There is no fail-safe formula.

Even if the selection is as direct as simply hiring the same architect who built existing facilities or a prominent local architect, even if it is a single-entry selection, there will be public interest and comment. Since museums are civic buildings that become symbols of community pride, the public has proprietary sentiment about them. Boards should therefore be sensitive to community interests and choose a method of selection that can be defended fully as a responsible one.

In addition to sensitivity to external factors, the museum must ensure that there is a consensus of the board and director regarding the method of selection and the final choice. There have been instances in which, after a selection has been made and even after designs are well under way, members of the project's leadership have ordered a change of architect. In like manner, if there is a change of leadership at the level of director or chairman, the new leadership, dissatisfied with the original choice, may replace the architect. While such changes may be unavoidable, it is important to note that they are expensive and time-consuming.

There are several methods for selecting architects, ranging from handpicking to holding an international competition. Although this text does not recommend any one method over another, it does advise that, since a museum building will last a long time, the greatest care be taken in selecting its designer.

Direct Selection (Handpicking)

It is not uncommon for a director or chairman to make an informed recommendation to the board and have a vote taken and a decision reached. This is a very simple approach; however, it requires that those involved in the final vote be completely satisfied and prepared to endorse the recommendation. Selecting an architect in this way without a broad investigation or search is valid only if there exists an individual or entity charged with the decision that is sufficiently well informed to make the choice. It is not a recommended method, based on the assertion of many museums that research is essential in making this choice.

At the same time, this approach can work if all involved are thoroughly versed in a project's requirements and the capability of available architects, and if the choice is indeed obvious. For example, consider a museum whose

original building is only twenty years old. The design is exemplary; the architect is still in practice. The board and director decide to approach the architect about adding to or renovating the existing building, and the architect's thoughts are in accordance with the institution's desires. The choice is evident.

The sources of a project's funding should not play an influential role in selecting the architect, but sometimes they do. This issue must be managed properly and carefully, especially when funds come from government allocations. When a museum is under the regulation of local authorities, it is imperative that it become aware of what governs the selection process. Procurement rules are also often insensitive to the special needs of art museums. Therefore, it is important that the museum's administration challenge any such regulations and make its particular needs known early in the process.

Such choices should not be made for a museum by an uninformed outside regulatory party. In order to protect the use of public funds against the biased letting of contracts, it is possible, for example, that there may be a lottery or "next-in-line" system in place. However, exceptions should be granted in order to produce the most qualified contenders. Most governance of this sort is in the form of regulations, not law; therefore, reason, research, and the availability of private matching funds should be marshaled to provide a convincing argument for a more informed selection process.

Surveying the Field ("RFP" / "RFQ" Method)

Most boards and government agencies will prefer a more open, researched method in accordance with their fiduciary responsibility. The increasingly common method of selection is to develop a list of candidates, usually referred to as a long list, and then reduce this list to a few serious contenders (the short list) to interview. Some museums might develop the long list by sending a letter, stating the intent of the search and describing the qualifications required, to professional colleagues, trustees, professional staff, and architectural advisers, and asking them to make recommendations, which become the long list. The difficulty then is in cutting the long list down to a short list. This process is expedited by sending an "RFP" (request for proposal) or "RFQ" (request for qualifications). Over time, there has come to be less of a distinction between the RFQ and the RFP, but the objective in both cases is to ensure that the desired information is requested in a clear and equitable manner.

The RFQ asks only for information about a firm's credentials and qualifications for the specific job: for example, the principals' and partners' experience and credentials; the members of the project-management team (with accompanying résumés); lists of projects similar to the museum's project; types of building experience, such as historic restoration, institutional work, govern-

ment buildings, new buildings, additions and renovations, and adaptive reuse; the current activity of the firm; and the dollar value of projects built. Firms are also asked to describe their proposed working method if they were chosen for the job and to submit photographs of a prescribed number of projects.

The RFP asks for all of the above as well as for submission of a proposal, which also includes fees. In addition, it implies that to be able to calculate a competitive fee, more information about the project may need to be elicited from the client. The RFQ method is often used when there is no existing building or site. Less information is available, and it may be a museum's intention to use its selected architect to assist in choosing a site or perhaps even in developing the architectural program. This approach may also be used initially to survey the field of architects in a two-stage selection process, so that after the field is narrowed, an additional request for information may be distributed to a shorter list of candidates.

A museum should prepare a formal program before beginning the RFP process, especially if there is an extant building or site. Beneficial results can be achieved if institutional goals have been defined and quantified for the contending architects. In addition, the museum should provide site data and extant building documentation if relevant. This will require work by the museum's management staff and perhaps the help of an outside consultant.

The RFP process is more competitive. If asked only for qualifications, an architect can expect to be reviewed based on previous experience through the success of built projects, staffing, training, managerial skills, and design distinctions. A proposal will usually require fee estimates and often design intentions or approaches. In competing against one another, architects will often seek to present design concepts, sometimes in the form of drawings and documents. Sometimes payment is offered for these services, sometimes not. If drawings and estimates are requested, it is appropriate to pay for them, and many architects resist preparing proposals without receiving any fees, since this work generates direct costs.

The information obtained from architects' submissions is reviewed by the selection committee, which narrows the field to a manageable number of candidates, the short list, to be interviewed. It helps if this part of the process follows a standard procedure; however, one must not overlook the relevance of whether or not one likes the built work of the architect, and one should not be seduced by renderings and "produced presentations." It is always best that the committee look at actual built projects. If that is not possible, the members should study them thoroughly in photographs and in interviews with former clients.

As the committee works with the short-list candidates' submissions, which at this stage are composed of qualifications, fee proposals, and a written statement of design intentions, it may elect to request design sketches by the

final few candidates. Payment for such services may be in order and worthwhile in order actually to see what prospective architects have in mind before a final choice is made.

The Competition

The use of a request for proposals often is, but should not be, misconstrued as an architectural competition. Whenever a field of consultants has been asked to participate in bidding on a project, the process is a competitive one, but it is not necessarily an architectural competition. Indeed, there are specific rules and supervising guidelines to follow in conducting the time-honored tradition of an architectural competition. The American Institute of Architects has produced an excellent and inexpensive guide on how to run an architectural competition,[1] defining the different types of competitions and outlining rules for their supervision. This publication is an essential starting point for all who consider this method. In addition, the Design Arts Program of the National Endowment for the Arts provides grants to assist in administering competitions.

There are essentially two ways to conduct a competition. The open competition is advertised as open to all who qualify, with no limit on the number of entrants. It provides the broadest possible range of candidates but requires heavy administration, and entrants usually pay a fee to offset the costs of administration.

In an invitational competition, firms with known qualifications are asked to submit qualifications and, eventually, proposals. These competitors are paid, usually at the finalist stage, to produce designs. The difference between the standard RFP method and the invitational competition is that the competition is run by an independent, professional adviser, preferably a registered architect who sets and administers the rules of the competition. The adviser ensures that the competitors are given information equitably and is the only person to communicate with the contestants during the competition. An independent jury, which should be composed of architectural peers and the museum's leadership, makes the final selection. After finalists are selected, the selection committee's involvement ends; for continuity, it is therefore recommended that representative board members of the selection committee sit on the jury.

There are many variations on both types of competition, and the main advantage of each is the opportunity to see the architects' intent in a developed form before making a decision. Two well-documented art museum competitions are those of the Center for the Visual Arts at Ohio State University (1984) and The Brooklyn Museum's Master Plan Competition (1986).[2]

After there is a field of candidates to be reviewed—whether it be a short list compiled by word of mouth, solicitation, an RFP, or a competition; whether the process goes from long list to short list, or when eliminating names from a short list—a question remains: How is the final choice made?

The selection committee by this stage is well aware of the objectives and specifications of its project, knows the qualifications of the candidates and how they relate to the museum's project, and has established criteria for making its choice. Now, all the committee members have to do is ask questions and make their selection by rating the answers. This may seem oversimplified, but in actuality it is what happens, and the selection committee that does not feel it has the particular expertise to do so should by all means seek outside professional participation.

When soliciting information from candidates, it is important to request pertinent staffing information (see Chapter 8). The architect's design team is composed of a variety of players. In addition to the project-management staff, whose credentials should be reviewed carefully, there are a number of important consultants—mechanical, structural, landscape, lighting, and security—whose credentials, qualifications, and experience should be checked.

The interview is, of course, essential, involving both the architects and all design consultants. Questions should be based on the specifics of the project. However, some essential questions concern the architect's relevant previous experience. Has the firm proved its capability with work of equivalent scope and magnitude? Has it had civic architectural experience or worked on symbolic buildings? Has it done institutional work with other museums, hospitals, or academic institutions? In the end, previous museum experience is not necessarily key, since almost all museums are unique according to the specifications of their collections. One must not forget that James Stirling's Neue Staatsgalerie in Stuttgart was his first built museum, and often the first of a building type by a particular architect may be his or her best work.

NOTES

1. American Institute of Architects, *Handbook of Architectural Design Competitions,* 2nd ed. (Washington, D.C.: American Institute of Architects, 1982).

2. See Peter Arnell and Ted Bickford, eds., *A Center for the Visual Arts: The Ohio State University Competition* (New York: Rizzoli, 1984), and Joan Darragh, ed., *A New Brooklyn Museum: The Master Plan Competition* (New York: Brooklyn Museum and Rizzoli, 1987).

7

BRINGING THE ARCHITECT
ON BOARD

AFTER THE ARCHITECT has been chosen, the press conference held, and
receptions introducing the architect to the museum community are
over, it is time to prepare the contract. This negotiation can take
considerable time, sometimes up to several months, which should be allocated
in the schedule. If not already on board, a legal adviser should be engaged at
this point as a key member of a project's administration. Given a museum's
size, legal advice might be available from its in-house general counsel, from a
special counsel well versed in architectural and building issues, or as a service
donated by a board member.

THE CONTRACT

During contract negotiation, the partnership between client and architect is
formed. Contractual concerns also help focus the project and raise issues that
will prepare the professional staff for internal structuring and identify new
resource requirements. It is not only the architect but the museum client as
well who has a job to do, requiring time and staff resources. This is the time,
too, to realize that the museum will also have responsibilities under the
contract—to stay on schedule, to provide information, and to perform re-
views.

The contract is also a useful tool to help clarify for a project's administra-
tion important procedures and requirements. The contract identifies what
will be expected of the client, clearly outlining the architectural-design and
construction commitments of both the client and the architect.

For the uninitiated, it may be helpful to review the AIA's standard form of agreement as early in the process as possible, even before selecting the architect.[1] The AIA has written many contractual forms to expedite contract implementation, and clients are cautioned to remember that these forms are written for and on behalf of the profession and therefore are seen by most to favor architects. Museums that receive government or university funds also should determine if they should be using a more appropriate form of contract.

This review will focus attention on a number of important issues—for example, that interior-design and related costs are not necessarily part of the basic services fee. The project administration will want to look closely at issues of interior design, whether for offices, storage, or exhibition galleries. What other consultants might be required? What role will the architect have in designing those interiors? How does one coordinate efforts between overall architectural design and interior design?

The AIA form can become the basis for a more individualized contract through appropriate modifications as suggested by the museum's counsel. Becoming aware of contractual issues in advance not only will be an advantage during the process of selecting the architect, but, by making nuances of the working relationship between the museum and architect apparent, will help control costs. Such enlightenment will be beneficial throughout the process, and the enlightened client can almost always help to avoid unnecessary expenditures.

How Many Architects Have Been Selected?

To begin contract negotiations, the museum must first know with whom it is to negotiate. When the search for an architect begins, the design architect is usually the point of focus. The design architect develops the overall design direction for the job, and the design will be executed under his or her supervision. However, there are many methods of working with architects, and circumstances often dictate that the design architect not be the contracting party.

For instance, the location of the design firm's office is a significant factor. The design firm may be headquartered in a city other than that in which the museum is located and may therefore engage a local architect at this juncture. In addition to having specific knowledge of local laws, conditions, and the like, a local architect can save the client time and therefore money. Once the design process begins, the museum staff will be working daily with the architectural team, so proximity is crucial.

If the firm is not nearby, a local architect, as an associate, can provide more direct administration to the job. Or another architect with specific experience, such as historic restoration, may be required. In any case, with specialized building types such as museums, however, there can often be more than one

architect involved. The museum then has the choice to contract individually with each firm or to require a partnership, legally a "joint venture," in which the museum client holds a single contract with the joint-venture entity. In this arrangement, one architect becomes the architect of record, stamps the drawings, and assumes liability for the project's architectural development. Joint ventures are not common, but they are frequent enough to deserve some explanation.

A project's joint-venture, or associate, partner is as important to a project's success as the design partner, even though this firm may not have the same public profile. The museum must have the right to approve the associate partner. Once it is determined, during the selection process, that an additional firm's services will be required, the selection committee should review the credentials of the associate firm as closely as it reviews those of the design firm. If the firm of record must submit to local governance and oversight and if local funding is also involved, it should be qualified on the basis of relevant government building experience. If special expertise in a field such as historic restoration is needed, the selection committee should become equally familiar with that particular field of candidates.

The architect of record produces the construction documents, manages the project on site, and, most important, stamps the drawings with the official seal that he or she is licensed to use. He or she is also responsible for filing building documents with local authorities. Since a museum must use an architect who is licensed and registered in the state in which such documents will be filed, a local architect is often necessary to fulfill this role when the design architect is not registered in the state of contract.

In some cases, especially when working with a foreign firm, it is necessary for a museum to have two separate contracts with its architects: one independently with the design firm, which is not licensed and therefore can produce only the design concept through design development, and the other with a local firm of record with responsibilities to coordinate services, provide construction documents, and supervise construction. Alternatively, the museum might decide to have the foreign firm work as a subcontractor to a local firm.

Other Design Consultants

Design consultants are brought in by the architect at various stages of a project and many must stay with a job through construction (see Fig. 2). Most become active (at least to the client's knowledge) in a limited way during schematic design and more fully during design development. For example, the mechanical consultant provides all the design services for heating, ventilation, and air conditioning (HVAC), plumbing, and electrical systems, working with security and lighting consultants, among others.

Before finalizing the contract, and certainly as one more step in a negotia-

tion process, a museum should require the presentation of all consultants, since they must also be reviewed and approved by the museum, and the museum should reserve the right to decline any of the architect's recommendations.

When negotiating the contract, it becomes immediately clear what is and what is not included for professional consultants' fees. Returning to the AIA standard form of agreement will show that only the services of the mechanical, structural, civil, and landscaping engineers are typically included under basic fees. A highly technical and specialized museum building, however, can require a long list of other consultants: acoustical, life safety, disabled accessibility, code, lighting, art storage, retail, food service, telecommunications, exhibition design, security, graphics (see Fig. 2). At the time of contract, the parties should determine which consultants are required, what fee arrangements will be made, who will manage the consultants, and who will assume liability for their work. It may be preferable for the architect to manage all consultants so that their services are coordinated, documents are integrated, and overall liability rests with the architect. However, the museum may also need to contract certain consultants directly (see Fig. 2).

Indeed, in addition to the consultants whom the architect might typically bring to a project, there is a growing number of specialists in the museum field whom the museum can hire directly to help it review design and construction documents or other specialized issues. For example, the field of accessibility and universal design is relatively young (see Appendix A), and many architects may not be fully conversant with the concept. It may be wise, therefore, to consider a consultant or a team of disabled people to review this aspect of the project for the museum client.

Additional technical services are often sought to cope with the challenge of specialized environmental systems. Issues such as the regulation of temperature and humidity, the zoning of art and non-art spaces, and the exhibition of art objects in environments that must also be designed for visitor comfort are challenging to architects and engineers. The installation of vapor barriers in extant buildings, the distinctive characteristics of specific collections and their varying environmental requirements, issues of automation and computerization that will require specialized design and properly oriented operating personnel to make systems function as planned—all these needs must be addressed. The museum should consider bringing required expertise on board in a timely way so that those who will operate new systems and those who are particularly knowledgeable about them can participate in their design. There are now consultants who specialize in museum environments, and the best way to find them is through colleagues in the field with prior experience.

There are also customized requirements for storing art and furnishing spaces to house collections. Although colleagues who have recently designed

and constructed art-storage furnishings and new spaces are a good source of information, there are also consultants who specialize in these areas who can help with individualized needs.

Increasing concern over security issues has also led museums to consider hiring security consultants. Often an extant operation may have a security firm that works with professionals on staff on security operating and maintenance issues. The architect may advise bringing on a security-systems designer, but design expertise is different from operating expertise, and a consulting security-systems designer will need to have an in-house counterpart who has equal familiarity with operating and maintenance issues to review design and construction documents. Further, if a museum is upgrading to a more sophisticated system, it should consider adding staff with the appropriate expertise, if this is not otherwise available on staff.

Fees and Compensation

Negotiating architect's fees brings a dose of reality to the first budget, or proposal budget, as described in Chapter 5. Until now, the budget has been an estimate based largely on orders of magnitude—square-footage take-offs and approximate unit costs. During the architect's contract negotiations, all the consultants' fees should be examined, including all fees and compensation to architects and their consultants, and their combined "reimbursables," which are discussed at length later in this chapter, together with any other direct costs they incur.

The architect's fee can be a standard percentage of the cost of construction or a fixed fee plus charges for direct costs. There are several variations on both choices, and they should be carefully considered. If a fee is based on a percentage of the cost of construction, the precise definition of "cost of construction" should be carefully reviewed and understood in the architect's contract. Estimates of the cost of construction will vary during the design phase, and the actual cost may not be fixed until final audit at the end of the construction phase.

The cost of construction is typically the hard, or brick-and-mortar, cost of a building project—that is, the actual cost of materials and labor, together with contractor's expenses and fees. The cost estimate almost always includes contingencies, general conditions, construction manager's fees (if applicable), escalation, and other related fees, which will be discussed further in Chapter 8. However, the cost of construction on which the architect and possibly other consultants base their fees may or may not include all these additional costs. They may become a point of negotiation, and this is therefore where legal counsel and specialized expertise are required to ensure that all parties have the same understanding. The finalization of the contract should also parallel the review and approval of the most current project scope and estimated cost, in relation to the architect's negotiated fee.

Since the architect's fee as outlined in the contract will cover only basic services, the nature of those basic services must also be fully understood before finalizing the contract. (For a review of typical basic services, see the AIA standard form of agreement.) For museums, the most important service that is typically not considered a basic service is interior design, which encompasses collection-exhibition design.

Unspoken Costs: Reimbursables and Out-of-Pocket Expenses

The architect's basic fee is only part of the architect's total charges. The balance is a combination of direct costs to the architect, out-of-pocket expenses, and subconsultants' fees charged to the architect that are not included under basic services. (For a listing of the range and types of consultants, see Fig. 2.) It is the responsibility of the architect to negotiate these fees on behalf of the museum. And it is the museum's right to review, and to accept or decline, fee proposals. It is often best to put a cap on these fees at the outset, so that a museum can budget precisely for the cost of such services. However, sometimes as a job progresses there will be circumstances under which consultants may reasonably request to renegotiate a fixed fee, and a museum may grant additional compensation. At the same time, if fees are not capped at the outset, billing for services rendered can easily get out of hand.

In addition to subconsultants' fees, there are other legitimate reimbursable costs to both architect and subconsultants. One such expense is the cost of duplicating documents, for which it is important to insist on estimates early on and to try to set a maximum price. The balance of reimbursable costs will be for consultants' project-related expenses, such as telephone, postage, photocopy, messengers and express mail, car services, travel, special photography, and binding costs. It is the responsibility of a museum's project director to review such expenses throughout a job's progress and make sure that they are in line with the budget.

Integrated Contracts

The responsibility of the architect to the owner is different when working with a general contractor from what it is when working with a construction manager. The AIA has provided two different forms of construction-related agreements, one for working with a general contractor and the other for working with a construction manager.[2] If using a construction manager, the museum should be sure to protect itself by having integrated contracts for its architects and its construction manager, in order to prevent an overlap in responsibility. The construction manager's role has been developed over the past twenty years, and often what used to be the architect's responsibility under construction-inspection services is now the concern of the construction

manager. It is important that each party know its specific obligations, and integration of the contractual documents can clarify many of the issues that otherwise will arise between the architect and the construction manager.

Also, if there are both design and technical or production architects and each is under a separate agreement rather than working in a joint venture, the production architect may add a surcharge for design-development review and coordination with the construction documents. The museum client must proceed with the same enlightened caution in negotiating this feature.

Negotiation of the architect's contract, which may take months and should be allotted adequate time in the project schedule, is more important than the actual signing of the contract. There may be occasions when a museum client chooses to proceed without a signed contract, especially if a project is behind schedule, but it should not do so without the advice of legal counsel. Most important is the focus that reviewing contractual issues brings to the job, which helps enormously in preserving the museum's status as a well-enlightened client.

WHO DESIGNS INSTALLATIONS?

Architects might argue that the only way to achieve a fully unified museum design is for the architect to control the installation design for exhibition spaces. This issue can and should be dealt with early in the contract stage. Because exhibition spaces are so visible, receive so much public attention, and are, indeed, the core of most museum project objectives, the architect will be interested in their appearance and in many cases will want to be included in, and have some or substantially all control over, their design. Museums, however, often prefer that architects not be involved in the design of art installations, and this is an appropriate time to bring up and resolve this issue.

The larger issue of designing permanent installations is worth examining more closely. Traditionally, installations at art museums have been the province of curators, usually with the support of art-handling or technical-display departments, since few museums have customarily had installation designers on staff. The rise of "blockbuster" exhibitions in the early to mid-1970s changed this approach. These installations were dramatic, even theatrical, and were designed as an expression perhaps of new policies geared toward attracting broader, more popular audiences.

Acknowledged as a primary reason for the significant increase in the number of visitors to art museums over the past twenty years, which in turn highlights the demands that have physically challenged the art museum as a building type in recent times, the blockbuster phenomenon has also resulted in an expectation among art museum professionals and the visiting public of

A

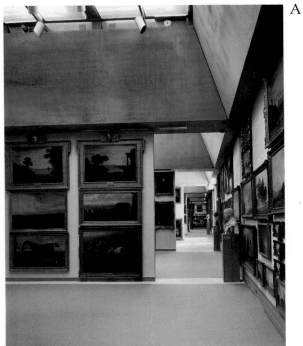

B

(a) Study galleries at the Yale Center for British Art were designed especially to permit a dense installation of study collections in a manner that makes them accessible for public viewing. (b) Some collections require uniquely designed facilities, not just interiors, as does the Pavilion of Japanese Art at the Los Angeles County Museum of Art (Bruce Goff, 1988). ([a] Courtesy Yale Center for British Art. Photo: Richard Caspole. [b] Courtesy Los Angeles County Museum of Art. Photo: Peter Brenner)

Models and renderings can be very illustrative. They help staff and other professionals who are deeply engaged with the planning process, as well as donors, potential donors, and other supporters, visualize how an unbuilt building will look.

A

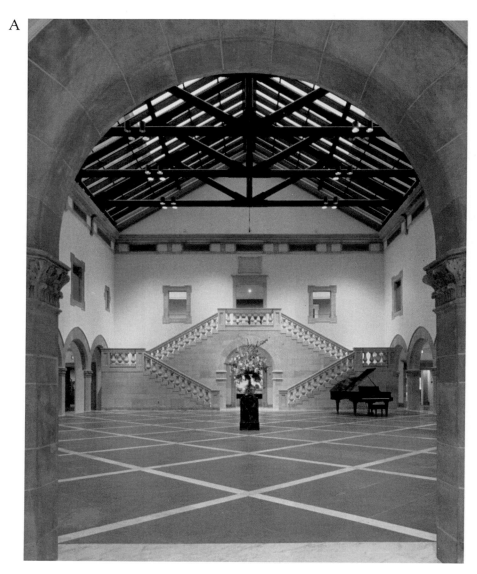

The view of the courtyard of The Chrysler Museum, Norfolk, Virginia (a), compared with the same view in the architect's model (b) (Hartman, Cox, 1988). (Courtesy The Chrysler Museum. Photo [b]: Peter Aaron)

high standards of installation design that not only demand more sophisticated spaces, but also take seriously the museum's educational and interpretive roles.

A professional specialty has evolved to service this demand, either through in-house departments and positions or, if operating funds are not available,

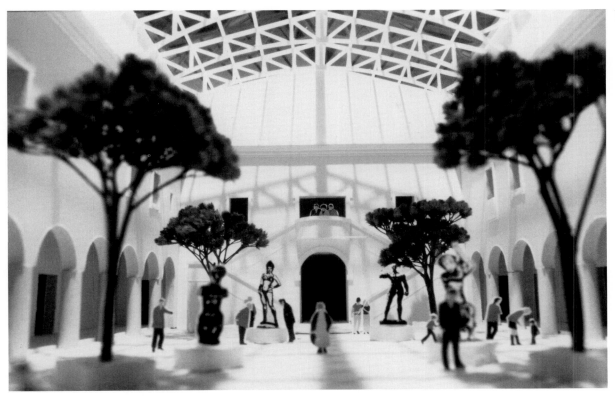

through contract consultants. Today installation designers can be expected to deal with a host of technical and aesthetic issues that are related to the problems of exhibition design per se. They can include interior architecture, visitor traffic flow, lighting, installation and promotional graphics, audio-visuals, and, at times, even questions of art handling and mounting. What separates museum-installation specialists from department-store or trade-show designers is their particular skill in working with museum curatorial, conservation, and educational issues and, most important, into art objects.

With the rise in the number of new and expanded museum buildings, designers have come to find themselves interacting with architects and engineers, as well as with their traditional colleagues in the museum profession. They have become part of the overall museum-design process in many ways, but generally at the later stages of project design.

Often the installation designer is brought into the process only after the museum and the architect have determined gallery-design specifications—that is, plan and elevation dimensions, adjacencies, finishes and details, floor-

A

B

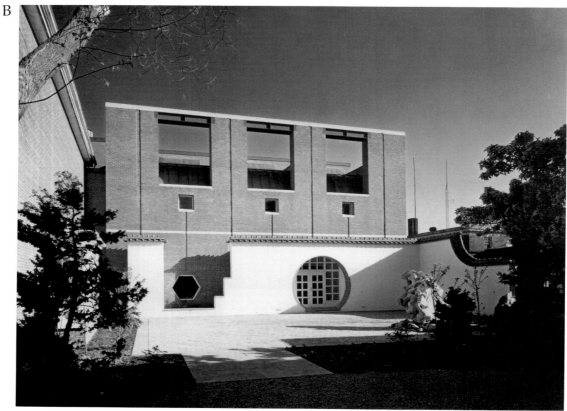

The Peabody Museum of Salem, Massachusetts, is shown both in rendering (a) and in photograph of the actual built façade (b) (Kallmann McKinnell & Wood, Architects, Inc., 1988). ([a] Courtesy Kallmann McKinnell & Wood, Architects, Inc. [b] Courtesy Peabody Museum, Salem. Photo: Steve Rosenthal)

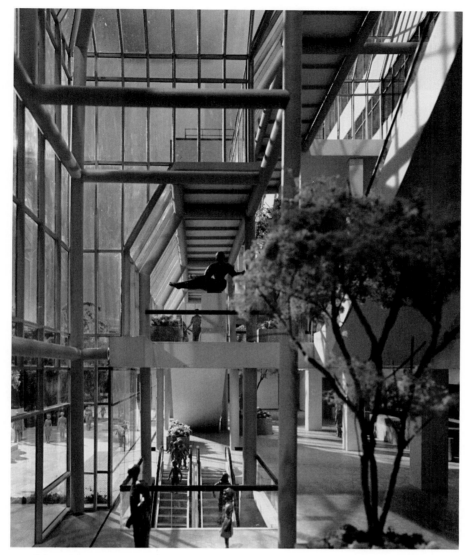

Models and mock-ups are often the best way to inform the museum client's awareness of what is to be built. One can actually peer into this Museum of Modern Art model looking east across the Garden Hall space from the second floor landing—experiencing a view and spatial configuration that could not otherwise be understood successfully from two-dimensional representations. (Photo: Copyright 1980 Wolfgang Hoyt/ESTO, 1980)

ing, lighting plan, and so on. There is an increasing awareness, however, that the museum and the process can benefit from earlier involvement with those on staff or hired as consultants who will be involved with installation design.

What is critical for fruitful museum project management is that a harmonious understanding—at minimum, artistic compatibility and mutual respect—exist between architect and installation designer, so that the installa-

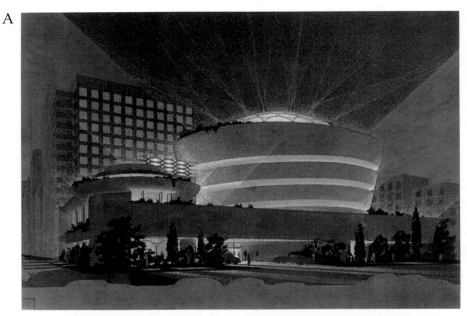

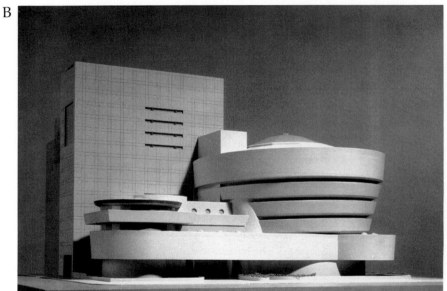

(a) Renderings can be interpretive, as in this drawing by Frank Lloyd Wright of The Solomon R. Guggenheim Museum at night. (b) The drawing, done in 1959, is still being used to document an earlier design intention of the original architect to expand the building in a manner not unlike that shown in the design by Gwathmey Siegel & Associates Architects for the new museum addition. (Photos: David Heald)

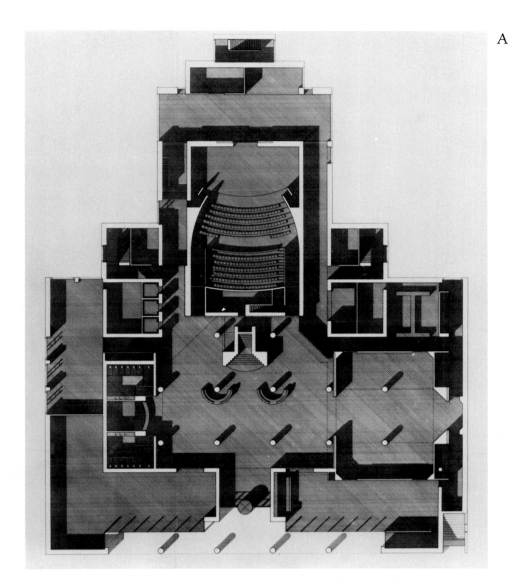

San Francisco Museum of Modern Art (Mario Botta, 1990). These four illustrations show the cumulative benefit derived from a basic ground-floor plan (a); then a longitudinal section (b), which enables the viewer to see through the building at all levels; followed by façade-elevation renderings (c and d), which give only single points of view but which detail significant façade features, like the central cylinder. (Photos: Ben Blackwell)

B

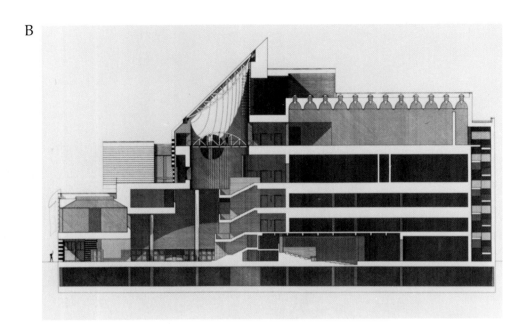

C

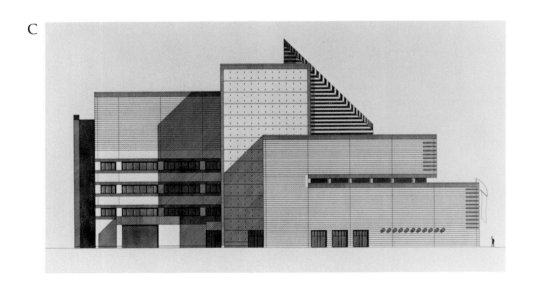

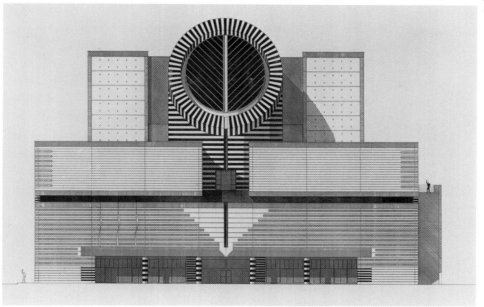

tion designer is a part of the architectural program development process, along with all other professional staff members. Participation should be encouraged through all stages of design reviews.[3]

TYPES AND OWNERSHIP OF DOCUMENTS

A full discussion with the architect, at the outset, is in order about the types of drawings and models that will be used in the design development and review process and for fund raising. The museum client must understand what drawings and renderings will be required that do not fall under basic services, and it is helpful to have the architect draft a recommended list and discuss it point by point with the project's leaders. Museums should also consider the residual uses of these materials. For example, a rendering of a gallery, done for the purposes of fund raising, may be used later as a poster, an invitation announcement to the museum opening, or even a T-shirt image.

Many of the museums surveyed agreed that the use of models and mock-ups, especially for public spaces, was invaluable to understanding a project's design. At the same time, models and renderings for fund raising and presentation can become very expensive. For a large-scale project, the charge for full-scale mock-ups can be very substantial—for example, if gallery lighting is being installed for a gallery mock-up, in special spaces and with custom ceilings and finishes.

A separate, but related and potentially important contractual consideration is the ownership and exclusive right to publish original architectural drawings and materials. Since art museums collect, preserve, and display works of art—which architectural renderings and sketches are considered to be—and put premium value on archival documentation, they might want to consider claiming ownership of original materials. Only original, stamped contract documents—the construction documents (CDs)—must be held by the architect and cannot be altered without liability to the architect. In most instances, however, the museum is more concerned about rendered design drawings and presentation documents. The museum is entitled to right of ownership, a fact that should be pointed out during the contract-negotiation stage. The museum client might also consider negotiating for illustrative and process drawings. These come more in the form of sketches, usually done in the hand of the signature architect, and they are usually retained by the architect. A less formal approach is for the museum to urge the architect to contribute these drawings to its collections.

The architect may also want to use a museum's designs to display his or her firm's expertise. If the museum, for administrative and planning reasons, does not want its designs published until the museum is ready to release them, this must be made very clear at the outset. This process can be very difficult to control, yet it can be critical to the timing of a publicity event or the heralding of a capital campaign, since crucial timing of the release of public information can be undone otherwise by an architectural firm that is eager to show its wares. This point should be addressed initially and contractually, with an understanding that the client does not wish to prevent publicity, just to control its timing, which can benefit both parties because the museum's success in capital fund raising can be the source of the architect's success as well.

NOTES

1. *Standard Form of Agreement Between Owner and Architect, Construction Management,* 1980 ed. (AIA Document B141/CM).

2. When working with a general contractor, see *Standard Form of Agreement Between Owner and Architect,* 1987 ed. (AIA Document B141). When working with a construction manager, see *Standard Form of Agreement Between Owner and Architect, Construction Management,* 1980 ed. (AIA Document B141/CM).

3. The authors wish to acknowledge the contributions of Stuart Silver, President, Stuart Silver Associates, Scarsdale, N.Y., regarding installation-design issues.

8

ENTERING THE DESIGN PHASE

U PON CONTRACTING with the architect, a project's design phase begins. The museum at this point must be prepared, both administratively and psychologically. The administrative issues are easily outlined, and each will be specifically addressed in this chapter. It is psychological factors, however, that can make or break a project. Respect and trust among the members of the project team are essential, and it is the responsibility of the director of the museum to establish this tone early in the process. If this has been handled well in the planning stages and if the staff is kept well informed about institutional priorities and how decisions are made and is given an opportunity to register its concerns, the job will be made that much easier.

Buildings are not perfect environments, and yet professional staff can have standards of perfection in their own work that simply are not achievable in designing and constructing buildings. The most common opinion expressed in this project's survey, in fact, was that compromise is inevitable. The director must deliver these simple truths to staff members to prepare them for their role in the design and construction of a new facility. During such an imperfect process, mistakes will be made and unfortunate circumstances will arise that will make some feel lost and discouraged. There is a tendency, which should be avoided if possible, to point fingers and look for fault when something goes wrong. (This phenomenon grows especially confusing when liability issues with consultants and contracts actually require tracing the lineage of responsibility to determine responsibility and related financial liability.) But at the staff and team partnership level, pointing the finger of blame only lessens the effectiveness of the team and is ultimately unproductive.

Internal personnel and an appropriate review procedure should now be in place. Since the design phase begins with the architectural program, the program will be reviewed at this time. If the program has been prepared by someone other than the design architect, as is generally the case, the design architect must have time to become familiar with it. And since the program is a working tool, the museum administration must anticipate changes and adjustments recommended by the design architect. This is an important opportunity to confirm performance criteria, to affirm guidelines that are specific to the museum, and to emphasize their importance to the architect.

And before design proceeds, the museum as client/owner and the architect must review, evaluate, and mutually agree on the architectural program. As the official written blueprint for the ensuing project, the architectural program is as significant as the later design and construction documents, and it is the owner's responsibility to provide it in its final and endorsed form.

THE TEAM AND COMMITTEE STRUCTURE

Team is a commonly used term to describe the project-management form for designing and constructing buildings. It is a different concept from *committee*. The team is a group of people, each of whom has a specific role in managing the job. Collectively, they are the workers. There is always a team; it is the only effective management approach to building, whether the project is a housing development or a museum (see Fig. 2). As noted in Chapters 1 and 3, team members may vary throughout the project from planning through occupancy. Some players may only be required during a specific stage; others will remain from start to finish. In fact, it is highly recommended for the success of the project that there be continuity in the following team members and among the design consultants.

Project director, museum. As the team captain, the project director provides staff leadership and reports directly to the museum director. He or she remains responsible for ensuring that appropriate decision making has taken place.

Project manager, museum. Depending on the size of the project, the museum may hire what is commonly referred to as an "owner's representative," a special consultant who generally comes from the construction professions. It is advisable that he or she begin work during the design phase or, at the latest, once the construction documents are in progress, some time before final documents are completed and the bidding phase begins. This position can be full-time or part-time and most likely would be contractually arranged. A standard form of AIA contract also exists for this position.

Project architect (manager), architectural firm. The project architect administers the project from the architect's office and coordinates all work on that

end. It is important to note that contractually the architect's project manager has an obligation to run, or to assign the administration of, all design-review meetings during the design phase and to take meeting minutes.

Project manager, construction-management firm. If the construction-management method is selected, this person administers the project for the construction-management firm, which, during the design phase, will be estimating costs and performing critical design reviews to test the building's viability. He or she will also lead the effort to monitor costs during design and will actually manage the job on behalf of the owner during construction. If a general contractor is to be used for the construction phase, these responsibilities during design are handled by the owner's representative, working under the project director. Then, once construction begins, management of the job becomes the responsibility of the general contractor's project manager. In either case, the museum's project director or its owner's representative must thereafter oversee the construction manager or the general contractor's project manager as well as all other aspects of the ongoing construction process.

In addition to the project team, museums can have review committees. The principal such "committee" is usually a board review and approval body, which is not involved with the daily business of making the building but which bears fiduciary responsibility for the museum and therefore has final approval. There may also be a separate or integrated staff committee that participates in all design reviews. In most instances, the director or the project director is the intermediary between the team and the board committee. The project director supervises the staff committee, if one exists separately. The board committee must also have strong leadership, normally resting with its chairman.

As emphasized in Chapters 2 and 3, who will lead and manage a project internally should be determined early in the planning stage. The museum's size and internal capability must be reviewed to determine the resources that will be required to administer its building project. No matter what size the project, no matter how large or small the museum, there are three principal institutional players without whom the project cannot be accomplished successfully: a board representative who has accepted the challenge of carrying the flag for the project and who represents the board's vision and responsibility in decision making; the director, who provides the professional vision and leadership and is ultimately responsible for decision making by the staff; and the project director, who either is on staff in an expanded existing position or is added as a resident consultant for the duration of the project, if existing staff resources are not available. By the start of the design process, these roles must be fully clarified.

The first task the director will face is delegating the responsibility of

managing a project to the project director. In most instances, it is neither practical nor reasonable for the director to manage the job directly. And it is critical that the director delegate these duties to a qualified person, for the project director is responsible for an extraordinary number of daily tasks and detailed procedures.

The director makes decisions regarding the overall administration, the physical operation, and the curatorial programming of the museum. The architectural program has translated the priorities of the museum into a text that will be understood by the consultants. The director's responsibility is to work with the professional staff to make sure that the new building's development from planning through occupancy fulfills the objectives set forth in the program. It is also the director's responsibility to ensure that decision-making and reporting procedures work smoothly. His or her primary concern, however, is always that the museum building live up to the expectations of the board and staff, satisfying the needs of both the collections and the public.

The project director's responsibility to the director is to represent the professional staff's voice throughout the project's development and to recommend and oversee appropriate procedures for the project's execution. From the planning stages through occupancy, the objectives set forth in the architectural program will go through many changes and adaptations, and it is the responsibility of the project director to ensure that the museum's interests remain paramount and that the obligations of the participants' contracts and the design-development process accurately reflect them. It is essential that the project director inform the director of all significant events and any recommended changes—and it should be stressed that there will be changes.

Early in the planning process, an institution's vision is either defined or redefined. It is the director's charge to ensure that that vision be preserved intact. The project director's charge is to implement the project by leading the team and realizing the vision embodied in the architectural program. Finally, in an attempt to make some distinction between the needs of smaller and larger institutions, it should be pointed out that most museums engaged in building projects are indeed on the brink of changing scale. Project-management structures and procedures, however, should not vary materially. What will vary is the commitment required of time and resources, based on the magnitude of a given project.

PROJECT ADMINISTRATION

Under the leadership of the project director, the team at this stage consists of the architectural firm's members and consultants; the owner's representative, construction manager, or cost estimator; a local government representative, if required; and a recommended in-house review body.

The Architect's Team

The principal or partner-in-charge will be the architect whose name is on the letterhead or the design professional on the basis of whose work the museum made its architectural selection. The principal architect will provide the vision and the basic scheme for the building as well as guidance and direction on design matters throughout the project. Design architects are caricatured commonly as roughing out designs on the backs of napkins over cocktails or lunch with a client and passing them on to others to execute. However, there is obviously much more to their responsibility. Although approaches to working with a client may vary, the principal's role is paramount in any project. The ceremonial role of the architect, especially for a museum project, should also not be taken lightly, and museum clients often need their architects to present projects to prospective donors, local government officials, and community leaders.

The project architect is responsible for administering the project. This person will lead the architect's in-house team, not all of whom will be well known to museum personnel. The project architect will be a familiar face at the museum, coordinating all job meetings and acting as liaison between the museum's project director and the subconsultants. As the scribe, the project architect is also responsible for taking all meeting minutes. Additionally, he or she may have more administrative responsibilities, such as ensuring that subconsultants live up to contractual obligations, preparing budgets, billing, and dealing with any major problems of job administration.

The architect's subconsultants will always include mechanical, electrical, and structural engineers, whose work is considered part of the architect's basic services. (In some cases, owners contract directly with these consultants, but there can be problems with decentralized liability for a project in such instances.)

Additional consultants can include experts in lighting, security design, code and life safety, acoustics, elevators, historic preservation, disability access, and graphics. It is generally advisable to have consultants (with some exceptions) be subcontracted by the architect and to have the architect accept responsibility for their work. Customarily, architects are entitled to a markup, usually of 10 percent, for such consultants' fees that are not covered under basic services.

Construction Management

Museums can choose to hire a construction manager to take over responsibility for managing project development and construction under a variety of contractual arrangements.

Since preconstruction design-related services can be valuable, the decision of whether or not to hire a construction-management firm should be made by the start of the design process, during the negotiation of the architect's

contract. Some institutions choose to contract with a construction manager for preconstruction design-related services only; others choose to use an owner's representative for this function. In either case, this party will watch over design development and provide construction-related advice as design proceeds, evaluating designs and determining if they are both buildable and within the project budget.

Construction managers and owner's representatives can also provide a service called value engineering, making alternative recommendations to build comparable structure in a more cost-effective way than that proposed by the architect. For example, if the architect has specified a particular finish for an ornamental metal railing, the construction manager might review the specification and propose a less expensive alternative, without changing the design concept. The result may be that the railing will look the same but be hollow instead of solid, at a 30 percent reduction in cost. A specified stone flooring of a certain thickness and size of block may need to be set by a stone setter. However, if the architect agrees to change the specification, reducing the dimensions of the block and the thickness of the stone, then perhaps it can be set by a tile setter, reducing not only the cost of the material but also the cost of the labor.

Most architects value these services and are appreciative of cost savings. They allow everyone to be able to share in the success of bringing a job in on budget. If a change is recommended and the architect does not agree, it may be due to an issue of aesthetics or liability, and since the architect's stamp is on the documents, he must be in agreement. It is the job of the project director to keep the peace and to ensure that there is a harmonious working relationship among these parties.

In-house Administration and Staff Review Committees

In addition to the project director, there may be clerical personnel assigned to manage project documentation, of which there will be volumes, and independent full- or part-time bookkeeping may be required. The clerical burden will also be heavier if local government funding is allocated to the job and the museum is responsible for accounting for and requisitioning these funds. This can increase the work load enough to add an additional part- or full-time person.

Staffing must be geared to the size of the project rather than the size of the museum. This is especially important for smaller institutions that are substantially adding to their size. The members of the project team might outnumber the regular staff, and in most cases their salaries and benefits will be competitive with those in the building industry. Museum salaries, which are generally lower than those in private industry, may not be competitive enough to hire experienced project personnel. Taking them on as special

temporary consultants may ease the tension of having to pay salaries that are in some cases even higher than the director's. A museum may choose to bring them in under special contract and capitalize their expense. It is in any case important to remember that the museum is undertaking a project where time is money, and experienced personnel can be cost effective.

In addition to the project administration staff, there can be a staff review committee made up of building and collections managers, key players who represent the users of the museum. (A new museum or a small one with limited staff may have to hire additional consultants for this purpose.) These staff representatives review design documents and become a part of the design process. The disadvantage of such a method is that it may prolong the process and therefore add to its cost. And it is also likely to generate more changes, which always cost money. The advantage, however, is that the end result will be more responsive to professional needs, and there are likely to be fewer changes after the project is built, which can be even costlier. A critical procedure for managing this part of the project-design process is to dictate that the project director or a designated substitute communicate in a singular voice on behalf of such a group with the outside consultants.

In-house staffing is identified in Figure 2. Reporting directly to the project director will be the project administration, including any clerical, accounting, or specialized consultants. Also reporting directly to the project director on design reviews are the staff representatives. One way of organizing this level of input is to identify key functional areas of the museum: for example, administration, physical plant, curatorial activity, and public service. According to this division, a staff committee might include the assistant director or the equivalent; the building or operations manager; the chief curator, installation designer, collections manager, or registrar; and the principal educator or public-information officer. An important member of any such review body is someone designated to review designs on behalf of disabled and older adults. In fact, it is strongly recommended that an outside consultant be considered if an appropriate person is not available on the staff. Architects follow code requirements and federal minimum guidelines for making their buildings accessible, but the result is not necessarily adequate for a facility to be truly "open" to its public or fully user-friendly.

Professional staff members serving on any such review body have a demanding responsibility. If the museum proceeds with this type of review, not only must the participants be prepared to put in the additional time, but project planning should take into account the time they will have to give, and temporary staff may have to assume some of the usual operational workload. Especially demanding is the time required of operations staff. The technical detail of the design process is rigorous, and the turnaround during design must be kept on schedule. Daily operational crises will interfere, and, if not accommodated by staffing-up, the building program may bear the brunt of

such delays. The museum must prepare for these demands by carrying appropriate budget allocations to cover such supplemental costs.

MANAGING THE TEAM

Building is a tough business, a far cry from the perceived gentility of the art museum environment. The project director must maintain control of the job and must ensure that the museum behaves like a professional client. Museums are known to be difficult clients because of the number of challenging and often contradicting programmatic needs to be fulfilled. When the project is an addition to or a renovation of a functioning museum, the job is particularly stressful. It is nearly impossible to preserve and care for fragile and priceless works of art in a construction site. Many precautions must be taken, and the project may need to be carried out in phases as collections are moved about, often at extra cost. The quality of the relationship among all the team members lies in the hands of the project director. Strong leadership is required, along with good statesmanship.

Every job progresses cyclically. The consultants retrieve information, produce designs, and present them to the owner. The owner reviews designs and returns them to the consultants. The consultants rework designs and give them back to the owner, and so on, until the job is done. To manage this process, certain administrative tools are used, which are the same for all jobs: meetings documented by minutes and reviews accompanied by written comments.

Meetings

During the design stage, project meetings should occur every two weeks, although this schedule varies with the type of job and the speed with which it progresses. The meetings are usually run by the project architect or project manager and are always attended by the project director. The minutes, which must be kept for every meeting, are taken by the project architect. The minutes will serve as the repository for all information and project history that later will be called up for reference, so each meeting should be assigned a sequential number. The meetings can sometimes be design presentations and often are information exchanges between the client and the consultants.

Presentation and Review

Preliminary and final design presentations are scheduled periodically. Preliminary reviews should be presented to the project director to find out necessary information from the owner before proceeding further. Final designs are

presented formally to the director and usually also to the board building committee and often to the full board. The catch, if one is working with a schedule, is that the owner, as well as the consultants, be required to keep to it. If after a final presentation the museum decides to make a change and the change can easily be accommodated during the next stage of design, fine. If there is a substantial change to be made in the scheme, however, an additional review may be required, which can be time-consuming.

Architects should be aware that institutional clients, because of their internal structure, may require a longer review period than commercial clients. The project director must develop the schedule for reviews around the availability of the director and the board, and the trustees involved in the reviews must be aware of their obligation as well. Presentations must be scheduled far in advance, and additional time to get the job done should be recognized during the contract schedule, since delays will affect fees.

Reviews are internal. Upon receiving the latest design documents, the project director should have them distributed to the members of any in-house review committee. All comments from this review body should be analyzed by the project director. (Duplicate copies of documents can be a significant budget item.) The comments will fall into several categories.

Request for additional information or clarification. The operations manager may ask to see a switch diagram for lights in new galleries to give to the staff electrician for review. The collections manager may want to have the door widths of the freight elevator confirmed. The education or public-information office may want to know where a smoking section for visitors during special events will be. The assistant director can request verification of the placement of computer terminals in the new finance offices and ask if there will be buzzer access to the offices. The disability-access consultant may ask that the height of the buzzer be verified.

Corrections. The operations manager may point out that no floor drain has been provided in a pump room. The collections manager can note that the placement of thermostats in the galleries interferes with installation and ask if they can be moved. The public-information officer observes that the checkroom is too close to the information desk, which might cause a traffic-flow problem. The disability-access consultant notes that the baby-changing tables in the ladies' room are too high for use by women in wheelchairs and that there are none in the men's room, although they had been specified in the program.

Scope changes. The operations manager requests that a security console room be upgraded in this phase of renovation, even though it was not defined in the scope. The collections manager may ask for a change in the layout of the art storeroom, which will require additional cabinets. The education specialist requests an extra classroom to accommodate a new program for older

adults and asks for individual seat numbers to be added to the new auditorium seating. The disability-access consultant identifies the need for an infrared system to assist the hearing impaired in the auditorium.

The project director should request all comments from the staff in writing. They can be written directly on the drawings, and all members of the review body should sign off on their copies after reviewing each stage of design. The project director then summarizes the requests for clarification and the corrections and returns them to the architect.

Scope changes are handled differently. Since a scope change will almost always result in additional costs, the director and/or the board committee chairman should review these requests for change through their formalized process. After a decision is made, it must be formally approved and submitted in writing to the architect, who will be entitled to extra fees for changes in scope.

The Decision-making Process

The procedure for making decisions must be in place at the outset to expedite the design schedule. The project director must have access to the museum director when required, for example, and should not be forced to be the only person responsible for decisions regarding scope changes. The project director has the responsibility to report to the director the recommendations of any staff review committee. It is the director's responsibility to decide both whether change of any magnitude is appropriate and when change is of sufficient magnitude to require being brought to the attention of the board for review and approval.

In addition to a formal system of review and approval, which should take place at regularly scheduled meetings when decisions are formally approved and documented, there is a need for an informal system of approval, so that the project director can call on the director or a board designee, when that level of approval is required, to make prompt decisions when it is appropriate to do so. These informal decisions may be made over the telephone or during brief drop-in visits at the office, but they should be documented. A handy tool for documenting telephone conversations is a printed telephone memorandum form. It provides for all appropriate information to quickly be filled in by hand, and the handwritten record of the conversation can go straight into the file with copies to the appropriate parties.

REVIEWING THE ARCHITECTURAL PROGRAM

After the contract has been negotiated, the team is in place, the procedures have been presented and approved, and everyone is at the ready, the first task for

the architect, in what is a research phase, is to gather as much information as possible regarding the program, the site, and the nuances of the institution.

Museum buildings are specialized building types with requirements and performance criteria that challenge physical-plant operations. Throughout the design process, the function of the building, the operation of its mechanical systems, and the operating budget that will be required when the project is turned over to the client must always be kept in mind by the board, the museum director, and the project director. Requirements for the exhibition and safekeeping of the collections are paramount. Public amenities and the experience of the visitor, where orientation is a key issue in the layout of public spaces, are also vital to the successful operation of the building. The special storage and circulation requirements of the collections must be considered. These programmatic issues must be continually reviewed during the design process.

Foremost in the architect's consciousness may be the public space of the museum, and so the architect's design team must be introduced to the museum's other circulation requirements. One must track not only the route of a visitor from entry through exhibition, but also that of a work of art as it leaves its home in storage, goes to conservation to be treated, and then is prepared for exhibition. How does it travel through the museum, and what are the specific requirements of the collections? Perhaps the collections comprise standard-size cabinet paintings and move easily in and out of normal-size elevators on hand trucks; in that case, the requirements are less demanding than if the museum has a collection of monumental sculpture that must be moved using special motorized equipment. Art objects do not travel well over stairs and sloped floors. Bumps are to be avoided. Moving oversized pieces through a series of spaces with different ceiling heights and undersize doorways can be a problem. The architect's job is to accommodate the demands of transporting the collections as well as of installing them. Less attractive is the question of how rubbish will travel through the building. As suggested in Chapter 4, if one were to track the visitor, the work of art, and the trash on their daily routes, one would cover the most essential museum circulation problems.

Points of entry are a security concern as well as a basic consideration in planning visitors' access. What happens when works of art going out on loan are being loaded at the same dock where the food concession is receiving a shipment? What are the security and conservation implications of such a scenario? These are the types of situations that must be anticipated by reviewing daily procedures with the staff. At some point, the architect's staff will want to visit the site and observe these functions firsthand. If they do not express the desire to do so, it is advisable for the project director to require it.

The design-development phase can be thought of as a rendering of the architectural program. The review of the program by the architect must culminate in the formal agreement between the architect and the owner on

the program as defined by the owner. From concept to drawing, certain realities then are tested. In the testing of those realities, changes occur. The review process is critical to ensuring the feasibility of the program.

The responsibility of the museum client through the project director is to ensure that the architects understand the program adequately in order to make the design functional. Although architects do want to service the client museum and do share the client's interest in producing an optimally functional building, the responsibility for translating the architectural program into a finished museum cannot be left entirely to them. Operational and functional reviews of design through all stages are essential, and operating staff as well as users must be involved. The architects depend on information from the prospective users, an exchange that must be expedited by the project director.

Not all project leaders will agree on the best forum for and extent of staff involvement, and this can be addressed in many ways. However, most architects will agree on the importance of staff involvement and will want to talk at some point to the actual users of space. Perhaps the best way to handle this situation is to make staff members aware, regardless of the forum chosen, that their responsibility is to recommend specifications for the use of new space, but that their voice ultimately must be spoken through the project director and that decisions ultimately are the director's and the board's.

Utilizing the Program

During the contract-negotiation stage outlined earlier, the architect will most likely have completed in good faith a program review. (For a discussion of the development of the program's scope, see Chapter 4.) Site visits will be made by the architect at this time to determine what additional information is needed. In the case of an extant building, existing building plans will have to be verified with field measurements. As-built plans that show specific existing conditions may have to be developed. Interviews will be set up with the staff and users of the building to enhance the architect's understanding of the operation.

If there is no extant building, the architects may have to travel to other museums with similar collections to get a feel for the job. In general, traveling with your architect is invaluable. Most institutions are in regions where there are similar art museums nearby. If not, the architects should visit a city or cities with examples that come close to their vision for their museum and spend some time studying what others have done.

There are plenty of professionals at other museums who are happy to share their experiences, and everyone is fascinated and informed by the details of the experience of others, especially when they are unusual. At one major art museum, where the freight elevator had been sized to accommodate the

collection's larger pieces, the mechanical engineers sized a duct and ran it across the ceiling so that the clearance requirement was not met. At another institution, the assigned city architect's mechanical consultant designed the electrical system so that one had to go to the fourth floor to turn on the lights on the sixth floor. Such snafus happen in the best of circumstances, and the more discussion that takes place among colleagues, the more enlightened a client the museum will be, and fewer mistakes will be repeated.

Museum-building projects do not always run a smooth and continuous course. Due to lapses in fund raising, turnover in leadership, political intervention, or a variety of other causes, projects may be stalled periodically. If there has been a pause between the time the original program was written and the start-up of design, a review of the program should be conducted by in-house staff as well as by the architect.

Perhaps there has been a change of acquisitions policy, or an important new donor has appeared with a specific collection requirement that will affect the program. The program is a working tool and will change. This is the time to make changes if required.

Phasing of a particular building project should also be considered, for a number of reasons. Perhaps the magnitude of the impact on the existing operation may be too great to consider doing all at once. Can an institution afford publicly to shut down its entire operation while undergoing a major redressing? If not, phasing can provide a viable alternative. If a pause has occurred due to a shortfall of funds or a sluggish economy and skittish donors, perhaps priorities may have to be rethought or the overall project scope portioned into priority-directed phases. Multiphased projects are often referred to as master plans.

Performance Criteria

The architectural program must document a large quantity of specified technical criteria. If this outline has been drafted before selecting the architect, it must be reviewed, revised, and approved by the architect in advance of the design process. In an attempt to introduce program categories for performance criteria and specifications, several appendixes are included in this volume. Revising criteria before the design process begins (and, in some cases, before the architectural program is finalized) is helpful.

Appendix A, "Accessibility," describes the process and critical issues involving accessibility design and use by physically disabled and older people. It introduces the concept of universal design.

Appendix B, "Performance Criteria," reviews relative humidity and temperature, lighting, air quality, acoustics, weight loads, electrical loads, and other performance issues.

Appendix C, "Climate Control," describes various climate-control systems,

including specifications for heating, ventilation, and air conditioning (HVAC) as well as temperature and humidity controls and how to choose among them. This is, perhaps, the single most debated technical issue in the art museum field.

Appendix D, "Lighting," explains various approaches to predicting and controlling the effects of light sources.

Appendix E, "Fire Protection," looks at both fire-detection and fire-suppression systems and the inherent dilemma of protecting artworks with systems that potentially can also damage them.

Finally, Appendix F, "Security and Life Safety," reviews techniques for assessing the risks to lives and collections. It also discusses how to build security considerations into the early design stages and maintain security during the construction process.

BUDGET AND SCHEDULE ISSUES

At the beginning of design development, the project will have been assigned a budgetary order of magnitude, or proposal budget (see Chapter 5). From this point forward, the budget must always be determined in relation to the current stage of document development. Early budgets are estimated from incomplete documentation, and appropriate contingencies should be carried in order to cover inevitably swelling costs during the development of the design. If budget reporting does not include an appropriate explanation of the related status of the design, reflecting adequate contingencies, then the project can easily exceed its budget before it gets started.

The Budget

Typically, construction budgets are divided into hard and soft costs (for a sample budget breakdown, see Table 2). Soft costs include architects' fees and reimbursables (including consultants' reimbursables); predevelopment, legal, and real-estate costs; special testing and probes; air monitoring and sampling; travel; meeting expenses; project insurance; filing fees, and the like. Early budgets that are based on net square footage hard-cost estimates must evolve accordingly. As the design develops, soft costs will increase proportionally along with hard costs.

Hard costs are generally referred to as the brick-and-mortar costs. More specifically, they are the estimated amounts for the general construction and include contractor's mark-ups, overhead and profit, general conditions, escalation, controlled inspections, and construction contingencies. We now elaborate particularly on two categories of hard costs—mobilization and occupancy—that are incurred before and after the more typical brick-and-mortar costs.

Table 2. SAMPLE BUDGET BREAKDOWN

Fund raising	Soft costs	Mobilization costs	Hard costs	Occupancy costs	Publicity costs
Capital campaign consultants	Architect's fees	Site preparation	Trade estimates	Furnishings and equipment	Opening ceremonies
Publicity consultants	Architect's reimbursables	Art-relocation expenses	Overhead and profit	Telephones	Reception costs
Personnel	Subconsultant's fees	Personnel relocation	Markups	Computers	Special events
Cultivation events	Subconsultant's reimbursables	Public awareness/signage	Escalation	Window treatments	Special photography
Brochure production	Owner's consultants	Construction protection	Contingencies	Audiovisual equipment	Media-video
Mailings	Legal and real-estate fees		General conditions	Lamping up (lighting)	
	Project administration			Moving-in costs	
	Personnel			Art moves	
	Travel			Personnel moves	
	Meeting expenses			Facilities services	
	Duplication			Exhibition* installation	
	Postage			Special interiors*	
	Telephone			Retail shops	
	Miscellaneous			Restaurants	
	Insurance			Libraries and study centers	
	Borings and probes			Art-storage furnishings	
	Air monitoring				
	Filling fees				

*Depending on how this work is contracted, these costs can fall within hard costs, or a separate budget category for special installations.

Mobilization Costs

Mobilization is the term contractors use for the preparation of the site before building. It entails a logistical analysis of the site: the grounds, the roadways used for the transport of materials, and the positioning of cranes, lifts, and other heavy machinery; the utility hookups, toilets, and amenities for the workers; and storage areas for building materials and supplies as they arrive on site. If the site is an existing operating museum, there are many details to be worked out, from the wording of signs on construction fences, to orientation and greeting of the public, to the building of partitions that will isolate the construction area from the operating museum's functioning spaces.

The costs of preparing for construction for an existing museum are borne in part by both the contractor and the museum. The contractor is responsible for clearing and preparing an unoccupied site and for providing protection for occupied areas. The museum must evacuate areas that will undergo construction and must take precautions for the safety of collections and the ongoing operation of the organization.

The contractor's mobilization costs are usually carried under "general conditions," a subcategory of spending assigned to the contractor or the construction manager along with other general site-maintenance costs. Art museums, however, must determine the percentage of these costs that will be administered directly by museum operations and assigned to another budget category. For example, if construction phasing calls for separating gallery A, which will continue to operate during the construction period, from gallery B, which is to be renovated, the museum must first decide if, in order to provide security and control, it wants to build the construction partitions itself. If so, the cost must be accommodated in one of its own budget lines, and time must be allocated in the construction schedule.

Often security and protection of the site are provided under general conditions. The museum may elect to have its contractor or construction manager hire an outside guard force, or it may decide to expand existing staff and train museum guards to provide protection during construction. The latter option provides more control, and the additional costs can then be carried as a one-time expense, capitalized as part of the museum's own mobilization budget.

The moving, temporary storage, and relocation of collections probably make up the largest expense under mobilization for art museums. Any collections either in storerooms or on exhibition that will be in the vicinity of construction most likely will have to be moved. The costs associated with these moves, which must be budgeted by the museum, include overtime for personnel in art handling and conservation, additional temporary personnel contracted as a one-time expense, materials and supplies used for the moves and for storage, special equipment costs for handling and rigging, and, if the collection is to leave the building, off-site leasing costs and transport expenses.

There may also be the costs of relocating staff and reassigning telephones and computers. Temporary offices may have to be set up in education classrooms, in galleries, or off site until the end of construction. Loss of revenue also should be factored in if retail shops or restaurants have to close temporarily or if fewer programs that charge fees can take place.

If a new museum is planning a new building without an existing site, temporary office space—and related budget allowances—will have to be provided for its staff. If an existing museum is eventually moving to a new location, will the project team be situated at the old site or the new site? If a building is expanding because of a space squeeze, the project team may reside off site, or perhaps in prefabricated structures, and this cost must also be budgeted.

Occupancy Costs

Most costs associated with the interior installations of the building—office furnishings, art-storage equipment and cabinets, capital-equipment purchases, exhibition installation, audiovisual equipment, telephones, computers, and window treatments—are part of a separate budget. They may be carried in hard costs under the category of FF&E (furniture, fixtures, and equipment, or items that are not fixed or attached to any structure or operating system). By definition, this category would not usually cover such items as fixed seating in an auditorium or an installed wired sound system, which would otherwise be part of general construction. It is important primarily to make sure that all items are accounted for. For example, hard costs will carry the lighting track for the galleries with a sample of various fixtures specified by the lighting designer. However, additional fixtures and the cost of bulbs (lamping-up costs) may or may not be included. It is the project director's responsibility to see that budget estimates cover all the bases. The occupancy costs also include office furnishings, from telephones, fax machines, computers, and photocopiers to accessories such as wastebaskets. Wiring for office equipment should be carried under the general construction categories in the budget for hard costs. Floor coverings are generally carried under hard costs as part of the contractor's obligation.

Estimating Costs

A successful understanding of the cost of a project is totally dependent on the estimating process. Most architects do not prepare project estimates, nor should they. This responsibility is not usually considered part of their basic services, and for the most part, they are not very proficient at it. Either a construction manager or an outside cost estimator engaged by the owner's representative, or both, should be used. And verification, or second, estimates are usually cost effective.

The frequency of estimates varies, but they should be done at the end of each review stage of design and at least twice later, during the development of construction documents. Awareness of which expenses are increasing during design is crucial to keeping the budget in line. One way to hold costs to budgeted levels, as has been mentioned, is to employ value engineering where possible; another is to reduce project scope. There is no preferred method, but if the scope has to be reduced or project elements redesigned to stay within budget parameter, these steps should be taken as early as possible while the architect has adequate and informed staff assigned during the design stage.

Future Operating Costs: What No One Wants to Face

The single most important economic phenomenon acknowledged by the museums surveyed (and also universally throughout the field) is that museums often are not adequately prepared for the high costs of future operations. These costs must be computed as a parallel exercise throughout planning, design, and construction, and they will be a major fund-raising issue. Most institutions will require either new endowment or other new revenue resources to supply incremental operating funds (see Chapter 2), and these needs should be considered during the planning and programming stages.

Projecting increases in operating expenses is a key implication of enlarging a museum's physical facilities (see Chapter 3). Everything that is added requires personnel to operate, often with increased expertise requiring increased salaries. Energy costs in museums generally tend to be high. Even though architects and engineers should consider all opportunities for energy efficiency, it is expensive to operate and maintain sophisticated new lighting and mechanical systems.

During design, the client must continually ask, What will it take to operate the new building? Extra staff, new equipment, more professional technical management? For example, the architect has specified new wood flooring in the gallery. The old gallery floor was vinyl tile and was mopped daily. What will it cost to pay extra personnel to polish the new floor, and how much will be needed for machinery and supplies? The lighting designer has specified new fixtures that use a different wattage from those currently used. Will they require extra bulbs as well as additional power? The climate-control system will require that specialized chemical filters be changed at specified intervals, which will add $50,000 to the operating budget, or laying off two security guards to cover the cost of the filters. This is the reality that many museums have had to face, and capital funds to endow these operating needs are for the most part much easier to raise during a related building campaign than is general operating support for the same purposes.

The Schedule: Time Is Money

If the design is scheduled to take eight months, the architect will plan to assign staff personnel for that period. If the museum takes too long to turn around reviews and comments, or if delays are caused by the pace of the museum's internal procedures, the architect may have cause to charge additional fees. It is the project director's responsibility to keep the project moving, and the museum director's responsibility to make sure that decisions are executed in a timely way and that appropriate board groups are available for review as needed. Architects may similarly not always keep to the schedule, and the museum's project director must also maintain necessary pressure on this side as well.

9

THE DESIGN-DEVELOPMENT PROCESS

THE DESIGN PROCESS is easy to define and never changes, whether the building under construction is a courthouse, a garage, or a museum. There are three distinct stages: schematics, design development, and construction documents. As design progresses, two conditions are guaranteed: there is necessarily less opportunity for change, and the cost estimates get higher.

DOCUMENTING THE PROCESS

Once the museum has entered into legally binding contracts with one or more consultants, records are required to make a credible case if one of them fails to perform. Or there may be cause to revisit an earlier decision, especially when analyzing the need for proposed scope revisions. Many records should be kept.

1. Minutes of meetings
2. Logs of important telephone conversations
3. Fax transmittals
4. Incoming and outgoing correspondence
5. Copies of contracts (originals and amended versions, if any), letters of agreement and intent, and the like
6. Permits, insurance policies, and so on

The architect will be keeping a roughly comparable set of files and will be responsible for holding all plans and documents relating specifically to the

design process. What is most important is that approvals and decisions be documented in the minutes. No one will remember twelve months after the samples were approved why a particular model of smoke alarm was specified. Later, when it is time to purchase the equipment and that model has been discontinued, the rationale behind the decision may need to be revisited.

To manage all this paper, the project-management office will have to have ample space for filing not only standard-size documents, but project drawings and plans as well. The project director will need to refer regularly to the files of design documents, and, at the end of the job, contract documents and shop drawings, of which there will be many, must be turned over to the building facilities or operations office. In many cases, after a capital project is finished, especially if it is a single-phased project or a completed multiphased one, the remnants of a project-management staff, together with all relevant records, are merged with the in-house operations staff—a logical conclusion, since the in-house operations manager is the source for in-house technical data before, during, and after construction.

SCHEMATICS

Schematics, or the preliminary schematic-design stage, result in the first picture of what a building will look like. This picture will be simple. Adjacencies will be determined, and the basic shape of the design will appear. This will be the architect's first translation of the written program, supplemented by research, into a newly interpreted structure. The team will be tested during this stage, as the process of presentation, review, and submission of written comments commences. This is the period of investigation and exploration by the architect as well as the staff, who need to be active participants in this stage of the review process.

The earliest drawings may be conceptual, rough sketches, which the architect may choose to present to the museum to evoke a first response to the design. Toward the end of this phase, the basic design will become a reality, and the board and staff review processes will become very important. There are specific questions and concerns to review.

Does the developing design work within the context of the site? Do points of entry work? Does the design satisfy parking requirements? How will the building relate to its environment: will it rise majestically, as prescribed by the program, or will it blend into the site if that is the goal? What are the zoning limitations, and have they been adhered to? Have all building codes been considered?

Have the needs of the collections been met? Have the collection program adjacencies been considered, as prescribed in the program? Sections and eleva-

tions should be reviewed, as well as plans. Museum scale is extremely important, especially for the installation of collections. Issues such as ceiling heights must also be considered in the developing scheme at this time. The architect should walk through the drawings with the staff—from the arrival of a work of art at the loading dock, through the various handling procedures, to its final home either in storage or on display.

Does the design respond to operational needs? It is not too soon for the operating engineers to question the location and size of mechanical spaces, or for the registrar to identify freight-loading and -unloading issues. Have the architects departed from the original program and recommended changes? Do these changes work? The architect should walk the staff through the route of a shipment of non-art freight from its arrival to its destination. The architects should also take out the garbage in a similar exercise. The security manager should test a general staffing plan for guards in the public spaces, with their positions noted on copies of the drawings. All assumptions should be tested.

Have the needs of the visitor been met? The first questions to be asked should concern accessibility. Drawings of sections and elevations must be reviewed. There are few one-story museums. This is therefore the ideal time to discuss access not only for physically and sensory disabled visitors, but for general visitors as well. How do they get to the café, book shops, and auditorium? What about access after-hours for visitors to special programs? What entrance would they use? Can visitors have access to the café from the auditorium after-hours without sacrificing museum security?

Checklist. Have all program requirements been incorporated? Now is the time to review details (how many toilets? closets?), since they need to be developed and corrected in the next phase.

At the end of this phase, a new budget estimate should be developed, and the job will grow increasingly real. A design contingency should be carried through the various design stages to allow for creeping costs based on final decisions on materials and other design criteria. In the schematic phase, the budget estimate represents schematics only and is not final. Caution is therefore in order when presenting preliminary figures for board committee review. The greatest opportunity for change is between the schematics and the next stage of design development, and this is therefore concomitantly the greatest opportunity for costs to escalate. Now is the time to verify procedures for cutting back: How can the project stay on budget? Who will make what decisions?

Some serious projections for operating costs are now also in order, calculations that should develop along with the design and should always be a part of the design-review process. Architects and engineers should help in looking for possible operating- and maintenance-cost savings because requisite endowment funds and operating grants to support such costs are not glamorous, nor are they as easy to come by as capital construction donations.

Preliminary engineering and other specialized design efforts must start during schematics, and related issues raised at this time will need to be fleshed out during design development.

DESIGN DEVELOPMENT

The architect's subconsultants now have a scheme to respond to and can start to create the systems that will merge with it. In addition, the museum's review of the schematics will give more information to the architects, to be rendered accordingly. When architectural plans are drafted, the architectural, structural, mechanical, electrical, plumbing, security, and lighting plans are drafted separately. It is the responsibility of the architect to ensure that the documents are coordinated (a term that will be used frequently). It is especially difficult to coordinate completion of all consultants' efforts, since some plans are dependent on other consultants' work, and a delay early in the process can have ramifications throughout the planning process.

In-house personnel must request a lot of clarification and in writing. Even though it may be the consultants' responsibility to do so, it cannot be assumed that consultants will remember all critical needs and priorities while coordinating documents. That is how ducts are installed that interfere with specified ceiling-height clearances and how electrical switches end up on the wrong floors. It is impossible to overstate the importance of museum management and staff review during the design-development phase, when some of the most expensive components of the museum (i.e., mechanical systems) are being chosen. Mistakes made now are very costly to correct at later stages.

By this stage, there should be someone on staff with the professional expertise to analyze the technical specifications in the documents with an acumen beyond that of most museum professionals. Such supervision is the owner's direct responsibility, as will be the expense of correcting oversights.

As mentioned in Chapter 7, if the designer of the museum's collection installations has not been chosen by this time, that decision must now be made. It was an overwhelming consensus of this project's survey that museums prefer to use either their own staff or a museum-design specialist to execute these installations. The nature of these installations will differ, depending on the nature of the collections, and these efforts should be concurrent with overall design development.

At the end of design development, a precise, well-organized body of information should be in hand.

1. Architectural plans, elevations, and sections depicting every component of the art museum. Special attention should be paid to junction points. Elevations of portal-types for all public spaces should also be reviewed. These details are very important aesthetically.

2. Mechanical, HVAC (heating, ventilation, air conditioning), plumbing, sprinkler, and electrical outline plans, and key details and calculations.

3. Site plans indicating landscaping grading and all roads and points of access. The site plan should include a roof plan and may also be requested at smaller scale in order to encompass more of the site and provide a sense of the design's relationship to the site, since the approach to a museum is usually an important part of the design. It is also important to check disability access.

4. An outline specification draft that will begin to spell out material types written for each trade or subcontractor.

5. A cost estimate.

6. Presentation documents. The institution's fund-raising requirements may call for special color renderings of certain public spaces, especially if they are to be presented to potential donors for naming opportunities. Since the production of presentation documents and models is usually not included in the architect's basic-services fee, a budget for them, with a cap, should be established. Simple design matters such as portals that can bear a donor's name over the door or the specification of bronze- instead of steel-toned letters may be significant from the fund-raising perspective.

A museum might at this stage consider having its design-development estimate verified by a second source. No matter how good the cost estimator or construction manager, everyone makes mistakes, and it is always the client who must pay for such mistakes. It is therefore better to spend a little extra up front for this purpose.

This is also a good time for the director and the board to declare a "no changes" policy—an effective tool that can help the project director keep the job in line. There will almost always be a cost associated with change, especially after the design-development phase. For any changes proposed hereafter, it is important to consider if it is a scope change, which bears additional design fees and hard costs. How will it affect the schedule, keeping in mind that time is money and the clock is ticking?

THE CONSTRUCTION DOCUMENTS

Construction documents are the working drawings and specifications that are drawn up in the final phase of design. They are also known as bid documents or contract documents, along with the written contract, special conditions, and general conditions. They are a package of precise and detailed drawings and written specifications that enable builders to prepare bids and see to the job's construction.

Obviously, the package for an art museum will be a bulky one. Indeed, the preparation of the construction documents is the architect's single most time-consuming task. Tedious to review, they take considerably more time than earlier documents. Often, they are considered too technical and are not reviewed carefully enough by the museum's technical staff. They also require an allotment of time that most regular staff cannot afford to give. However, these documents are not simply a guarantee of design agreements between the architect and the owner, but a binding contractual attachment, and therefore their details must be reviewed thoroughly. It is at this point that details are presented that can, for example, make or break the ultimate accessibility of the museum for the disabled visitor (e.g., 1/2-inch thresholds at a door can effectively block a wheelchair). Although review of such detail gets wearisome, now is not the time to tire.

During the preparation of construction documents, final budget figures will be developed. Operating projections should be ready for presentation as well.

Changes made at this stage will affect cost estimates and are difficult to execute because of the architect's coordination that must occur among all the subconsultants' documents. A change in the security plans may affect the electrical design as well as documents for other disciplines. By the end of this stage, all materials will also be specified and all approvals given. Samples should be mounted on boards and retained. Museums are especially sensitive to hardware concerns in public spaces. Samples should be reviewed whenever possible, and mock-ups of specialized custom work should be prepared. These are seemingly costly, but in the end, they are cost effective. In some cases, models of full-scale sections of galleries should be made, especially to test lighting; even though these mock-ups may cost a considerable amount of money, they can save much more in the end.

Design clarifications should be requested at this stage whenever possible. Thermostat placement, for example, may be a detail of little consequence to other building types, but if such details are not specified on the drawings for museum buildings, the contractor may resolve them in the field, often leading to costly amendments later.

At the end of this phase, the project is ready to bid. This is an appropriate time to verify the procedures for filing for building permits, which can be a time-consuming process. If the architect can expedite the filing process, it should be discussed now and implemented while bidding is under way.

SPECIAL PROBLEMS FACED BY MUSEUMS

Project Continuity

Museum jobs sometimes start and stop, which costs money. Caution should be taken to proceed only when funding is assured, and steps should be taken to make sure that contracts can be suspended between design stages.

Venturi, Rauch & Scott Brown's design for the Laguna Gloria Art Museum, Austin, Texas, developed from early sketches (a) and evolved through a final scheme depicted in this 1985 model (b). (Courtesy Venturi, Scott Brown & Associates, Inc.)

Delays

Project continuity is extremely important for an art museum. Internal planning must be handled prudently, and it must be understood that any schedule that is to be attached to a contract governs all parties—the consultants and the museum alike. If a project involves an existing, ongoing operation and the museum is scheduled to shut down a part of its operation by a certain date and cannot do so, that delay will be costly. If fund-raising efforts lapse, causing a delay, that delay will be costly. Any time added to the project will cost the museum money; this is simple economics, and such delays should be avoided. However, the consultants must also understand that delays can—and realistically do—occur.

Government Oversight

If public money will be used to fund a project, the museum may be requested to submit design documents to a government review agency. Local governments usually keep a watchful eye on budgets. Some cities actually execute the construction contracts on such jobs or require that certain city or county regulations be followed. Government involvement invariably slows a job, which usually ends up costing more as a result of the delay.

Many cities have historic-landmark or art-commission reviews of city-owned properties. Projects with federally funded challenge grants for construction involving historic buildings might also require review by state historic-preservation officers. All such reviews require time.

Legal Issues

In many cases, the museum's land can be the local government's contribution, and its buildings eventually are subject to city or state ownership at the end of a leasing-agreement term. There can also be jurisdictional issues between city and state or state and county authorities over gifts of land. These legal issues may add time to the schedule and expense to a project's execution.

Terms of legal agreements with donors who are naming spaces should be made available to the project director, who needs to know if special design detailing or other considerations should be made.

Most existing museums are aware of their zoning and land-use restrictions. For new buildings, environmental-impact studies have to be done and appropriate land-use and zoning regulations investigated.

With the passage in 1990 of the Americans with Disabilities Act, any place of public accommodation can be liable for noncompliance with accessibility codes. Retrofit can also be exceedingly expensive, and thus initial compliance must be ensured.

Hazardous Materials

The removal of hazardous materials from a site can also be costly and time consuming. The most prevalent problem is with asbestos. A museum that was built between 1890 and 1980 can be plagued with this problem. Asbestos was used instead of horsehair in the 1890s as a binding agent in the undercoats of plaster to help it adhere. Its continued use through the twentieth century is prevalent; it might appear in ceiling and floor tiles, or it might have been sprayed on as a fireproofing agent. One museum recently spent $4 million of its $23 million budget for construction hard costs to remove asbestos-contaminated plaster. Addressing the problem of hazardous materials

can be so costly that it can eliminate a particular building or site from consideration as a location. Major design reconsiderations may have to be made because of prohibitive removal costs.

Architects, construction managers, and general contractors may not touch asbestos because of insurance-liability restrictions, so that one of the first specialized consultants hired for a project in an existing building should be a specialist in environmental testing and hazardous waste. Museums must beware and be prepared.

Site Considerations

Is the site in an earthquake area or a sinkhole area, or is it vulnerable to any geological irregularities? Is it subject to flooding or hurricanes, or is it in the line of chaparral fires? Has access to the site by public transportation, major streets, highways, and the like been investigated?

Morale

Design is a very heady process. It is a creative and constructive one. Thus far everything is on paper, and there is as yet no dust. Information on the progress of the job needs to be shared with the staff, the entire board, and the public. That sense of progressive accomplishment and anticipation will benefit development and fund-raising efforts, as well as the morale of all involved.

III

CONSTRUCTION

10

PREPARATION AND BIDDING

THE START of construction is the beginning of the hard reality of any project. During the design phase, the staff and director are challenged yet elated. Drafting the vision is a grand and positive experience. Getting it all down on paper, tidily designing to produce a beautiful yet functional museum, is an exhilarating task. But from ground breaking until the doors part on opening day, the construction period is a roller-coaster ride of highs and lows. The joy of watching structure take form and realizing the effort that went into making it happen can be interrupted by incidents such as shortages of critical materials, unexpected field conditions, contract disputes, and labor problems. Controlling the bottom line becomes the overriding issue. And a tight, efficient management structure is imperative.

The design phase of a project ends with the final execution of the complete construction drawings or bid documents, including not only plans but also written specifications, although the design of the building can in reality continue virtually until the end of construction. During the bidding process, the management team that will oversee construction should be in place. This term is composed of three players: the owner, the architect, and the contractor. It is the close interaction of the three that makes for a successful job.

GETTING STARTED: THE MANAGEMENT TEAM

The Contractor: Construction Manager or General Contractor?

Deciding who will build the structure is as important as determining who will design it, so that the selection of the contractor(s) now is as important as was

A

B

The evolution of design takes on various forms, as in the case of The Brooklyn Museum's Iris and B. Gerald Cantor Auditorium (Arata Isozaki & Associates/James Stewart Polshek and Partners, 1991). The initial concept was introduced in a rough sketch (a), showing an elaborate ceiling design, and was later presented to the client in a computer-generated drawing (b). The rendering (c) was commissioned for presentation purposes, and construction (d) was finally finished with the opening on April 9, 1991 (e). (Courtesy The Brooklyn Museum. Photos [c–e]: Pat Bazelon)

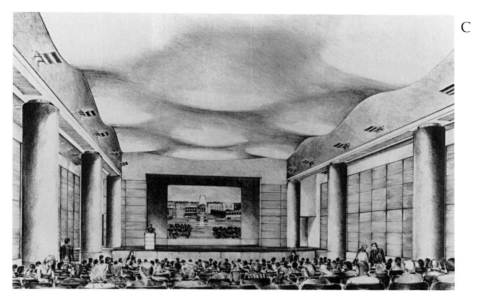

C

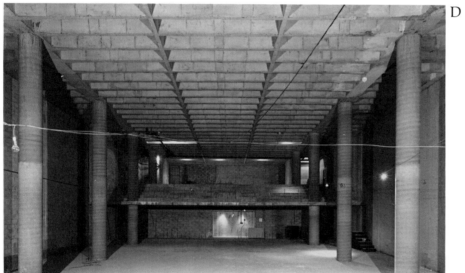

D

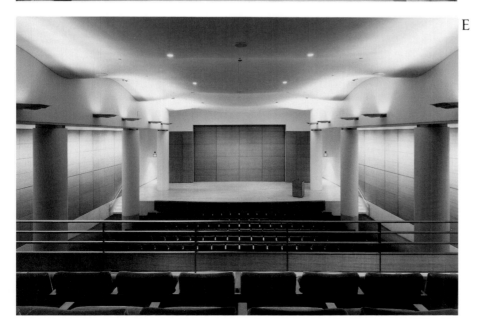

E

A

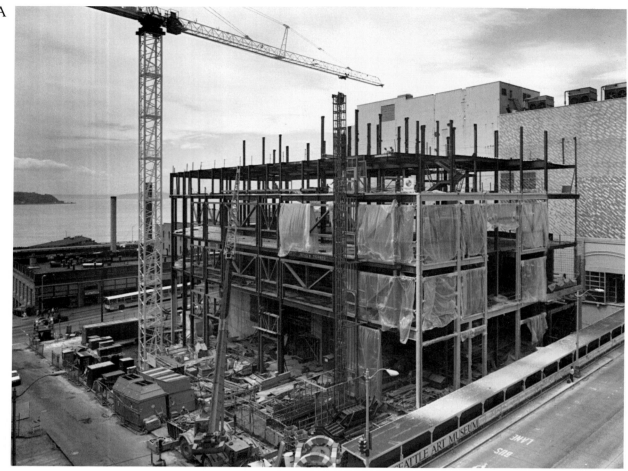

During construction, two-dimensional designs unfold in the emergence of three-dimensional physical structure, as in these views of the Seattle Art Museum (Robert Venturi). One can compare these views of the museum during construction in 1991 (a and b) with an earlier model (c) and a longitudinal section (d). (Photos [a and b]: Jim Ball. [c and d] Courtesy Venturi, Scott Brown & Associates, Inc.)

the selection of the architect. Early in design, the owner must decide whether it wants to use a construction manager (CM) or a general contractor (GC).

In today's construction industry, *general contractor* has come to mean the principal or prime contractor. When the term *GC* is used contractually, it means that a principal contractor is given total responsibility for the entire job, generally on the basis of a fixed-price contract, and is financially obligated to bring the job in on schedule and on budget. The general contractor can staff certain trades directly and subcontract the specialized trade work, such as mechanical, electrical, and plumbing (for sample trade list, see Table 3). Alternatively, all work can be subcontracted with individual trade contrac-

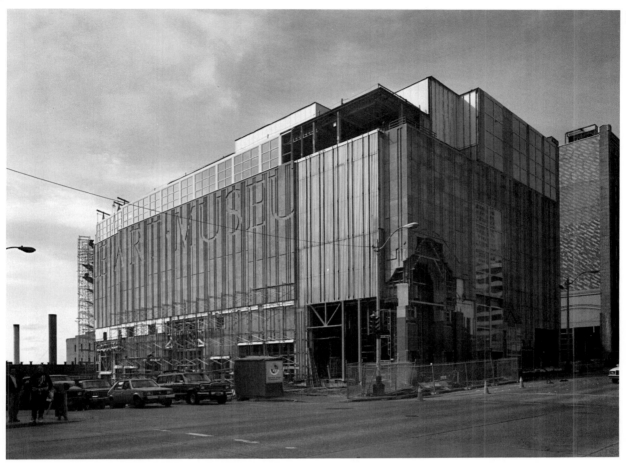

tors. In either event, all subcontractors, representing the various trades, are directly responsible to the GC, not to the owner.

An alternative is to engage a construction manager. The construction manager can be hired either on a guaranteed-maximum-price (GMP) basis or as a consultant. With a GMP arrangement, there is little difference between using a construction manager and a general contractor, in terms of the operational control over the subcontractors on the job. On the other hand, the construction manager hired as a consultant is essentially an agent for the owner, assuming the GC's role as broker to the trades, but without responsibility for final cost or schedule and without risk financially.[1]

Before selecting a CM firm or a GC, the museum must have an opportunity to meet the team members who would be assigned to the job by the firm, since it is the skill and experience of the individual team members, especially the project manager or executive in charge, that will complete a job successfully. A project manager who has worked on other museum jobs and

C

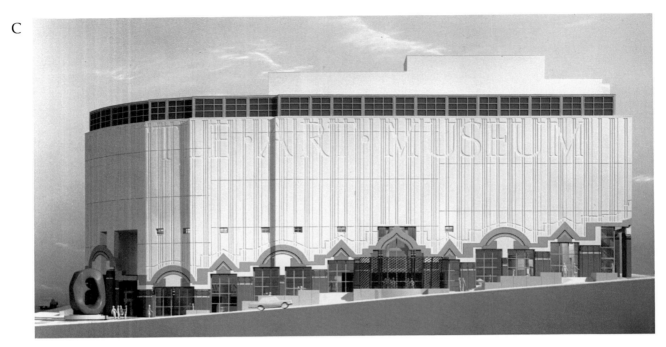

D

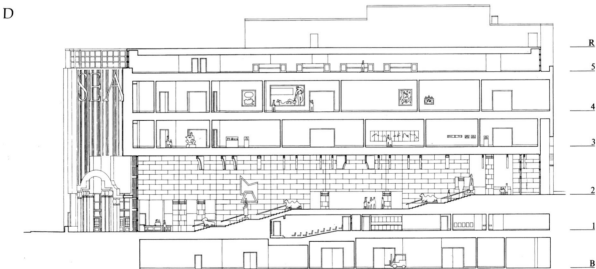

has had experience primarily with other institutions, such as hospitals and schools, would appear to be more desirable than one whose experience is primarily with office buildings and housing.

The Museum's Management Structure

During construction, a management structure similar to that of the design team during the design phase should be in place. In fact, continuity is critical

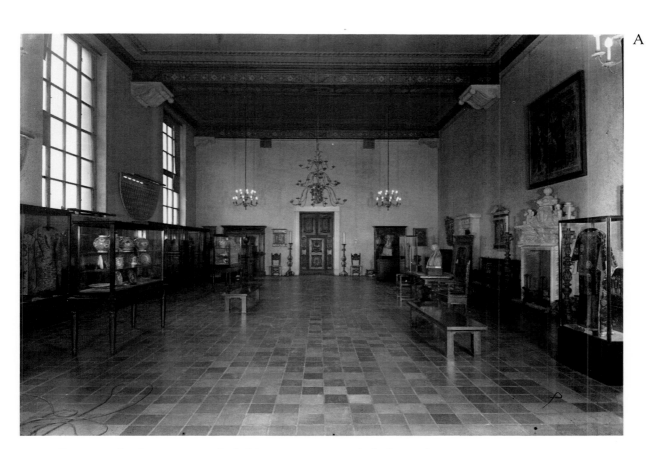

An excellent example of renovation and rehabilitative use in a single facility is the transformation at The Brooklyn Museum of the Renaissance Hall (a) (McKim, Mead & White, 1927) to a temporary, 300-seat lecture hall in 1934 (b). The area was reconstructed in 1990 (c) to create 10,000 square feet of climate-controlled art-storage space (d) (Arata Isozaki & Associates/James Stewart Polshek and Partners) housing collections of paintings, sculpture, costumes, textiles, and Egyptian and classical objects. (Courtesy The Brooklyn Museum. Photos: [a–c] The Brooklyn Museum; [d] Pat Bazelon)

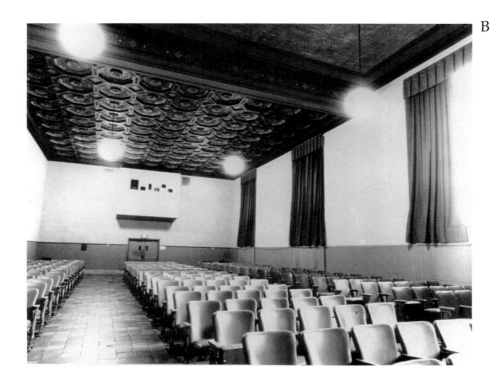

C

D

Table 3. SAMPLE TRADE CONTRACT LISTING

Site	Superstructure	Mechanical and electrical	Interiors
Site improvements	Concrete	Plumbing	Carpentry
Demolition	Structural steel	Sprinkler	Lath and plaster
Excavation	Miscellaneous metals	HVAC (heating, ventilation, air conditioning)	Drywall
Landscaping			Painting
Hazardous waste	Masonry	Electrical	Ornamental metals
	Stone	Elevators	Acoustical ceramic tile
	Spray-on fireproofing	Security systems	Restroom partitions
	Windows	Fire-detector systems	Terrazzo
	Curtainwall	Lighting	Wood flooring
			Stone flooring
			Carpeting
			Millwork
			Doors
			Hardware
			Interior glass
			Graphics
			Audiovisual systems
			Theater seating

Note: For a complete listing, see Construction Specification Institute categories.

at this juncture. The in-house project director remains the team captain (see Fig. 2). The architect may plan to change project managers, choosing to use certain personnel with design expertise during the design phase and construction specialists during the construction phase. The museum must reserve the right to insist that there be continuity, however, and to approve all changes of personnel, making sure that there is adequate continuity throughout, especially from design through construction.

Construction is the most demanding phase of the job, requiring inordinate vigilance and supervision. An institution's board leadership and committee structure must remain in place, and decision-making procedures and checks and balances must be well understood. The owner's representative, architect's project manager, and CM's (or GC's) project manager must all report to or through the museum project director. The project director and director must continue periodically to report on the job's progress to the board review committee and the full board.

The Owner's Representative

Owner's representative is a term that usually applies to an individual, but a management firm can also fulfill the role. The owner's representative is generally hired under the project budget as a consultant to the museum's project director and as a member of the construction team to help oversee construction. The person in this position is especially helpful when there is not particular or specialized expertise on staff with construction management experience. The primary areas of responsibility for the owner's representative are cost and quality control and schedule monitoring of the CM or GC to make sure that the project remains on time and on budget. This person is being paid by the museum, and his or her allegiance is to the museum and not to any of the outside parties.

The owner's representative's focus should always be time, cost, quality, and special problems. The owner needs to review any changes the architect requests, and their necessity and cost should always be challenged. Most changes will be technical, and less costly methods should be sought to achieve them. While this is also the job of the CM or GC, the owner's representative's role is to participate for the benefit and protection of the museum. Some museums also hire cost-control firms to provide this service. Special problems might include scheduling long-lead items such as sun-controlled, louvered shades and skylights; elevators; transformers; and custom furnishings for art storage, which may need to be coordinated with interior installa-

tion. In addition, there may be site-related coordination requiring special handling, such as hoists or lifts. These are all problems that the GC or CM should be solving for the client, but the owner's representative monitors the CM or GC to ensure proper attention to critical issues of quality, schedule, and cost.

The owner's representative may require a clerk of the works, who reviews the job's progress in the field and whose specific function is to verify that what is built in the field conforms with what is specified in the construction documents.

THE BUDGET REVIEW

The Estimate

During the planning and design phases, several periodic estimates from "first budget" to 100 percent construction documents (CDs) will have been prepared. Estimates should occur at specific percentages of completion stages—that is, 40, 60, and 100 percent or 50 and 100 percent. The 100 percent CD estimate is the last estimate before bidding, unless substantial changes have occurred or significant time has elapsed, and any changes that appear as documents are finalized should be incorporated. It is essential to verify the estimate, since it is, after all, only an increasingly sophisticated guess, especially with the highly specialized finishes and complex technical aspects of a museum building.

Estimating is done by using a variety of methods. There are prescribed industry standards in the form of unit costs that can be used at an advanced stage of design. Price quotes are received from suppliers and contractors. If the design calls for standard finishes and equipment, the guess will be more accurate than if the design calls for special materials, supplies, and equipment, such as, for the museum client, stone finish for a restoration project to match existing stone or custom chemical air-purification filters specified by the mechanical engineers. Ambiguities in estimating are more likely to occur in museum buildings where the CM or cost estimator may not have had prior experience costing out specialized items such as these.

The accuracy of the estimate will be revealed as the bids are awarded and the contract price is determined; the budget may require adjustment if these awards vary from the original estimates.

Contingencies

Particularly at this stage, planning and design cannot be fully resolved, and no decisions are final. Budgets should therefore carry a contingency allocation, specifically to accommodate the unknown, the unresolved, and the as yet unforeseen.

Contingency is also the budget line against which changes are charged (see Chapter 12). A good practice is to charge only field-related changes and essential scope changes against contingencies. All other optional changes in scope should require a budget adjustment and appropriate review and approval; the board and the director should be especially concerned about how all such additional costs are handled.

At each stage of the estimate, contingencies must be reviewed. In projects that involve adding to an existing structure, such as renovation and historic restoration where many unknown conditions exist, the construction contingency is usually 10 to 12 percent. For museums, this figure should be at least 15 to 20 percent. The problem with a contingency is that designers and builders often perceive it as a cushion to cover initial cost problems. Responsible architects and contractors will share the client's concern about bringing the job in on schedule and on budget.

One way in which the museum can protect itself is to carry a management reserve as part of its cost. This percentage, not made known to outside consultants, can allow the museum to cover unforeseen cost increases and effectively provide additional contingent resources.

Operating Expenses During Construction

Certain one-time expenses incurred during construction legitimately belong in the capital budget and should be accounted for as part of a project's cost. At the same time, a museum should be careful not to use the construction budget as budget relief for the operating budget, which can be tempting at such times when capital budgets seem large and operating budgets can be particularly strained.

Personnel costs are the most difficult such costs to identify and segregate. If there are one-time expenses that are solely related to the construction of a new area, they can be incorporated as capital items. A museum might, for example, need administrative staff for the construction office, security guards for site security and site supervision of the contractors, or art handlers to relocate collections to be housed specifically on the new site.

There are several types of contracts and a number of ways to pay for construction work.[2]

Lump Sum, or Fixed Price

A lump sum, or fixed price, contract stipulates an amount agreed to by the contractor as the price of a job, based on the bid documents. This is the most straightforward and risk-adverse form of construction contracting, particularly when done on the basis of fully complete construction documents. Any additional work not specified in the contract documents is considered a change and will have related costs, for which budget contingencies become extremely important. Additional work that is not part of the lump-sum bid is charged based on an agreed-on method of payment, usually on a cost plus—or materials plus labor, overhead, and profit—basis.

Cost Plus

The cost plus contract is used only in unusual circumstances, such as when a project is proceeding on a fast-tracked basis. Sometimes speed is essential, and the cost plus method can be used to get a job moving when there is no time to prepare complete contract documents. If this method is used, extra contingencies must be built into the estimates. The contractor bills the actual cost of materials and labor plus overhead and profit or fee. This is an open-ended arrangement, and the contractor has no incentive or risk to bring the job in at a predetermined and agreed-on price. It is the method of least control but greatest speed. In times of high inflation—or when external pressures dictate a project schedule—this approach may be considered desirable or necessary. However, it has many potential dangers and should not be chosen without careful consideration.

GMP (Guaranteed Maximum Price)

The GMP method is also frequently used in situations where contract documents are not complete. Usually this method carries a clause that provides for any underruns or cost savings to be shared with the CM or GC as an incentive for the contractor or CM to finish the job under budget. Sometimes, when using this method, owners prefer to give the contractor a greater share in the

savings to increase this incentive. This method has the least risk when used on a new building of a standard type, but care must be taken that ad hoc substitutions not affect the quality of the building in an effort to reduce costs aggressively. Museum projects, especially those that involve renovation or restoration, come with many uncertainties, making this method less desirable than the lump sum or the cost plus approach.

Penalties and Incentives

Penalty clauses in construction contracts are usually added to protect against delays, especially if there must be a guaranteed opening or delivery date. Where penalties are provided, offsetting incentives must also be offered. And incentives such as premiums or bonuses can help contractually where there is a tight schedule or where completion deadlines are absolutely critical. Recent practice in construction litigation shows that penalty clauses are most enforceable when balanced by incentive clauses, so they go hand in hand. Both are very hard to enforce from the point of view of the benefiting party, as there are always offsetting issues to argue. Their main value is therefore often psychological.

THE BID DOCUMENTS

The 100 percent construction documents, including narrative specifications, contract conditions, and plans and drawings, make up the bid documents. Yet during the review of the construction documents and the early start of the job, changes will still take place. Changes made prior to the award of the contract are known as addenda. Addenda are issued by the architect, reviewed and approved by the owner, and added to the bid document package. The price associated with such add-ons is included in the bid. After the contract is awarded, a bulletin is usually issued to initiate a change. Addenda and bulletins are very important documents that must be kept in a master file. As soon as changes are approved, they must be recorded on the plans and specs (see Chapter 12).

THE CONSTRUCTION SCHEDULE

Most museums require a ceremonial start and finish to a project. Adhering to a construction schedule is very important for publicity; press releases must be sent, and public and private gatherings need to be planned and held on time. Since jobs often take longer than originally planned, museums should give themselves an ample cushion of time in planning for ceremonial openings. If delays occur because of a labor action or shortage of materials and public announcements have been distributed, invitations sent, and speakers

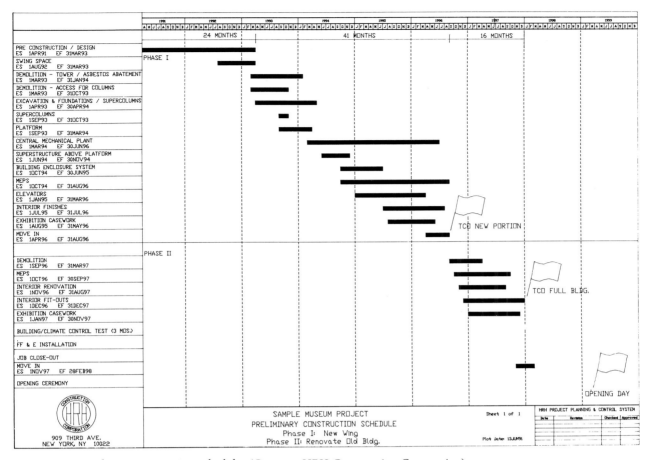

Figure 3. Sample museum project schedule. (Courtesy HRH Construction Corporation)

engaged, most likely the institution will still have to open on time, but at a cost. Projects that are behind schedule have been known to be brought in on time with a serious push at the end—and often it takes a firm date to galvanize completion—but this can mean large overtime bills, other related costs, and hastily executed finishes. It is wise to try to budget for both a delay contingency and a cushion of time. Contractors should not be apprised of the details of any such delay cushion, but often they will assume that one exists (see Chapter 15).

Coordinating the construction schedule with the occupancy of the new facility is essential (Fig. 3). More often than not, many new players appear at the time of occupancy, since interiors are often built or installed by separate teams. Architects can have special clauses in their contracts specifically outlining interior coordination and installation of furnishings as other than basic services, an arrangement that should be clarified during the negotiation of the architect's contract. Some large firms have a separate division that deals exclusively with interiors. This arrangement can also apply to contractors and

construction managers. There may be custom-designed art-storage furnishings that have structural and electrical requirements. Some exhibition installation may require structural and mechanical services as well as special design services. As mentioned in the preceding chapters, the use of the project architect for exhibition-installation design can be controversial, and museums are urged to seek the advice of their experienced museum colleagues regarding different approaches.

The project director must keep a close eye on the construction schedule and the move-in date. Building tests for mechanical systems have to be accommodated in the schedule. (This point is elaborated in more detail in Part IV, but is mentioned here as a reminder to chart the course in advance, leaving ample time for testing and installation.) Museums especially require climate-control testing before art can be moved into storage and exhibition areas, and conservators ideally prefer six months to test and adjust systems through seasonal changes. It is rare to have this luxury.

FAST TRACKING

A fast-tracked job is one in which the design is not finished, but, due to schedule pressures, the work must commence. Building according to design-development documents or incomplete CDs bears great risk and should be considered only if time is truly of the essence (Table 4). It is impossible to guarantee that the job will be finished on budget, but compensation is looked for in time saved and related financing costs. If there is no such payback, there is no benefit. While changes are usually made to contract documents throughout their development, during fast tracking they are likely to be made in bricks and mortar rather than on paper. This approach is certainly not cost-effective, but, weighed against the value of a timely early start, it may be justified in the end.

Originally, this technique was developed to offset financial carrying costs, rapid inflation, or expiring trade union–contract periods; and the client or user to employ this method most frequently has been the private developer.

Table 4. FAST-TRACK VERSUS GMP AND FIXED PRICE METHODS

Method	Cost	Time
Fast track	Greatest risk	Fastest start
GMP	Less risk	Medium start
Fixed price	Least risk	Slowest start

Whether the choice has been made to go with a GC or a CM, legal counsel is key before deciding on the type of contract to use. The AIA has produced standard forms of agreement for each method discussed earlier: lump sum, cost plus, and GMP. It is essential that the owner, the owner's legal counsel, and the architect review the standard contract form.

It is equally important to review certain items for which the contractor is reimbursed.

General Conditions

One of the most substantial and elusive costs of a project, general conditions, must be thoroughly understood by the owner from the beginning. Table 5 outlines the types of costs that may fall under the category of general conditions. A CM may have a lower fee but a higher percentage of general conditions. This is an important line item in the budget and must be explained in detail by the CM or GC. General conditions are often fixed at a percentage of the cost of construction or, with a GC, as a fixed portion of the lump sum contract amount.

Insurance

Insurance is a substantial part of the cost of construction. The owner pays for the cost of each contractor's or subcontractor's insurance. Depending on the magnitude of the job, the institution may retain a "wrap-up" policy, which is an umbrella policy including comprehensive general liability and worker's compensation for all contractors. If the owner expects to carry a wrap-up policy, it is best to have the contractor identify the cost of insurance separately so it can be part of the negotiation, and the price fixed. Insurance decisions take time and should be made at the time of contract development. It can be more expensive if the contractor or subcontractors make an allocation to the owner for their cost of insurance, especially because there is no way to verify the contractor's allocated cost. In fact, the contract should permit an audit of the contractor's payroll and premiums.

Also, the owner must carry builder's risk insurance. Builder's risk covers the value of the construction to insure the building while under construction. It covers labor and materials for the new project. If an existing building is being renovated, the policy covers only within the limit of the site boundaries. An amendment that would also cover the existing building is beneficial, since the nature of construction during renovation or expansion enhances the risk of significant damage to extant buildings due to such catastrophes as fire or flood.

Table 5. SAMPLE GENERAL CONDITIONS

Job office and personnel	Site	Miscellaneous
Project manager	Tool sheds and workmen's lockers	Permits
Superintendent	Temporary fences and gates	Engineering surveys
Assistant superintendent	Temporary toilets, maintenance	Progress photographs
Engineers and assistants	Temporary roads	Ceremony expenses
Master mechanic	Temporary overhead protection	Material inspection and tests
Mechanical superintendent	Temporary water and plumbing	Liquidated damages
Office clerk	Temporary electric power	Insurance, payroll taxes, and funds
Watchmen	Temporary ladders and runways	Fire extinguisher insurance
Project office and furniture	Temporary light and maintenance	Contingent, contractual, and miscellaneous insurance
Telephone	Temporary heat and maintenance	Completion and performance bond
Project petty-cash expenses	Temporary bridges and/or trenches	
Travel expenses, main office personnel	Rubbish chutes	
	General cleaning	
	Rubbish removal	
	Cleaning supplies	
	Final cleanup and punch lists	
	Washing windows	
	Small tools, rainwear, and boots	
	Blueprints and offsets	
	Project signs	
	Glass breakage	
	Replacement of lost or stolen articles	
	Operation of hoists	
	Hoists and towers rental	
	Operation of house cars	
	Miscellaneous scaffolding	
	Pumping	
	Opening and closing windows during temporary heat	
	Walk, street, and drain protection	
	Extermination service	
	Winter protection	
	Environmental control	
	Teamster shop steward	
	Miscellaneous protection and safety	

Bonding

A payment bond is a guarantee from a surety company to the owner that in the event of a failure of the contractor to complete the work, the cost to finish will be covered.

Bonds are another expense that must be budgeted. Most private jobs using known reputable contractors do not require bonding. Government projects, however, generally mandate that contractors carry payment and performance bonds, although some exceptions are made for small businesses or minority contractors. Contractors will charge a premium to the owner for carrying a bond, and this premium should not be overlooked in the estimate.

Contractors' Rules and Regulations

The contract should be explicit about regulations governing the contractor and work crews. This is most important when construction is being done in an existing museum, since construction work is so incompatible with ongoing operations. To establish the ground rules from the beginning of construction, certain regulations should be mandated in the contract. One especially important issue is the relocation of artwork. For example, a contractor installing and drilling in an approved area may, due to unforeseen conditions, have to get into an adjacent restricted area, such as a gallery or an art storeroom, to complete the work. Contractors do not usually understand what is required to move a piece of art. It may be a 3,000-pound sarcophagus that requires special rigging and several days to make the necessary arrangements. It may be a contemporary wall- and floor-bound work that requires a special crew to move and, often, advance notification to the lender. A seventy-two-hour clause is helpful, stating that the museum has the right to delay the contractor until necessary arrangements have been made. Security regulations regarding workers' access to the site demand a detailed, preset game plan involving the museum's security management. If the museum's public café has seating for only thirty visitors and the construction crew has thirty workers in dirty work clothes, the museum may want to reserve the right to consider the café off limits to construction crews.

BUYING OUT THE JOB: SELECTING THE CONTRACTOR

The Bidding Process

The bidding process falls between design and construction and constitutes the period when, through GC selection or ongoing CM activity, the construction of the project is priced and contracted.

During the bidding period, design is still taking place in many cases, as

final reviews indicate that addenda to the design are mandatory. It is during the bidding stage that the inevitability of further changes begins to sink in. As many times as one thinks there will be no more, another arises. Changes also continue to be issued as bids come in from subcontractors.

Competitive Bidding versus Direct Selection

The desired method of selecting a CM, a GC, or trade contractors is competitive bidding. Competitive bidding to select a GC or trade contractors allows a number of contractors to bid on the prepared construction documents, after which the bids are reviewed and negotiated. The intent is to bring in the negotiated lowest bid that best represents the true value of the job.

Open public bidding is almost always required for government contracts or in work that receives government funding. The bidding is advertised, and anyone may participate. The bids are opened under supervised circumstances, and the lowest bidder is awarded the contract. A museum that receives government funds should carefully review bidding procedures to ensure that it is complying with the regulations. A mandate that dictates accepting the low bidder is not usually advantageous for a museum, since the museum building type is too specialized, and the low bidder may not be qualified. If a negotiated low bid is acceptable government practice, then at least the project manager has the opportunity to evaluate the bids and eliminate bidders who have not responded to the job's requirements. Under the procedures for a negotiated bid, the owner reviews in detail, for example, the three lowest bids for compliance with the CDs and pursues negotiations with all of them to ensure that there are no discrepancies.

A contractor is usually directly selected only when there is a time crunch, such as in a fast-tracked job, and a contractor is needed immediately. However, this practice does not provide the opportunity to get the best price.

Preselected Bidding

The most secure bidding method is to use a list of preselected contractors who have substantial credentials and experience, are known to the GC or the CM, and are financially secure. They are sent an invitation to bid, along with a copy of the trade-contract construction drawings and specifications, or bid package. If a museum has government funding, it is important to make the bidders aware that the contract may be preapproved, and it must be understood that the conditions of the contract are nonnegotiable.

Buying Out the Job

Getting started is the most difficult part; it seems to take forever to get the machine well tuned and humming. The buyout stage does tend to take time,

which should be anticipated. Whether a CM or a GC is used, a period for bidding and buying the job must take place.

Receiving the bids and negotiating them takes some time. A common mistake in scheduling a job is to be overly optimistic about the bidding and award period. Many times, incomplete bids are received. A prospective GC or trade contractor may not have understood certain aspects of the job. It is essential for the CM or GC to hold prebid conferences so that the bidders can tour the site and ask questions.

NOTES

1. There are many variations and opinions on the CM or GC discussion. The authors recommend reviewing C. Edwin Haltenhoff, ed., *Construction Management: A State-of-the-Art Update* (New York: American Society of Civil Engineers, 1986), chaps. 1 and 2.

2. For a more detailed discussion of types of contracts, see Sidney M. Levy, *Project Management in Construction* (New York: McGraw-Hill, 1987), pp. 7–16.

11

CONSTRUCTION
ADMINISTRATION

AFTER THE JOB has been bought and the bulldozers are ready to roll, the chain of command becomes most critical. Decisions are made almost every day and can be changed even by the hour. Time is an important cost quotient during the building phase, and decisions must be made efficiently and with authority.

THE JOB-REVIEW PROCESS

The construction phase requires regular job meetings that usually occur weekly, with the museum project director, the owner's representative, and the project managers on behalf of the architect and general contractor (GC) or construction manager (CM). If the project is an alteration or addition to an existing building, the museum's facilities or operations manager should also be present. Also attending will be the site superintendent, who reports to the CM's or GC's project manager on the daily progress of the job, and the clerk of the works, if there is one reporting to the owner's representative. The site superintendent is on the site most of the time, whereas the project manager usually works in a field office, expediting reams of paperwork and resolving issues with the subcontractors or trade contractors.

The job meeting's purpose is to review the progress of the job and resolve day-to-day issues, such as site access, and "house coordination" issues, such as utility hookups or shutdowns. For example, if the installation of a new transformer in an operating museum requires a twenty-four-hour shutdown of the facility, the in-house staff has to schedule and accommodate the shut-

down. Perhaps a contractor has an unexpected delivery of piping that requires 2,000 square feet of on-site storage. This may require closing down part of a parking lot, installing site protection, and perhaps even upgrading site surveillance. Essentially, the meeting allows the project director to be fully up to date and to track the job's progress.

In addition to site conditions and requirements, the job meetings deal with the many design changes that will take place during the course of the job. The contractor may identify a field condition or a necessary change and submit a request for information (RFI) to the architect. It is the architect's responsibility to document these requests and to provide information quickly in order to expedite the change. In response to the RFI, the architect can either supply information directly or issue a bulletin to initiate a change to the contract, which most likely will result in a change order. The final authorization required to proceed with a change must be approved by the architect and the owner (see Chapter 12).

The process is by necessity one of rigorous documentation, and an accurate record is essential. However, no job would be built if there were not an auxiliary method of informal oral approval that paralleled the written, formal process.

In addition to regular job meetings, the project director should hold periodic owner's meetings that focus on cost. Participants may include the director, the building committee chair, and possibly also key executive staff members (such as deputy or assistant directors or the controller) to deal primarily with bottom-line impacts on schedule and cost. The architect's partner or principal in charge usually attends, as well as a project executive representing the GC's or CM's central office. This executive session allows the director or the board representative to be fully apprised of the job's progress. The controller will be most interested in the payouts and cash-flow issues. This approach can vary based on the need for regular updates. The director and building committee chair may prefer a written report or just a meeting with the project director alone. There is nonetheless some psychological value in having the principal design architect and the chief executive representing the GC or CM report periodically before an individual or committee representing the board. Such accountability on a quarterly or semiannual basis helps to ensure that the principal consultants remain attentive to the job.

SITE MOBILIZATION

One of the first tasks of the contractor is to prepare the site. In populated centers, one area of concern is the relocation of utilities, whether they are underground or overhead, to ensure that they are not cut off during construction. One survey participant reported that in excavating for the foundation of

A

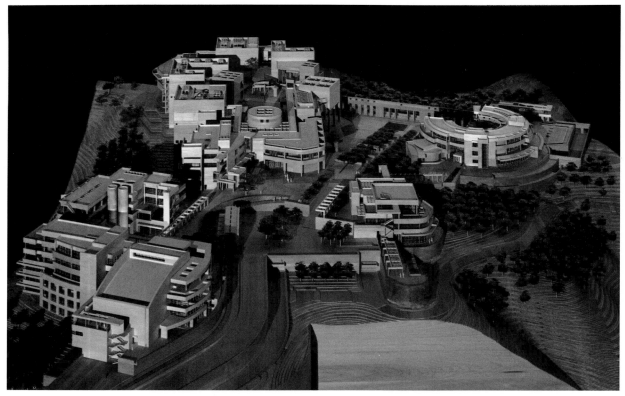

Site mobilization is an important component of any project, in terms of time, dollars, and requirements for specific expertise. Extensive site preparation was required for the new Getty Center in west Los Angeles, California. Since the complex is located on a hilltop, roadbeds had to be graded and prepared and utilities brought to the site. The first completed structure is a parking facility to accommodate not only future visitors, but also construction crews. (a) Model of the Getty Center (the museum is the larger building in the upper-left center) (Richard Meier & Partners, 1990). (Copyright The J. Paul Getty Trust and Richard Meier & Partners, 1991. Photo: Tom Bonner, 1991) (b) The Getty Center site before any site mobilization, 1987. (Copyright The J. Paul Getty Trust. Photo: Vladimir Lange) (c) View of site under construction, 1990–1991. (Copyright The J. Paul Getty Trust. Photo: Vladimir Lange)

an addition, all the telephone lines for the existing building were cut. On the other hand, in more rural settings, power and even water may need to be brought to the site not only for the new building, but also to service the contractors while the work commences. Often these services include providing sanitary facilities and other basic amenities. Access must be provided for contractors. Sometimes roadways have to be created, and the site has to be cleared. Demolition of extant buildings or structures may be required; and, in undeveloped areas, sites may have to be cleared of brush, trees, and roots.

For an existing museum faced with an alteration or addition, site preparation can be formidable. The area that is to be occupied by a new wing may affect adjacent areas during the construction phase. The site must be parti-

B

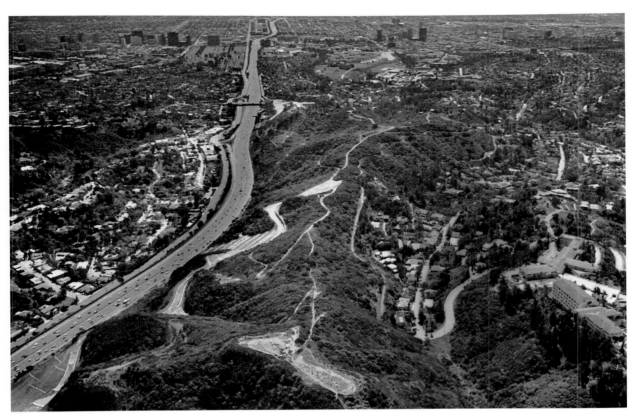

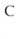
C

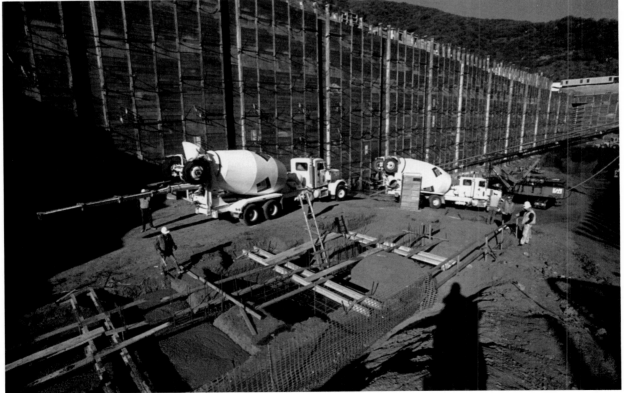

tioned off and protected, which often will encroach on other functioning areas. Museum grounds frequently tend to be parkland or are designated for recreational public use. The museum must be sensitive to the needs of the public, and it is now that the community's earlier cultivation can pay off. The site fence should reflect not only the museum's aesthetic sensibility, but also its responsiveness to the community. Museums usually take this opportunity to display illustrated descriptions of the activity on the other side of the fence and how it will improve the facility and in the end enhance the visitor's experience. The costs incurred for this type of public-awareness campaign should be factored into the general conditions budget.

A morale campaign for the staff may be needed as well. There will be a lot of extra work for everyone, especially if the adjacent operating spaces are affected. If an extant building is adding a mezzanine level to a storage area, for example, connecting the structural steel may cause considerable vibration along beams and columns, which can travel to other sections of the museum. Art handlers and technicians may have to provide extra protection and possibly temporarily remove art from certain areas. A thorough walk-through of the site with the curatorial and collections-management staff will be very helpful in identifying precautions to be taken.

An important rule of thumb in preparing for construction is that the contractor is responsible for protecting the site, which means constructing partitions that will keep out dust and, to some extent, noise. Certain precautions can be written into the demolition contract—for example, specifying places in the museum where certain tools or machines cannot be used. However, if the contractor's construction methods are limited, it must be noted that such stipulations can be an additional expense. Dismantling costs and the value of keeping collections available to the public have to be weighed against such delays. It is finally the museum's responsibility to take all necessary precautions. For example, if the room above a densely packed art-storage area is to receive a new floor and the extant floor must be prepared to receive it, the method of preparing the floor should be carefully considered. If the contractor is recommending that the floor be acid etched and there is any chance of acid seepage to the collection below, the museum must weigh its options: moving the collection (considering the cost), asking the contractor to change the method of floor preparation (again, considering if this will require an extra charge), or taking the risk.

There will always be noise, vibration, and dust. Some can be tolerated, and some cannot. By planning ahead and preparing the staff, the job will be smoother. Often complaints heard from museum staff about construction

Staff moving (a) and protecting (b) collections at the National Museum of American History, Washington, D.C. The costs of "mobilization" absorb not only staffing and materials, but also emotional resources. (Courtesy the National Museum of American History, Smithsonian Institution. Photo Numbers 89-11714, 89-6846)

B

projects are no different from those heard in hospitals, universities, and office buildings. This is not a pleasant period for any project, and its success depends on the team effort of administration and staff.

PROJECT DOCUMENTATION

The construction phase will produce more paper than any museum blockbuster exhibition ever has. Typically, the museum has entered into a contractual obligation that eclipses any expense or project budget encountered under normal operating conditions. Careful documentation procedures must be in place at the start, for each piece of paper may be called on at any time in case of a dispute.

Addenda (changes initiated during the bidding process) must be attached to the specifications. Bulletins (which initiate changes after contract) have to be

tracked, reported on, and eventually authorized as change orders. Job files have to be carefully organized, and drawings have to be maintained. Often the clerk of the works performs this task. After a change has been approved on a drawing, that drawing must be integrated into the bid set, superseding any previous document. All must be under the watchful eye of the project director, either directly or delegated, since this is an area where things can really go awry.

SHOP DRAWINGS

Shop drawings are the drawings from which the contractors build. Mainly the responsibility of the architect and the CM or GC, but also a difficult task for the project director or the owner's representative, is to ensure that there is a firm and efficient procedure for the production and review of shop drawings. Upon receipt of the contract award, specified contractors, manufacturers, and suppliers must prepare drawings that specify details of how the job will be built. For example, the joining of two pieces of structural steel may be drawn by the structural engineer to clarify the method of joining, but exactly how the work will be done is left to the contractor. The shop drawings must be reviewed and accepted by the architect and the engineer before the contractor can begin to build. At the end of the job, shop drawings, as well as as-built drawings, are turned over to the owner, for the purpose of documenting exactly what was built, to assist in managing the new facility. There is a tendency for the contractor to proceed without approval, a method that can cause problems. Although the contractor accepts the liability for proceeding without approval, the changes that may be required can cause delays. The owner must be vigilant, since this practice is the source of many construction disputes.

START-UP TRADES

The CM or GC will want to begin working with certain trades immediately. The mechanical and electrical trades are usually the first, and, if the museum is dealing with an extant building, the contractor may need information from staff electricians and other maintenance staff. There will be extra demands on the staff, and they must be prepared to cooperate, for delays in getting necessary information can hold up the job. The contractor will also want to get onto the site to begin field measurements for such items as structural steel.

LONG-LEAD ITEMS

There are special circumstances where custom equipment and materials may have to be ordered and manufactured in advance. Elevators, generators, transformers, and boilers are long-lead items. In museum construction, long-lead items may include such furnishings as specially designed sun-controlled louvers to regulate natural light in skylit galleries. Lab equipment and custom furnishings require a long lead, and specialized filters for the heating, ventilation, and air conditioning system that are not standard manufacture may also take time. These items usually require advance payment and should be highlighted when the contractor or CM is preparing cash-flow projections for the job.

12

CHANGES AND REVIEWS

C HANGES HAVE BEEN MENTIONED repeatedly. They result from any amendment to the contract documents, and they are endemic to the construction process.

CHANGES = MONEY

Changes usually create additional expense, but can also occasionally yield savings; each must be carefully reviewed and negotiated. Other than the contract documents, the change order is one of the most significant pieces of paper in the project file.[1] Changes are reviewed by the architect, the owner's representative, the construction manager (CM), and the project director to ensure that they are necessary and that they are costed properly, which will depend on how carefully and well they are negotiated. Since the trade contractor or subcontractor who is to execute a change is no longer in competition with other bidders, the competitive advantage has been eliminated. However, a cost proposal for a change can almost always be negotiated to a lower price.

In addition to the management team's review, if staff members participated in the design review, they may need to verify a change. Whenever possible, staff should review technical changes to ensure their correctness. Changes can add to the scope of a job or reduce it, and they can delay or speed the job's progress.

Museum administrators must be prepared for the complaints from the staff that usually accompany scope reductions. During design, the approved bud-

get and estimate may have been adequate, but during construction, site conditions, estimating errors, material costs, and the like may change the economic picture. A job budgeted for $10 million may have become $12 million. The board may have to ask for a reduction of scope to balance the bottom line. Such situations are disappointing, but often are also inescapable. When starting out, the staff has an expectation of new and better facilities. If the budget must be reduced, new may become only somewhat better, and not all will be satisfied if they begin to see their area or department getting less than anticipated.

Field Changes

A field change is one that has to be made because of an unexpected condition in the field: an abandoned duct running across an area identified for new structural steel, for example, or asbestos discovered in an area that was supposed to have been asbestos-free. No architect or contractor can predict what is behind a wall in an extant building, especially if the building is relatively old and there is little available documentation.

Field changes are usually charged against contingency; they must be expected, and usually there is little choice but to authorize the work. Often there can be associated costs of overtime and added labor. Field conditions would also cover problems such as flooding caused by inadvertently drilling into existing water lines where none should have been. Such occurrences have to be left to the site superintendent and project manager to repair immediately, without further negotiation, in order to minimize damage and any schedule impact.

Some field conditions, especially those that would be expensive to change, may require redesign. If existing structure exposed in demolition encroaches on design space—for example, if an unexpected column appears in the middle of what is to be programmed gallery space—redesigning might be a more efficient solution than relocating at considerable expense.

Changes in Scope

A change in scope is an owner-generated design change that is desired or required but is not within the original scope of the job. It can be generated by a newly found field condition, but it is more often an optimal rather than an essential change. Perhaps the mechanical room above a newly created art storeroom was supposed to have been waterproofed to prevent seepage to the floor below in case of leaks. When it is discovered that this work was never done, the mechanical engineer may recommend that, in addition to the waterproofing, water alarms be installed as an extra precaution. On the same

job, the refurbishing of old restrooms immediately adjacent to a new gallery may not be covered in the original scope. A desire to upgrade these adjacent spaces may surface. Both are scope changes, and each would clearly result in added project cost. Faced with a budget decision, the waterproofing and water alarms to protect the collection may have to take precedence over the cosmetic refurbishing of the restrooms if funds are limited. These decisions are the responsibility of the project team's principals—to be made by the project director with guidance from the director and board leadership.

Not all scope changes are volitional changes, and many are unexpected. Opening up a wall as part of a renovation in an old landmarked building, one survey participant found that all existing roof leaders had deteriorated and needed complete replacement, even though the original scope of work involved only one floor of a multistory building. It was clearly essential that the work proceed, since some areas of the renovation would have been vulnerable to damage as this condition worsened over time.

Another form of scope change, and perhaps the most difficult to address, is a reduction of scope. These changes are normally implemented to yield budget savings. If an existing four-story wing is to be renovated and only three of the four floors are completed due to budget concerns, this is a reduction of scope. If a proposed skylight treatment is modified to a closed roof and ceiling to effect a cost saving, this is also a reduction in scope. Scope reductions can occur in the furnishing or installation work at the end of a job, generally for two reasons: first, by the time a project is deemed to be over budget, it is often too late to make other changes in scope; second, furnishings such as office furniture, storage cabinets, and audiovisual equipment can always be purchased at a later time, when the museum may be better prepared to supply the funds.

Decisions Regarding Changes

Choices about changes in scope are the kinds of decisions that the staff does not usually share in and often does not understand. The director and the board, however, who are charged with managing available financial resources, must execute decisions that are best for their museum. The architect will want the restrooms to look as good as the newly designed galleries. The contractor will want the extra money. The owner has to pay the bill. The project director and director must balance these forces and act responsibly, making recommendations that keep the project within financial limits.

The director and project director must also not forget, under the pressure of time, that certain key staff members should always evaluate changes with operational implications. Any technical changes in the mechanical systems, the lighting, the size of doorways and passageways, the size of classrooms,

the audiovisual equipment, and so on should be reviewed with those who need to operate these systems or work in these spaces. Often the leaders of the team feel encumbered by the burden of additional staff reviews, since decisions about changes must be made quickly. Yet those responsible for such decisions should have the users' needs in mind when authorizing a change. Everyone must also keep in mind that often staff is the source of requested changes, and even though these may seem highly desirable to a department head, the director has to respond to larger project, budgetary, and institutional issues. Morale, therefore, remains a constant issue. Formal construction updates can be made regularly by the project director at staff meetings to keep the staff "informed." During the course of the work, when safety permits, the project director or director might also lead staff tours through the site (see Chapter 14). This boosts morale and gives the staff an appreciation of exactly what is going on in the field.

BOARD REVIEW

Cost Management and Progress Reporting

The project principals will be meeting regularly to review the job's cost and schedule and its overall performance. Cost-reporting and cost-control methods should be worked out before the job starts. Each month, the CM or GC should provide a progress report, with a detailed cost breakdown per trade. This report will compare the budget with actual costs by reflecting the original budget, with any adjustments, changes made prior to contract, the value of the award of the contract, any changes in scope, any contracts that are yet uncommitted, and approved and pending changes. It should also show a projected final cost.

If this bottom line in the cost report indicates that the project is on target with the current approved budget, everyone will be happy. This should be, but often is not, the case. During the course of the job, there may be problems with buying out the job—for example, if a particular type of stone has been specified that is not readily available, resulting in either a costly delay or the expense of having to pay a premium for delivery. The estimate on a particular piece of equipment may have been too low. The finish on laboratory paint may have become subject to environmental restrictions since the time of the estimate, and a more costly method of applying the paint may have to be used. These situations will happen, and a reporting system that highlights variances early on should be used as a tool to regulate budget. Increased expenses on one aspect of the project may have to result in reductions in scope for others. In the end, if required, the contingency is used. These funds must be allocated and spent carefully and deliberately.

If too many problems occur or contingencies are inadequate, the project will go over budget. If it becomes apparent that the budget will be overspent, all of those in the decision-making process will have to consider available options. Authorizing additional expenditure, assuming funding or financing is available, usually means that the board will have to step up fund-raising efforts, take money out of capital reserves, or trigger other available sources of financing. A more common alternative is to try to reduce scope through cuts or to attempt to value engineer via alternative specifications or building methods to achieve the same results.

The purchase of many items, as mentioned earlier, can be deferred. Furnishings and audiovisual equipment are most easily cut out because they can be purchased at the end of the job or later. However, one critical item that is often vulnerable under these circumstances but should not be cut is the graphic-design package for architectural signage. During planning and design of a new facility, all are concerned about the public's need for signs and information. Much preparation will go into creating a graphics plan, but since it is usually one of the last items bid and bought out, it can easily be deemed something to address later. Yet its proper execution is critical to the success of the public's experience with new space.

Tough decisions have to be made, and no one is ever happy about them. The board must focus on what will be achieved, rather than on what will not; staff may do the opposite. The director needs the support of both the board and the staff. Morale will be greatly boosted if the museum administration can get all to focus on the benefits of what will be realized on completion.

Visits to the Site

During construction, the board will most likely be pursuing vigorously its fund-raising efforts, since many projects begin without all funds having been raised. Board members' involvement is critical to the success of the job, and they should periodically be invited to visit the site. Everyone loves a hard-hat tour. Job progress is invigorating, and no evidence is more concrete than actually following the building's structural development through completion. Museums are special buildings; if there is something of particular interest, the board should be invited to see it. Such visits can also be disorienting, and Chapter 14 will address in more detail how and why this experience can be made a positive and special one.

GOVERNMENT AND COMMUNITY REVIEW

Most institutions with strong government and community participation have public representatives on their boards. During the excitement of construction,

the museum may want to include other government and community figures on site visits and to publicize progress updates more widely. Government and community support often has been enlisted to raise funds for a project, and there should be a gesture to acknowledge that participation.

PUBLICITY

During the course of construction, everyone is so busy building that it is hard to think about public information and promotional needs. The GC or CM is usually responsible for taking regular progress photos of the site. Museums need extra documentation. A professional architectural photographer may be called on periodically to take more artful photographs for publicity purposes. Video documentation is also becoming much more common. Museums must keep in mind that capital expansion leads to increased public attention. An expanded facility must maintain this momentum and interest, and appropriate documentation is very helpful in these efforts, affording donors and the public alike the opportunity to see work in progress.

NOTE

1. For sample change orders and a thorough review of how to approach a change, see Sidney M. Levy, *Project Management in Construction* (New York: McGraw-Hill, 1987), pp. 144–62.

13

FINISHING UP

CLOSING OUT the job is a critical part of the construction phase. Its administration should be considered at the start of construction and adequately planned for in the schedule. It takes time, personnel, and a great deal of patience. This stage can be an aggravating time, filled with psychological pressures as well as pressing move-in deadlines. Everyone expects to be finished, but completion continues to seem "so near yet so far."

There is a point at the end of each job when "substantial completion" is achieved—when the owner, the architect, and the contractor agree that the job, with the exception of work that is on what is called the punch list, is mostly complete, and final payments, with the exception of a percentage held in reserve for completion, are made. Upon final completion, all warranties and guarantees take effect. In order to grant substantial completion, the architect must first complete a punch list of incomplete and incorrect work and submit it to the owner for approval. The contents of the punch list must be determined at this time, and often there is disagreement about what it should contain. These topics are summarized in the following passages but are elaborated in the succeeding chapters of the book, which fully discuss completion and initial occupancy—stages intricately connected with the last stages of construction.

Often at this point in the job, and in order to save on general-conditions costs, the CM or GC may replace the regular project manager with a subordinate who will follow up on details. This arrangement may work, but it should not be used at the expense of continuity. Museums have exceptionally high standards for quality of finishes, and the project manager who has been on the job from the start may need to stay on to ensure that quality is delivered.

PUNCH LIST VERSUS INCOMPLETE BASE CONTRACT

As the project nears completion, the architect begins to develop the punch list. This is a long and detailed index of items that must be completed before the contractor receives final payment, encompassing details as minor as the relocation, adjustment, and completion of small items (such as missing electrical outlet covers), the replacement of broken emergency exit signs, the realignment of handrail brackets, or the relocation of light switches. Perhaps a stone stair tread was cracked during installation and needs to be replaced, or a door threshold has to be raised or lowered. Many items relate to satisfying certain finish requirements, such as painted surfaces and wood finishes (for a sample punch-list page, see Fig. 4).

The development and completion of this list can be a process of considerable duration, and the subject of much debate and negotiation. Primarily, it should be thought of as a checks-and-balances system to ensure that the owner has received all work as stipulated in the contract documents and at the level of quality specified. Because this is the point of final payment, contractors may urge that certain items of incomplete base contract work be considered punch-list items, so that they can be paid before the work is completed. To guard against such tactics, the architect must review assiduously which items are appropriate for inclusion on the punch list and determine with the owner the payment amounts to be withheld as leverage, pending completion of all punch-list work.

MANUALS, TRAINING, AND ATTIC STOCK

Contract documents will have specified that the owner receive, upon completion, certain operating manuals that are essential to understanding the operation of machinery and equipment. These manuals are highly technical and often come in multiple volumes, a master copy of which should be kept under lock and key. After receipt of manuals, training sessions, again as specified in the contract, are given to in-house operating personnel. Videotaping these sessions can be invaluable for future reference.

Attic stock and spare parts are also quantified in the contract. They may include light bulbs or extra carpeting, paint, or ceramic tile. Often these are custom items to match colors or finishes that are difficult to reproduce. The owner must keep close tabs on such end-of-the-job items and make sure that everything that is bought in the contract is received.

SPECIAL INTERIOR-DESIGN TRANSITIONS

As mentioned earlier, there are also issues at this stage of special interior design. In museums, these relate primarily to gallery and storage installa-

The Brooklyn Museum
Lecture Hall - Architectural Punch List
May 8, 1991

THIRD FLOOR MEZZANINE

STAIR 3MZDD47
 Architectural work appears complete

CORRIDOR 3MZCC45
 floor: patch base
 walls: patch hole over door
 paint walls
 ceiling: no comment
 other: provide wall mounted railings for new steps

EXIT BALCONY 3MZBB45
 floor: carpet not trimmed correctly at railing posts
 vinyl base at door to be re-affixed
 provide vinyl base under curved railing
 walls: patch crack at louver and repaint
 ceiling: no comment
 other: gap between walls and curved railing exceeds specified 5" (code violation)
 signage at exit door not fabricated or installed per specification
 provide lamps in all light fixtures
 heat detector escutcheons to be provided

CORRIDOR 3MZBB42
 floor: no comment
 walls: no comment
 ceiling: provide heat detector escutcheons
 other: provide signage at FHC
 paint FHC

STORAGE 3MZY42
 floor: provide vinyl base
 walls: paint
 ceiling: no comment
 other: provide light fixture for further observation

VESTIBULE 3MZDD38
 floor: no comment
 walls: no comment
 ceiling: no comment
 other: FEC not as specified
 FEC to be painted - apply specified signage

Figure 4. Sample punch-list page.

tions of collections. However, they can also include restaurant services, retail shops, other specialized storage areas, conservation laboratories, and other technical spaces. All design consultants for such spaces must work in concert, and continuity is important. The architect and contractor may be finished with the base building at this point, but the project director might just be starting afresh with new crews for interior work, and coordination with remaining base-building work therefore remains critical.

IV

OCCUPANCY

In a process that is riddled throughout with psychological tension and with the alternating emotions of exhilaration and apprehension, one of the most traumatic times is the moment of completion and start of occupancy, when the museum as client becomes the museum as owner and occupant of its realized premises. This is a daunting moment, since it brings home a point that no amount of preparation can make with comparable force: on completion, the museum is left holding the bag. Completion and occupancy are the culmination of the planning, design, and construction process. All the mechanisms and procedures engaged to support, supervise, and control a project bear fruit at this moment, and the success or failure of those efforts is made clear.

In coping with this phase it is helpful to keep in mind two important points:

1. The dust, both figuratively and literally, may never settle, and certainly it does not settle at the moment of a project's completion. The end of construction simply signals the beginning of operation in a new facility, and it is only over a long period of time that the dust of transition dissipates.

2. It is not realistic to expect to have complete control over all the variables that affect transition.

These chapters shed some light on the realities of this concluding phase of a project, outlining the major variables that influence the progress of a project as occupancy approaches, as well as the psychological and emotional sensitivities that come into play at this stage. They will try to distill some practical advice for moving in successfully and with minimal trauma and then highlight the issues, both technical and emotional, that arise in the aftermath, as a museum adapts to its new facilities.

14

SETTING THE STAGE

THERE ARE THREE major factors that govern a project as the time for occupancy draws near—schedule, standards for quality, and cost constraints.

<div align="right">PROJECT COMPLETION</div>

The Schedule

A consideration of schedule immediately raises the question of how much control a museum can hope to have over the process of completion and occupancy. Ultimately, the schedule for completion is set by working backward from an official opening date, and fixing that date becomes increasingly important as construction advances. For a museum's own purposes internally, the move-in period—the period between initial occupancy and the official opening—should be as long as possible. Although the building contractor may argue for the maximum extension of construction time, in fact fixing the dates for completion and opening can be an effective way to galvanize the construction team to finish its work.

Many within the museum will logically press for early completion to maximize move-in time. A completed building needs time to season itself. Real dust must settle; gases must dissipate. Curatorial and conservation staff will argue that a building's environment needs time to achieve equilibrium and to neutralize itself before the art first enters its spaces. Building management staff will lobby for a significant block of time to test, operate, and shake down systems before occupancy. Installation staff will argue for the max-

imum time to achieve perfection and to consider, and reconsider, installation options. These kinds of concerns all warrant genuine and sympathetic attention.

Conversely, a significant ceremonial opening date, perhaps coinciding with a major institutional anniversary or civic event, can generate enormous internal pressures to minimize shake-down and to accelerate the final steps before move-in. The museum director, with the full backing of his or her public-relations staff, may feel that a symbolic date has overriding importance because of the critical and public attention that an opening can generate. Board members and volunteer committee members can similarly be persuaded that a significant opening date will enhance visibility.

Beyond a museum's internal considerations, external pressures must also be taken into account. If a project has been built with substantial public support and endorsement—if the land or facilities are publicly owned or if publicly voted financing has been provided—local officials may have strong feelings about the timing of completion. Perhaps a project has been supported as part of a significant municipal anniversary or in conjunction with some other public celebration or major municipal promotion. These kinds of interests can bring substantial pressure to bear on timing decisions that can affect fundamental issues of professional museum practice. What is clear is that maximizing the move-in period is the most desirable objective, and the challenge then becomes one of balancing pressures, both internal and external, to achieve this end.

Deadlines are not to be avoided, but should be emphasized as a method of asserting control to the extent that this is possible. The prospect of a ceremonial opening can take on great importance. It can be made absolute and sacrosanct, motivating the staff, board leaders, contractors, and construction crews to make targeted deadlines for completion and occupancy.

Last, it is important to keep in mind that there are also technical hurdles to overcome in determining a schedule for completion and occupancy. Voluminous code-related filings and inspections must be accomplished, involving the coordinated efforts of architects, general contractors, expediters, and local government inspectors before a certificate of occupancy is issued. And while responsibility may rest with these various parties, without the museum's vested interest in achieving occupancy, the coordinated effort required to accomplish it will not materialize.

Quality Standard

An issue that is equally as critical as schedule is quality. Quality of finish is a paramount concern in the execution of a museum job. Museums stand for quality and therefore must aspire to the best possible execution of even the most minute details in their facilities. Quality of finish can be judged only as

a project approaches completion. Unfortunately, that moment in a project's schedule is precisely when the whole range of pressures outlined earlier converges to fix absolute deadlines for completion. Accelerating these pressures can undermine the care that must be taken at precisely that same time to achieve quality: haste yields poor quality and provides a ready excuse for diminished standards and performance. It is of the utmost importance at this stage to reaffirm standards for quality and then to ensure that they are recognized and endorsed by those who are otherwise influencing schedule considerations.

Cost Constraints

Cost constraints also affect the progress toward completion. This moment, as the project nears completion, is one of the last remaining occasions for significant and unforeseen pressures on the project budget to arise. As completion nears and related pressures mount, the demand that the work accelerate can be costly and can have serious and negative consequences for the quality of the job. A quickened pace can easily add expense and trigger precisely the wrong reaction on the part of contractors and construction crews: just as a project approaches its close and work should be winding down, the flow of funds to quicken the pace of work can signify a lack of restraint and a heating up, rather than a cooling off.

Control of schedule, quality of result, and containment of cost: with continuing attention to these variables as a project approaches completion, a museum can hope to assert some control at the moment when a project reaches what may be its most sensitive stage, when it begins to see the concrete results of its extended labors. This is also a moment of heightened emotional and psychological sensitivity, and it is therefore useful to outline some of the especially key sensitivities.

PSYCHOLOGICAL SENSITIVITIES

The importance of a museum's developing a sense of ownership of its building program has been stressed throughout this book. During the building process, the museum as client must be forceful and assertive to ensure that its interests and objectives are being served first and foremost. To the extent that this sense of ownership is strengthened during the construction process, the physical reality of a completed building can be daunting, even for those who have been intensively involved throughout. It is therefore essential that everyone have the chance to become familiar with the building as it evolves and particularly as it reaches completion. Otherwise, experiencing the completed building only in its final and literally concrete form can be a shock.

Site visits at various stages of a project's development can be immeasurably helpful, especially as a project draws to a close. For the professional staff, seeing the spaces whose dimensions and criteria they have helped to specify, either directly or indirectly, as they take final form can affirm for them the value of their participation, at whatever level it has occurred. Since most staff members are not schooled in translating two-dimensional plans into three-dimensional space, site visits can also be a way to verify the correctness of spaces that cannot be visualized readily. Professional staff who are weary of the rigors of life during construction also need a reminder by this time of what lies ahead. A visit to the site nearing completion can provide that boost and strengthen everyone's resolve to press on to a project's conclusion.

Since a site even on the verge of completion at times still only vaguely resembles the finished result, even the most informal site visit therefore requires some orientation and explanation. Endorsement and uplifted morale are desirable objectives in giving the professional staff access at this moment, and proper orientation only enhances such goals.

Of course, this exposure has objective as well as psychological benefits: professional staff members bring a fresh eye to the site and can spot problems or errors in places where their special interests may focus their attention. Where field conditions may have resulted in what can seem to be minor adjustments to critical height clearances, the placement of electrical outlets, and the like, the professional eye, particularly with a vested interest, can spot any resulting problems and, where possible, press for their correction.

At the time of occupancy, a museum's building management staff accepts responsibility for the operation of its physical plant. In a well-integrated planning, design, and construction process, operating staff will have been involved at every stage, either by participating in making the critical decisions during each phase or by being kept abreast at all times of the operating implications of the facilities' design and construction. Hand in hand with this involvement should go the opportunity, from the beginning of the construction phase, to become familiar with the new physical plant and systems. In the case of operating staff, this kind of familiarity reinforces both a sense of participation in the building process and a sense of ownership of the new facilities.

As much as its staff, a museum's board and volunteer leadership need to be familiar with a project as it becomes a physical reality, and for the same psychological reasons. This constituency's understanding clearly need not be so technical, but its endorsement can be very beneficial. This group can work effectively with local government and community to secure as well their endorsement of a completed project, to enhance a project's public relations, and to stimulate broad public interest and enthusiasm. Last, if there are major individual donors to a museum's project, it is important to remember their vested interest in the final physical result and to offer them the opportunity to visit the newly completed site.

A concerted effort to introduce the completed project to each of the participants described here can only benefit the success of its reception—internally and externally, professionally and publicly.

Why do subjective psychological and emotional factors play so significant a role in setting the stage for what would seem to be so objective an exercise as occupying new space? Whether or not one chooses to pursue a conclusive answer, what matters is the recognition that the question is important and that it focuses on a moment of utmost sensitivity. The change in physical environment, the transition from old to new space, and the experience of new space all have an impact that cannot be overlooked.

For an existing museum that is moving to a new or a newly expanded or renovated facility, there is the memory of what existed previously. This point was emphasized in earlier discussions of the planning stage, and it is similarly important here. The memory of what was can be colored by nostalgia, and it can be made appealing by virtue of its familiarity, particularly in the face of the new and unknown. In the planning phase, the danger of clinging to the familiar is that it can hamper one's ability to realize the benefits of what is new and innovative. Staff members long accustomed to certain facilities, cramped or deficient as they may have been, may not easily accept a changed environment, even if it is successfully designed and executed to yield improvement. Trustees and longtime supporters may have difficulty accepting the look of new facilities, regardless of their success, based on a fond memory of the old. Visitors may be the most unyielding in this regard. They do not easily change their perceptions of how a given institution's collections and exhibitions are best housed, often preferring simply the familiar. And there is also a period of adjustment to how collections look as they are installed in new surroundings.

In the case of new institutions, the basis for comparison is perhaps even more skewed. Instead of a preexisting building, a wholly new museum must live up to expectations of the "reality" of a long-imagined idea, and one that may have taken many different forms in the minds of founding professionals, board leaders, supporters, donors, and community constituencies. Notions of space become deeply internalized over the course of conceiving, planning, and building a project. Completion therefore requires reconciling these internalized notions with the reality that has been achieved, and this reconciliation can be arduous. While there are no easy answers, the simple recognition of the interplay—and potential discrepancies—between real and imagined space can be most helpful.

In large part, the burden of this moment is a product of the success of the process that brings a museum project to completion. This book has focused in each phase on an organic and reverberant process, one that begins with planning for a specific project's development in the context of the kind of long-range thinking that sees a project in relation to the programmatic, financial, and operating implications for its future. Each stage of the process

unfolds to become the next, and, at each stage, there is the opportunity for assessment—to consider whether a project continues to address the goals and objectives for which it was initiated. In this way, needs assessment yields to planning, which generates design, which requires construction, which resolves finally in completion. From the moment that a museum moves to occupy its facilities, it begins to test whether or not it has successfully fulfilled the needs set out at the start of its planning process. It also begins to test whether or not the periodic process of review has refined accurately its assumptions regarding the implications of new facilities for programs, finances, and operations. It is useful to accept outright the likelihood that the physical and operational realities of a newly completed museum will not be entirely consonant with what was envisioned at the outset of the project. Rather, the final reality will be the result of much thoughtful consideration and reconsideration. And original assumptions, through related and ongoing refinement, may properly be the basis for new assumptions about current and future operations.

What matters most is to recognize that the completion of a given project represents change. For an existing museum, completion can also result in a significant change of scale. For a new museum, change is the transformation of an idea to an operating entity. In both instances, planning assumptions become operating assumptions, which themselves become the basis for further planning. The burden that this realization brings to bear on the process of completing and occupying a new facility is great.

PHYSICAL SENSITIVITIES

Turning from the psychological to the physical, it is important in preparing to occupy new space to acknowledge that museums are literally among the most sensitive kinds of facilities, so that mobilizing to occupy new facilities must be orchestrated with great sensitivity.

Chapters 6 to 13 have emphasized how complex and specialized museums are as building types. Museums consist of many varied and specialized components, each of which has its own spatial and environmental criteria. Museums are public facilities, but with areas of restricted or prohibited public access. Museums accommodate potentially large numbers of visitors in vast public spaces, galleries, and auditoriums, and yet they also hold collections in precisely designed and environmentally controlled locations. They may serve food and sell books and other merchandise. They also provide scientifically and technologically advanced facilities for conserving and storing works of art.

Museums are similar to hospitals in their broadly varied and precisely specialized planning requirements, and, to extend the analogy, their collec-

tions take on the singular status of a hospital's patients at the point at which new facilities are ready to be occupied. Concrete and objective criteria must be established to determine whether or not a new museum facility is ready to receive its works of art. Indeed, a further reason to familiarize professional staff with new facilities at the earliest possible moment is to encourage curators, conservators, and registrars to begin to evaluate the extent to which conditions in new facilities are appropriate for receiving art. While concurrently adjusting psychologically to new space, these staff members, along with operations, security, and administrative staff, need to be engaged in an objective analysis of whether or not mechanical systems are balanced enough to provide stable environmental conditions, based on predetermined criteria, and whether or not security and life-safety systems are sufficiently debugged to provide adequate protection.

Wrestling with these criteria, a museum must finally step forward to occupy new facilities, thereby concluding the last phase of its building cycle and initiating the first phase of its future operation.

15

ACHIEVING OCCUPANCY: BETWEEN COMPLETION AND OPENING

OCCUPANCY BEGINS the moment a new facility ceases to be the province of construction crews and is instead occupied by the staff, furnishings, equipment, and collections of the museum. It is the point at which the museum as owner becomes responsible for the facility and for its operations.

Of course, as with every other step in this process, many variables influence precisely how the occupancy stage is achieved for any given project. Among them is the project's construction phasing: whether it is wholly new construction, accomplished at one time on a single stand-alone site, or phased, so that discrete portions are complete at different times; or whether it is the expansion or renovation of an existing facility, either accomplished all at once or phased to permit temporary relocations of staff and operations while work progresses.

In an ideal situation, a new stand-alone facility is completed all at once, and the museum is able to occupy a fully finished site. However, it is more likely that different parts of a project will be completed on a staggered schedule, requiring a museum to plan its move in phases as well. This may seem a more complex approach to occupancy, and it is. Yet if managed properly, it enables a museum to ease into its new facilities and to determine a sequence for moving that can accommodate the kinds of psychological and physical sensitivities that have been discussed. It is also, in many instances, unavoidable.

Phased occupancy can be logistically complex. It entails sealing off certain spaces, wings, or portions of a building from others. It requires banishing contractors and construction crews from those spaces, except when prearranged. It can exacerbate the difficulty of achieving final completion through-

out the remainder of a facility, simply by increasing the operational complexity of the site. However, it can also be an enormous help to the museum as it prepares to move in, since it provides for a testing of the waters before plunging in, and it can make the otherwise monumental effort of moving in seem rather less forbidding, by reducing it to what may seem to be more manageable challenges, met on an incremental basis.

TAKING POSSESSION: A CONTRACT TERM

Moving in is itself contractually significant, with technical and legal implications that need to be understood in advance. A museum moves into new space only after taking possession of it from the contractor or construction manager, who has been responsible for it as a construction site. In taking possession, the museum thereafter accepts responsibility for the condition, operation, and occupancy of that space in whatever condition it has been received.

To do so, the museum must be able to rely on the representations of its contractor or construction manager that the space is complete and ready for occupancy. The only exceptions will be incomplete items of work listed by the architect in the formal punch list following his or her scrutiny of the completed space. The architect and contractor must agree on the extent of this list before the owner accepts the space.

As in so many other instances, the museum must take care to protect its own interests at this point. To ensure the full and final completion of its space, the museum must be able to ascertain the completeness of the punch list. To do so requires rigorous participation in the process of creating the punch list during the construction phase (see Chapter 13) and careful review of the architect's summation of the work that remains. As the formal record of a contractor's legal obligation and responsibility for work to be concluded after a museum accepts its space, the list must be exhaustive.

Ideally, time would not be an issue, and a museum would not accept its new facilities until all the work was completed, obviating the need for a punch list. However, the many pressures described earlier in this chapter affect a museum's decisions regarding when and how completion and occupancy are achieved, so it is far more commonly the case that a museum takes possession and begins occupancy with an agreed-on punch list. The verification of the punch list therefore becomes a consuming assignment, engaging all the members of a museum's project team, those who have overseen work in the field together with staff who, by this stage, should be well attuned to the operation and condition of the spaces into which they are moving.

Before the museum takes possession of and moves into its new building, evidence of the legal right to occupy space in a newly completed facility is also required. Again, this responsibility rests jointly with the general contractor

or construction manager and the project architect. The museum is likely also to have engaged an expediter, independent of both contractor and architect and with specialized knowledge of the intricacies of local approval processes, to assist with this effort. Their task together is to ensure that all the inspections required by local authorities are scheduled and completed, that all the necessary documentation is properly recorded and filed, and that the appropriate local governing authority has issued the required certification for occupancy. Procedures and requirements vary from city to city. However, they are always the responsibility of the contractor and the architect, generally coordinated by an expediter, and they must result finally in the issuance of public-assembly permits and of a certificate of occupancy enabling legal occupancy.

Again, the museum owner is not free of responsibility for making sure that all the necessary steps are taken, and it is probably fair to say that the inspection and certification process is never completed smoothly. There is always some confusion among the parties, and there are always some dropped balls that must be retrieved before the game is over.

In preparing for occupancy, it is helpful at each step to think in terms of the following questions:

1. Is the space ready for professional staff to use it and to work in it?
2. Is the space ready for works of art to be handled, stored, and installed in it?
3. Is the space ready for use by the general public?

Staff, art, and public: the considerations and timing of occupancy differ for each, and the sequence in which the steps take place is therefore important.

STEPS TO ACHIEVE OCCUPANCY

Curing the New Facilities

Once new space has been turned over, even in the most complete possible condition, it must be allowed to run on a continuous and typical operating basis for some period of time simply to achieve physical equilibrium.

Mechanical systems must be operated both to test their performance and to demonstrate that they can achieve and then maintain required environmental criteria. In dry climates, humidity must be introduced, and finished facilities will require time to absorb it before equilibrium is achieved and stable conditions are guaranteed. Similarly, in damp climates, spaces will need to be dehumidified before a system can demonstrate that it is able to produce and maintain required conditions. Ideally, this process would allow for as much as a year's climatizing. More realistically, a museum should simply attempt to

preserve as much time as it can for this purpose, with three months as a minimum.

This step can also be anticipated somewhat through an advance period of beneficial occupancy during which operating staff works on the site, together with contractors and trade contractors' representatives, in training and orientation sessions specifically devoted to understanding the operation of new systems and reviewing operating manuals and warranties.

Fire-protection and security systems, and the central monitoring for all such systems, also require debugging, and their operating capability must be demonstrated.

The accumulated dust of the construction process needs time to work its way through all the operating systems. While efforts can be made to filter this residue, it is most effectively eliminated simply by sustaining continuous operating time during a facility's shake-down period. Further, many new surfaces and finishes expel gases that need time to dissipate. Paint finishes, plywood, and carpeting are only a few of the many common building materials that emit chemical vapors that should be released before a museum's spaces receive works of art and, in some instances, people. The use of non-noxious materials and finishes, particularly for art-storage areas, can minimize this time period. However, this problem cannot be escaped altogether, so the best method for addressing it is to become knowledgeable: indeed, as a result of increasing government and professional enlightenment about materials in the workplace, it is likely that a museum's own conservation and operations staff will be well versed in this area.

Last, new facilities must be cleaned to eradicate the grime of the construction workplace. It is likely that new techniques will need to be introduced to clean and maintain unfamiliar materials and finishes. And, as construction dust makes its way through a building's mechanical systems, cleaning must be done not once, but repeatedly. In ideal circumstances, all such cleaning and preparation activities would precede any occupancy by staff, since, with the added encumbrance of furnishings and equipment, they can only impede the staff's efficiency. It is essential, in any case, that cleaning be completed as the first step in occupancy.

Preparing the Galleries

As discussed in Chapter 7, it is not uncommon for museums to assign responsibility for the design, detailing, and execution of collection, installation, and exhibition spaces to in-house staff—curators or installation designers—or to consultants who specialize in exhibition and gallery design. Under such arrangements, it is also not uncommon for the related construction and installation of these spaces to be executed not by a general contractor (or by trade contractors engaged by a construction manager) but by in-house pro-

A

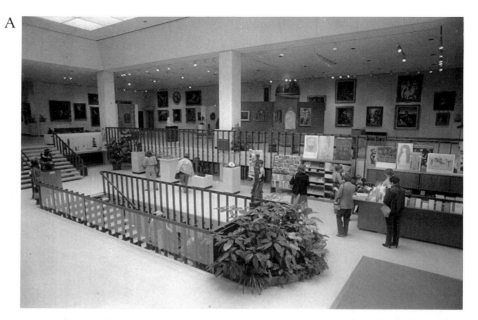

B

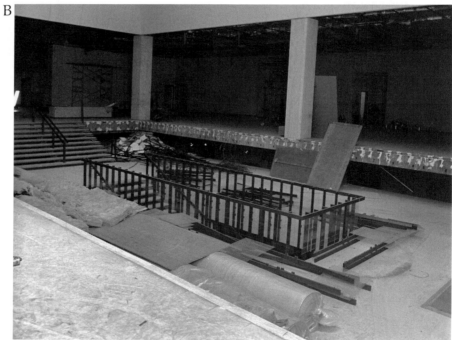

Renovation of the Marquand-Mather Court, The Art Museum, Princeton University. (a) Before renovation; (b) during renovation in 1989; (c) following completion of the new space. (Photos: [a and b] Clem Fiori; [c] William N. Taylor)

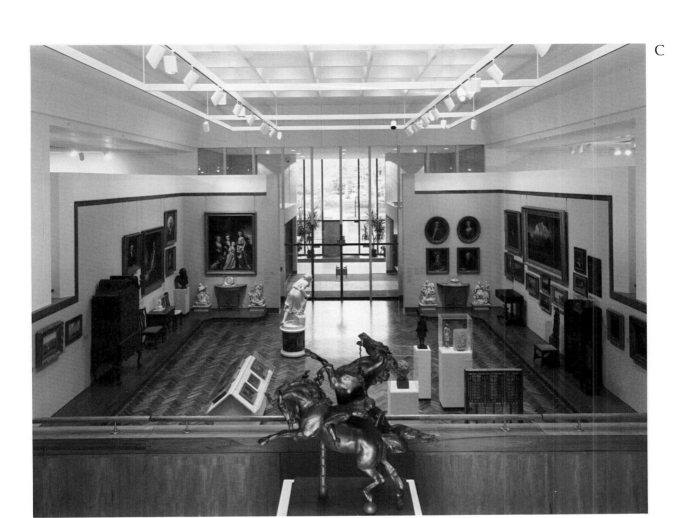

duction crews or by specialized installation contractors engaged by the museum either directly or through a consulting designer. This design and production schedule is then likely to be entirely separate from the base-building project's schedule.

Questions of trade-union jurisdiction on a work site or of the underlying incompatibility of types of work generally also dictate that this work be done after a museum has taken possession of its space. While such work may not be cleaner than base construction, it is likely to be finer. Its details may require more time for development, and their execution will doubtless be subject to greater refinement, and possibly even reconsideration, than is possible in an overall project. Indeed, it may be desirable to keep this activity separate from the completion of construction and simply to assert that its execution under the museum's direct supervision is an important independent step in the occupancy process. After all, it is inextricably part of the task of organizing the galleries in which collections and exhibitions are displayed,

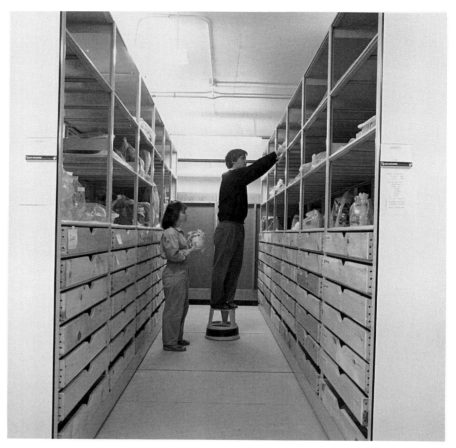

Moving into the new art-storage area at the Peabody Museum. (Courtesy Peabody Museum of Salem, Massachusetts. Photos: Mark Sexton)

which must always be among the preeminent concerns of any museum. And it is important to remember that this activity extends, with increasingly precise execution, to the completion of display mounts and cases, gallery lighting, installation typography, and, finally, wall labels and other interpretive signs.

For precisely the same reasons, this situation may apply to the completion of other art-related spaces, such as storage centers and collection study spaces, where museums may want to have direct control and possibly to execute the work for storage tills, examining tables, easels, and the like. These areas are also likely to require specialized interior installations, with special materials and systems, for which a museum may seek particular consulting expertise and engage specialized installation crews.

If the schedule overall is driven by an absolute and immovable opening date, the period allocated for initial occupancy must include the time necessary for these kinds of installation requirements, which also then necessarily compresses even further the schedule for the contractor's completion of con-

struction and the museum's acceptance of space. If the opening date has some flexibility, the time needed to perform this kind of work must simply be built in as one of the first steps after the completion of construction and acceptance of the space.

Moving In and Installing Art

All other considerations pale by comparison with the determination of when and how art is mobilized to occupy new space, and all other hurdles become inconsequential when compared with the emotional and psychological issues that must be addressed in planning and executing collection moves. Museums, after all, are first and foremost about their collections. In theory, housing to provide properly for the care and preservation of collections must be among the major initiatives for undertaking any museum project, so moving works of art into new space comes very close to symbolizing the core accomplishment of any project.

These moves obviously must be under the direction and supervision of the professional staff—the curators and conservators, registrars and preparators, who are responsible for the care and safekeeping of collections. Unfortunately, the staff must rise to the occasion to accomplish this most critical task at precisely the moment when a new facility is at its most vulnerable operationally—that is, when it is brand new and therefore, of necessity, not fully tested.

At the same time, it is only after the sequence of steps outlined earlier has been completed that responsible professionals initiate the movement of collections, and then only when they are satisfied that the requisite criteria for environment and safety have been met. Of course, regardless of the specificity of these criteria, they are measured in relative rather than absolute terms, so the judgment to move in will, at a certain point, be a subjective one. It is nonetheless a cautiously managed step. Works of art are most vulnerable when they are on the move, and, in spite of all best efforts, collections are unquestionably exposed when a major move is in progress. It must also be recognized that the staff members who handle art are under enormous pressure at times such as this. Tight schedules and unfamiliar territory unfortunately only add to the strain at precisely a time when one would hope for the least pressing conditions. Furthermore, it is now that the professional staff is confronted for the first time with the functional reality of new facilities, in a true test of the planning, design, and execution of the museum's most critical support systems and spaces.

Again, unlimited time to accomplish this step would ease the strain substantially; however, moving art only after a new facility is fully tested and all installation sites are fully prepared is an ideal that most move-in schedules, sandwiched between completion and opening, are not able to accommodate.

Test Running the Public Facilities

Testing the mechanical plant, running the systems, and preparing for and then receiving and installing art ought to be accomplished only in the presence of professionals—staff members, project team members, and hired experts whose purpose is to ensure the success not only of each step, but also of the entire new museum as an operating facility. However, in reality, a new museum must function well not only when occupied by the professionals who have nursed it through completion and its preparation for opening, but also when fully burdened by the volume of new and unfamiliar public for which it has been conceived, designed, and built—a public that is enthusiastic but not always obliging.

Oddly enough, while working through the several other steps described

here, a new museum environment can begin to take on the aura of a scientific laboratory. Perhaps as a reaction against the extent to which so many variables in this process are uncontrollable, these final steps can become heavily controlled; it becomes easy to forget that museum facilities are not only for the knowing professionals, but also for the unknowing, unpredictable, and therefore uncontrollable public. Indeed, after the intense concentration of moving in, it can be a rude awakening to stumble on public visitors in a new museum space. Contrary to the obvious objective of making new facilities for the public, visitors can actually seem out of place precisely in those spaces designated for them.

It is therefore essential to remember that new public facilities are indeed intended for the public that they will serve. It is important during the move-in phase to attempt to test in a number of ways the new facilities' capacity to accommodate that public, since it is impossible to assess accurately the success of various designs and systems without exposing them to a substantial number of people.

1. Mechanical systems are designed to meet loads generated by anticipated volumes of traffic. No amount of continuous operation without anticipated loads can verify the ability of those systems to perform properly and well.

2. Ticketing and coat-checking systems are designed to handle projected rates of traffic flow, and no amount of mechanical testing can guarantee that they are able to function as planned.

3. Public spaces and circulation systems are planned to accommodate crowds at certain densities and certain rates of flow, which can be tested only by generating those volumes of traffic.

4. Specialized facilities such as auditoriums and restaurants can be put to a true test only by serving capacity crowds.

These tests, although not easy, can be a crucial last step in the move-in process. First, they can help make the transition from the experience of a handful of professionals to real public use by putting facilities to the test of true operating conditions. Experiencing these conditions before opening can stimulate a healthy confidence among those who will shortly be faced with running a new site, since the operation of new museum facilities is affected by the confidence and experience of the staff responsible for them, as well as by the performance of the facilities themselves.

Although the simulation of a museum crowd is admittedly not easy, staff, trustees, and other volunteer support groups are often willing participants in these kinds of exercises, which can benefit greatly the staff who will shortly be operating, maintaining, and managing new public facilities.

In summary, given the myriad real and psychological factors that affect occupancy and the actual physical demands required for successfully moving in, it is too easy to become overwhelmed by details. A few objectives should be foremost as the staff works its way toward settling in.

Sustaining Priorities and Accepting Reality

It is important to keep in mind the major priorities for building the new facilities, and then to insist on complete familiarity with the site as construction progresses to ensure that these critical objectives are met. Museums are about quality, and quality must be evident in the detailing and execution of work in the field. While the achievement of quality can be judged finally only when a project is complete and ready for occupancy, it can also be perceived as work progresses. While striving for quality and pursuing the ideal, museums must also be prepared to accept the realities of new facilities. Spaces can extend only to their real physical dimensions. Materials and finishes can be exploited only to the limits of their physical properties. Familiarity with the site while these realities are taking shape can dispel undue expectations and ensure that the result will be appreciated on its own terms.

Providing Early Access for Staff

Provide the earliest possible access to the site for operations and maintenance staff. To build a facility with quality is only the first step. It must also be operated well, and achieving that end requires careful indoctrination. A new museum facility is a wholly new animal. Its mechanical systems will have been designed by mechanical engineers, who will doubtless employ new and sophisticated technologies to meet the criteria that the museum itself has specified. Operating staff may well have been consulted in the course of planning and designing these systems, but they must get to know the systems' capabilities through familiarity with their installation and operation.

Most mechanical installation contracts will provide for a limited amount of this kind of orientation, and the greatest familiarity will come from observing during initial occupancy the full process of installing, starting up, and shaking down new equipment and systems. Effectively achieving this in-depth familiarity on the site and through coordination with installation contractors can yield confidence in the operation of new equipment and systems, strengthening the foundation for a successful move-in.

Operating staff must also insist on receiving all operating manuals, guides, warranty information, as-built documents, and spare stock for all operating systems and equipment. These transmittals are an important part of taking

possession that is often forgotten as attention turns from completion to the rigors of operation.

Maximizing the Schedule for Moving In

The museum should exert whatever influence it can to preserve an extended move-in period, despite completion schedules that fall behind and opening dates that, at a certain point, are immovable. Each step in the move-in process will seem to need more time than is realistically available. And the time for each step will be further compressed by delays in preceding steps.

A museum has limited control over delays, beginning with its inability to guarantee a contractor's compliance with a completion schedule. System start-ups can go well or poorly. Gallery and other installation work being done on a separate schedule can fall behind. And the movement and installation of artwork can proceed only as quickly as these other steps are completed.

In many cases, the official opening date dictates how much time is available for each of the preceding occupancy steps. Yet with sufficient lead time and planning, the opening date can in fact be somewhat controlled: Does the opening date depend on a major traveling exhibition's schedule? Can backup planning ease that constraint? If an opening exhibition is being mounted at the museum, how much flexibility can there be in its schedule? Does the actual opening schedule first contemplate any informal, in-house events leading up to a grand opening, such as previews before opening night? How long a period is available for this sort of dry run? Such events can enhance the move-in process as well as provide some preopening flexibility. These considerations emphasize as well the importance of open and fluid communication during this phase, not just between operating and curatorial staff but also with staff and consultants responsible for special events, publicity, and all other aspects of a museum's planning for its opening.

Avoiding the opening squeeze, if at all possible, can enable a museum to move with greater confidence from completion to full-scale operation.

Informing Professional and Administrative Staff

Enlighten professional and administrative staff about what to expect from newly completed facilities. If, over the course of a project's development, the project team and its leadership have developed an effective internal network, this mechanism will have ensured that professional and administrative staff have been kept informed throughout the process. Even well-informed staff will need to be briefed about what to expect upon first occupying the new space. If there has been no significant involvement along the way, it is even more important at this stage that staff members be briefed about new space,

so that they can know and understand its functional realities and limitations before beginning a move.

With or without reason, staff may expect that new space can instantly provide the perfection that existing space never had or that their vision of new space always assumed. The reality, on the other hand, is that, at the outset, nothing will work perfectly smoothly. Without a concerted effort to defuse unrealistic expectations, it can be difficult to garner the support and enthusiasm of the staff, just at the moment when it is most needed to mobilize for occupancy.

Assuming that space is accepted with a punch list, work will remain to be done, and contractor's representatives and work crews will have to have some access to the building. It is also highly unlikely that precise environmental control will have been achieved fully at the time move-in begins. The staff should be made aware of these and other similar conditions, and the project team should communicate its commitment to limiting and controlling them. It is important that the leadership's message at this moment dispel any sense of benign resignation to what cannot be achieved.

Since the prospect of a move makes everyone feel vulnerable, the project team's efforts to communicate in this way can help to ensure a climate of understanding and security. It can also effectively heighten staff awareness of the problems and questions relating to moving in and make staff part of the expanded team for controlling and containing those conditions that may still be unresolved. In this way, moving in becomes a mutual effort among those who have been involved with a project's execution and those who will occupy the completed space and be responsible for its operation, as well as for the care and safekeeping of the collections it will house.

Monitoring the Details of Completion and Possession

Regardless of the temptation to put such matters as securing permits, arranging inspections, and filing for certified occupancy in the hands of an expediter and of the architect and contractors who are formally responsible for them and who may well assert that these matters are being "taken care of," a museum must stay close to this process until it is completed. Having readied an entire operating and professional staff to mobilize for moving in, nothing could be more frustrating than to be stymied by the failure of others to take care of such technicalities.

16

COPING AFTER THE MOVE

N O MOVE HAPPENS overnight. With phased occupancy, the steps out-
lined in Chapter 15 may in fact extend over a long period of time
and involve equally long periods of dislocation and temporary re-
location. Sooner or later, though, a museum finds itself fully installed in its
new facilities. As in every other stage of this process, concerns then will
almost immediately arise, and on the same two fronts as during every other
phase of the project: the physical and the psychological.

As has been emphasized repeatedly, new facilities are never perfect, and, to
temper heady anticipation and unrealistic expectations, this point needs to be
stressed at all times. After the move, it will be clear not only that facilities are
not perfect but also that, in seemingly endless ways, numerous items of work
will remain incomplete and possibly even be wrong. When incomplete, they
become part of the final punch list. When they are wrong, other consider-
ations must be made.

 If architectural and construction contracts have been well executed, the
museum will have recourse to them to ensure that errors and omissions on
the part of the architect, general contractor, or trade contractors engaged
through a construction manager are addressed. If such items are clearly
identified in contract documents as the contractor's responsibility, they be-
come part of the punch list of remaining work. However, it is more often the
case that these kinds of errors and omissions arise from ambiguities in the

documents, and they must then be resolved through negotiation. If mistakes or omissions are the architect's, similar protections are available, but they, too, are likely to be resolved through negotiation. Clearly, completion and occupancy rarely signal final completion, and the project team should stay intact until well after the move. In all likelihood, the members who have been most closely involved during construction and completion will be involved in an extended period of negotiation to resolve errors and omissions, as well as to oversee the resolution of outstanding punch-list work.

If negotiation with contractors and architects is necessary, the retainage that, on the basis of contractual terms, the museum withholds from payments for completed work will be its leverage in dealing with unresolved items at a project's conclusion. That sum should not be released without full consideration of work that the architects or contractors may have failed to perform or that may have been performed unsatisfactorily.

A second major category of mistakes results not from contractual errors, which can be relatively clear-cut, but from a museum's own errors of judgment. The experience of being in a new space is far different from the experience of planning it. Once a museum occupies new facilities, it will almost inevitably begin to feel that some of its decisions were wrong. Staff will experience waves of this kind of uncertainty in the short time that follows completed occupancy and opening. The urge to rethink is real, and it should not be denied; nor can it be ignored. At the same time, every caution should be made against reacting too quickly and calling immediately for change. No contract protects a museum against its own such reactions. No mechanism exists magically to fund changes that may seem to be required because of a museum's own reconsideration of designs that it has approved and caused to be executed.

Every effort should be made to prolong the review of such issues to allow for some perspective after a museum has settled into its new home and has been able to evaluate with some objectivity the operation of its facilities. Changes made too soon do not necessarily yield improvements. And, after exercising fiscal restraint throughout a project's development, this is not the moment to become financially irresponsible by spending funds on hastily conceived alterations.

It is a certainty that all will not be right, however, and at some point, changes will be warranted on the basis of a museum's assessment of its new facilities. This condition should not be interpreted as an indication of an unsuccessful project. It should simply be accepted as the fine-tuning that comes as a benefit of experiencing the completion and operation of new space.

PSYCHOLOGICAL ISSUES

Nothing affects professionals more deeply than the environments in which they work and carry out their professional obligations. If the project-development process has successfully engaged a museum's staff, that staff will

certainly have developed a sense of ownership of newly completed facilities. They may or may not turn out to be what was expected. The reality may or may not conform with the staff's memory of its conception. During the enormous adjustment that will be required in the move to new facilities, nothing will be perfect, and completed space may in fact not be fully complete for some time. A fond memory of what existed previously, regardless of how inadequate it may have been, may seem more appealing than what is new. It is important to remember that these feelings will simply take a long time to dissipate.

It is also important to remember that completion of a project will represent for all the conclusion to a monumental undertaking. Staff will have worked hard to achieve this goal, and it will be difficult to see this accomplishment as other than an end in itself. Nonetheless, at the exhausting, and hopefully exhilarating, moment of completion, it is not easy for the staff to look immediately to the next horizon, and some postpartum depression is to be expected. At such a time, a little rest is in order. Recognition of the level of the staff's participation is certainly called for, and credit should be given where it is due; taking stock of the accomplishment that has been achieved can have a restorative effect.

Such an exercise should not be interpreted as undue coddling or unseemly self-congratulation. Too many museums have successfully completed building projects only to find themselves feeling inexplicably unfulfilled, with their staffs burned out and unable to make the transition to the challenges of the future. There are no simple answers here, but understanding the phenomenon is helpful.

AFTER COMPLETION

The psychological state just described offers an appropriate prelude to some closing thoughts on institutional life after completing a major building program. Once a project is over and the figurative dust has settled, a museum must perforce carry on and accept outright the burden of moving forward in a manner that fulfills the goals and objectives that have been formed, reformed, and refined during the course of the project's progressive stages as outlined in this book.

The initial concept, shaped and refined in response to stated needs, and then evaluated in the context of programming, financial, and operating assumptions and projections, has finally been realized in newly completed space. This larger context then immediately becomes the framework, albeit theoretical, for evaluating the finished project, together with its programming and operating capabilities. What were the original expectations for the new facilities? What were the programming assumptions derived from the consideration of how to use those facilities? What were the operating projections generated by those programming assumptions?

Renovation projects can be especially vexing, complicated by logistical complexities, harrowing relocations, and general operational discomfort. However, when existing gallery and nongallery spaces are rebuilt to provide new gallery space for museum collections, the results can be particularly rewarding. At two museums, renovation produced subtly yet significantly enhanced gallery environments for displaying collections, using new technologies for environmental control and lighting and fresh design detailing.

A

The Museum of Fine Arts, Boston, Evans Wing (Guy Lowell, 1915). Renovation in progress (a) and completed installation (b) of the Impressionist Gallery (I. M. Pei & Partners, 1982–1986). (Courtesy Museum of Fine Arts, Boston)

B

The Ackland Art Museum, Chapel Hill, North Carolina. Before (a) and after (b) renovation of painting and sculpture collection galleries (Newman & Jones, 1988–1990). (Courtesy Ackland Art Museum, The University of North Carolina at Chapel Hill. Photos: [a] Quintin Sawyer; [b] Jerry Blow)

Many new museum buildings, once complete, become symbols through their architectural distinctiveness, as is certainly true of Frank Lloyd Wright's original Guggenheim Museum and, in this past decade, Richard Meier's design for the High Museum, Atlanta.

The Solomon R. Guggenheim Museum, New York. The rotunda, looking down from above (Frank Lloyd Wright, 1959). (Photo: David Heald)

High Museum of Art, Atlanta (Richard Meier & Partners, 1983). (Photo: Alan McGee)

These are the questions that were asked during the initial planning phase and that, from the first determination of a preliminary concept, stimulated an outline of long-range planning considerations about a building's future operating potential. Now, these issues and the projections that evolved from them can be reviewed again. The point of the exercise is not, however, to judge the completed project's success, but to understand the uninterrupted flow from initial planning assumptions to a project's operating reality.

The completed project, the product of its planning process, now becomes a living and breathing institution, which itself becomes the basis for its own future planning efforts. The tools and techniques used to forge a new museum—refinement of mission, assessment of needs and resources, and long-range planning in the context of programmatic, financial, and operating requirements—are simply adapted to become the tools and techniques for planning and sustaining the museum's future. The operating projections of the planning phase, modified, become the operating results of the new museum, and those results then form the basis for projecting the museum's operating future.

Acknowledging this flow from past to present to future is helpful in coming to terms with new museum facilities. They do not stand alone as completed space. They must be evaluated on the basis of the considerations that formed them. And those considerations will provide the basis for judging the performance of new facilities in relation to future needs and responsibilities. That this continuum may one day lead to the need or desire once again for new space only reinforces the notion of an organic whole, binding past, present, and future through responsive and responsible institutional planning.

APPENDIX A
ACCESSIBILITY

Although many museums claim in their promotional literature that cultural institutions are open to all, museum design in the past has not always been this accommodating. Inappropriately designed parking areas, walkways, entrances, elevators, telephones, drinking fountains, door hardware, toilets, auditoriums, exhibitions, and the like have precluded the use of museums for an increasing number of disabled and older people. Visitors are not the only people who must be considered: there are disabled museum employees, artists, administrators, board members, and donors. Accessibility must extend beyond the public spaces into all areas of museums.[1]

All people must have access to and be able to participate in our country's rich and diverse museums. The Americans with Disabilities Act (1990) mandates such access to all places of public accommodation. Common decency demands it, and good business sense dictates it. This goal can be achieved, however, only if museums are built according to universal design principles and if exhibitions are presented in ways that allow everyone to participate.

Museum administrators cannot assume that they may leave the details of accessibility to the architect(s) and special program staff. Accessibility is an issue in which all staff members must become involved. All aspects of the organization—membership, public relations, fund-raising, gift-shop sales, exhibition design—and all staff members must be involved in ensuring that all people, whether they are short or tall, old or young, disabled or not, will be able to understand the program and have access to it.

The demographics of our society are rapidly changing. A 1986 study by the Bureau of the Census concluded that more than 37 million people out of a population of 181 million noninstitutionalized persons age fifteen or older

had functional limitations; 13.5 million in this group had severe limitations. Of those with severe limitations, 55 percent, or 7.5 million, were sixty-five years of age and older. These figures become even more important when we look at the expected growth in both the number and the percentage of the older population during the twenty-first century. By 2000, we expect there to be 35 million people over the age of sixty-five. By 2030, when the last of the baby-boom generation reaches age sixty-five, there will be 64.4 million older adults, or one out of every five Americans. It is likely that nearly 60 percent of these people will have functional limitations. At the same time, the number of people over age seventy-five who have disabilities will reach almost 30 million, or about 10 percent of the population. And these numbers do not include children, who benefit from many access features; parents pushing strollers; temporarily disabled individuals; or the families, friends, and associates of persons with physical disabilities.

Disabled people are not as limited as is often presumed and are in virtually all professions and in all types of jobs. Individuals who do not have disabilities today, of course, may also be temporarily or permanently disabled tomorrow. The conditions they have will not likely change the things they like to do or the skills they were trained to perform, especially with the advent of new medical and rehabilitation training and technology. Physical barriers can be overcome through training, personal assistance, assistive devices, or architectural modifications. Because of our reliance on assistive devices as one of the means of accommodation, we must design the environment to accommodate these devices and new technologies (assistive listening systems, wheelchairs, walkers, and such) as well as the people they serve.

Disabled people should be involved in the planning and design of museums. Understanding the various abilities of the people who will use museums is critical in designing facilities.

The study of accessible design over the last twenty-five years has shown that there are a few basic functional abilities that must be considered in designing buildings so that they can be used by the vast majority of the public. Those abilities are mobility, vision and hearing, and dexterity.

MOBILITY IMPAIRMENTS

People whose mobility is impaired range from those who lack stamina or strength, who may use a cane or lower-leg brace, to those who are totally unable to walk and may have little or no use of their arms, shoulders, and hands. They use a range of mobility aids: crutches, canes, walkers, standard manual wheelchairs, power wheelchairs, and the increasingly common three-wheel scooter. Changes in level pose serious problems to this group unless there are ramps or the floors are served by an elevator or a lift.

Those who can walk but do so with difficulty may also have trouble sitting, bending, and kneeling and may be hampered by having their hands occupied with walking aids. Many of those who use walkers, canes, and crutches lack stamina or strength. They need direct access from transportation to entrances, and stable, firm, slip-resistant walking surfaces. Grab bars in toilets and handrails at steps and ramps are crucial. Resting places at frequent intervals may be a necessity.

SENSORY IMPAIRMENTS

Visual Impairments

Visually impaired persons may be totally blind or, like many older people, have limited vision. Some are able only to perceive light and dark, whereas some may see a very fuzzy image of the world. They need stable and firm pathways that are free of protruding objects or obstructions. Cantilevered drinking fountains, for example, sometimes protrude into a corridor and are undetectable by the long canes used by many visually impaired people or people with low vision. Many low-vision people (including older adults) have great difficulty reading standard print and exhibition signs. It is hard for them to distinguish the edges of objects. Items on display must be examined closely. Glass display cases often keep objects at a distance, where viewing is impossible. High contrast, large-print signs and labeling, carefully designed displays, and good lighting are essential. It is important to note that older people may need twice the lighting that younger people with average vision need. While we must attempt to avoid glare, brighter lighting is needed at stairs or turning points along a path.

Information desks and other sources of audible information are most useful for all visually impaired persons. Descriptive audio cassettes can provide self-guided tours while describing significant features of objects that may be hard to examine through glass display cases. A vision-impaired person's experience and appreciation of an object is enhanced by exploring it through touch.

Hearing Impairments

People with hearing impairments have great difficulty communicating with others and receiving audible information. Those with partial hearing may depend on hearing aids. Others rely on sign language, writing, or lip reading. Carpeting and other soft surfaces can significantly improve the acoustic environment by keeping reverberation and other confusing background noises to a minimum. Auditory signals such as fire alarms and announcements on public-address systems cannot be heard by deaf people and must be supple-

mented with visual information, especially in the case of emergency warnings.

DEXTERITY IMPAIRMENTS

People with dexterity impairments include those with amputated arms, hands, or fingers; those with upper-spinal-cord injuries; and the increasing number of people who experience difficulty because of arthritis or rheumatism. For these people, gripping, twisting the hand at the wrist, and fine finger coordination may be impossible. The "closed fist" rule (it must be possible to turn on a faucet or open a door with a closed fist) has been developed to remind designers of the needs of this population. Lever hardware on doors and lavatories, large buttons on vending machines and elevator controls, and large rocker switches (instead of small wall switches) are examples of controls that the vast majority of the population is able to use with independence and dignity.

AGING

Older people not only are more likely to have multiple impairments, but are subject to accidents and falls that frequently result in injuries or additional temporary impairments. Stairs are the most common cause of falls.

LEGISLATION AND CODES

Architectural Barriers Act (1968)

In 1968 Congress passed landmark legislation that signaled the beginning of mandated access in the public buildings of the United States. The Architectural Barriers Act stated that any building or facility with any federally funded construction must be designed to be accessible to the disabled. All public construction, whether new or renovation, was to be designed to be accessible from that time on.

Section 504 of the Rehabilitation Act (1973)

In 1973 Congress went further and required access to all federally funded programs. Section 504 of the Rehabilitation Act is the most important national legislation concerning accessibility to federally funded cultural facilities. The National Endowment for the Arts' *The Arts and 504-a 504 Handbook* states that the federal law does not "require access to every area of a

museum. . . . Instead, portions of programs and facilities will suffice, provided that disabled people have an equal opportunity to the organization's program offerings when viewed in their entirety." Section 504 references the *Uniform Federal Accessibility Standards* (UFAS) for design guidance.[2] In addition, designers should look to their local building codes and the access guidelines of the Americans with Disabilities Act to determine the most restrictive criteria. Because disabled persons can often suggest effective and inexpensive ways to design for accessibility, forming an advisory committee of persons with various kinds of disabilities to help plan and evaluate museum programs and activities is highly recommended.

Americans with Disabilities Act (1990)

In 1990 Congress passed the most far-reaching of its regulations to date, extending the guarantee of accessibility as a basic civil right to all people in all places of public accommodation. For the first time, the mandate of accessibility extended to private buildings that are open to the public. The Americans with Disabilities Act (ADA) requires immediate modifications to correct accessibility problems that are "readily achievable." It also requires all new construction (and any renovation) to be designed and built in accordance with the *Americans with Disabilities Act Accessibility Guidelines* (ADAAG).

Building Codes or Construction Standards

All these laws cite a set of construction standards as the means of accomplishing accessibility. The basic standard is the American National Standards Institute's (ANSI) A117.1. This standard, first published in 1961, gives detailed information on how to design a building so that it can be used by disabled and older people. ANSI A117.1, in its current version, is used as the basis of all federal, national, and state building codes. The most important of these are the *Uniform Federal Accessibility Standards* and the *Americans with Disabilities Act Accessibility Guidelines*. These regulations differ from ANSI A117.1 in one important way: they specify the number of elements or spaces that must be made accessible, whereas ANSI only describes how to go about making the space or element accessible. Architects and designers must be familiar with ANSI, UFAS, and ADAAG.

ACCESSIBLE OR UNIVERSAL DESIGN

Universal design is a revolutionary but practical leap forward in the evolution of design. It is a way of designing spaces and products at little or no extra cost so they are both attractive and functional for *all* people, regardless of age or

disability. The intent is to remove the "special" label and eliminate the institutional appearance of many current accessible designs. Improved design standards, better information, new products, and lower costs have made it possible for design professionals to begin designing all buildings, interiors, and products to be usable by everyone, instead of responding only to the minimum demands of laws that require a few special features for disabled people. Universal design is a concept that makes economic and social sense. By incorporating the basic access features and universally designed products and elements into the building design, a variety of users will be guaranteed accessibility over the life of a facility and throughout their own lives.

The concept of universal design has become widely accepted with the adoption of the ANSI standards by over thirty-five states and with the adoption of uniform accessibility standards by the federal government. As a result, almost all building codes now reference common design standards, and universality of details is becoming commonplace. This uniformity makes it possible for designers to apply one set of minimum technical requirements to all their design projects. It also makes it possible for product manufacturers to produce larger runs of lower-cost products that can be marketed across the country.

Accessibility is not only a law, but also an important consideration for safety and for audience development. Further, universal designers find that design that is good for disabled people is also safer and easier to use for the entire population. Disabled people can be expected to be among a museum's board, employees, and volunteers, as well as visitors. In a world of limited human and fiscal resources, it makes eminent sense to open museum doors to everyone. To ignore these populations not only violates the law, wastes money, and limits potential, but also denies millions of citizens the opportunities to experience our nation's vast cultural wealth.

Since the early 1960s, much has been learned about how to achieve accessible design in a cost-effective manner. Studies have shown that access features integrated into the early concept stages of the design of new facilities increase costs by less than .5 percent on most projects. The key is early planning. Universal-design concepts will make the most impact if included in the initial basic planning and conceptualization of the process. They should then be applied and considered during the conceptual-design, plan-development, product-specification, and design-documentation stages.

Products must be carefully considered, too, for their ease of use, such as appropriate door hardware for people with arthritis and low-nap carpet for those who use wheelchairs. When it is impossible to select universal products or details, it is important to provide a variety of options to allow people with different abilities to use the service or product. Pay telephones are an example of a product that cannot be positioned at a height that is accessible to all individuals. Therefore, if a bank of public telephones is provided, it is desir-

able to mount them at various heights to accommodate wheelchair users, short people, and children, as well as taller standing adults.

The focus is inclusion and access with dignity. For example, wheelchair seating should be integrated into assembly areas by removing two seats along the aisles. The space must be 30 inches by 60 inches and level, enabling the audience member to sit with companions. Stage and backstage areas must be wheelchair accessible as well.

Technological advances in modern electronics are making universally designed products economically feasible. Infrared listening systems, remote alarms, wireless devices, and computers open up unlimited possibilities for communicating information to people with all types of perception abilities. In today's society, it will always cost more to build a few special and different features than to mass-produce them to be usable by everyone.

Program Evaluation

Once the new facility or space has been built, it is important that museum staff take the final step and evaluate plans for setting up exhibitions and presenting information. It is extremely important at this phase to work with a committee of knowledgeable people to evaluate the accessibility of museum programs. This committee must include not only museum staff, but also people with various disabilities. This approach has been shown to be the most cost-effective way of planning and evaluating programs and services. Several of the publications listed in the bibliography discuss proven methods of effectively using such advisory committees.

As with any audience-development effort, including disabled and older people in the program and facility planning and evaluation process can improve significantly the quality of the museum experience. By adopting universal design, museums will not only comply with the law, but also be able to offer all visitors an easier, more informative and enjoyable experience. As our population continues to change and grow, the universally designed museum will be valued and vital for years to come.

NOTES

1. This appendix makes extensive use of material from Ruth Hall Lusher and Ronald L. Mace, "Design for Physical and Mental Disabilities," in *The Encyclopedia of Architecture* (New York: Wiley, 1989). The author wishes to thank the publisher and authors for permission to use material from their work in this effort to further the accessibility of museums throughout the world.

2. The Architectural and Transportation Barriers Compliance Board, an independent federal agency, is a major resource for accessibility solutions, materials, and information (including free copies of the *Uniform Federal Accessibility Standards* [UFAS] and the *Americans with Disabilities Act Accessibility Guidelines*). They are available from the

board, 1111 18th Street NW, Suite 501, Washington, D.C. 20036; (800) 872-2253 (phone VOICE/TDD).

BIBLIOGRAPHY

Adaptive Environments Center. *Access Improvements Workbook: Help for Facility Managers in Preparing Capital Budget Requests.* Boston: Adaptive Environments Center, 1986.

> Step-by step planning guide created for use in Massachusetts state facilities to provide accessibility for people with disabilities. Explicit information concerning architectural features (doorways, elevators, signs, bathrooms) makes it broadly applicable for institutional use. Includes a facility survey and cost-estimate forms. Not a code manual.

American National Standards Institute. *American National Standard for Buildings and Facilities: Providing Accessibility to Usability for Physically Handicapped People.* New York: American National Standards Institute, 1986.

> Basic illustrated technical standards on which all other building codes, guidebooks, and technical manuals are based.

Americans with Disabilities Act Accessibility Guidelines (ADAAG). Washington, D.C., 1991.

> Accessibility standards for new construction and alterations in places of public accommodation and commercial facilities, as required by the Americans with Disabilities Act (1990). The guidelines ensure that facilities are accessible to and usable by individuals with disabilities in terms of architecture, design, and communication.

Battaglia, David. *The Impact of the Americans with Disabilities Act on Historic Structures.* Washington, D.C.: National Trust for Historic Preservation, 1991.

> Discusses the impact of the Americans with Disabilities Act on historic resources and reviews how a number of organizations have taken innovative approaches to preserving the past while making it accessible to everyone.

Bowe, Frank. *Rehabilitating America: Toward Independence for Disabled and Elderly People.* New York: Harper & Row, 1980.

> Explores what society must do to make it possible for older and disabled people to function productively and creatively. Includes a bibliography.

Bureau of the Census. *Disability, Functional Limitation and Health Insurance Coverage 1984/85.* Series P-70, no. 8. Washington, D.C.: Government Printing Office, 1986.

> Data and information about people with disabilities based on the Survey of Income and Program Participation conducted from May to August 1984. Provides social, economic, and insurance statistics on the 37 million people with functional limitations, out of the population of 181 million noninstitutionalized individuals age fifteen and older.

Department of the Interior, Special Programs and Populations. *Accommodation of Disabled Visitors at Historic Sites in the National Park System.* Washington, D.C.: Government Printing Office, 1983.

> Suggests ways to resolve problems concerning differences between the needs of disabled visitors and preserving the integrity of historic sites. Includes many pho-

tographs and drawings, worksheets, case studies, a list of access devices and suppliers, excerpts from pertinent laws and regulations, and a bibliography.

General Services Administration, Department of Defense, Department of Housing and Urban Development, U.S. Postal Service. *Uniform Federal Accessibility Standards.* Washington, D.C.: Government Printing Office, 1985.

Sets standards for facility accessibility by physically disabled persons for federal and federally funded facilities. Includes copy of the Architectural Barriers Act (Public Law 90-480) of August 12, 1968, as amended through 1984.

Grinder, Alison L., and E. Sue McCoy. *The Good Guide: A Sourcebook for Interpreters, Docents and Tour Guides.* Scottsdale, Ariz.: Ironwood, 1985.

An all-inclusive manual that provides background on learning processes and application of learning theories to museum touring, as well as details of the training of guides in all kinds of museums. Sections devoted to touring for older adults as well as disabled visitors. Includes bibliographies with each chapter.

Groff, Gerda, with Laura Gardner. Photos by Oraien E. Catedge. *What Museum Guides Need to Know.* Access for Blind and Visually Impaired Visitors, 1989.

How to make facilities and programs readily available to blind and visually impaired people, including a training outline for museum professionals, a bibliography on art and museum access for blind and visually impaired people, and guidelines for preparing large-print, braille, and cassette materials.

Kenney, Alice B. "Museums from a Wheelchair." *Museum News* 53, no. 4 (December 1974): 14–17.

Still timely in its down-to-earth suggestions concerning exhibition installation and graphics from the point of view of a visitor in a wheelchair. Reminds museums of the need for collaboration between themselves and community organizations representing disabled people.

Lifchez, Raymond, et al. *Getting There: A Guide to Accessibility for Your Facility.* Sacramento: California Department of Rehabilitation, 1979.

Ways to achieve better physical accessibility in existing facilities; procedures for evaluation, establishing priorities, and considering both physical and social/attitudinal aspects. Includes cost estimates, which, although they must be adjusted for current cost levels, are still helpful. Appendix includes bibliography.

Majewski, Janice. *Part of Your General Public Is Disabled: A Handbook for Guides in Museums, Zoos, and Historic Houses.* Washington, D.C.: Smithsonian Institution Press, 1974.

An informative manual and companion video, with full descriptions of mental and physical disabilities, that, along with suggestions as to attitudes and techniques, provide sufficient information to make the inclusion of disabled people in regular museum tours an ordinary occurrence. Includes a list of resource agencies and a bibliography.

National Endowment for the Arts. *The Arts and 504-a 504 Handbook for Accessible Arts Programming.* Washington, D.C.: Government Printing Office, 1985.

Clear and concise explanations of the endowment's 504 Regulations and descriptions of various approaches to access through design, audience development, and staff training. Discusses specific arts disciplines—the visual arts, performing arts, literary, media, and design arts. Marginal notes suggest publications, films, and organizations pertinent to the subject matter.

Walker, Lou Ann, and Nancy Rosenblatt Richner. *Museum Accessibility for Hearing-Impaired People*. New York: Museum of Modern Art, 1983.

Report on a project that involved bringing deaf and hearing-impaired persons into ongoing museum programs. Museums range from The Museum of Modern Art to The New York Zoological Society to The New York Botanical Garden. Evaluations and recommendations for starting a similar project.

APPENDIX B
PERFORMANCE CRITERIA

Thinking of the art museum in terms of a highly technical machine may help the client address difficult technical issues early in the planning process. The machine-like functions of the building have a significant impact on its design. If ignored, they may result in design modifications that affect the aesthetics of the museum. The client must convey to the architect, generally in the architectural program, the performance criteria necessary to meet the physical needs of the collection and to ensure the safe operation of the museum. Specifications can be stated in quantitative terms—light levels, temperature, relative humidity, and air quality—or in terms of needs, qualitative or specific. These specifications will vary from institution to institution; in the absence of guidance from the museum, the architect will have to rely on building codes, published industry standards, or experience to set parameters, which may or may not be sufficient for the needs of a particular collection or museum.

ENVIRONMENTAL CONTROL

Establishing performance criteria for the museum environment is a balancing act from the beginning. The conditions best suited for the preservation of the collection are weighed against the comfort of staff and visitors. The climate and site, and the well-being of the building itself, must be considered, especially in the case of an existing or a historical structure, which may be threatened by the very conditions that best safeguard a collection. Costs must also be factored in, and actual costs include not only the initial expense for equipment but also the life-cycle costs of maintenance and operation.

Relative Humidity and Temperature

Although we tend to think of collections in terms of their curatorial divisions, the temperature and humidity requirements for objects within each department can vary greatly. Research has shown that of the two values, relative humidity is the more critical for the preservation of objects. All organic substances seek a state of equilibrium with the relative humidity of their environment. Below 35 percent at room temperature, objects tend to dry out, shrink, or become brittle. At high relative humidities, above 65 percent, they may swell. Paper can stain, soluble glues may weaken, and mold can appear. Changes in temperature cause expansion and contraction of heat-conducting materials such as metals. Heat can also desiccate organic materials and raise the rate of chemical activity by a factor of two for every increase of 18°F. However, moderate variations in temperature may not be deleterious as long as the relative humidity is stable.

An exercise that has proved useful to many museums has been to class objects by categories of sensitivity. The number or percentage of objects in each department can then be charted on a matrix. The result may suggest certain strategies for the design of storage and exhibition areas. While appropriate categories may vary from institution to institution, the following guidelines from the Royal Ontario Museum are given as an example of one possible method.[1] The same exercise, using light as a category of sensitivity, is useful in determining appropriate light levels (see Appendix D).

Group I: Objects able to tolerate variable conditions
 Ceramics, unpolychromed stone and marble, gold, silver, stable glass
RH 25 percent winter minimum, 50 percent summer maximum, ± 10 percent RH daily
Temp. 70°F to 76°F

Group II: Objects that require stable conditions
 Organic materials, paintings on canvas, wood furniture, polychromed wood, cellulosic materials, paper, books, textiles and costumes, leather, parchment, bone, ivory (including miniature paintings)
RH 35 percent winter minimum, 50 percent summer maximum, ± 6 percent RH daily
Temp. 70°F to 76°F
(Some conservators recommend tighter tolerances than does the Royal Ontario Museum for relative humidity, suggesting a range of 35 to 45 percent RH with only a 2 percent variation.)

Group III: Objects that require extremely stable conditions
 Inlaid, gilded and lacquered furniture, wooden musical instru-

ments, panel paintings on wood, icons, illuminated manuscripts, Japanese screens

RH 50 percent ± 2 percent daily
Temp. 70°F to 76°F

Group IV: Objects that require dry conditions
 Iron and steel, archeological bronze, unstable or iridescent glass, textiles with metal attachments
RH 20 percent minimum, 35 percent maximum
Temp. 70°F to 76°F

Group V: Objects that require cool conditions
 Fur and fur-trimmed garments, birdskin garments
RH 30 percent ± 5 percent
Temp. 40°F

Micro-Climates and Buffering

Traditionally, the burden of providing an appropriate environment has been placed on the mechanical systems, which have not always been up to the task. Once the conservation analysis has revealed the array of sensitivities, the number of objects actually requiring stringent conditions may be fewer than anticipated. If this is the case, the systems may be designed to less exacting standards. An object requiring precise controls can be accommodated in a micro-climate—that is, an air-tight container or case that resists environmental swings in the immediate surroundings. For example, in a gallery of oil paintings, one or two panel paintings might be accommodated in a special case with internal climate control. On a larger scale, if a number of objects that would be exhibited together is substantially different as a group from other parts of the collection, its gallery or galleries might be segregated into a discrete heating, ventilation, and air-conditioning (HVAC) zone (in much the same way as conservatories that have desert houses and tropical houses). Chinese garments might be shown in a gallery next to, but in a different HVAC zone from, related bronzes.

 Micro-climates in the form of sealed storage cabinets for wrapped or boxed objects can be considered for storage to provide added stability. By locating storage areas carefully within the building, it is possible to take advantage of passive buffering. The spaces on the perimeter of a building are more likely to be affected by weather changes than those buried deep in the interior. Sensitive objects can in this way be given micro-environments, rather than making the whole building a macro-climate.

Maintaining Environmental Control

The axiom that the ideal climate is 72°F ± 2° and 50 percent RH ± 5 percent has in recent years come into question because, although it may represent an ideal, it has proved difficult and expensive to sustain in many museums. Contained spaces, such as interior storage rooms, may not pose a problem, but areas on the perimeter of the building and areas subject to opening doors, large crowds, or exhibition lighting may be difficult to control.

The mechanical systems that provide critical conditions are often less than perfect. Humidity sensors are often inaccurate and the systems slow to react. Existing buildings may have multiple systems that have been installed over many years. Changing use patterns and remodeling create additional problems, even for the best of systems. Settings and the actual operation of the systems may be inaccurate and incorrect. Tight standards that may be impossible or too expensive to meet reasonably often lead to dissatisfaction and frustration. Also, many museums work against their systems' effectiveness by not operating and maintaining them correctly.

Strict environmental standards may have consequences for buildings, especially older, masonry buildings in cold climates. Moisture migration through the walls of buildings results when there is a difference of humidity and temperature between the interior and the exterior at different times of the year. During the winter, condensation (and even ice) may form as the warm, moist air of the interior permeates the wall encountering the cold, dry air outside. The reverse happens in hot weather when the HVAC system is in its air-conditioning, dehumidifying mode. The moisture in the exterior air meets cool, dry surfaces inside and causes condensation inside the building. The problem is exacerbated when a positive air pressure is established inside to prevent outside polluted air from penetrating into the filtered environment. Heavy insulation in walls and attics, double or triple glazing, and vapor barriers are used to buffer the building. Unfortunately, an absolutely impermeable vapor barrier is difficult to achieve, especially as a retrofit in an existing building, and if not absolutely airtight it can itself cause damage.

Some museums have, therefore, set standards that allow for seasonal variations. For example, from The Art Institute of Chicago's program:

> The desired settings are: 68°F temperature and 40% relative humidity in the winter and 75°F temperature and 50% relative humidity in summer. Fluctuations should be held to a minimum, especially for relative humidity, with maximum variation in the range of plus or minus 3° and 3% from desired settings. The change from winter to summer settings and vice versa shall be gradual over a period of months. The Special Exhibit area may require maintenance of 50% relative humidity in winter for selected exhibits. Special requirements for higher or lower settings will be handled within a sealed case or specially equipped room. Some exceptions are noted on the detailed room requirement sheets.

The J. Paul Getty Museum in southern California has a far less brutal climate to deal with, but its criteria also allow for controlled fluctuations:

> [T]he basic need is for highly filtered air maintained constantly at (1) a control temperature of 70 degrees Fahrenheit, never ranging lower than 68 degrees or higher than 72 degrees and never varying by more than 2 degrees in any 24 hour period, and (2) a relative humidity of 55%, never going below 48% nor higher than 62% and never varying by more than 3% over any 24 hour period or 5% in any 72 hour period.

Air Quality

Indoor pollutants come from a variety of sources: the building materials, the mechanical systems, human occupants, the objects themselves, and the intrusion of outside air.

Building Materials

New concrete is usually alkaline and, although dry to the touch, requires time to cure and release its moisture. Chemicals used in the manufacture of many common building materials—plywood and insulation, for example—can be the source of formaldehyde. Interior finishes, as well as the sealing and adhesive substances used with carpets and wall coverings, may also emit noxious gases. A minimum period of sixty to ninety days with HVAC systems in full operation is generally recommended to purge interior spaces of construction residuals.

Heating, Ventilation, and Air-Conditioning (HVAC) Systems

Much indoor air pollution, gaseous and particulate, is delivered by ventilating systems. Without filtering, sulfur dioxide (SO_2), nitrogen oxides (NO_x), and ozone (O_3) can reach high enough concentrations to affect collections seriously. If not vented properly, solvents used in conservation laboratories and workshops may find their way into other parts of the building. Anticorrosive chemicals used in the steam lines of the central plant can be extremely deleterious to objects. Deposits of dust, soot, tobacco smoke, and even lint from visitors' clothing can accumulate with amazing rapidity if not effectively filtered.

Outdoor Pollution

As many museums forsake their parkland sites in favor of downtown locations, collections become increasingly subject to industrial and automobile emissions. Smog is a problem for many museums in urban settings; the placement of air intakes should be carefully considered.

There seems to be a relative consensus in recently published standards for air quality, although exact specifications and suggested methods may vary.[2] Filtration of air-borne particulates is specified in terms of efficiency and size—for example, 80 percent efficiency for 1-micron particle size. The re-

moval of gaseous pollutants is somewhat at the mercy of the best technology available, although nitrogen oxides, sulfur dioxide, and ozone are the chemicals most often considered deleterious. In general, particulate filters are screens or meshes placed across an air stream to catch air-borne dirt. To remove gaseous contaminants, filtering materials are placed in chambers or trays in the path of the air. Simple activated carbon, potassium permanganate, or other catalytic and oxidizing media are used. Water washes may be effective but are often a maintenance problem. Maintenance is an important consideration in the design of any system, as the ease of checking and replacing filters is crucial to the system's efficiency.

ACOUSTICS

A serious effort should be made during design and construction to reduce and control the noise generated by the building and its eventual occupants. The very nature of museum spaces, the intensive HVAC systems, and the multiplicity of functions and activities that take place in museums add up to potentially noisy buildings. In the absence of standards dictating decibel levels for galleries and other areas of museums, the client needs to address the problem of acoustics with the architects and engineers. In some instances, acoustical consultants may be sought for special situations, such as auditorium design.

Noise can be controlled by three factors: the reduction of noise generated by equipment and its installation, the use of materials and construction methods to reduce the transmission of noise, and the use of sound isolation to reduce the transmission of noise from spaces where noise is unavoidable.

The more rigid the connections of the building parts, the greater the sound transmission. Noise can spread through large areas of a building and is apt to be amplified by the "sounding-board effect." Air-borne sound can change direction easily and can be heard for long distances, such as through ventilating ducts or hallways. Noise from an impact overhead will be louder than noise generated by machines a long distance away because the former transmits energy directly, while the latter emits waves into a much larger network. Thus control is more effective at the point of generation than at the point of reception.

Room Acoustics

When sound hits a wall or another room surface, it is variously reflected and absorbed, and a small amount is transmitted to adjacent rooms. Hard surfaces, such as plaster walls, reflect much of the sound they receive. Ceilings may further echo, amplify, and reverberate. Sound reflection and impact

noise are typical from hard floors. Sound absorption, on the other hand, is a function of the porosity, density, and thickness of the material itself, as well as its method of installation. Thus a gallery wall covered with canvas attached to intermediate frames will absorb a great deal of sound. But absorption is greatly reduced if the porosity of the material is compromised (painting acoustic tile, for example). Using resilient flooring materials, floating the floor itself on sleepers (intermittent supports), and suspending ceilings help to reduce noise. In general, noise reduction is best achieved when all room surfaces are treated approximately equally.

Sound isolation between rooms can often be achieved with common sense and careful planning and may be less costly than containing the noise disruption by physical barriers. Rooms such as children's activity areas may generate high voice levels to the horizontally adjoining spaces as well as impact noises to spaces below, so their relationship to adjacent spaces should be considered carefully. Restaurants are the source of a number of sounds—voices, clanking dishes and silverware, and kitchen noises. Physical or acoustical isolation of an auditorium or a lecture room is necessary for the sake of both the audience and those in areas adjacent to the auditorium. One strategy is to look for the possibility of using quiet or unoccupied spaces, such as storage areas or corridors, as buffers.

Mechanical Systems

All the various components of mechanical systems make noise, and unfortunately they are located throughout the building: air-conditioning and air-handling units, fans, compressors, cooling towers, ductwork, and so on. Plumbing may transmit pump noise for long distances. Elevators, escalators, and freight elevators also add noise to a building. Generally, the more power something consumes, the noisier it is.

Machine noise, both air-borne and structure-borne, is the result of vibration. To control machine noise, vibration itself may be reduced by the design and configuration of the machine and its various components. The mechanical-equipment room can be soundproofed with the machinery mounted on resilient supports. Connections (pipes, ducts) to the machinery should be flexible so as not to conduct vibration.

The air turbulence within ducts creates noise and increases with velocity. The longer the run of the duct, the higher the required air speed. The lowest possible velocity is therefore desirable but may necessitate a larger duct size. The design and layout of the ducts, such as smooth transitions where ducts change size and large radius turns where there are bends, can help reduce noise. (Unfortunately, the larger the duct system, the more it tends to take up usable space.) Although ducts with runs of greater than fifty to sixty feet are sometimes lined to control noise, lining should not be required if the ducts

are sized properly and fan noise is diminished. In addition, a damping material may be glued onto the outside of the duct to prevent the thin metal from resonating. The fans may also need silencers or mufflers, as the ducts will transmit the noise their motors produce.

Electrical Equipment

Transformers and fluorescent-lamp ballasts can be the source of low-frequency noise that is difficult to reduce. Transformers should not be located near or immediately outside quiet areas. They should be mounted on vibration isolators, on as large a slab as possible. Flexible conduit connections should be used. Roof-mounted HVAC equipment may be economical, but may also be noisy due to vibration, short duct runs, and sound reflection off other surfaces.

The buzz of fluorescent and high-intensity discharge lamps can be annoying, especially when such lamps are used in quiet areas such as libraries or offices. The effect can be particularly unpleasant when a large number of lamps are banked together, such as above a laylight in a gallery, and the sound is magnified. Solutions include installing absorptive materials in the sealed architectural spaces (plenums) and using resilient mounting devices and flexible conduit. Aging ballasts should be replaced.

Building Site and Landscape

Outdoor noise sources, such as traffic and mechanical systems or the cooling towers of nearby buildings, can be an intrusion. Careful siting of a building might take advantage of noise barriers in the natural terrain, such as thickly wooded areas. A hollow or depression might be avoided. The building's configuration may reduce or enhance noise problems; for example, a U-shaped or central courtyard, while aesthetically pleasing, might form an echo chamber. Where exterior noise cannot be avoided, quiet areas of the building can be protected from exterior noise by interposing less sensitive functions between them and the offending source.

WEIGHT LOADS

It is the responsibility of the architect and engineers to see that the building supports its own weight (dead load) and that of the occupants and contents (live load). It is incumbent on the client, however, to inform the designers if there are any extraordinary objects, such as heavy sculpture, that must be accommodated. If a piece is to be permanently installed, the floor in the immediate area may need to be specially supported. However, if a piece is to move, every point along its potential path has to be considered, as well as the

strength and durability of the flooring material over which it will move. The weight of the forklift used to move it must be factored in as well. Forklifts, jacks, and hydraulic ladders are notorious for concentrating enormous amounts of weight on small wheels (high point loads). They may wreak havoc on floors and stress elevators, even though the stated weight capacity may be sufficient. If flexibility of installation is desired or many heavy pieces are involved, a higher load specification may be required for a large area of the museum. If objects are to be densely housed in storage, the load factor there should also be considered.

Related to special weight concerns are those of size. Ceiling and door heights must be sufficient to allow for the clearance of very large paintings, but a very high door from a storage or loading area is essentially useless if somewhere between it and the gallery there is even one standard-height interior door. A hallway may have a high ceiling, but if it is narrow and it makes a turn, there may not be enough turning radius for a large painting. Although ceiling heights are usually stated, it is important to allow for actual headroom after ductwork is installed. It is therefore necessary to make sure that dimensions are understood to be "clear." And the determining dimension may not be obvious—the diagonal of the door or cab of a freight elevator is often the operative figure. In addition, the dimensions of carts and dollies must always be considered.

ELECTRICAL LOADS

The electrical loads for any building include lighting, miscellaneous power (outlets, small motors), HVAC, plumbing, elevators, kitchen, and special equipment. The electrical engineer may assume loads based on industry charts, thereby possibly underpowering the museum (a potentially dangerous situation) unless its special requirements are recognized. For the engineer to get an accurate idea of the number and size of the circuits necessary, the kinds of lighting and the light levels in the galleries must be determined. Possibly more difficult to predict, but just as important, are the other power needs. Workshops often use 220 volts, and some equipment requires special wiring, such as charge-ups for battery-operated lifts. Dust-collection systems and compressors may have to be accommodated. Flexible outlet grids may also be desired. Exterior lighting must also not be forgotten.

Probably the toughest task of all is to estimate future needs. One rule of thumb is to multiply by two all estimates of future needs.

PLUMBING

Depending on occupancy and building size, the building codes will indicate the minimum number of restrooms. However, adequate accommodations for

staff also need to be considered, in addition to public facilities. The client must specify special requirements, such as darkrooms or sinks and water fountains in children's educational areas. Janitors' closets with slop sinks are often forgotten or eliminated.

The greatest concern to the museum is the position of plumbing relative to collection areas. It may be desirable to require that all pipes carrying water be segregated in central cores and never run over exhibition, storage, or conservation areas.

NOTES

1. Royal Ontario Museum, *In Search of the Black Box* (Toronto: Royal Ontario Museum, 1978), p. 37.
2. Garry Thomson, *The Museum Environment,* 2nd ed. (London: Butterworth, 1986), pp. 130–62.

APPENDIX C
CLIMATE CONTROL

No other aspect of constructing and occupying a new museum causes as much consternation as the mechanical system—its design, cost, and operation. There are many variables concerning building character and composition, climate, occupancy, available technologies, and economics, all of which are further compounded by the functional and preservation demands of a museum.

One of the first decisions made during schematic design is the siting of the building. The perimeter of the building will be most affected by the geographical location, climate, orientation, and specific site conditions, such as the amount of shade or exposure to wind. The south side of a building can be hotter in February than its north side is in July. The amount of glazing in skylights and windows, and the orientation—north, east, south, or west—of the windows and doors will have a tremendous effect on the heat load of the building. Although the perimeter can be a major source of heat gain, it is only through the perimeter that heat is lost. The interior will also gain heat from lights, electrical equipment, and people. Areas characterized by different conditions can exist within the same structure.

The wide variety of activities typical of museums places contradictory demands on the climate-control system. A storage area that is dark and virtually unoccupied, except for an occasional staff member, is a very different problem for the heating, ventilation, and air conditioning (HVAC) system than a gallery full of visitors where track lights are on all day and thus are generating heat. Even within one gallery, conditions change drastically between day and night. Varying the height of ceilings will cause different conditions of stratification, the multiple layers of air at graduated tem-

peratures. The rearrangement of walls or partitions in temporary galleries often interrupts the air-distribution systems, creating pockets or interfering with thermostats. Lobbies and entries may be subject to the influx of outside air as people move through doors. And it is often in the lobbies and other public, non-gallery areas where large amounts of glass are present. Furthermore, the temperature and relative-humidity range best suited for many objects is not comfortable for people.

CLIMATE CONTROL

Climate control is defined as the maintenance within prescribed limits of a number of atmospheric factors: temperature, relative humidity, particulates (including organic, such as pollen and bacteria), gaseous pollutants and odors, air motion and pattern, and noise and vibration.

To meet the specifications set for temperature and relative humidity, four interrelated operations are necessary: heating, cooling, humidifying, and dehumidifying. Any system should be designed to meet the challenge of the unusual, if infrequent, extremes in weather, as well as the swing seasons of spring and fall when conditions can vary widely day to day. The design of the distribution system—sheet-metal ducts or sealed architectural spaces (plenums) in combination with fans, supply registers, and return grilles—determines air-movement characteristics. Filters of various types take care of pollutants. Noise and vibration, the by-products of mechanical action and air movement, must always be countered. (Standards for each aspect of these systems are discussed in Appendix B.)

CLIMATE-CONTROL SYSTEMS

There are four basic types of climate-control systems: all-air, air–water, all-water, and direct refrigerant. Each has certain functional and economic attributes that make it suitable for specific applications, but the all-air system, in one of its several variations, is most often employed in current art museum construction.

In an all-air system, air is the medium of heat transfer between the central station (mechanical room) and the rooms or zones it serves. Beginning at the central station, the air is heated or cooled, humidity controlled, mixed with fresh air, and filtered, before it moves through the distribution system and is delivered to the zone by way of the supply registers. It is exhausted through the return grilles and sent back to the central station, where the cycle begins again. Although the configuration and order of events may differ, the various systems rely on similar components. The central station is assisted by air

handlers, which also contain coils for additional heating and cooling. The humidity is increased by injecting steam or water into the moving air and is decreased when the air passes through a cooling coil, condensing the moisture out. (The resulting temperature drop is usually then countered with a reheat phase.) Filtering is accomplished in two ways. To catch particulates, screens or bags made of permeable mesh are placed in the airstream. Gaseous pollutants are removed when they pass over trays of chemicals, such as activated carbon or potassium permanganate. The air is delivered to the conditioned spaces or zones by way of sheet-metal ducts or sealed architectural spaces behind walls or under floors. The air enters the room through supply registers, is exhausted through return grilles, and then returned to the central station, where it is usually mixed with some amount of fresh air. Automatic sensors in the ducts and rooms measure temperature and relative humidity and adjust the fans, dampers, and valves that regulate and control the system.

Single Duct, Variable Air Volume (VAV)

Depending on the weather and indoor conditions, the central air station supplies either a heated or a cooled stream of air at normal velocity. As the needs in a zone change, the volume of air delivered is adjusted at the terminal diffuser. If the central station is supplying cold air and a zone needs more cooling, it will receive more air. An unoccupied room having no heat gain, or one with a loss through a perimeter wall, will get less air.

The VAV system works well for buildings that tend to have interior heat loads that require cooling. Exterior rooms in cold climates are often zoned by exposure. Because it relies on a single-duct system, the VAV system requires less space than does a system with separate cool-air and warm-air ducts. It is also often chosen for reasons of economy.

Single Duct with Reheat

Similar to the VAV in that it uses one distribution tree, this system consolidates all the major equipment at the central station, with the exception of small reheat coils added to the ducts near the rooms or zones. The air supplied by the central station must be cold enough to meet the cooling demand of the hottest zone. The other zones then must reheat the air to meet their needs, which often proves to be expensive.

Double Duct, Constant Air Volume (CAV)

The CAV system requires a very large, space-consuming distribution tree because two sets of ducts are used: one for heating and the other for cooling. Although at the height of the summer only the cooling component may be

needed (and vice versa during the winter), most of the time the two airstreams work in tandem, being custom mixed at the air terminal in each zone. Control is achieved because both temperature and air volume can be adjusted. This is true especially for stable, reduced-load areas, such as collection-storage areas, where CAV is often recommended. Although the most flexible system because of its ability to maintain varying humidity requirements, its disadvantages are high installation and operating costs, as well as the considerable size of the ductwork.

Multizone Systems

Multizone systems deliver an individually mixed airstream to each zone through a central air-handling apparatus. Each zone thus requires its own delivery duct system, although the return system may be collective. Functions that have similar heating and cooling needs are theoretically grouped into separate HVAC zones. The building's configuration is thus an important determinant of the efficiency and cost of multizone systems. This is the least flexible of the four systems, and, once established, it is almost impossible to change without major reconstruction.

DECISION MAKING

The mechanical system, of which HVAC is a major component, can account for as much as 40 percent of the cost of a museum. It is vital that the client carefully evaluate the benefits of the various approaches as well as the corresponding price tags. The choice of the systems will have to be made on the basis of a number of considerations: initial and life-cycle costs (operating and maintenance); appropriateness for type of occupancy; amount of area required for equipment, ducts, and so on; reliability and maintenance; accuracy and simplicity of control; and building codes.

Discussions about technical issues must begin during programming. The museum must have not only a clear idea of what it expects the mechanical systems to do, but also a realistic sense of what they can do. There are technological limitations that may be difficult, if not impossible, to overcome. For example, standard temperature sensors are quite accurate, while those for relative humidity typically are not. With that said, there are new electronic sensors on the market that can be used in very sensitive areas, such as prints and drawings storage. They may, however, be too accurate, causing the machinery to cycle on and off so frequently as to cause minor but nonetheless excessive temperature and humidity changes.

Arrangement of spaces that make sense from a museological or functional point of view may prove to be at cross purposes environmentally. Overcomplicated systems are costly not only to run, but also in terms of the space that they require.

APPENDIX D
LIGHTING

PLANNING FOR LIGHTING

Good museum lighting is a partnership of art, science, and engineering, as it integrates the aesthetic and preservation needs of the collection, the form and character of the building, and the technical systems of the building. From the earliest stages of planning, even before design begins, decisions must be made about lighting. Proper illumination is not just a matter of equipment and light levels; or it goes to the heart of the museum experience. Light, being both sensual and emotional, is central to the perception of a work of art. The quality of the light in a gallery is determined not only by its source, but also by the character and configuration of the space, the way the light strikes the objects and the architecture (being variously absorbed and reflected), and the way it is received by the mind and eye of the viewer.

Achieving consistent and pleasing visibility is a complex task. The amount, distribution, color, direction, and movement of the light contribute to visibility. The eye goes to the brightest spot in its field. It follows, then, that the painting should be brighter than the wall, the picture-hanging zone of the wall brighter than the area above or below, and the wall brighter than the floor. A 3:1 ratio is enough to attract attention; a 10:1 ratio will accentuate.

CONSERVATION CONCERNS

Damage from improper lighting can take many forms—fading, embrittlement, differential expansion and contraction, cracking, and drying. Such damage can be caused by the amount of light falling on an object, the duration of the exposure, and the spectral components of that light.

Visible light is a small segment on the spectrum of radiant energy, ranging from approximately 380 to 760 nanometers. Ultraviolet and infrared rays are produced by the sun and various artificial light sources but do not aid in visibility. They are deleterious to works of art, so they should be eliminated. Ultraviolet rays are responsible for most photochemical damage—that is, chemical change induced by light. They can be filtered at the fixture or the window or skylight. The effect of the level of illumination and the duration of exposure combine to set recommended maximum levels for various materials depending on their sensitivity to light.

The only way to ascertain light levels is with a light meter. The eye is not reliable because it perceives the light reflected off objects, not the light falling on them. Inexpensive meters are available that are fairly reliable, although they tend to be less accurate at the lower levels. The American unit of measurement is the footcandle. Because many of the standards for light levels were established in Europe, the "lux" is used there. A footcandle is the equivalent of approximately ten lux. When making measurements, the light cell of the meter must be held parallel to the surface being checked (vertically for a painting, horizontally for a table top.) The entire surface of an object should be scanned for hot spots. Measurements should also be taken throughout a room, as well as at different times of the day and year if natural light is admitted, and always after rearranging the lighting or relamping.

Higher ratios may be dramatic but require the eye to adjust, since it tends to adapt to the average viewing conditions in its field. Too much brightness contrast causes shadows that can be overly dense and impenetrable. Too much light falling on a painting can obscure details. Diffuse light, which is omnidirectional, fills the shadows and softens highlights. Diffuse ambient light gives a smooth overall wash to walls and floors.

Just as the eye adjusts to brightness, it adapts to the color of the light and comes to perceive the colors of objects or surfaces as being constant. But changes in color, such as between cool daylight and warm incandescent, can be very noticeable. Color rendering is a function of the distribution and amount of the wavelengths present in the light, not its relative "coolness" or "warmness." If a color is absent in the light source, it can never be seen in the object, even though that color may be apparent in the object under other sources.

Maximum Light Levels

In his book *The Museum Environment,* Garry Thomson groups categories of art according to their sensitivity to light and makes recommendations about the introduction of natural light into the gallery environment.[1] His work is the source of the following information on light levels and the intensity of daylight.

Group I: Objects especially sensitive to light
Textiles, costumes, watercolors, tapestries, prints and drawings, manuscripts, miniatures, distemper, gouache, dyed leather, wallpaper, most natural-history exhibits, botanical specimens, fur, feathers
Maximum illuminance: 5 footcandles (50 lux)
Ultraviolet radiation: 75 microwatts/lumen

Group II: Objects less sensitive to light
Oil paintings, tempera paintings, undyed leather, horn, bone and ivory, Oriental lacquer
Maximum illuminance: 20 footcandles (200 lux)
Ultraviolet radiation: 75 microwatts/lumen

Group III: Objects insensitive to light
Metal, stone, glass, ceramics, jewelry, enamel
Maximum illuminance: 30 footcandles (300 lux)
Ultraviolet radiation: 75 microwatts/lumen
(Although these objects can take higher levels, such illumination may produce excessive heat. A limit of 30 footcandles may also be desirable to keep within the ranges of easy eye adaptability between galleries.)

NATURAL LIGHT

Consideration should be given to whether artificial lighting will predominate or whether the introduction of daylight is aesthetically and economically feasible. Both have planning consequences, but daylight is the more complex issue.

Daylight, whether bright or dim, always offers a continuous spectral curve, meaning that it can reveal all colors in works of art. Natural light changes constantly with the time of day. The involuntary muscular action of the pupils in the eye, constantly readjusting to these changes, helps ward off fatigue and keeps the viewer more alert. Buildings that admit daylight usually also allow glimpses of the outside, which are refreshing and can aid in orientation.

There are also disadvantages to admitting daylight into museums. In northern latitudes, high levels on a sunny day with fluffy clouds can easily reach 2,000 footcandles, but a painting inside might have an allowable limit of only 20 footcandles. Conversely, the gloom of a gray winter afternoon can pervade the galleries. Even on the dreariest days, natural light can be damaging to works of art and must be filtered and controlled.

If daylight is desirable, a number of questions must be addressed. What are

the implications for building orientation and site planning? How will daylight affect the functional program? How will it be integrated with artificial lighting? How will the transitions between daylit and artificially lit spaces be handled? What is the impact of natural and artificial lighting on heating and cooling systems, and what will be the subsequent energy requirements? How will the subdisciplines—structural, mechanical, even landscaping—accommodate the daylight? How can it be assured that all technical solutions will be within the environmental tolerances set for the preservation of collections? Finally, what function is light intended to perform within each space: provide ambient lighting, illuminate hanging surfaces, allow views to the exterior, act as a focal point, provide drama?

Technical and Design Considerations for Daylighting

The availability of daylight varies with latitude, season, weather, time of day, and local conditions, such as orientation of site, pollution, and surrounding features. On a clear day, light comes not only from direct sunlight but also from blue sky and reflections from the ground and other objects. A partially cloudy sky will still provide direct light, but it will change constantly. An overcast day provides relatively stable, uniform light. The design of a building must respond to the predominant conditions of a particular site, while still providing for variations. The strategies usually employed to accomplish this are to design for maximum conditions allowable for collections and to screen out excess, or to design for minimum exterior or seasonal conditions and to supplement with artificial sources.

The design response to the site conditions and goals of the daylighting program are seen first in the form and massing of the building. During design, the problem of how the apertures through walls and roofs are to relate to the building form is explored simultaneously with how the massing can be arranged to provide opportunities for light to enter. Some control will invariably be necessary to reduce or redirect light. Light-control devices can be exterior, interior, integral to the glass itself, or a combination of all three.

Top-Lighting

The quality and quantity of light admitted into a building is determined not only by the size of openings and any filtering or shading devices, but also by the position of openings. Skylights provide the most abundant light relative to the size of the opening. They are usually considered for use in single-story buildings or for the top floor of multistory buildings, but they can be combined with light wells and plenums to bring light down into lower stories.

While skylights may reduce electrical consumption by eliminating some of the need for artificial light, they may also either add to the heat load (a possible advantage in cold weather, but a clear disadvantage in the air-

conditioning season) or lose some building heat. Whether skylights are economically feasible depends on a year-round climatic analysis and proper engineering, utilizing heat-transfer controls. Condensation and leaks often plague skylights, pointing to the need for careful installation and vigilant maintenance.

The penetration of direct sunlight into spaces containing vulnerable works of art is usually prevented by a system of louvers and by filtering or diffusing media. Because ordinary window glass absorbs only part of the ultraviolet rays in daylight, specially treated glass or acrylic is usually employed. Louvers can be designed to reduce or redirect light and may be exterior or interior, fixed or movable. The simplest are fixed louvers, which are most successful in areas with relatively constant sky conditions, but, if carefully engineered, they can also be satisfactory where seasonal or weather variations are pronounced. To meet changing conditions, elaborate systems have been developed for museums using photoelectric cells and computers. Objections have been voiced concerning their complexity and high rate of mechanical failure, their cost, and their tendency to be in almost constant motion, responding to every passing cloud. Manually adjustable louvers are a compromise between the intricacies of automatic systems and the inflexibility of fixed louvers. They can be adjusted as necessary or set seasonally.

Many galleries combine skylights with a flat, translucent ceiling, or laylight, which further reduces the amount of natural light entering the space. The laylight evens out the shadows cast by the louvers above it and helps diffuse light. It may also be designed to redirect the light.

Artificial-lighting systems are usually integrated with laylights, often taking the form of supplemental floodlights above or point-source lighting below. Tracks can be incorporated into the design of the laylight to provide spotlighting or additional wall washing. Like the skylights above them, laylights can be a maintenance headache because of leaks and accumulation of dirt, which is often distressingly visible from below. They can also be responsible for glare, as they are usually perceived as being very bright.

There is an inherent problem with trying to illuminate pictures with natural light from above. Without thoughtful intervention, more light will reach the floor than the vertical surfaces where it is needed. Louvers and diffusers can be used to help redirect and reduce the light, but often top-lighting is combined with a manipulation of ceiling and upper wall surfaces to make the entire room cavity act as a reflector, bouncing light off several surfaces to help diffuse and soften it. Coves, vaults, and coffers help to mediate between the brightness of the overhead source and that of the wall. The colors and materials of interior surfaces can also help to mitigate another problem encountered with skylights—gloom. A by-product of the reduction of light levels mandated by conservation concerns, gloom often afflicts top-lit galleries in the winter or when heavily tinted glass has been used in the skylight to

reduce incoming light. Artificial lights may be necessary to combat the dreariness.

Light monitors or lanterns, alternatives to skylights, also admit light from above and have the advantage of using vertical panes of glass mounted with standard, weatherproof window-installation methods. They are easier to maintain than skylights, being less likely to leak. They can be oriented to maximize or minimize heat gain and to admit or block sunlight. The shape of the monitor is often designed to bounce light around before it enters the space. Like skylights, monitors may be used in tandem with louvers, diffusers, and artificial sources.

Side-Lighting

Clerestory windows have most of the advantages of skylights but are exposed to less light. When combined with exterior features, such as light shelves, clerestories can deliver abundant light deep into a room. Their efficiency is further increased when light is bounced off the ceiling. A direct view of the sky can be blocked with louvers or baffles. Because they are high on the wall, clerestories do not reduce the amount of hanging space.

While windows are useful in providing a view to the exterior, they can produce an uncomfortable contrast between exterior brightness and the adjacent interior surfaces, although deep or splayed jambs can help soften the contrast. A screening device is usually necessary to reduce the amount of entering light. This is especially true for large areas that are effectively "window walls." Special glass, incorporating mesh of various densities, is available, as are many shading materials. Conventional shutters and Venetian blinds can be quite effective at blocking out the glare of the sky while allowing light reflected from the ground to enter. (Both must be secured in the desired positions, as visitors invariably adjust them.) If possible, the outside surface of the shading device should be treated with a reflective coating. Caution must be exercised to be sure that the device does not impart a color to the light entering the gallery.

If windows are glazed with very dark tinted or reflective glass, brightness-contrast problems may result, and the advantages of daylight (the "sparkle") may be lost. In this case, clear glass combined with a shading device may be preferable. Double-paned glass, which incorporates a screening material between the layers, is also available. Glazing materials that filter ultraviolet light are available for exterior and interior use. Films can be applied to existing windows, but they may be susceptible to condensation.

ARTIFICIAL LIGHT

Daylight, as the great "form-giver of architecture," is at its best illuminating and enlivening to the overall museum environment. Accent lighting for individual objects, exhibits, and cases will probably have to be accomplished

with artificial light. The artificial system will have to carry the full burden, of course, at night and in museums where there is no natural light. In addition, electric lights of various types are used in most work areas, for security, and for night lights.

Artificial light is in many ways the antithesis of daylight. It is constant and predictable. With a track system, it can be rearranged at will to suit a particular need or exhibition. It is much easier to control and limit and can be designed to deliver even light and good visibility no matter what the time of day or the outside conditions. But it can also skew color, lower or heighten contrast, or manipulate emotional effects. As with daylight, planning goals must always be balanced by conservation goals.

Incandescents

The mainstay for most gallery applications are tungsten lamps. They have good color-rendering capabilities, even at low levels, and come in a variety of wattages and forms, such as "Rs" (or reflector) made of seamless blown glass and "PARs" (parabolic aluminized reflector) made of pressed glass. Beam spreads vary from spots to floods. They can be controlled with dimmers to lower light levels, which also increases lamp life. (Choosing the appropriate wattage is a better method of controlling light levels than dimming, because the color of the beam gets redder as the lamp is dimmed.) Although incandescents do not emit a significant amount of ultraviolet rays, they do produce a great deal of heat and are therefore inefficient from an energy standpoint. Besides the thermal heat generated at the fixture, incandescents also emanate infrared heat, which warms the objects on which they are focused. Infrared can be reduced with filters. Dichroic reflector, or cool-beam, lamps, which direct much of the heat out the back of the fixture, can also be used where infrared heat may be a problem.

Tungsten-halogen lamps are sometimes called "quartz-iodine" lamps because the envelope surrounding the filament is made of quartz rather than glass. As such, a glass filter should be used to reduce ultraviolet rays.

Low-voltage lamps do not run on line voltage, so they require a transformer to step down to 5.5 or 12 volts. They produce less heat and a tighter beam spread, and are not as warm in color as standard R and PAR lamps. The larger low-voltage lamps can throw a tight beam from a long distance, so they are useful for high ceiling mounting. Although the lamps and fixtures are expensive, they are more energy efficient and are less taxing on the air-conditioning system, characteristics that make low-voltage lamps attractive.

Fluorescents

By the very nature of the way they produce visible light, fluorescent lamps emit large quantities of ultraviolet rays. Although low-UV tubes are avail-

able, ordinary tubes can be filtered with UF-3 sleeves. However, they are prone to light leaks at the ends and must not be confused with ordinary (nonfiltering) industrial sleeves used to prevent mechanical damage.

Fluorescents have limited use for display in art museums because, in addition to conservation concerns, they produce a diffuse, flat light that tends to obscure details in three-dimensional objects. Although they come in a number of types, such as cool white and warm white, they do not have good color-rendering abilities. One great advantage, however, is that they do not produce much heat, so they are sometimes used for in-case illumination. Because they are inexpensive and have long lamplife, they are the most common light sources for offices and utility areas.

High-Intensity Discharge Lamps

Mercury and metal-halide lamps produce great quantities of ultraviolet rays. Although color-corrected versions are often used in department stores, their color-rendering abilities are not up to museum standards. They should be avoided for most museum applications. However, high-pressure sodium-vapor lamps produce virtually no ultraviolet rays. They are cool and efficient to operate. Installed in an indirect fixture—that is, one that bounces light up off the ceiling—they can be used economically in service areas and even in storage rooms where good color rendering is unnecessary.

Track Systems and Mounting

Unless the lighting system is integral to the ceiling system—for example, as part of a coffer arrangement or in recessed down-lights—tracks are commonly installed to carry lighting fixtures because they provide great flexibility. They can be mounted in almost any configuration, although overuse, coupled with too many fixtures, can lead to a cluttered effect.

Energy Conservation

The electrical load drawn by artificial lighting can be considerable and must be figured carefully by the electrical engineer. If primarily incandescent, the lights will also add substantially to the heat load of the building, probably requiring extra air conditioning. Although energy conservation is always a desirable goal, in some localities it is legally mandated. Such guidelines can have a considerable effect on lighting choices and on operating projections.

PREDICTING THE EFFECT OF LIGHTING SCHEMES
Daylight

Solar data are available for every part of the country. Predictions can be made for the behavior of light relative to its entrance into the building. For example,

the angle of the sun on the winter solstice can be established to check how far into a room the sun will penetrate. The size and height of windows may then be adjusted to prevent light from hitting the walls.

The use of scale models is an invaluable tool for developing concepts and evaluating the results when designing a daylight system. No drawing or calculation can equal a scale model in revealing the quality and distribution of light. The model need not be elaborate; it can, in fact, be quite crude, but it must be large enough in scale to accommodate a light meter or test probe. The surface textures, colors, and reflectance values should match as closely as possible those being contemplated. The apertures of the model should be glazed with proposed materials as well.

As good as a model may be in predicting the behavior of a lighting scheme, there is no substitute for a full-size mock-up, which should be used if at all possible. Being able to stand in the light and respond to its qualities as it illuminates a real painting is a different order of experience from a scale-model prediction. The mock-up can be fine-tuned if necessary before actual construction begins, when any such modification would be much more costly.

Artificial Light

Lamp and fixture manufacturers provide photometry charts (usually found in the back of catalogues) that predict footcandle levels at various distances and angles to the wall. They are based on laboratory testing so are approximations of real performance. Experience and some testing with a light meter will provide more accurate data. It is important to remember that it is the type of lamp itself that determines its beam characteristics, not the design or shape of the fixture (assuming, of course, that the fixture does not have a lens or other accessory). A cylinder or sphere connects the lamp equally well to the power source, although one might be preferred for its particular appearance.

As important as selecting the right lamp is its placement relative to the object it is illuminating. As a general rule, two-dimensional works of art are lit at a 60-degree (from horizontal) angle. A steeper angle will produce frame shadows; a lower angle, glare. The plasticity of three-dimensional objects is best accentuated at a 45-degree angle. To check the placement of tracks or fixed-lighting positions, the distance from the wall as indicated on the drawing of the reflected ceiling plan should be plotted on the ceiling, as shown on the section drawing of the gallery. A protractor will then give a reading of the size of the angle.

NOTE

1. Garry Thomson, *The Museum Environment*, 2nd ed. (London: Butterworth, 1986), p. 23.

APPENDIX E
FIRE PROTECTION

Fire protection is not simply a matter of hoses and hardware; it involves architectural, mechanical, plumbing, and electrical systems, as well as the establishment of and adherence to fire-prevention practices. Many diverse concerns, from the selection of the site to the choice of construction materials, safety practices on the job site, and staff training, contribute to the ultimate safety of the museum.[1]

THE PRINCIPLES OF FIRE PROTECTION

The quick and efficient detection, containment, notification, and suppression of a fire are the objectives of any program. A variety of approaches and systems can be used, but no one standard will be technically and economically appropriate for every collection, every building, or even every part of a given building.

When designing a new museum, specifications should call for fire-resistive construction as opposed to noncombustible or ordinary construction-grade materials. Compartmentation of the building by the use of fire walls and fire doors substantially helps confine fires and provides safe areas of refuge for personnel. Smoke and hot gases rise, so special precautions must be taken to segregate enclosed stairwells, elevator shafts, pipe chases, ducts, and other vertical openings through floors. Conversely, any water used to fight a fire will descend, so spaces where one may expect a fire to originate should not be placed on the floor directly above or below highly sensitive areas. (A restaurant kitchen should not be above a collection-storage area, for example.)

Horizontally, the problem is not only the adjacency of incompatible functions, but also the ventilation system itself, a prime mover of fire and its by-products. Death or human injury and physical damage to the building and its contents often occur far from the actual site of the fire from smoke traveling through the ventilating system. Consequently, its layout must be carefully examined in the design stages. While current building codes may require "shut downs" on heating, ventilating, and cooling equipment and incorporation of fire dampers within some areas of ductwork, few require automated smoke dampers to minimize the risk of smoke moving from one area of the building to another.

Occupancy and the "combustible loading" of a space help determine the amount of fire protection required by current building codes. As assembly occupancies, museums are generally classified as light-hazard buildings; that is, the quantity or combustibility of the contents is assumed to be low, and fires with relatively low rates of heat release are expected. However, the reality of the modern museum is that it often houses within the same envelope many functions of widely varying susceptibility to fire. Conservation laboratories, loading docks, and workshops, for example, constitute extra hazards. The combustible loading of a collection-storage area may be very high. The concentration of values of irreplaceable works of art or artifacts in storage, holding, or preparatory areas will likely require extra precautions, such as rated enclosures, lighting only from enclosed fixtures, and inclusion of both fire-detection and fire-suppression systems.

FIRE-DETECTION AND FIRE-ALARM SYSTEMS

Because the first five minutes of a fire are more important than the next five hours, immediate identification of the existence of a fire and notification of the fire department are imperative. Manual pull stations should be provided in both work and public areas to sound the building evacuation alarm. Automatic fire detectors are recommended in all areas, especially in those housing valuable collections or hazardous operations. (These are usually installed on the ceiling.) Heat detectors are least expensive and least prone to nuisance or false alarms, but a fire may be well developed before they are triggered. Ionization smoke detectors, which are sensitive to the invisible products of combustion, are used to indicate the existence of a fire in its incipient stage, even before smoke or flames are visible. Photoelectric smoke detectors respond better to smoldering fires generating smoke. Smoke detectors may also respond to extraneous air-borne matter—such as dust, insects, and solvent vapors—and send a false alarm. Flame detectors, which respond to infrared or ultraviolet light rays, are best used where little smoke is expected to be generated or in large spaces where smoke may never reach the ceiling.

Any fire-alarm system should audibly and visually notify building occupants so that emergency measures may be taken to notify the fire department, extinguish the fire, evacuate the building, or take other appropriate action. Fire-alarm systems can be designed to perform a number of functions—close fire doors, operate dampers in ventilating ducts, and shut down power supplies to hazardous operations, for example. Last, systems should not only alert a central security-control station within the museum but also be wired directly to the fire station or private twenty-four-hour control station outside the museum.

FIRE-EXTINGUISHING SYSTEMS

Automatic fire-suppression systems are designed to control or extinguish fires while they are still small with minimal damage. They disperse a fire-extinguishing agent—water, gas, or chemical—chosen in relation to location, risk factor, and the nature of the potential combustible. Dry chemicals and high-expansion foams can be corrosive to some objects and leave a residue that is difficult to clean up. Carbon dioxide, while inert, is a threat to human life because of oxygen deprivation and is usually not well suited for extinguishing ordinary combustibles. At present, water or Halon gas systems are usually the only appropriate choices for a museum.

Sprinklers

There are three basic types of sprinkler systems: wet pipe, dry pipe, and preaction. They are all piping networks (usually overhead) connected to a reliable water source. Attached to these pipes are sprinkler heads activated individually by heat to release water directly onto the fire. Sprinkler heads may be upright, pendant, or sidewall-mounted and are equipped with either a fusible link or a glass bulb filled with liquid. When heated, the liquid expands, breaking the glass, or the fusible link melts away, allowing water to flow through the head. Heads are available that activate at temperatures ranging from 135° to 650°F. Depending on the occupancy hazard classification, each head will cover a specified number of square feet, most likely 100 or 140 square feet in a museum. On–off sprinkler heads automatically shut off the water as soon as the temperature drops to normal, thereby significantly reducing the potential for water damage.

Wet-Pipe System
The simplest, cheapest, and most reliable sprinkler system, the wet-pipe system is always filled with water under pressure. When a head opens, water is immediately dispersed onto the fire. Because of the presence of water above

spaces containing collections and the possibility of accidently damaging a head, wet-pipe systems may be cause for concern in many museum installations. However, this type of sprinkler system has an excellent safety record, due in part to its strict installation and testing standards. Most museums that have sprinkler systems utilize the wet-pipe system.

Dry-Pipe System

In the dry-pipe system, the pipes are filled with air under pressure rather than water. When a head activates, air pressure within the pipe drops and a valve opens, allowing water to flow into the pipe and out through the activated head. This system is most commonly used in areas subject to freezing. In a dry-pipe system, there is a greater likelihood of more heads being activated than in a wet-pipe system, thus increasing the potential for fire-related and water damage.

Preaction System

As in the dry-pipe system, pipes in the preaction system are filled with air, which may or may not be pressurized, but the valve allowing water to flow into the pipes is activated by a separate fire-detection system. This independent system must be triggered first in order to open the valve and convert the normally dry system to a wet system. Even when the system has filled with water, none is released until the individual heads are activated by heat buildup directly under them.

Halon

Halon 1310 is an odorless, colorless, electrically nonconductive gas that is extremely effective in extinguishing fires by interfering with the chemical process of combustion. As the gas itself poses no chemical threat to objects, Halon is often the fire-extinguishing system of choice where collections are present. However, Halon systems are expensive, and to be effective they require well-sealed spaces. They are, therefore, usually considered for discrete areas, such as vaults and small storage rooms. A concentration of only 5 to 7 percent is necessary to stop most combustion. Below 7 percent, it is safe for people to remain in the area during discharge, but above a concentration of 10 percent, it can be deadly. Halon discharge nozzles must be located carefully because the force with which the Halon is expelled is quite powerful and may blow small, light objects off shelves or damage pieces in its path. Halon, unfortunately, is a chlorofluorocarbon (CFC) and is a particularly serious threat to the ozone layer. The United States has signed the Montreal Protocol on Substances that Deplete the Ozone Layers, which limits future production of Halon to 1986 levels, but the U.S. Environmental Protection Agency is requiring that Halon be phased out no later than the year 2000. Several replacement gases are being tested, and they may be available before Halon is banned.

A museum professional contemplating fire-protection systems should always think first of the needs of the collection. However, building codes mandated by law are intended to ensure that minimum levels of safety are provided for life safety first, property protection second, and, last, the minimum disruption of normal business. A conflict may arise when the system that is supposed to protect irreplaceable works of art is seen as a potential threat in and of itself. This is pointedly true of sprinkler systems, since a loss due to water damage is regarded by some as being as devastating as one due to fire. Realistically, one must bear in mind that artworks damaged by water are usually salvageable; those damaged by fire never are.

One possible strategy is to seek a compromise with building-code requirements by proposing a different but equivalent means of protection. For example, if by alternative construction methods or building configuration, it can be shown that a particular design meets or exceeds the level of fire resistance and protection required by code, a variance may be granted. Some locales are more lenient than others, and museums in the past have been successful in appealing. However, it is also not uncommon that proposed construction alternatives prove to be prohibitively expensive.

In determining whether a fire-suppression system should be installed, the choice must balance two sets of risks. The first is the omnipresent possibility of a malfunction, either from a false alarm or from poor design and workmanship. As mentioned earlier, the safety performance of sprinkler systems is excellent, virtually unequaled in the world of mechanical systems. Unfortunately, the same cannot be said for Halon, as some one-quarter of the museums using it have reported accidental discharges. Redundancy can help reduce unwarranted activation. For example, in the case of a Halon preaction sprinkler system, fire detection should be cross zoned. That is to say, two detectors on separate zones would have to go off before Halon would be released. If only one device malfunctioned, it could not set the release sequence in motion. It goes without saying that regardless of the system chosen, proper installation and testing are essential. Properly installed, tested, and maintained systems should be virtually trouble free.

The other major risk that must be evaluated is the damage that will likely be sustained if the fire department must fight a fire where no automatic system exists. A sprinkler head typically delivers 15 to 20 gallons of water a minute to the area of the fire; a fire hose delivers 250 gallons, with great force and not necessarily directly on the fire. When a fire struck the attic of the Franklin D. Roosevelt house in Hyde Park, New York, in 1982, far more damage was caused by water than by fire: to evacuate the tons of water poured into the structure, holes had to be chopped through the floors, inundating the lower, uninvolved stories. (The only fire where there is no water

damage at all is one in which there is total loss due to fire.) Time is a crucial factor as well. By the time the fire fighters are on the scene, even if they are summoned directly by the detection and alarm system, extensive smoke damage may have occurred and the fire spread well beyond its origin. Once again, the first five minutes are more important than the next five hours.

Fire risks may be reduced drastically (but never eliminated completely) by instituting strict policies regarding staff activities. If no heat-producing or electrical equipment is allowed in storage areas, save that essential for shelving and retrieving objects, the risk of fire there is minimal. Objects stored in closed metal cabinets are at less risk from both fire and water than those kept in the open. Safety training and fire drills should be routine, as well as regular inspections of electrical and mechanical systems. Emergency procedures for evacuating people and objects should be planned and practiced.

It is also important to consider fire-suppression systems in institutions to which a museum is lending works of art. While there are no consistent guidelines or policies among museums about the facilities of borrowing institutions, each must be aware of the conditions in borrowing facilities and make determinations based on its own standards and on its own insurance requirements.

NOTE

1. The National Fire Protection Association (whose standards are the basis for most building fire codes) publishes *Recommended Practice for the Protection of Museums and Museum Collections* (NFPA 911), an invaluable resource explaining the potential risks particular to museums. It also describes the various fire-detection and -suppression systems, suggests safety measures, and includes a sample self-inspection form. Other guidelines of interest to museums are *Protection of Libraries and Library Collections* (NFPA 910), *Protection of Historic Structures and Sites* (NFPA 913), and *Fire Protection in Rehabilitation of Historic Buildings* (NFPA 914). These publications are available from the National Fire Protection Association, Batterymarch Park, Quincy, Mass., 06669–9101; (800) 344-3555.

APPENDIX F
SECURITY AND LIFE SAFETY

Security implies safeguarding and protecting the collections, building, contents, property, staff, and visitors from theft, vandalism, safety hazards, fire (see Appendix E), and environmental hazards (see Appendix B).

A museum embarking on a building project must look carefully at its security needs and how the proposed project will affect them, in terms of both the design of the new building and its future operation. As with all technical issues, security must be addressed in the programming phase. Thinking of security as an "overlay" to design development or construction documents is a mistake that can prove to be expensive, even disastrous. Retrofits after occupancy are costly and never work as well as a properly integrated system, and more than one museum has had to increase its guard force substantially to make up for poor gallery layouts and ill-designed electronic systems. In addition, the museum must plan to maintain security during demolition and construction, when fire losses are most likely to occur, and during the move to a new facility, when artwork and equipment will be vulnerable to a number of threats.

PLANNING FOR SECURITY

Anticipated activities, public functions, occupancy schedules for the new building, and the "new way of doing business" must be identified because they all have a major impact on every aspect of design relating to security and life safety. The museum planners and staff as a whole should be aware that virtually every decision and choice will have some effect on the overall safety

of the building and its occupants and the continued operation of the institution. These include the choice of site and whether there is an adequate water supply for fire fighting, as well as the risks posed by geography and climate, such as earthquakes, fire, floods, landslides, tornados, and hurricanes, which may require special architectural responses. They also include the configuration of the building, which may be more or less vulnerable depending on its size and the number of openings on its perimeter. The interior layout will further determine the ease of surveillance: obscured sight lines may necessitate a larger guard force. The nature of adjacent structures must also be taken into account; for example, they cannot interfere with the museum's electronic equipment.

Operating modes and occupancy schedules of the staff, guard force, and public vary in the life of a museum, as does its reliance on electronic surveillance systems or security personnel. There is a direct relationship between operating modes and security needs, which, in turn, has implications for the arrangement of spaces in the building. The use of each space must be evaluated according to possible operating schedules: occupancy by staff and security personnel on a workday when the facility is closed to visitors; occupancy by staff, security, and the public; occupancy by security and the public on holidays and weekends with occasional staff present; and occupancy by security staff at night. Spaces with similar operational characteristics may best be grouped in one area of the building. A lecture room or an auditorium used after regular hours, for example, is probably best located near the perimeter. Rest rooms should be adjacent to it so the public does not need to travel through galleries to reach them, thereby requiring additional guards.

As plans are being developed by the architect, staff members and appropriate users should take imaginary walks through proposed spaces to help identify security lapses or problems. Especially sensitive activities, such as receiving and unpacking shipments for temporary exhibitions, should also be rehearsed. Any problems, such as obstructed views of the loading dock from the security station window, can be addressed in the design-development stage, before major design decisions have been made.

ASSESSING RISK

Regrettable though it may be, it is reasonable to assume that a museum will suffer some sort of vandalism, theft, accidental damage, extortion or ransom, fire, natural disaster, or crime against persons at some time during its existence. In order to best concentrate its security efforts and financial resources, the museum must first ascertain which events are most likely to occur and which could be associated with the greatest possible losses. Also, each space and activity must be evaluated relative to identified risks, and any risk assess-

ment must take into account the specialized nature of various collections. Factors such as probability of occurrence and the relative impact on the facility can be charted, and a list of priorities can then be established.

Identifying Threats

The first step is to list all the dangers to which the museum might be exposed. Categories might be natural hazards, (rainstorm, hurricane, tornado, lightning, blizzard, flash flood, earthquake, volcano, forest or range fire), physical malfunctions or mechanical failures (structural failure, explosion, air-conditioning failure, heating failure, water-supply failure, sprinkler-system malfunction, smoke generation or air pollution, leaks in roofs, windows, or doors), accidents (vehicular, machinery, injury to staff or visitors, damage to objects during transport, installation, or construction), violence (riot, civil disorder, insurrection and war, bombing, terrorist attack, robbery, theft, defacement, destruction of an object, disorderly conduct), and nonviolent crime (larceny, burglary, embezzlement, forgery, shoplifting, vandalism, graffiti, trespassing, pickpocketing).

Probability
Assessing the likelihood of a future event depends in part on whether it has occurred in the past and the likelihood of its recurring in the future. There is no guarantee that because an event has occurred, it will be repeated, or if it has not happened to date that it will not in the future. Most important, the more ways in which an event can happen, the more likely it is ultimately to occur.

Categories of probability should then be ranked and given a numerical correlation:

Virtually certain	100%
Highly likely	75–99%
Moderately likely	50–74%
Unlikely	20–49%
Highly unlikely	0–19%

Impact
The impact of a loss on operations depends on the museum's size, collections, staff, physical plant, financial status, and the like. An assessment of how critical the loss is can begin by determining its monetary value due to damage or destruction of property and its repair or replacement. Another index is the disruption an event would cause, from mild disruption to total curtailment of activities. However, intangibles such as loss of irreplaceable cultural patrimony and the ancillary effect on future visitation, staff morale, and public opinion should also be considered.

Disastrous	100%
Very serious	75–99%
Moderately serious	50–74%
Tolerable	20–49%
No effect or only minor	0–19%

Once the system has been established for ranking probability and impact, the relative hazards can be illustrated in chart form, rated, and ranked.

Potential event	Risk	%	Impact	%	Rating
Leaky pipe	Highly likely	75	Tolerable	25	1,875
Earthquake	Unlikely	5	Very serious	75	375
Fire	Improbable	20	Very serious	85	1,700
Shoplifting	Highly likely	80	Minor effect	2	160

The hypothetical example given in the chart indicates that fire and leaky pipes, while less devastating than an earthquake, probably pose the greater overall threat and therefore deserve more attention and resources in the security plan.[1]

PLANNING THE BUILDING

Building Codes

The size of a building and its occupancy classification, as well as its type of construction and whether it is to have a sprinkler system, will dictate the number of exits the local code and building officials will require. The number of exits, corridor widths and lengths, bearing capacity of walls and floors, mechanical requirements for electricity and plumbing, and so on are under code jurisdictions. While the codes are written to protect life and property, some of the specific requirements, such as the number and placement of exits, may work against securing a collection. A thorough analysis of local building codes should be undertaken during the preliminary design stage with reference to the functional program, future occupancies, and public programs. Plans should be evaluated at every stage to make sure they continue to comply with current codes.

Handicapped Accessibility and Amenities

For a full discussion of this topic, see Appendix A.

Security During Construction

Construction and renovation present great security dangers. Maintaining security during work can be a nightmare. Disruption and inconvenience are

daily events and may continue for months. Normal services, such as electricity and water, are often interrupted, disarming existing security systems. As work proceeds, collections in proximity to the work may be threatened by vibration, dust, and fumes and may have to be moved out of harm's way. The presence of construction workers and the nature of their work make it imperative that the museum require certain safety measures and set specific interim security policies and procedures.

NOTE

1. For more on this method of analysis, see J. L. Paulhus, "Planning for Safety and Security," in *Planning Our Museums,* ed. Barry Lord and Gail Dexter Lord (Ottawa: National Museums of Canada, 1983).

APPENDIX G
UNDERSTANDING DRAWINGS
AND MODELS

That cumbersome roll of drawings tucked under the arm of the architect or laid out across a sawhorse on the construction site can have a daunting effect on the client. The final set of drawings for a given project—actually a part of the contract documents—provides a collection of interrelated views and descriptions, both graphic and verbal, that represent in a very condensed and abstract form the future physical reality of a building. Produced during months of work, drawings are the key to the final results of a project. Everyone involved in the project must therefore understand them.

During the schematic-design phase, architects and designers use preliminary drawings, simple models, or renderings to study design problems and to communicate their ideas to the client in design presentations. Some representations are simple, even crude, while others are very detailed and polished. A simple white-cardboard model is often a great help to the client in visualizing spaces, but a more elaborate, larger model with color and realistic finishes is a powerful tool for public and fund-raising presentations, as are formal presentation drawings, such as a rendered and colored perspective of the exterior.

After the basic design ideas have been approved, the project moves into the design-development stage, where the defining elements, the spaces, the materials, and the systems—structural, mechanical, and electrical—are precisely established. Rooms become rooms, and dimensions are fixed; spatial relationships are settled. Issues raised during the previous stage are resolved—the use of daylight, the level of finish, the proportions of public or programmatic areas to support, and the like.

To participate meaningfully in the design and approval process and to communicate with the architect and contractor, it is imperative that the client understand drawings. Unfortunately, the language of architectural drawings is not purely visual, but conventional and specific to the building disciplines. Except for differences in style, drawings are executed in a relatively consistent way throughout the architectural profession. Classes in reading architectural drawings and in construction methods are available at community colleges and technical schools. Some museums have held their own classes, led by an architect or another design professional, for the board and staff. Particularly useful are tours of an existing building with plans in hand. The actual forms can then be compared with their two-dimensional representations.

The most familiar and basic representation is the floor plan—a horizontal slice of each story of the building that shows the arrangement of rooms, exterior and interior walls, and door and window openings. Although it can be taken anywhere, the cut is typically assumed to be about four feet off the floor so that it shows most of the significant features. The floor plan might also indicate items such as furniture, exhibition cases, and equipment. The complement to the floor plan is the section, a vertical slice showing the relationship of parts that stand side by side or one above the other. In a simple building, two sections—one through the longest dimension, the longitudinal section, and a transverse section—may be enough. For a building as complex as a museum, however, a number of sections will be necessary, and they will be taken wherever a special condition needs to be illustrated.

The actual character of the surfaces cut through in the plans and sections is described in elevations. Exterior elevations—at least one for each face of the building—give information about the massing, composition, height, and materials of the façades. Similarly, interior elevations show detailing of the walls and significant information such as the size and shape of doors and windows, which could only be suggested as an opening on the plans. Elevations often look distorted because they are not intended to be what the eye sees (that would, of course, be the perspective view, with its converging lines). They are flat projections with all planes pulled up to the front plane, which is assumed to be parallel to the paper and perpendicular to the viewer's line of sight. All surfaces not parallel to the drawing surface appear to be foreshortened; those that are parallel are true to size, shape, and proportion.

The way in which elements are represented in drawings is relatively standard. Basically, there is a hierarchy of lines combined with a set of symbols that may be self-explanatory or arbitrary, in which case they simply must be learned. Generally speaking, the heavier the line, the more dominant the feature. On a plan or section, for example, exterior walls will be heavy, thick lines; interior walls, thinner and lighter ones. Dashed lines represent ele-

ments that are not physically present where the cut is taken but that are significant, such as balconies or skylights. Other line styles, hatchings, or patterns are used to delineate different materials. In addition to those representing physical features, more lines, usually the thinnest and lightest of all, are used to give information, such as dimensions, or to indicate column grids.

The symbols that appear on drawings may be used to help lead the viewer to further information about a particular spot, or simply as a shorthand device. For example, circles or octagons with numbers appearing on floor plans usually refer to enlarged details or notes found elsewhere. The triangular symbols at either end of a line running across a floor plan refer to a particular section and, as important, point in the direction of whichever of the two possible views is intended. The arrow pointing up or down on a stairway indicates the direction from the level of that particular floor plan. In other instances, rather than laboriously drawing every interior elevation of every room, generic items such as switches and outlets will be shown as symbols on a plan (in this case, the electrical plan), possibly with notes indicating such information as height from the floor. Unfortunately for the client, each of the subdisciplines, such as electrical and plumbing, also has its own set of symbols and shorthand devices, but a key to such symbols is almost always provided.

The client must also understand the way a set of drawings is organized and how individual drawings interrelate. Usually the first drawing is a site plan, giving geographical and topographical information. The exact location of the building and how it is oriented relative to natural features and existing elements, such as roads and utilities, have implications for construction and legal issues, such as property boundaries, easements, and zoning. The drawing also illustrates the approach and entry sequences—the beginning of the museum experience for the visitors. Although much of what is shown on site plans is technical, the general aspects of the landscape may be indicated. The location of trees may be noted, and the shape of the terrain is illustrated by contour curves (the closer the lines, the steeper the slope). Although a wealth of information is contained on a site plan, the scale is usually rather small, as its purpose is to set the building in a larger context.

Following the site drawings are the architectural or design drawings, which explain the characteristics of the building—its size and shape, materials, finishes, and details represented and explained through plans, elevations, sections, details, and schedules (charts that list all the door sizes, wall finishes, or lighting fixtures, for example). Construction drawings, such as foundation and framing plans, show how things are to be put together. Engineering drawings by structural, mechanical, and electrical consultants delineate how all the building subsystems will be integrated. Drawings by other consultants dealing with issues such as lighting, security, and exhibition design will usually also be included in the master set.

Because no one drawing can give the full story of a particular detail or quality, different aspects may be explained on different sheets (sometimes coming from different specialists or consultants). For example, to determine the height of a doorway shown on a floor plan, the appropriate elevation or section must be found. If the opening is to have a door, the door schedule should list its dimensions and the type of design that has been specified. Checking for water pipes that run over exhibition or storage areas can be knotty, as plumbing and HVAC (heating, ventilation, and air conditioning) plans are often shown not as flat plans, but as very schematic, three-dimensional diagrams so that runs and drops can be shown simultaneously. To understand the lighting system in the galleries, the lighting designer's reflected ceiling plan ("reflected" because it is a mirror image and therefore has the same orientation as the floor plan below) should be checked. But the location of the switch panel will probably be shown on the electrical plan, and the number and size of the circuits may be listed elsewhere on the panelboard schedule. Unfortunately, there is no shortcut to understanding the drawings and no substitute for carefully studying them, reading the notes and schedules, and cross-referencing through the various sheets, cumbersome as this effort might be at times. If something is not clear, ask the project manager, architect, or engineer to explain it. The language of the drawings is a coded language that must be learned and practiced.

Visualizing the Building

The real challenge for the client is to visualize from the abstract lines and shapes on the drawings how the actual spaces and forms will look, how the spaces will relate to one another, and how big they will be. The scale of representation will always be indicated somewhere on the drawing, if only in the title block, when everything on a particular sheet is consistent. The greater the complexity, size, and need for clarity, the larger the scale. The scale of floor plans is often 1/8 inch = 1 foot or 1/4 inch = 1 foot, with details at a larger scale. Related drawings may or may not be at the same scale: an elevation may be shown at 1/8 inch = 1 foot, but the related floor plans and sections might be at 1/4 inch = 1 foot and 3/8 inch = 1 foot, respectively. It is not necessary to have an architect's scale to determine dimensions. A desk ruler or tape measure will do. For example, a distance that measures 4 3/4-inch long at 1/8 inch = 1 foot would be 38 feet. If the scale is indicated graphically by a bar graph similar to a scale of miles found on a road map, a quick tracing on a piece of scratch paper can make a handy measuring device.

Envisioning how big a physical space is from numerical dimensions is not always easy. By measuring or pacing off familiar spaces—an office or a gallery—mental modules can be formed that can be the basis for evaluating proposed spaces. Even better, if plans for existing spaces are available, study-

ing the correspondence between the plan and the actual space will help develop a sense of the representation of size and scale. The height of known spaces should be ascertained as well, because the feeling of size is related to volume, not just horizontal extension. A large room will always feel smaller if it has a low ceiling, and, conversely, a small room will feel less constricted if it has a high ceiling.

A floor plan itself can be confusing because what is shown horizontally is actually an opaque vertical surface and because the observer looking down on the drawing can see spaces and elements simultaneously that would never be revealed except by physically moving sequentially through the spaces. Therefore, a mental walk-through of a plan must be done with great self-discipline. The mind's eye must be made to stop at walls and only be allowed to see through intended openings. Index cards held upright in the position of the walls can help suggest the feeling of enclosure. As important as enclosure is the vista, especially in gallery and circulation areas. The mental walk-through should include a notation of what is seen at the end of each vista, such as another opening, or a specific area of a wall.

The size and configuration of spaces must be related realistically to the size of the objects in the collection. To ensure that passageways will be wide enough and turning radii sufficient to accommodate large art objects, simple paper models of the footprint of these works cut to the same scale as the plan can be moved across the drawing from loading dock to gallery to storage. Similarly, profile paper models can be used to check heights on elevations and sections.

MODELS

After all, nothing can take the place of a three-dimensional representation (save, perhaps, the full-scale mock-up), and models are therefore strongly recommended. Although presentation models are very expensive, less elaborate study models made of mat board or foam core can be perfectly effective and easily modified. At a scale of 1/2 inch = 1 foot, a model will be large enough to accommodate scale objects, perhaps made of paper or modeling clay (and little model people to help give a further sense of scale). What may have been unclear or overlooked in two dimensions may suddenly become apparent in three. But, as with floor plans, there is a tendency to look down into a model and see the horizontal plane (that is, the floor) instead of the walls. Removable walls can permit an eye-level view, as can a simple periscope made of a cardboard tube and hand mirrors. (A device called a Modelscope is available from art and drafting supply stores that can be attached to a camera.) For a client unsure about how building spaces will look, work, and feel, having a model is a wise investment, and if natural light is to be

admitted into the building, a professional daylight model is virtually indispensable. Made at a sufficiently large scale (3/4 inch = 1 foot), light-meter readings can be made and interpolated to predict actual light levels. Models are also enormously helpful in determining color, materials and surfaces, and level of finish.

CONTRACT DOCUMENTS

When the form of the building is approved, the architect produces construction drawings to show how the elements are to be built. They are often very technical and difficult for the layperson to understand, but along with a written compendium of specifications, they are part of the legal agreement with the contractor and subcontractors delineating exactly what will be constructed. They must be checked relentlessly by the client (usually at points of 40, 70, and 100 percent completion) to ensure that the building conforms to what was approved at the earlier stages of schematic and design development. Dimensions are apt to change as mechanical systems are fit into the envelope. (Ductwork always seems to take its toll.) Continuing code reviews and even changes in codes may require modifications that have a serious impact on the building.

Coordination of the drawings and specifications provided by the various specialists and consultants is extremely important, and someone representing the client (usually the project director) must take the responsibility for that task. Ultimately, oversights and mistakes in the working drawings will result in expensive change orders for the client.

One final set of drawings, not always seen by the client, is composed of shop drawings. They are not made by the architect but are submitted to the contractor and architect by the subcontractors and suppliers. They propose how the actual components will meet the architect's design requirements and specifications. In addition, material samples and sometimes full-scale mockups will be required for inspection before final approval is given.

At the beginning, with program in hand, the design process should open up as many options as possible. Many proposals may be considered before the optimal solution is found. But as the process moves forward, decisions of an increasingly specific nature have to be made. The ease with which the client can move through the various stages depends to a large extent on how well it understands what at first may seem like an alien world of strange marks, unfamiliar jargon, and indecipherable drawings. The more unknowns that can be eliminated from the process, the more smoothly it will proceed. Surprise may be the spice of life, but not when opening day is fast approaching, and no one knows quite what the gallery walls will look like, or if the centerpiece of the collection will fit through the doors of the loading dock.

SUMMARY
THE MUSEUM DESIGN
PROJECT SURVEY

Listed below are the twenty-one institutions that participated in a survey conducted by Liza Broudy between December 1988 and June 1989. The interviews took place either by telephone or through a site visit. All survey participants were sent a survey questionnaire before they were interviewed. Different questionnaires were prepared, in consultation with the Advisory Committee: for trustees and staff, for the architects, and for contractors and consultants. The objective of the survey was to identify key issues and problems encountered during the planning and building process and to understand these issues from the points of view of the various participants. Information gathered from the survey has been incorporated into the introduction, text, and appendixes.

We are immensely grateful to the institutions and individuals who so generously shared with us their experiences. The candor and thoughtfulness with which they responded to our many questions and requests represented not only a significant commitment in time but also a significant contribution to the museum field.

The individuals interviewed are identified below by the title they held at the time the interview took place. If they were no longer at the survey institution at the time of the interview, they are identified both by their title during that museum's project and by the position held at the time of the interview.

THE ART INSTITUTE OF CHICAGO
Chicago, Illinois

Renovation of West Wing 1987
Architect: Skidmore, Owings & Merrill

Construction of new addition 1988
Architect: Hammond, Beeby and Babka, Architects, Inc.

James H. Wood, Director
Katharine C. Lee, Assistant Director
Calvert Audrain, Assistant Vice President for Operations
Milo Naeve, Curator of American Arts
Lynn Springer Roberts, Curator, European Decorative Arts and
 Sculpture
Michael Turnbull, Staff Architect
Thomas H. Beeby, Architect

THE ART MUSEUM, PRINCETON UNIVERSITY
Princeton, New Jersey

Renovation of existing building and construction of new addition 1988
Architect: Mitchell/Giurgola Architects New York

Allen Rosenbaum, Director
Bruce Thompson, Mitchell/Giurgola Architects New York

BOISE ART MUSEUM
Boise, Idaho

Renovation of existing building and construction of new addition 1988
Architect: Mark Mack/Trout Young

Dennis O'Leary, Director
Patrick McMurray, President, Board of Trustees
Ray Hoobing, Contractor
Mark Mack, Architect
Steven Trout, Architect

THE BROOKLYN MUSEUM
Brooklyn, New York

Architect: Arata Isozaki & Associates/James Stewart Polshek and
 Partners

Joan Darragh, Vice Director for Planning
Claudine Brown, Assistant for Government and Community Relations
Linda S. Ferber, Chief Curator and Curator of American Paintings and
 Sculpture
Daniel Weidmann, Vice Director for Operations

THE CHRYSLER MUSEUM
Norfolk, Virginia

Renovation of existing building and construction of new addition 1988
Architect: Hartman-Cox Architects

David Steadman, Director

DALLAS MUSEUM OF ART
Dallas, Texas

New building 1984
Architect: Edward Larrabee Barnes Associates

Harry S. Parker, Former Director*
Steven A. Nash, Former Chief Curator†
Anne R. Bromberg, Curator of Education
Barney Delabano, Curator of Exhibitions
Vincent Carozza, President, Board of Trustees
Bill Austin, Contractor, J. W. Bateson & Company

EMORY UNIVERSITY MUSEUM OF ART AND ARCHAEOLOGY
Atlanta, Georgia

Renovation 1985
Architect: Michael Graves, Architect

Maxwell L. Anderson, Director
Clark Poling, Former Director and Professor of Art History, Emory
 University
John Howett, Professor and former Chairman, Art History Department,
 Emory University
Monique Seefried, Consultant Curator of Archaeology
Lori S. Iliff, Coordinator of Operations/Registrar
Karen Nichols, Michael Graves, Architect

HIGH MUSEUM OF ART
Atlanta, Georgia

New building 1983
Architect: Richard Meier & Partners

Gudmund Vigtel, Director
Peter P. Morrin, Former Curator of Twentieth-Century Art‡
Albert J. Bows, Chairman, Building Committee and Board of Trustees
Lawrence Gellerstedt III, General Contractor

J. PAUL GETTY CENTER
J. Paul Getty Museum
Malibu and Los Angeles, California

New building
Architect: Richard Meier & Partners

Stephen Roundtree, Director of Getty Trust Building Program

*Director, The Fine Arts Museums of San Francisco
†Associate Director and Chief Curator, The Fine Arts Museums of San Francisco
‡Director, J. B. Speed Art Museum, Louisville, Kentucky

Bret Waller, Associate Director for Education and Public Affairs
Deborah Gribbon, Associate Director for Curatorial Affairs

LAGUNA GLORIA ART MUSEUM
Austin, Texas
New building Not built
Architect: Venturi, Rauch & Scott Brown

Laurence D. Miller, Director
Sharon E. Greenhill, Director of Planning
Annette Carlozzi, Former Curator*
Sylvia Stevens, Museum Education Coordinator
Peter Mears, Preparator

THE MENIL COLLECTION
Houston, Texas
New building 1987
Architect: Renzo Piano, Atelier Piano/Richard Fitzgerald & Associates

Paul Winkler, Assistant Director
Renzo Piano, Architect

MONTGOMERY MUSEUM OF FINE ARTS
Montgomery, Alabama
New building 1988
Architect: Barganier McKee Sims Architects Associated

J. Brooks Joyner, Director
Grace M. Hanchrow, Assistant Director of Development
Margaret Lynn Ausfield, Curator
Tara Sartorius, Curator of Education
James Sigler, New Building Committee–City Administrator
Kenneth Bryan, Architect

MUSEUM OF ART
Fort Lauderdale, Florida
New building 1985
Architect: Edward Larrabee Barnes Associates

George S. Bolge, Director

THE MUSEUM OF CONTEMPORARY ART
Los Angeles, California
New building 1986
Architect: Arata Isozaki & Associates

*Director, Aspen Art Museum, Aspen, Colorado

Richard Koshalek, Director
Sherri Geldin, Associate Director
Julia Brown Turrell, Former Curator*
Randall O. Murphy, Acting Manager of Facilities and Operations
Frederick M. Nicholas, Chairman, Building Committee

THE MUSEUM OF MODERN ART
New York, New York
Renovation of existing building and construction of new addition 1984
Architect: Cesar Pelli & Associates

Richard E. Oldenburg, Director
James S. Snyder, Deputy Director for Planning
Riva Castleman, Director, Prints and Illustrated Books, and Deputy
 Director for Curatorial Affairs
Eloise Ricciardelli, Director of Registration
Jerry Neuner, Exhibition Production Manager
Richard Jansen, Consulting Staff Architect
Donald B. Marron, President, Board of Trustees

THE NEWARK MUSEUM
Newark, New Jersey
Renovation of existing buildings and construction of new
 addition 1989
Architect: Michael Graves, Architect

Samuel C. Miller, Director
Mary Sue Sweeney, Assistant Director
Gary A. Reynolds, Curator of Painting and Sculpture
Valrae Reynolds, Curator of Oriental Art
David Palmer, Exhibits Coordinator
Karen Nichols, Michael Graves, Architect

NEWPORT HARBOR ART MUSEUM
Newport Beach, California
New building Project will not be realized
Architect: Renzo Piano, Atelier Piano

Kevin Consey, Director
Renzo Piano, Architect

PEABODY MUSEUM OF SALEM
Salem, Massachusetts
New addition 1988
Architect: Kallmann McKinnell & Wood, Architects, Inc.

*Director, Des Moines Art Center, Des Moines, Iowa

Peter Fetchko, Director
Fiske Crowel, Project Architect

POLK MUSEUM OF ART
Lakeland, Florida
New building 1988
Architect: Straughn Furr Associates, Architects
Ken Rollins, Director
Earnest A. Straughn, Architect

ARTHUR M. SACKLER MUSEUM, Harvard University Art Museums
Cambridge, Massachusetts
New building 1985
Architect: James Stirling Michael Wilford and Associates, Chartered
 Architects
Elizabeth Buckley, Former Capital Projects Manager
Suzannah Fabing, Former Deputy Director, Harvard University Art
 Museums

TRITON MUSEUM OF ART
Santa Clara, California
Renovation of existing building and construction of new addition 1987
Architect: Wayne Barcelon, Darlene Jang
Bill Atkins, Director
Orlando T. Maione, Member, Board of Trustees
Wayne Barcelon, Architect
Darlene Jang, Architect

VIRGINIA MUSEUM OF FINE ARTS
Richmond, Virginia
New addition 1987
Architect: Hardy Holzman Pfeiffer Associates
Paul N. Perrot, Director
Stephen G. Brown, Deputy Director
Richard B. Woodward, Director of Art Services

BIBLIOGRAPHY

Abercrombie, Stanley. "MoMA Builds Again: Cesar Pelli's Tower and Additions." *Architecture* 73 (October 1984): 87–95.

Adams, Brooks. "The Delirious Palace." *Art in America* 77 (December 1989): 136–45.

"Addition to Center for American Arts, Yale University." *AIA Journal* 68 (May 1979): 188–89.

"Addition to the Allen Memorial Art Museum, Oberlin College, Oberlin, Ohio, 1976." *Harvard Architectural Review* 1 (Spring 1980): 197–201.

"Additions to the Guggenheim and Whitney Museums." *International Journal of Museum Management and Curatorship* 5 (March 1986): 92–95.

"All-Star Team for Mass MoCA." *Progressive Architecture* 69 (December 1988): 17.

American Association of Museums. *Museums for a New Century: A Report of the Commission on Museums for a New Century.* Washington, D.C.: American Association of Museums, 1984.

"American Heritage Center and Art Museum." *Progressive Architecture* 71 (January 1990): 96–98.

American Institute of Architects. *Handbook of Architectural Design Competitions.* Rev. ed. Washington, D.C.: American Institute of Architects, 1988.

————. *You and Your Architect.* Rev. ed. Washington, D.C.: American Institute of Architects, 1986.

Amery, Colin. "East Building, National Gallery of Art, Washington." *Architectural Review* 165 (January 1979): 28–31.

Ames, Peter J. "A Challenge to Modern Museum Management: Meshing Mission and Market." *International Journal of Museum Management and Curatorship* 7 (1988): 151–57.

————. "Guiding Museum Values." *Museum News* 63 (August 1985): 48–54.

"Anchorage Historical and Fine Arts Museum, Municipality of Anchorage, Alaska, 1984." *Process: Architecture,* no. 81 (March 1989): 74–79.

Anderson, Grace M. "MoMA." *Architectural Record* 169 (March 1981): 94–99.

Anderson, S. R. "Symposium Explores Recent Museum Building Boom." *Architecture* 78 (August 1989): 22, 24.

"Antoine Predock: University of Wyoming American Heritage Center and Art Museum." *A + U,* no. 218 (November 1988): 124–25.

"Antoine Predock/Edward Larrabee Barnes: Museum of Fine Arts." *A + U*, no. 218 (November 1988): 97–104.

Aoki, June. "The Brooklyn Museum." *Japan Architect*, no. 358 (February 1987): 24–25.

"Architect Grosso Guides Gallery's Expansion." *University of Rochester: Memorial Art Gallery: Gallery Notes* (February 1986): 4.

Architectural Forum 47 (December 1927): entire issue.

Architectural Forum 56 (June 1932): entire issue.

Architectural Record 66 (December 1929): entire issue.

Architectural Record 145 (June 1969): entire issue.

Architectural Review 175 (February 1984): entire issue.

Architecture 73 (October 1984): entire issue.

Architecture 75 (January 1986): entire issue.

"The Architecture of the Art Institute of Chicago." *Museum Studies* 14 (1988): 5–107.

Arnell, Peter, and Ted Beckford. *A Center for the Visual Arts: The Ohio State University Competition*. New York: Rizzoli, 1984.

"Art Institute of Chicago: Centennial Additions, Chicago, Illinois, 1977." *Space Design*, no. 176 (May 1979): 34–39.

"Arthur M. Sackler Museum, Harvard University, Cambridge, Massachusetts." *GA Document*, no. 19 (January 1988): 82–89.

Banfield, Edward C. *The Democratic Muse: Visual Arts and the Public Interest*. New York: Basic Books, 1984.

Banham, Reyner. "In the Neighborhood of Art." *Art in America* 75 (June 1987): 124–29.

Bank, Gretchen G. "Determining the Cost: Architect George Hartman's Formula." *Museum News* 66 (May/June 1988): 74.

———. "England to California: The Changing Faces of Museums." *Museum News* 66 (January/February 1988): 24–26.

———. "Something Old, Something New and Something Added On." *Museum News* 66 (March/April 1988): 16–18.

Banta, Bob. "For Art's Sake." *Austin American Statesman*, 9 February 1987, sec. B, p. 1.

Barna, Joel W. "More Vaults for Kahn's Kimbell." *Progressive Architecture* 70 (October 1989): 27.

"Barnes Revisits the Walker." *Architecture Minnesota* 10 (November/December 1984): 7.

Baumel, Jeffrey. "More for Museums." *Inland Architect* 3 (May/June 1986): 17, 20.

Bazin, Germain. *The Museum Age*. New York: Universe Books, 1967.

Blake, Peter. "Hysterical Pitch." *Interior Design* 57 (March 1986): 256–57.

Blaser, Werner, ed. *Richard Meier: Buildings for Art*. Translated by T. Nisson. Basel: Birkhauser Verlag, 1990.

Boles, Daralice D. "A Bold Plan for Brooklyn Museum." *Progressive Architecture* 67 (December 1986): 27.

———. "Commentary: The Whitney Design Debate." *Progressive Architecture* 66 (September 1985): 25.

———. "New Orleans Aftermath." *Progressive Architecture* 67 (September 1986): 23, 25–26.

———. "Revised Whitney Unveiled." *Progressive Architecture* 68 (April 1987): 27, 29.

"Boston Architects: Kallmann McKinnell & Wood, Architects, Inc." *A + U*, no. 222 (March 1989): 91–94.

"Boston Museums to Protest Entertainment License." *Aviso* 12 (December 1985): 1, 3.

Branch, Mark A. "Another Try for Graves and Whitney." *Progressive Architecture* 70 (February 1989): 21–22.

———. "Kimbell Plans Ambushed in New York." *Progressive Architecture* 71 (March 1990): 23.

———. "Projects: Museums." *Progressive Architecture* 71 (May 1990): 124–28.

Brandt, Anthony. "The Way to Go." *Connoisseur* 212 (November 1982): 124–29.

Brauer, Roger L. *Facilities Planning: The User Requirements Method*. New York: American Management Association, [1986].

Brawne, Michael. *The Museum Interior*. London: Thames and Hudson, 1982.

———. "Museums." *Architectural Design* 43 (October 1973): 644–51.

———. "Museums, Mirrors of Their Time?" *Architectural Review* 175 (February 1984): 16–19.

———. *The New Museum*. London: Architectural Press; New York: Praeger, 1965.

———. "Object on View." *Architectural Review* 126 (November 1959): 248–53.

———. "The Picture Wall." *Architectural Review* 125 (May 1959): 315–25.

Brenner, Douglas. "Et in Arcadia Ambasz: Five Projects by Emilio Ambasz and Associates." *Architectural Record* 172 (September 1984): 120–33.

Brenson, Michael. "Are Museums Hospitable to Art and People?" *New York Times*, 21 August 1988, sec. 2, pp. 29–30.

———. "Large Spaces, Large Questions at the Met." *New York Times*, 15 March 1987, sec. H, pp. 35–36.

———. "Museum and Corporation—A Delicate Balance." *New York Times*, 23 February 1986, sec. 2, p. 1.

"The Brooklyn Museum." *Oculus* 48 (January 1987): 3–7, 16–23.

Brown, Catharine R., William B. Fleissig, and William R. Morrish. *Building for the Arts*. Santa Fe, N.M.: Western States Arts Foundation, 1984.

Brown, Theodore. "Landscape Strategies: The New Orleans Museum of Art Addition." *Princeton Architectural Journal: Landscape* 2 (1985): 165–87.

"Bruce Goff/Bart Prince." *GA Document*, no. 22 (1989): 112–19.

"Building Types Study 571: Museums." *Architectural Record* 170 (February 1982): 90–105.

Buildings for the Arts. New York: McGraw-Hill, 1978.

Bunnell, Gene. "The Interplay of Old and New." *Museum News* 59 (September 1980): 5–17.

Buras, Nina. "Pavilion for Japanese Art." *L.A. Architect* (July 1988): 6–7.

Burt, Nathaniel. *Palaces for the People: A Social History of the American Art Museum*. Boston: Little, Brown, 1977.

Caldwell, Ian. "Building Strategy for Museums and Galleries." *International Journal of Museum Management and Curatorship* 5 (1984): 327–35.

Calisher, Hortense. "Museums." *New Criterion* 1 (June 1983): 56–62.

Campbell, Robert. "A Special Kind of Classicism: GBQC's Speed Museum Addition, Louisville, Kentucky." *Architecture* 73 (October 1984): 80–86.

Cannon-Brookes, Peter. "Frankfurt and Atlanta: Richard Meier as a Designer of Museums." *International Journal of Museum Management and Curatorship* 5 (March 1986): 39–64.

Cannon-Brookes, Peter, and Michael Williams. "The Arthur M. Sackler Museum: I. James Stirling's Arthur M. Sackler Museum; II. Fresh-Air Climate Conditioning at the Arthur M. Sackler Museum." *International Journal of Museum Management and Curatorship* 5 (December 1986): 319–36.

Cantor, Jay. "Temples of the Arts: Museum Architecture in Nineteenth Century America." *Metropolitan Museum of Art Bulletin* 28 (April 1970): 331–55.

Canty, Donald. "Building as Event: I. M. Pei & Partners' East Building, National Gallery of Art, Washington." *AIA Journal* 68 (May 1979): 104–13.

———. "What It Takes to Be a Client." *Architectural Forum* 19 (July 1963): 84–87, (September 1963): 92–95, (December 1963): 94–97; 20 (February 1964): 104–7, (April 1964): 106–9.

Carrier, David. "Art and Its Preservation." *Journal of Aesthetics and Art Criticism* 63 (Spring 1985): 291–300.

Casper, Dale E. *Architecture for Preserving the Fine Arts: Museums and Art Galleries, 1980–1985*. Monticello, Ill.: Vance Bibliographies, 1986.

"Cesar Pelli." *Architectural Design* 55 (1985): 32–37.

"Cesar Pelli & Associates: The Museum of Modern Art, New York, New York, 1984." *A + U*, no. 171 (December 1984): 31–66.

"Cesar Pelli & Associates: The Museum of Modern Art Gallery Expansion and Residential Tower." *GA Document*, no. 12 (January 1985): 42–49.

"Cesar's Palace." *Skyline* 1 (March 1979): 4.

"Chicago Art Museum Names Design Finalists." *New York Times*, 31 January 1991, sec. C, p. 18.

"Chicago Museum Is Expanding, Ready or Not: Plans for a New Site, More Space and Added Respectability." *New York Times*, 18 July 1989, sec. C, p. 13.

Chimacoff, Alan, and Alan Plattus. "Learning from Venturi." *Architectural Record* 171 (September 1983): 88–96.

Clark, Sir Kenneth. "The Ideal Museum." *ARTnews* 52 (January 1954): 28–31.

Class, Robert A., and Robert E. Koehler. *Current Techniques in Architectural Practice.* Washington, D.C.: American Institute of Architects; New York: Architectural Record Books, 1976. (See chapters on programming, client relationship, and contracts.)

Coe, Linda C. "Where to Find Assistance." *Museum News* 59 (September 1980): 77–104.

Coleman, Laurence Vail. *Museum Buildings*. Vol. 1, *A Planning Study*. Washington, D.C.: American Association of Museums, 1950.

"Column and Balustrade." *Progressive Architecture* 69 (November 1988): 167.

Compton, Michael. "Art Museums: The Concept and the Phenomenon." *Studio International* 189 (May/June 1975): 197–201.

Constantine, Eleni. "I. M. Pei's West Wing." *Skyline* 3 (October 1981): 17.

"Controlled Tower." *ARTnews* 84 (Summer 1985): 15–16.

Coolidge, John. *Patrons and Architects: Designing Art Museums in the Twentieth Century*. Fort Worth, Tex.: Amon Carter Museum, 1989.

Costello, Thomas M. "The People Say 'Yes' to Museums." *Museum News* 63 (April 1985): 30–35.

Cuff, Dana. "After Architecture: Light, Rooms and Ritual." *Design Book Review* (Winter 1987): 42–47.

"Cullinan Hall—The Museum of Fine Arts in Houston." *Arts and Architecture* 76 (July 1959): 10–11.

"Cullinan Hall of the Museum of Fine Arts, Houston, Texas." *Architectural Design* 29 (September 1959): 354–58.

Curtis, Cathy. "Museums: Decision Making." *Arts and Architecture* 2 (1983): 48–56.

———. "Museums on the Move: Creative Alternatives in Real Estate." *Museum News* 61 (June 1983): 63–69.

Darragh, Joan, ed. *A New Brooklyn Museum: The Master Plan Competition*. New York: Brooklyn Museum and Rizzoli, 1987.

Davis, Douglas. "Making Museums Modest." *Newsweek*, 26 July 1982, 66–67.

———. "The Museum Impossible." *Museum News* 61 (June 1983): 33–37.

———. "Winging It: Does Adding On Add Up?" *Newsweek*, 23 February 1987, 70–73.

Dean, Andrea O. "The National East: An Evaluation: I. M. Pei's Landmark After Six Years." *Architecture* 73 (October 1984): 74–79.

———. "Renewing Our Modern Legacy." *Architecture* 79 (November 1990): 66–69.

———. "Seamless Addition: Courtyard Gallery, Dumbarton Oaks, Washington, D.C." *Architecture* 79 (June 1990): 74–77.

Dean, Christopher. "Introduction to Art Museums, The Concept and the Phenomenon." *Studio International* 189 (May/June 1975): 194–96.

"The Delicate Art of Expansion, in Fort Worth, the Kimbell Museum Furor." *Washington Post*, 13 January 1990, sec. D, p. 1.

Demetrion, James T. "Des Moines Art Center." *Iowa Architect* 31 (March/April 1984): 16–25.

Dennis, Michael. "Sackler Sequence." *Architectural Review* 180 (July 1986): 26–33.

Design Book Review 11 (Winter 1987): entire issue.

Dickerson, Eugenie. "Why Use Public Funds for Art?" *Philadelphia Inquirer*, 26 July 1986, p. 7A.

"Dignified Simplicity in a Mighty Landscape: The Anchorage Historical and Fine Arts Museum." *Architectural Record* 174 (April 1986): 112–19.

Dillon, David. "Shaping a New Home for an Art Institution." *Dallas Morning News*, 30 October 1985.

DiMaggio, Paul. *Nonprofit Enterprise in the Arts: Studies in Mission and Constraint.* New York: Oxford University Press, 1986.

———. "When the 'Profit' Is Quality: Cultural Institutions in the Marketplace." *Museum News* 63 (June 1985): 28–35.

Donhauser, P. "Lookalike Wing for New York Museum." *Progressive Architecture* 70 (January 1989): 24, 26.

Douglas, W. L. "Collaborative Effort for New Orleans Art Center." *Progressive Architecture* 72 (January 1991): 23.

Dowall, David E., and David Shiver. *Case Studies on Property Development: Oakland Museum Sale and Leaseback.* Berkeley: Institute of Urban and Regional Development, University of California, November 1982.

Drohojowska, Hunter. "LACMA Expands." *A + U* 2, no. 1 (1983): 26–30.

Dudar, Helen. "New York's Metropolitan Enters the 20th Century with a Bang." *Smithsonian* (May 1987): 46–56.

Duncan, Carol, and Alan Wallach. "The Museum of Modern Art as Late Capitalist Ritual: An Iconographical Analysis." *Marxist Perspectives* (Winter 1978): 28–51.

"Edo Treasures in L.A." *ARTnews* 87 (October 1988): 114–15.

"Education and Gallery Wing, Cleveland Museum of Art, Cleveland, Ohio 1970." *Process: Architecture*, no. 32 (September 1982): 74–77.

Educational Facilities Laboratories. *New Palaces for the Arts: Report from Educational Facilities Laboratories and the National Endowment for the Arts.* New York: Educational Facilities Laboratories, 1976.

Edward Larrabee Barnes' Museum Designs. Katonah, N.Y.: The Gallery, 1987.

Eickhoff, Harold. "Faculty Involvement in University Planning: The Lessons of Plato's 'Myth of the Cave.'" *Planning for Higher Education* 8 (Winter 1979): 13–15.

Elsen, A. "The Tyranny of Architects." *ARTnews* 89 (December 1990): 190.

"Excavating the Past: Venturi, Rauch & Scott Brown's La Jolla Museum Addition." *Cartouche* 13 (Summer 1988): 10–11.

"Expansion of the Institute of Arts in Detroit." *Architectural Forum* 125 (September 1966): 64–65.

"Expansion Plans Announced." *Everson Museum of Art Bulletin* (January 1986): 1–2.

Failing, Patricia. "Los Angeles Gets a New Temple of Art." *ARTnews* 85 (November 1986): 88–94.

Fain, William H., Katherine W. Rinne, and Mark R. Gershen. "New Identity for LACMA." *L.A. Architect* (December 1986): 10–11.

"Fame or Fashion: Two Stories." *Progressive Architecture* 66 (March 1985): 30.

Farrelly, E. M., Peter Davey, and Charlotte Ellis. "Piano Practice: Picking Up the Pieces and Running with Them." *Architectural Review* 171 (March 1987): 32–59.

Fehlig, Teresa Anne. *Museums and Museum Architecture: Guide to Recent Literature.* Monticello, Ill.: Vance Bibliographies, 1990.

Feld, Alan L., Michael O'Hare, and J. Mark Davidson Schuster. *Patrons Despite Themselves: Taxpayers and Arts Policy.* New York: New York University Press, 1983.

Filler, Martin. "Growing Pains." *Art in America* 75 (July 1987): 14–19.

———. "Magnificent Monster: A Bitarre Museum by Bruce Goff Rises Like a Dinosaur to La Brea Tar Pits." *House and Garden* 160 (October 1988): 58.

———. "Square One, Round Two." *House and Garden* 159 (July 1987): 16.

———. "The Sum of Its Arts: Graves Tops Breuer with an Ingenious Addition to New York's Whitney Museum." *House and Garden* 157 (August 1985): 80–81, 169.

———. "Wright Wronged: Gwathmey Siegel's Proposed Guggenheim Addition Raises Crucial Questions About the Museum's Role as a Cultural Caretaker." *House and Garden* 158 (February 1986): 42–48.

Fisher, T. R. "Introduction: Museum Form and Function." *Progressive Architecture* 71 (May 1990): 84.

Flacke, Christopher. "Isozaki's MoCA." *New Criterion* 5 (April 1987): 46–50.

"Fogg Launches Capital Campaign for 15.7 Million." *Newsletter—Fogg Art Museum* (November 1977): 1–7.

Forgey, Benjamin. "Chrysler Museum Renewed: An Architectural Transformation Daring in Its Sensitivity." *Southern Accents* 12 (November/December 1989): 72–80.

———. "An Exhilarating Triumph in Washington." *ARTnews* 77 (Summer 1978): 58–62.

"Fort Worth: Giurgola Defers to Kahn at Kimbell." *Texas Architect* 39 (September/October 1989): 8.

Foss, Abby. "Cullinan Hall Extension of the Museum of Fine Arts of Houston, Texas." *Museum (UNESCO)* 12, no. 1 (1959): 28–33.

Frampton, K. *Richard Meier.* New York: St. Martin's Press, 1990.

Freeman, Alan. "Demanding Showcase: Richard Meier's High Museum in Atlanta Considers Expansion." *Architecture* 78 (December 1989): 50–53.

Freiman, Ziva. "Gwathmey Siegel's Guggenheim: Redoing Wright." *Progressive Architecture* 66 (December 1985): 25.

Garfield, Donald. "The Smithsonian's New Museums Under the Mall." *Museum News* 66 (October 1987): 44–49.

Gebhard, David. "Harmonious Addition to an 'Arcadia': A New Gallery at the Huntington Garden Compound in California." *Architecture* 76 (February 1987): 54–57.

Gelder, H. E. van. "Museums: Their Functions and Architecture." *Museum* 4 (1951): 179–82.

"A German Architect for Chicago Museum." *New York Times,* 3 June 1991, sec. C, p. 15.

"The Getty Trust and the Process of Patronage." *Harvard Architectural Review* 6 (1987): 122–31.

Gibson, Eric. "Two Proposals for the 90s: Whitney and Guggenheim Museum Extensions, New York." *Studio International* 199 (September 1986): 4–11.

Gill, Brendan. "The Sky Line: Optimistic Ziggurat." *New Yorker,* 8 June 1987, 49.

Gilman, Benjamin Ives. *Museum Ideals of Purpose and Method.* Cambridge, Mass.: Museum of Fine Arts and Riverside Press, 1918.

Giovannini, Joseph. "A Grave Situation for Marcel Breuer's Whitney." *Artforum* 24 (November 1985): 84–86.

———. "Joseph Giovannini on Architecture." *Artforum* 25 (February 1987): 2–6.

———. "Museum Piece: Joseph Giovannini on Architecture." *Artforum* 25 (May 1987): 2–5.

Glaeser, Ludwig, *Architecture of Museums.* New York: Museum of Modern Art, 1968.

Glancy, Jonathan. "A Homely Gallery." *Architect: Journal of the Royal Institute of British Architects* 94 (September 1987): 38–41.

Glueck, Grace. "The Art Boom Sets Off a Museum Building Spree." *New York Times,* 23 June 1985, sec. 2, p. 1.

———. "Guggenheim Withdraws Design Change." *New York Times,* 28 November 1990, sec. C, p. 18.

———. "New Assembly Hall at Brooklyn Museum." *New York Times,* 8 April 1991, sec. C, p. 11.

———. "New Design for the Guggenheim." *New York Times,* 15 October 1990, sec. C, p. 13.

Goddard, Dan R. "Museum Going Post-Modern." *Express News,* 8 February 1986.

Goff, L. "Remaking Museums in Chicago." *Progressive Architecture* 69 (August 1988): 35–36.

Goldberger, Paul. "Adding a Little to the Whitney." *New York Times,* 15 March 1987, sec. H, p. 33.

———. "At Last, A 'Museum Without Walls . . . Gets Walls Worthy of It." *New York Times,* 14 June 1987, sec. H, pp. 33–35.

―――. "Design: The Risks of Razzle Dazzle." *New York Times*, 12 April 1987, sec. 2, pp. 31–32.

―――. "For San Francisco, A New Museum with Its Own Signature." *New York Times*, 13 September 1990, sec. C, p. 21.

―――. "The Inner Sanctums of the Newark Museum." *New York Times*, 18 March 1990, sec. 2, p. 34.

―――. "The Museum as Design Laboratory." *Museum News* 65 (April 1987): 7–12.

―――. "A Museum Exhibits Splendid Lack of Glitz." *New York Times*, 4 June 1989, sec. 2, p. 33.

―――. "The Museum that Theory Built." *New York Times*, 5 November 1989, sec. 2, p. 1.

―――. "The New MoMA: Mixing Art with Real Estate." *New York Times Magazine*, 4 November 1979, 46.

―――. "New Museums Harmonize with Art." *New York Times*, 14 April 1985, sec. 2, p. 1.

―――. "What Should a Museum Building Be?" *ARTnews* 74 (October 1975): 33–38.

Goldring, Marc. "Getting Together: Costs and Benefits of a Consortium." *Museum News* 65 (October/November 1986): 36–41.

Gombrich, E. H. "The Museum: Past, Present and Future." *Critical Inquiry* 3 (Spring 1977): 449–71.

―――. "Should a Museum Be Active?" *Museum (UNESCO)* 21 (1968): 79–82.

Goode, John M. "Merging Program, Budget and Facilities Planning." *Planning for Higher Education* 12 (Spring 1984): 18–21.

Goodman, Nelson. "The End of the Museum?" *Journal of Aesthetic Education* 19 (Summer 1985): 53–62.

Gordon, Leonie, ed. *The Arthur M. Sackler Museum, Harvard University.* Cambridge, Mass.: Harvard University Art Museums, 1985.

Grana, Cesar. "The Private Lives of Public Museums." In *Essays in the Sociology of Art and Literature.* New York: Oxford University Press, 1971. (First published in *Trans-Action* 4 [April 1967]: 20–25.)

"Graves Renovates Newark Museum." *Interior Design* 55 (October 1984): 43.

"Graves' Whitney Plans." *Progressive Architecture* 66 (July 1985): 23.

"The Great Museum Debate: Gwathmey Siegel & Associates Discuss Proposed Guggenheim Addition." *Oculus* 47 (April 1986): 4–5, 14–16.

Greer, N. R. "An Addition of Character to the Chicago Historical Society." *Architecture* 77 (November 1988): 82–83.

Grove, Migs. "The Monuments of Half a Century." *Museum News* 62 (February 1984): 30–32.

"Growing Pains." *Metropolis* 6 (May 1987): 22–23.

"Guggenheim: Wright or Wrong?" *Metropolis* 6 (October 1986): 32–33.

"The Guggenheim Addition." *Oculus* 47 (February 1986): 2–15.

"Guggenheim Expansion Underground?" *Oculus* 48 (November 1986): 4–5, 14–15.

"The Guggenheim Museum Addition." *A + U*, no. 223 (April 1989): 124–27.

"The Guggenheim Museum Addition: Scheme II." *Oculus* 48 (April 1987): 3–5.

"The Guggenheim Museum Announces Revised Expansion Plans." *Oculus* 48 (April 1987): 2.

Haacke, Hans. "Museums: Managers of Consciousness." *Art in America* 72 (February 1984): 15.

Hafertepe, Kenneth. *America's Castle: The Evolution of the Smithsonian Building and Its Institution, 1840–1878.* Washington, D.C.: Smithsonian Institution Press, 1984.

Haltenhoff, C. Edwin, ed. *Construction Management: A State-of-the-Art Update.* New York: American Society of Civil Engineers, 1986.

"Hammond Beeby and Babka, Inc." *Architectural Design* 59 (1989): 86–87.

Hardy, Hugh. "Inventing a Sixth Order to Honor a Beaux-Arts Building: Expanding an

Eclectic Art Gallery for a New Era of Use." *Architectural Record* 170 (August 1982): 102–11.

"Hardy Holzman Pfeiffer Associates." *GA Document*, no. 19 (1988): 114–23.

Harris, Neil. "Museums: The Hidden Agenda." Address to the Midwest Museums Conference, 24 September 1986.

Heck, Sandy. "Guggenheim Dilemma." *Building Design*, no. 803 (12 September 1986): 30–36.

Hendon, William S. *Analyzing an Art Museum*. New York: Praeger, 1979.

Herndon, John. "Combining Art and History." *Austin American Statesman*, 9 January 1986.

High Museum of Art. *High Museum of Art: The New Building, A Chronicle of Planning, Design and Construction*. Atlanta: High Museum of Art, 1983.

Hilberry, John D. "What Architects Need to Know, and Don't Want to Hear." *Museum News* (June 1983): 55–61.

"House of the Tranquil Mind: Pavilion for Japanese Art, the Los Angeles County Museum of Art." *Architectural Record* 176 (September 1988): 92–99.

Hudson, Kenneth. *Museums of Influence*. Cambridge: Cambridge University Press, 1987.

———. *Museums of the 1980s: A Survey of World Trends*. New York: Holmes and Meier, 1977.

———. *A Social History of Museums*. Atlantic Highlands, N. J.: Humanities Press, 1975.

Hughes, Robert. "How to Start a Museum." *Time*, 10 August 1987, 48–50.

Huxtable, Ada Louise. "The Legacy of Museum Design of the 1960s." *New York Times*, 29 November 1981, Arts and Leisure section, pp. 31, 36.

"In Progress: Houses by Anthony Ames and Morphosis, A Museum Addition by Burr & McCallum." *Progressive Architecture* 69 (September 1988): 41–42.

"Introduction." *Arts of Asia* 19 (September/October 1989): 87–89.

Iovine, Julie. "Will an Isozaki Grow in Brooklyn?" *Connoisseur* 217 (March 1987): 26.

Ivy, Robert A., Jr. "Modernism with Manners: Memphis Brooks Museum, Memphis, Tennessee." *Architecture* 79 (March 1990): 122–27.

"The J. B. Speed Art Museum, South Wing, Louisville, Kentucky, 1981–1983." *Process: Architecture*, no. 62 (October 1985): 122–27.

Jaffe, Irma B. "A Jewel of a Building for the Museum of Art." *ARTnews* 85 (March 1986): 129.

"James Stirling Michael Wilford and Associates, Chartered Architects." *GA Document*, no. 19 (1988): 82–89.

"A Jewel Box for Sculpture: Damberg, Scott, Peck & Booker Shapes an Artful Setting." *Architecture Minnesota* 15 (January/February 1989): 34–45.

Johnson, E. J., ed. *Charles Moore: Buildings and Projects*. New York: Rizzoli, 1986.

Johnson, E. V., and J. Horgan. "Becoming a Good Museum Client." *Museum News* 66 (May/June 1988): 72–75.

Johnson, Ken. "Showcase in Arcadia." *Art in America* 76 (July 1988): 94–103.

Johnson, Philip, James Freed, Richard Meier, Kurt Forster, Kenneth Frampton, Frank O. Gehry, Arata Isozaki, Phyllis Lambert, and James Stirling. "Kimbell Addition Plea." *Progressive Architecture* 71 (January 1990): 9.

Jordan, Anne Harwell. *Art Museums Designed for the Seventies: Bibliography*. Monticello, Ill.: Vance Bibliographies, 1982.

Jordy, William H. "The New Museum." *New Criterion* 1 (September 1982): 61–65.

"Joseph Giovannini on the New 20th Century Wing at the Metropolitan Museum of Art, New York." *Artforum* 25 (April 1987): 8–9.

Kent, Henry W. "The Why and Wherefore of Museum Planning." *Architectural Forum* 106 (June 1932): 529–32.

Kimball, Roger. "Architecture—How to Build a Museum: The Example of Louis Kahn." *New Criterion* 8 (June 1990): 64–67.

———. "Art and Architecture at the Equitable Center." *New Criterion* 4 (November 1986): 24–32.

————. "Michael Graves Tackles the Whitney." *Architectural Record* 173 (October 1985): 113, 115.

Kimmelman, Michael. "A Small Museum Is Growing Up." *New York Times*, 21 September 1989, sec. C, p. 19.

Knight, Carleton, III. "Virtuoso Performance in Stone: West Wing, Virginia Museum of Fine Arts." *Architecture* 75 (January 1986): 40–45.

Knight, Christopher. "New Wing Will House LACMA Gift." *Los Angeles Herald Examiner*, 20 April 1983, sec. B, p. 7.

Koerble, B. L. "Giurgola's Kimbell Addition Draws Fire." *Architecture* 79 (January 1990): 35–36.

————. "Kimbell Art Museum Expansion." *A + U*, no. 233 (February 1990): 4–7.

————. "Kimbell Art Museum Expansion Abandoned." *A + U*, no. 236 (May 1990): 4–5.

————. "Kimbell Art Museum Unveils Addition Scheme by Giurgola." *Architecture* 78 (October 1989): 19, 22.

————. "Kimbell Plan Draws Prominent Criticism." *Texas Architect* 40 (January/February 1990): 10.

Kolenbrander, Harold M. "Internal Politics and Strategies of Implementing Change with Limited Resources." *Planning for Higher Education* 11 (Summer 1983): 5–9.

Kovac, M. *Subterranean Museums*. New York: Pergamon Press, 1981.

Kramer, Hilton. "Showing a Little Respect." *Art & Antiques* (December 1989): 115–17.

————. "Triumph in Chicago." *Art & Antiques* (November 1988): 117–19.

————. "The Wexner Center in Columbus, Ohio." *New Criterion* 8 (December 1989): 5–9.

"Kramer Art Museum Addition: Architectural Design Citation: Booth/Hansen & Associates." *Progressive Architecture* 67 (January 1967): 96–97.

"L.A. Controversies." *Skyline* 4 (May 1982): 6–7.

"The Largest Object in the Museum's Collection." *Museum News* 61 (June 1983): 38–53.

"Latest Works of Kevin Roche John Dinkeloo and Associates." *A + U*, no. 211 (April 1988): 67–142.

Lavin, S. "Interiors Viewpoint." *Interiors* 148 (June 1989): 17, 19, 21, 23, 25.

Lee, S. E. *On Understanding Art Museums*. Englewood Cliffs, N.J.: Prentice-Hall, 1975.

————. *Past, Present, East and West*. New York: Braziller, 1983.

Levin, Michael D. *The Modern Museum: Temple or Showroom*. Tel Aviv: Dvir, 1983.

Levy, Sidney M. *Project Management in Construction*. New York: McGraw-Hill, 1987.

Lewis, Roger K. "Harvard's Tough Task: Putting an Addition on an Addition." *Museum News* 68 (May/June 1989): 18–19.

————. "Intimate Spaces for a Delicate Art: LACMA's Pavilion for Japanese Art." *Museum News* 67 (November/December 1988): 18–21.

————. "This Spacious Smithsonian Addition Works as Art and Eatery." *Museum News* 68 (January/February 1989): 20–21.

————. "Surprising Intimacy Pervades the New Newark Museum." *Museum News* 69 (March/April 1990): 27–29.

Lieberman, Laura C. "The Mint Museum: A New Look for North Carolina's Oldest Museum." *Southern Accents* 9 (September/October 1986): 66, 71, 73, 74.

Lilla, Mark. "Art and Anxiety: The Writing on the Museum Wall." *Public Interest* 66 (Winter 1982): 37–54.

————. "The Museum in the City." *Journal of Aesthetic Education* 19 (Summer 1985): 79–81. (A slightly shorter version, "The Great Museum Muddle," is in *New Republic*, 8 April 1985, 25–30.)

Lloyd, J. "Fort Worth: The Kimbell Extension." *Art International*, no. 10 (Spring 1990): 27.

Loftness, Vivian. *Architecture for Art's Sake: Vantage Point Evaluation of Museum Performance for Future Design*. Pittsburgh: Carnegie-Mellon University, 1988.

Lord, Barry, and Gail Dexter Lord, eds. *The Manual of Museum Planning.* Washington, D.C.: American Association of Museums, 1990.

————. *Planning Our Museums.* Ottawa: National Museums of Canada, Museums Assistance Program, 1983.

Lotus International 35, no. 11 (1982): entire issue.

Lotus International 53, no. 1 (1987): entire issue.

Lotus International 55, no. 3 (1987): entire issue.

Loud, Patricia. "After Architecture: The Critical Fortune." *Design Book Review* (Winter 1987): 52–55.

————. *The Art Museums of Louis I. Kahn.* Durham, N.C.: Duke University Press, in association with the Duke University Museum of Art, 1989.

Lynes, Russell. *Good Old Modern: An Intimate Portrait of the Museum of Modern Art.* New York: Atheneum, 1973.

McCleary, Peter. "After Architecture: The Kimbell Art Museum: Between Building and Architecture." *Design Book Review* (Winter 1987): 48–51.

McCullar, Michael. "Laguna Gloria Design: 'Scale and Presence.'" *Austin American Statesman,* 6 October 1985, sec. J, p. 1.

————. "Museum Rebuilds Momentum." *Austin American Statesman,* 9 February 1987, sec. B, p. 1.

McGuigan, Cathleen. "What Becomes a Legend Most: Three Famous Museums Try to Tackle an Old Dilemma: How to Grow Gracefully." *Newsweek,* 15 January 1990, 54.

Malraux, André. *The Voices of Silence.* Translated by Stuart Gilbert. New York: Doubleday, 1953; Princeton, N.J.: Princeton University Press, 1978.

Marlin, William. "The Metropolitan Museum as Amended: After 14 Years Its Current Master Plan Nears Completion." *AIA Journal* 70 (May 1981): 28–41.

————. "Mr. Pei Goes to Washington." *Architectural Record* 164 (August 1978): 79–92.

Martin, D. "The Future of Museum Buildings." *Museums Journal* 90 (March 1990): 23.

Marzorati, Gerald. "MoMA's Tower in the Sky." *ARTnews* 76 (April 1977): 54–56.

Matthews, Geoffrey Mark. *Museums and Art Galleries: Design and Development Guide.* London: Butterworth Architecture, 1990.

Mays, V. "Revealing Wright." *Progressive Architecture* 70 (April 1989): 82–85.

"Memphis Brooks Museum, Memphis, Tennessee." *Texas Architect* 37 (September/ October 1987): 56.

"Memphis Brooks Museum of Art: Architectural Design Citation." *Progressive Architecture* 69 (January 1988): 114–15.

Metropolitan Museum of Art. *The Second Century: The Comprehensive Architectural Plan for the Metropolitan Museum of Art.* New York: Metropolitan Museum of Art, 1971.

"Met's New Rockefeller Wing: Sleek Setting, Primitive Art." *AIA Journal* 71 (April 1982): 62–63.

Meyer, John. "Order Out of Hodgepodge." *ARTnews* 86 (December 1987): 28–30.

Meyer, Karl E. *The Art Museum: Power, Money, Ethics.* New York: Morrow, 1979.

Miller, Ross. "Commentary: Adding to Icons." *Progressive Architecture* 71 (June 1990): 124–25.

————. "Perspectives." *Progressive Architecture* 71 (June 1990): 124–25.

"Milwaukee: The Bradley Wing." *ARTnews* 74 (November 1975): 84.

"MoMA Tower Trust Approved by High Court." *Progressive Architecture* 60 (February 1979): 21–22.

Montaner, Josep Maria. *New Museums: Spaces for Art and Culture.* Princeton, N.J.: Princeton Architectural Press, 1990.

Montaner, Josep Maria, and Jordi Oliveras. *The Museums of the Last Generation.* London: Academy Editions; New York: St. Martin's Press, 1986.

Montebello, Philippe de. "The High Cost of Quality." *Museum News* 62 (August 1984): 46–49.

Moore, R. "Frank Gehry: Temporary Contemporary." *Architectural Review* 182 (December 1987): 68–72.

Morgan, Ann Lee. "Casting New Light on Tradition: The Art Institute's New South Wing." *New Art Examiner* 16 (December 1988): 38–41.

Morgan, William. "Up to Speed." *Progressive Architecture* 65 (February 1984): 28.

Morton, David. "Grand Trianon, New York: Frick Collection Addition." *Progressive Architecture* 62 (October 1981): 78–79.

———. "Guggenheim Revision." *Progressive Architecture* 68 (March 1987): 41, 43.

———. "HHPA Adds to LACMA." *Progressive Architecture* 68 (January 1987): 31–32.

Murphy, J. "P/A Awards Update: A Graceful Takeover." *Progressive Architecture* 71 (May 1990): 103–5.

Museum Architecture: Guide to Design, Conservation and Museum Architecture in the United States. Monticello, Ill.: Vance Bibliographies, 1985.

"Museum Architecture: The Tension Between Function and Form." *Museum News* 66 (May/June 1988): 12–16, 22–39, 44–45, 72–75, 97.

"The Museum Explosion Continues." *Interiors* 144 (August 1984): 37.

Museum News 59 (September 1980): entire issue.

Museum News 61 (June 1983): entire issue.

Museum News 65 (April 1987): entire issue.

Museum News 66 (January/February 1988): entire issue.

Museum News 66 (May/June 1988): entire issue.

"Museum of Fine Arts Addition and Remodel, Santa Fe: Institutional/Public Building Honor Award." *New Mexico Architecture* 26 (January/February 1985): 8–9.

"The Museum of Modern Art Gallery Expansion and Residential Tower." *A + U*, no. 121 (October 1980): 111–14.

"The Museum of Modern Art Gallery Expansion and Residential Tower, New York, 1984." *A + U*, no. 7 (July 1985): 200–216, 232.

"The Museum of Modern Art Project." *Perspecta*, no. 16 (1980): 96–107.

"Museum Project in Massachusetts in New Trouble." *New York Times*, 19 December 1990, sec. C, p. 15.

"Museum Roof as Flying Carpet." *Architectural Record* 177 (October 1989): 53.

Museum (UNESCO) 26, no. 3–4 (1974): 127–280.

Museum (UNESCO) 31, no. 2 (1979): 71–143.

Nesmith, Lynn. "Graves' Whitney Addition Debated at Landmarks Hearing." *Architecture* 76 (July 1987): 15–16, 18.

———. "Guggenheim Unveils Modified Gwathmey Siegel Addition." *Architecture* 76 (March 1987): 40, 42.

———. "Old and New: Gwathmey Siegel's Guggenheim Addition Draws Mixed Reactions." *Architecture* 74 (December 1985): 11.

———. "Proposals: Controversy Brews Over Graves' Whitney Addition." *Architecture* 74 (August 1985): 11–12.

———. "Proposed Guggenheim Addition Debated at Municipal Hearing." *Architecture* 75 (August 1986): 10–12.

———. "The Whitney: A Chance for Presentation and Discussion." *Architecture* 74 (September 1985): 48–49.

———. "Whitney Museum Unveils Graves's Third Scheme." *Architecture* 78 (February 1989): 22.

Netzer, Dick. *The Subsidized Muse: Public Support for the Arts in the United States*. London: Cambridge University Press, 1978.

"The New Jersey Society of Architects Architectural Exhibit and Awards Program." *Architecture New Jersey* 20 (October/November 1984): 11–20.

"The New MoMA: A 'Machine for Looking.'" *Studio International* 197 (1984): 54–55.

"New Museum Architecture." *Art International*, no. 10 (Spring 1990): 39–43, 54–59.

Newland, Amy Reigle. "Report from America (West Coast)." *Oriental Art* 34 (Autumn 1988): 223–28.

Nichols, K., Patrick Burke, and Caroline Hancock. *Michael Graves: Buildings and Projects: 1982–1988*. Princeton, N.J.: Princeton Architectural Press, 1990.

Noble, Joseph Veach. "Museum Meltdown." *ARTnews* 87 (February 1988): 176.

Norman, Joy Y. "Collections Needs in Twelve Museums." *Museum News* 64 (October 1985): 46–53.

Norment, Kate. "Los Angeles: New Face on the Block." *ARTnews* 86 (February 1987): 23–24.

Norment, Kate, and Charles Giuliano. "New England: Good Neighbors." *ARTnews* 86 (January 1987): 51–52.

"Notes and Comments: Beyond Perfection at the Kimbell." *New Criterion* 8 (March 1990): 3–4.

O'Connor, Michael. "The Block of the New." *Art and Antiques* (May 1984): 21.

Odendahl, Nora. "The Newark Museum Reopens." *Architecture New Jersey* 26 (1990): 21–23.

O'Doherty, Brian. "Inside the White Cube: Notes on the Gallery Space (Part I)." *Artforum* 14 (March 1976): 24–30.

———. "Inside the White Cube: The Eye and the Spectator (Part II)." *Artforum* 14 (April 1976): 26–34.

———. "Inside the White Cube: Context as Content (Part III)." *Artforum* 14 (May 1976): 38–45.

———. *Museums in Crisis*. Reprint of *Art in America* (July/August 1971).

"The Once and Future Whitney." *Metropolis* 5 (September 1985): 16.

Pach, Walter. *The Art Museum in America*. New York: Panther Books, 1948.

Papademetriou, Peter. "The Edifice Complex." *Connoisseur* 220 (March 1990): 30, 32.

———. "Four Not-So-Easy Pieces." *Architecture* 71 (March 1990): 88–95.

Pastier, John. "L.A. Art: Dissimilar Duo." *Architecture* 76 (February 1987): 40–53.

Patton, Phil. "Only in L.A.: The Los Angeles County Museum's New Japanese Pavilion." *Connoisseur* 218 (October 1988): 162–65.

Pearson, Clifford. "Order out of Chaos." *Architectural Record* 177 (July 1989): 114–19.

Peck, Robert A. "Living over the Museum." *Urban Land* 40 (December 1981): 17–20.

Perspecta 16 (1980): entire issue.

"Petition Protesting Proposal Submitted to Whitney." *Architecture* 74 (November 1985): 24, 28.

Pevsner, Nikolaus. "Museums." In *A History of Building Types*. Princeton, N.J.: Princeton University Press, 1976.

Piano, Renzo. "Renzo Piano." *Harvard Architectural Review* 7 (1989): 76–78.

"Piano and Fitzgerald Architects." *GA Document*, no. 19 (1988): 20–31.

Pinnell, P. L. "A New Brooklyn Museum: The Master Plan Competition." *Winterthur Portfolio* 24 (Spring 1989): 105–10.

Plagens, Peter. "Los Angeles: Two for the Show." *Art in America* 75 (May 1987): 146–61.

"Planning for Expansion." *Museum News* 69 (July/August 1990): 51–57.

Plattus, Alan J. "Friends and Enemies of the Museum." *Design Book Review* (Summer 1985): 20–25.

Potterton, H. "Museum News: New York, New York." *Apollo* 129 (April 1989): 270–71.

Powell, Earl A., III. "A Master Plan for a New Museum." *Apollo* 124 (November 1986): 390–91.

Powell, Earl A., III, Robert Winter, and Stephanie Barron. *The Robert O. Anderson Building*. Los Angeles: Los Angeles County Museum, 1986.

Price, Joe D. "The Pavilion for Japanese Art." *Arts of Asia* 19 (March/April 1989): 96–97.

Prince, Bart. "Bruce Goff." *GA Document*, no. 22 (January 1989): 112–19.

Progressive Architecture 50 (December 1969): entire issue.

Progressive Architecture 56 (March 1975): entire issue.

Progressive Architecture 59 (May 1978): entire issue.

Progressive Architecture 64 (August 1983): entire issue.

"The Proposed Whitney Expansion No. 3." *Oculus* 51 (February 1989): 9.

"Proposed Whitney Museum Addition and Residence, 1979." *Domus*, no. 600 (November 1979): 20–23.

"The Quest Whitney?" *Friends of Kebyar* 4.2 (March/April 1986): 4–5.

Rastorfer, Darl. "The Art of Construction." *Architectural Record* 176 (January 1988): 102.

——. "Putting It All Together: West Wing, The Virginia Museum of Fine Arts, Richmond, Virginia." *Architectural Record* 174 (June 1986): 154–63.

"Recent Project by Emilio Ambasz, New Orleans Museum of Art." *Space Design*, no. 237 (June 1984): 49–54.

"Renovation of and Addition to the Museum of Modern Art." *Space Design*, no. 192 (September 1980): 4–11.

Rico, Diana. "Collection of Edo-Period Works Comes to L.A. County Museum." *Los Angeles Life Daily News*, 21 February 1986.

Riegl, Alois. "The Modern Cult of Monuments: Its Character and Its Origin." *Oppositions*, no. 25 (Fall 1982): 21–51.

Rikala, Taina. "Oriental Reflection: The Pavilion for Japanese Art Designed by Bruce Goff and Bart Prince Has Opened in Los Angeles." *Building Design*, no. 907 (21 October 1988): 36–37.

Ripley, S. Dillon. *The Sacred Grove: Essays on Museums*. Washington, D.C.: Smithsonian Institution Press, 1969.

"Robert O. Anderson Building, Los Angeles County Museum of Art, Los Angeles, California, Completion: 1987." *GA Document*, no. 19 (January 1988): 114–23.

Robillard, David A. *Public Space Design in Museums*. Milwaukee: Department of Architecture and Urban Planning, University of Wisconsin, 1982.

Rogers, Meyric R. "A Study in Museum Planning, Being an Effort to Establish a Working Basis for the Solution of Current Problems in Museum Planning." *Architectural Record* 46 (December 1919): 518–28.

Rose, Frederick. "Wealth of Woes: J. Paul Getty Museum in California Is Beset by Critics, Uncertainty. Texaco–Pennzoil Fight Adds Looming Financial Cloud to an Artistic Imbroglio: The Uses of a Trust's Billions." *Wall Street Journal*, 16 April 1987, p. 1.

Royal Ontario Museum. *Communicating with the Museum Visitor: Guidelines for Planning*. Toronto: Communications Design Team, 1976.

——. *Opportunities and Constraints: The First Report of the Exhibits Communication Task Force*. Toronto: Royal Ontario Museum, 1979.

Rubin, William. "When Museums Overpower Their Own Art." *New York Times*, 12 April 1987, sec. H, pp. 31–32.

Ruder, William. "The Image in the Mirror." *Museum News* 63 (December 1984): 18–19.

Rudolph, Barbara. "Mixing Class and Cash." *Time*, 9 December 1985, 56.

Russell, Beverly. "Remodeling the Future: The Proposed Whitney Museum of American Art Addition. . . ." *Interiors* 145 (August 1985): 147, 211.

Sachner, Paul. "A Far Far Better Thing: The Guggenheim and Whitney Redesign Their Expansion Schemes." *Architectural Record* 175 (April 1987): 45, 157.

Salat, S. "Isozaki." *L'Architecture d'aujourd'hui*, no. 250 (April 1987): 14–17.

Samaras, Connie. "Corporations in the Arts: Sponsors or Censors?" *Utne Reader* (April/May 1986): 106–14. (First published in *New Art Examiner* [November 1985].)

Sasken, Louis C. "Evaluating the Feasibility of Renovation of Historic Landmarks and Other Buildings: Utilizing a Facilities Management Methodology." *Planning for Higher Education* 15 (1987): 11–16.

Schlinke, B. "The Nature of Monument: Design for the New San Francisco Museum of Art." *Artweek* 21 (October 1990): 12–13.

Schmertz, Mildred F. "A Gathering of Fragments: Robert O. Anderson Building, Los Angeles County Museum of Art." *Architectural Record* 175 (February 1987): 110–19.

————. "Hardy Holzman Pfeiffer Re-Establish the Formal Themes of a Great Beaux-Arts Building." *Architectural Record* 164 (October 1978): 85–96.

————. "Modern Architecture for Modern Art." *Architectural Record* 172 (October 1984): 166–76.

————. "The New MoMA: Expansion and Renovation of the Museum of Modern Art, New York City." *Architectural Record* 172 (October 1984): 164–77.

Schoonover, Stephen C., and Murray M. Dalziel. "Developing Leadership for a Change." *Management Review* (July 1986): 55–59.

Schupp, Priscilla Lister. "The Artist Now Paints Big Pictures: Museums." *San Diego Daily Transcript*, 15 May 1986, sec. 2A.

Scully, Vincent. "Charles Moore at Williams." *Architectural Digest* 44 (December 1987): 66, 70–71, 74, 78.

Searing, Helen. "The Development of a Museum Typology." *Museum News* 65 (April 1987): 20–31.

————. *New American Art Museums.* New York: Whitney Museum of American Art, in association with University of California Press, 1982.

"Second Time Around for New Orleans Museum of Art Addition." *Interiors* 146 (December 1986): 22.

Selig, Helmut. "The Genesis of the Museum." *Architectural Review* 141 (February 1967): 103–14.

Shalkop, Robert, and Steven M. Goldberg. "Northern Light in a Museum." *Museum News* 65 (April 1987): 40–51.

Shapiro, Benson P. "Getting Things Done: Rejuvenating the Marketing Mix." *Harvard Business Review* (September/October 1985): 28–34.

Shore, Harvey. *Arts Administration and Management.* New York: Quorom Books, 1987.

Simonson, Lee. "Museum Showmanship." *Architectural Forum* 53 (June 1932): 533–40.

Simpson, Jeffrey. "Two Cheers for MoMA." *ARTnews* 83 (September 1984): 56–61.

Slate, Jane. "A National Study Assesses Collections Management, Maintenance and Conservation." *Museum News* 64 (October 1985): 38–45.

Smith, Linell. "The Cone Sisters." *Baltimore Evening Sun*, 12 June 1986, sec. B, p. 1.

Smith, Marcia Axtmann. "Adaptive Use for Museums: A Planning Checklist." *Museum News* 63 (April 1985): 28–29.

————. "Renewed Museums: Ten Case Studies." *Museum News* 59 (September 1980): 19–61.

————. "Renewed Museums Revisited." *Museum News* 63 (April 1985): 13–29.

Sola-Morales, Ignasi. "The Modern Museum: From Riegl to Giedion." *Oppositions*, no. 25 (Fall 1982): 69–77.

"Solicitous Additions to an Architectural Icon." *Architectural Record* 177 (October 1989): 59.

Solomon, Richard Jay. "Toledo and Minneapolis to Build Gehry Museums." *Inland Architect* 35 (January/February 1991): 13.

Somol, R. "Wexner Center for the Visual Arts, Columbus, Ohio." *Domus*, no. 712 (January 1990): 38–47.

"Special Feature: Antoine Predock." *A + U*, no. 218 (November 1988): 75–130.

"A Spectacular New Wing." *New York Times Magazine*, 24 January 1982, 20.

Stein, Clarence S. "The Art Museum of Tomorrow." *Architectural Record* 67 (January 1930): 5–12.

Stein, K. D. "University of Wyoming American Heritage Center and Art Museum." *Architectural Record* 176 (October 1988): 92–93.

Stephens, Suzanne. "The Buildings in Close-Up." *Art in America* 75 (May 1987): 152–55.

————. "A Tale of Two Landmarks." *Architectural Digest* 45 (November 1988): 108, 114, 118, 122, 124–25.

————, ed. *Building the New Museum.* New York: Architectural League of New York, 1985.

"Sterling and Francine Clark Art Institute Addition, Williamstown, Massachusetts, 1973." *Process: Architecture*, no. 19 (1980): 94–97.

Steward, W. Cecil. "Building Reclamation: A Technique for Making Comparative and Performance Evaluations of Buildings." *Planning for Higher Education* 10 (Summer 1982): 5–13.

Suisman, Doug. "After Architecture: The Design of the Kimbell: Variations on a Sublime Archetype." *Design Book Review* (Winter 1987): 36–41.

Taylor, John. "Avant Guardians." *Building Stone Magazine* (November/December 1986): 24–35.

"Third Time's a Charm, Maybe?" *Architectural Record* 177 (March 1989): 43.

The Thirtieth Anniversary Committee of the Museum of Modern Art. *The Museum of Modern Art Builds.* New York: Thirtieth Anniversary Committee of the Museum, 1962.

Thomas, Rose. "'Invisible' Museum Attracts National Attention." *Building Design & Construction* 29 (March 1988): 108–15.

Thomson, Garry. *The Museum Environment.* 2nd ed. London: Butterworth, in association with the International Institute for the Conservation of Historic and Artistic Works, 1986.

Thorson, Alice. "Chicago: Simple Addition." *ARTnews* 87 (September 1988): 35–36.

"Tipping the Scales: Sackler Wing, Metropolitan Museum of Art, New York." *Progressive Architecture* 60 (May 1979): 98–101.

Tompkins, Calvin. *Merchants and Masterpieces: The Story of the Metropolitan Museum of Art.* New York: Dutton, 1970.

Truppin, Andrea. "Pure Theatre: Twenty-Five Years After Its Lively Beginnings, Hardy Holzman Pfeiffer Continues to Broaden the Designer's Role." *Interiors* 146 (July 1987): 161–79.

———. "With a Career Spanning 40 Years, Charles Moore's Influence as Seminal Designer Is Recognized and Currently Expressed in a Museum, Two Churches and a Library." *Interiors* 147 (September 1987): 192–208.

UNESCO. *The Organization of Museums: Practical Advice.* Paris: UNESCO Press, 1960.

Vance, David. "Planning Ahead: The Registrar's Role in a Building Program." *Museum News* 58 (March/April 1980): 60–63, 76.

Venturi, Robert. "From Invention to Convention in Architecture: The Thomas Cubitt Lecture." *Royal Society of Arts Journal* 136 (January 1988): 89–103.

Viladas, Pilar. "Full Circle: Hammond Beeby & Babka's Addition to an Art Museum." *Progressive Architecture* 69 (November 1988): 73–81.

———. "La Jolla Museum's Expansion Plans." *Progressive Architecture* 69 (July 1988): 30.

"Virginia Museum of Fine Arts, West Wing, Richmond, Virginia." *Arbitare*, no. 247 (September 1986): 375.

Vonier, Thomas. "Adding Two New Museums to the Mall." *Progressive Architecture* 68 (November 1987): 25–27.

Wallach, Amei. "In Art, Building Is All the Rage." *New York Newsday*, 8 February 1987, sec. 2, pp. 4–5, 17.

"Walters Art Gallery Addition, Baltimore, Maryland." *Architectural Record* 169 (1981): 126–29.

Ward, Richard B. "A Museum Grows in Brooklyn." *ARTnews* 85 (September 1986): 79–83.

Warren, Charles. "A Classicism of Timely Expression: Art Institute of Chicago." *Inland Architect* 33 (May/June 1989): 64–69.

"Well-Related Addition for Detroit Art Institute." *Progressive Architecture* 44 (September 1963): 69.

Wexner Center for the Visual Arts. London: Academy Editions; New York: St. Martin's Press, 1990.

"Wexner Center for the Visual Arts, Columbus, Ohio." *GA Document*, no. 26 (1990): 6–27.

"What Wright Has Wrought." *Metropolis* 6 (April 1987): 20–21.

Wheeler, Karen Vogel, Peter Arnell, and Ted Bickford, eds. *Michael Graves: Building and Projects, 1966–1981*. New York: Rizzoli, 1982.

Whiteson, Leon. "Eccentric Pavilion for Japanese Art." *Progressive Architecture* 69 (1988): 33–34.

"The Whitney Museum Announces Revised Expansion Plans." *Oculus* 48 (April 1987): 6–7.

"Whitney Museum of American Art Extension." *Architectural Record* 166 (August 1979): 54–55.

Williams, Sarah. "Galleries for Tomorrow's Art." *ARTnews* 83 (November 1984): 9–10.

Wilson, William. "Price Collection—An Airing at LACMA." *Los Angeles Times*, 2 March 1986, p. 2.

———. "The Scrutable Joe Price and His Museum." *Los Angeles Times*, 23 December 1984, California section, p. 83.

Wissinger, Joanna. "Metropolitan's New 20th Century Wing." *Progressive Architecture* 67 (June 1986): 25.

Wittlin, Alma S. *The Museum: Its Tasks in Education*. London: Routledge and Kegan Paul, 1949.

———. *Museums: In Search of a Usable Future*. Cambridge, Mass.: MIT Press, 1970.

Wittreich, Warren J. "How to Buy/Sell Professional Services." *Harvard Business Review* (March/April 1966): 127–38.

Woodward, Richard B. "Thinking Big Again in Brooklyn." *ARTnews* 85 (December 1986): 41, 178.

"Working Together: The Museum and the Architect." *Museum News* 66 (May/June 1988): 34–39.

Wright, Bruce N., and Mark A. Branch. "Two New Gehry Museums." *Progressive Architecture* 72 (January 1991): 25–26.

Yarrow, Andrew. "Met Plans Park Entrance and Restaurants." *New York Times*, 22 September 1989, sec. C, p. 29.